Mapping the Futures

There are now new experiences of space and time; new tensions between globalism and regionalism, socialism and consumerism, reality and spectacle; new instabilities of value, meaning and identity – a dialectic between past and future. How are we to understand these?

Mapping the Futures is the first of a series which brings together cultural theorists from different disciplines to assess the implications of economic, political and social change for intellectual inquiry and cultural practice. The series arises from and continues the concerns of *BLOCK* (1979–89), the journal of visual culture.

The collection offers radical reformulations of cultural theory in response to political, economic and technological change. In particular it focuses upon the intellectual project of speculating about the future, presenting a variety of approaches to thinking about change and its effects on hierachies, boundaries and identities. The first section establishes overviews of the key issues involved in the cultural politics of space; the second concentrates on the effects of change in specific localities; the third confronts the claims of theory to describe and evaluate the globalization of culture and new cultural forms and alliances. In conclusion, contributors examine the persistence of history and speculate on emergent realities.

The editors: Jon Bird, Barry Curtis, Tim Putnam, George Robertson and Lisa Tickner all lecture at Middlesex University.

The contributors: Micha Bandini, Jon Bird, Iain Chambers, Steven Connor, Barry Curtis, Peter Dunn and Loraine Leeson, Mike Featherstone, Ashraf Ghani, David Harvey, Dick Hebdige, Robert Hewison, Peter Jackson, Ruth Levitas, Doreen Massey, Meaghan Morris, Francis Mulhern, Tim Putnam, George Robertson, Gillian Rose, Neil Smith, Lisa Tickner, Judith Williamson.

FUTURES: New perspectives for cultural analysis

Edited by Jon Bird, Barry Curtis, Tim Putnam,
George Robertson and Lisa Tickner

Recent postmodern philosophers have undermined the viability of social
and cultural futures as an urgent priority for cultural theory. The 'Futures'
series sets out to reinstate the discussion of the future in cultural enquiry
through a critical engagement with postmodernity. Each volume will draw
together new developments in a range of disciplines that have taken as
their common focus some particular aspect of social transformation and
cultural analysis.

Mapping the Futures

Local cultures, global change

Edited by Jon Bird, Barry Curtis,
Tim Putnam, George Robertson
and Lisa Tickner

London and New York

First published 1993
by Routledge
11 New Fetter Lane, London EC4P 4EE

Simultaneously published in the USA and Canada
by Routledge
29 West 35th Street, New York, NY 10001

Typeset in 10/12pt Times by
Florencetype Ltd, Kewstoke, Avon
Printed in Great Britain by
Butler & Tanner Ltd, Frome

British Library Cataloguing in Publication Data
Mapping the Futures: Local Cultures, Global Change
 I. Bird, Jon
 306

Library of Congress Cataloging in Publication Data
Mapping the futures : local cultures, global change / edited by Jon
 Bird . . . [et al.].
 p. cm. — (Futures, new perspectives for cultural analysis)
 1. Social change. 2. Forecasting. 3. Postmodernism–Social
aspects. 4. Space perception. 5. Home. 6. Political culture.
I. Bird, Jon. II. Series.
HM101. M266 1993
303.4–dc20 92-8718

ISBN 0-415-07017-1 ISBN 0-415-07018-X (pbk)

Contents

Part III Moving times

Part IV Shifting values

Part V Thinking futures

Figures

Notes on contributors

Micha Bandini is Head of the Department of Architecture and Interior Design at the University of North London and teaches history and theory on the postgraduate programme at the Architectural Association. She is currently researching contemporary critical practice in architecture and large-scale urban design.

Jon Bird is Principal Lecturer in History of Art and Cultural Studies at Middlesex University. He is a founder editor of *BLOCK*, a co-editor (with Lisa Tickner) of a forthcoming art history series for Routledge, and has written extensively on contemporary art.

Iain Chambers teaches courses on contemporary British culture, cultural theory and aesthetics at the Istituto Universitario Orientale, Naples. He is the author of *Urban Rhythms: Pop Music and Popular Culture* (1985), *Popular Culture: The Metropolitan Experience* (1986) and *Border Dialogues: Journeys in Postmodernism* (1990).

Steven Connor is Reader in Modern English Literature and Director of the Centre for Interdisciplinary Research at Birkbeck College, University of London. He is the author of *Postmodernist Culture: An Introduction to Theories of the Contemporary* (1989) and *Theory and Cultural Value* (1992).

Barry Curtis is a Senior Lecturer in Cultural Studies, Film, Media and Design Studies at Middlesex University. A founder editor of *BLOCK*, he is working on architectural and cultural theory in postwar Britain.

Peter Dunn and Loraine Leeson are the founders of The Art of Change and Docklands Community Poster Project. They both teach fine art and critical studies at St Martin's School of Art.

Mike Featherstone is Professor of Sociology at the University of Teesside. He has edited *Theory, Culture and Society* since its foundation in 1982. His publications include *Consumer Culture and Postmodernism* (1991), *Global Culture* (ed.) (1990) and *The Body* (ed.) (1991).

Ashraf Ghani is Associate Professor of Anthropology at Johns Hopkins University. He is currently working on a book on Afghanistan.

David Harvey is Halford Mackinder Professor of Geography at the University of Oxford. His previous books include *Social Justice and the City* (1973), *The Limits to Capital* (1982), *The Urban Experience* (1989) and, most recently, *The Condition of Postmodernity* (1989).

Dick Hebdige is Reader in Communications at Goldsmiths' College, University of London, and is currently serving as Dean of Critical Studies at the California Institute of Arts. He has been a regular contributor to *BLOCK* with articles on design and taste. His most recent publication is a collection of essays *Hiding in the Light* (1988).

Robert Hewison is the author of *Future Tense: A New Art for the Nineties*, the companion volume to his study *The Heritage Industry* (1987). He has published a three-volume history of the arts in Britain, 1939–75, and is now working on a critical account of postwar cultural policies and politics. He writes on theatre and the arts for the *Sunday Times* and is a regular presenter of *Night Waves* on Radio 3.

Peter Jackson teaches social and cultural geography at University College London. He is the author of *Maps of Meaning* (1989) and the editor of *Race and Racism* (1987).

Ruth Levitas is Senior Lecturer in Sociology at the University of Bristol. She has published widely in the field of social and political theory. She edited *Ideology of the New Right* (1986) and is author of *The Concept of Utopia* (1990)

Doreen Massey is Professor of Geography at the Open University. She is a member of the editorial board of *New Left Review* and the author of several books on economic geography including *Spatial Divisions of Labour* (1984). Her most recent publication (with Paul Quintas and David Wield) is *High Tech Fantasies: Science Parks in Society, Science and Space* (1992).

Meaghan Morris is an Australian-based theorist and writer who has written extensively on film, cultural studies and feminist theory, and is the author of *The Pirate's Fiancée: Feminism, Reading, Postmodernism* (1988).

Francis Mulhern is Senior Lecturer in English at Middlesex University. He is the author of *The Moment of Scrutiny* (1979), and for many years was on the editorial board of *New Left Review*.

Tim Putnam is Principal Lecturer in History at Middlesex University and co-ordinates post-graduate courses in history of design and modern social

history. He has recently written (with Judith Alfrey) *The Industrial Heritage* (1991), and edited (with Charles Newton) *Household Choices* (1990).

George Robertson is a Research Scholar in Art and Design at Middlesex University. He lectures in cultural studies and art history and is working on utopian discourses and the avant-garde.

Gillian Rose teaches social and cultural geography at Queen Mary and Westfield College, University of London. She has published several papers on the construction of space and place, and has just completed a book-length study of the masculinism of the geographical imagination, *Feminism and Geography*.

Neil Smith is Professor and Chair of Geography at Rutgers University, New Jersey. He is the author of *Uneven Development: Nature, Capital and the Production of Space* (1984) and editor (with Peter Williams) of *Gentrification of the City* (1986).

Lisa Tickner is Reader in the History of Art and Design at Middlesex University. She is a founder editor of *BLOCK*, a member of the editorial advisory board of *Women: A Cultural Review*, and co-editor (with Jon Bird) of a series of art history books in preparation for Routledge. She is author of numerous articles on art history and theory and of *The Spectacle of Women: Imagery of the Suffrage Campaign 1907–1914* (1988).

Judith Williamson is a writer and critic who lives in London and teaches part-time at Middlesex University. She is the author of *Decoding Advertisements* (1978) and *Consuming Passions* (1986); her latest book is *Deadline at Dawn*.

Acknowledgements

BLOCK has always been a collaborative project and our friends and contributors over the years – too numerous to list – deserve our thanks first. The support of the Visual Arts Department of the Arts Council of Great Britain, and in particular and most recently that of Sandy Nairne and Sara Wason, has been invaluable. We are grateful to Nicholas Serota, Director of the Tate Gallery, for hosting (and introducing) the conference on which this book is based; and to Richard Humphreys, Head of the Education Department and his colleague Sylvia Lahav, who worked closely with us on its organization.

It is, of course, the contributors to the conference – audience and speakers – who made the event, and thus the book. We thank them all, but in particular David Harvey – for his original encouragement, for his suggestions of possible themes and participants, and for his willingness to engage in critical debate – and Meaghan Morris for coming halfway round the world to argue with him. At Middlesex University, we thank our colleagues and, in particular, Penny Chesterman for her endless patience and goodwill; George Robertson, conference organizer and fellow editor, for grace under pressure; and Melinda Mash for helping when help was needed. We thank Jessica Evans for allowing us to use her photo for the cover and Krzysztof Wodiczko for permission to reproduce the Homeless Vehicle pictures. At Routledge, we acknowledge with gratitude the support and encouragement of our editor, Rebecca Barden and desk editor, Virginia Myers. Finally, with some surprise, we acknowledge each other, and despite all the aggravations and sticky moments in difficult times, our own persistence in these extra-curricular activities.

Introduction

This book grew out of a conference which grew out of a journal – *BLOCK* – that first appeared in 1979. *BLOCK* was edited by a group of art historians with extra-curricular interests. It was intended not only to 'address the problems of the social, economic and ideological dimensions of the arts in societies past and present', but to contribute to an interdisciplinary study of representation in general, beyond the limits of art history as that was conventionally understood. In this, it was one more sign of the times; one of a number of similiar initiatives aiming to introduce into the field of visual culture a more rigorously materialist and political analysis. Ten years and fifteen issues later, it seemed to us that we had helped to achieve a useful merging and enriching of politics, cultural theory and aesthetics; but also that that original moment had, for various reasons, passed.

BLOCK tried to be timely as well as theoretical; to address popular as well as high culture; to apply the perceptions developed in some disciplines to analyses in others. This could produce problems for writers, editors and readers alike. Feelings ran high; it was hard to be rigorous, accessible and relevant in the 1980s without being occasionally opaque, dogmatic or beside the point. We like to think we managed it on the whole. We were much xeroxed (the ultimate accolade). Others will judge.

BLOCK, of course, has a material history of its own. The core group of editors has stayed almost unchanged since 1979. It is not a house journal, but all of us teach in the School of Art History and Related Studies at Middlesex University, and have benefited from the support of immediate colleagues as well as of a more dispersed circle of regular contributors and friends. All these people – and hence *BLOCK* itself – have suffered from cuts in resources in higher education. There are fewer writers, harder pressed, who, in consequence, publish less. The editors teach across a variety of courses in art history, design history, cultural studies and film: the contents and methodologies of which have grown out of work on *BLOCK* and found expression in it. On these courses, too, there are rapidly increasing student numbers and diminishing resources.

So in 1989, and despite an expanding readership, we decided to change direction. There were new pressures, but also new titles – a range of publications in the arts, cultural studies and media that had not existed in 1979 – and new opportunities (not least new audiences among those who had moved across subject boundaries and taught or studied on inter- and multi-disciplinary courses).

With help from the Arts Council of Great Britain and with the collaboration of the Tate Gallery and Routledge, we embarked on a programme of three conferences, each of which would focus speculation and debate in a particular area of cultural analysis and lead to publication in book form. This is the first. It *is* a book, rather than a collection of conference papers (it has additional contributors and a different structure). But we should at this point acknowledge the contributions and influence of all those at the November 1990 'Futures' conference at the Tate Gallery who made this book possible.

We wanted to begin by looking at space and place in a context of massive global change: political, economic, social, technological and geographic. We wanted to bring cultural studies and cultural geography closer together. We wanted to find ways of 'thinking futures' amid the accelerating instabilities of all kinds of value, meaning and identity. (We also hoped to avoid getting stuck in the now-rutted mire of 'postmodernity' as a catch-all term.) Geographers – particularly David Harvey as our keynote speaker here – have been able to bring to cultural analysis a new focus on space, distribution and the various and apparently paradoxical interpenetrations of the local and the global. Their views have not gone uncontested. And we do not mean to suggest that it is possible to bolt together political economy, cultural geography and cultural studies (let alone art history) into a new master narrative or *grand récit*. But the partial and contingent, while less presumptuous, may well fall short. A social and cultural analysis – or a series of related and supportive analyses – that is adequate (in its explanations), non-reductive (in its effects) and enabling (of positive social change) still has to be argued for.

Part I of the book groups together contributions from David Harvey, Meaghan Morris, Ashraf Ghani, Doreen Massey and Gillian Rose, all of which address (in different ways) the cultural politics of space. Part II, with essays by Neil Smith, Jon Bird, Peter Dunn and Loraine Leeson and Tim Putnam, looks at changes in particular localities and in the organization and representation of place, both public and domestic. Part III identifies the likely effects of traditional histories, loyalties and cultures on political futures within both global and local perspectives, with essays by Mike Featherstone, Iain Chambers and Francis Mulhern. Part IV, with contributions from Peter Jackson, Steven Connor, Micha Bandini and Robert Hewison, considers shifting values in cultural and critical practices in relation to the 'condition of postmodernity'. Part V, from Ruth Levitas,

Judith Williamson and Dick Hebdige, takes a speculative leap into the future, but a leap constrained, as they argue, by the exigencies of the present, including our own unexamined vocabularies and habits of thought.

Thinking about the future is not an everyday activity for people whose professional work is usually regarded as a reordering of the past. It is hard not to feel numb, or powerless, or apocalyptic. With so much of the world so recently, and in some cases so bloodily and comprehensively reordered, it is difficult to avoid a sense of momentous geographical trauma. For those of us who regarded our interest in culture as inevitably compounded with an awareness of the operations of power, this would seem to be a particularly significant time. The purpose of these essays is to try to gain some purchase on present changes and to extrapolate from them possible futures.

Jon Bird, Barry Curtis, Tim Putnam,
George Robertson, Lisa Tickner

Part I

The cultural politics of space

Chapter 1

From space to place and back again: Reflections on the condition of postmodernity

David Harvey

Counting the cars on the New Jersey Turnpike
 They've all gone to look for America
 All gone to look for America
 (Simon and Garfunkel)

INTRODUCTION

In the conclusion to *The Condition of Postmodernity* (Harvey 1989: 355) I proposed four areas of development to overcome the supposed crisis of historical materialism and Marxism. These were:

1 The treatment of difference and 'otherness' not as something to be added on to more fundamental Marxist categories (like class and productive forces) but as something that should be omnipresent from the very beginning in any attempt to grasp the dialectics of social change.
2 A recognition that the production of images and discourses is an important facet of activity that has to be analysed as part and parcel of the reproduction and transformation of any social order.
3 A recognition that the dimensions of space and time matter and that there are real geographies of social action, real as well as metaphorical territories and spaces of power that are the sites of innumerable differences that have to be understood both in their own right and within the overall logic of capitalist development. Historical materialism, in short, must take its geography seriously.
4 A theoretical and practical recognition that historical–geographical materialism is an open-ended and dialectical mode of enquiry rather than a closed and fixed body of understandings. Marx's theory of a capitalist mode of production, for example, is not a statement of total truth but an attempt to come to terms with the historical and geographical truths that characterize capitalism, both in general as well as in its particular phases and forms.

It is in this spirit that I turn to just one particular topic broached in *The*

Condition of Postmodernity and attempt both a clarification and an elaboration of its importance to the overall argument. I want to examine in more detail the shifting relations between space and place and to explain, in particular, why it might be that the elaboration of place-bound identities has become more rather than less important in a world of diminishing spatial barriers to exchange, movement and communication.

THE PROBLEM OF PLACE

An initial point of clarification will, I fear, not clarify much. There are all sorts of words such as milieu, locality, location, locale, neighbourhood, region, territory and the like, which refer to the generic qualities of place. There are other terms such as city, village, town, megalopolis and state, which designate particular kinds of places. There are still others, such as home, hearth, 'turf', community, nation and landscape, which have such strong connotations of place that it would be hard to talk about one without the other. 'Place' also has an extraordinary range of metaphorical meanings. We talk about the place of art in social life, the place of women in society, our place in the cosmos, and we internalize such notions psychologically in terms of knowing our place, or feeling we have a place in the affections or esteem of others. We express norms by putting people, events and things in their proper place and seek to subvert norms by struggling to define a new place from which the oppressed can freely speak. Place has to be one of the most multi-layered and multi-purpose words in our language.

While this immense confusion of meanings makes any theoretical concept of place immediately suspect, I regard the generality, the ambiguity and the multiple layers of meanings as advantageous. It suggests, perhaps, some underlying unity which, if we can approach it right, will reveal a great deal about social, political and spatial practices in interrelation with each other. So, although I shall concentrate mainly on the territoriality of place, the very looseness of the term lets me explore connections to other meanings. I shall suggest, for example, that while the collapse of spatial barriers has undermined older material and territorial definitions of place, the very fact of that collapse (the threat of 'time–space compression' as I called it in *The Condition of Postmodernity*) has put renewed emphasis upon the interrogation of metaphorical and psychological meanings which, in turn, give new material definitions of place by way of exclusionary territorial behaviour. Explorations of this sort should help clarify the thorny problem of 'otherness' and 'difference' (made so much of in postmodern rhetoric) because territorial place-based identity, particularly when conflated with race, ethnic, gender, religious and class differentiation, is one of the most pervasive bases for both progressive political mobilization and reactionary exclusionary politics.

There is, it also happens, a theoretical lesson to be had from such an enquiry. It permits reflection on the question of how to sustain and elaborate general theory in the face of particularity and difference. In this respect, geographers' experiences are of interest. When the rest of social science was dealing with general theories specified in time, geographers were struggling with the specificities of place. Furthermore, the incorporation of space into existing social theory, of whatever sort, always seemed to disrupt its power. The innumerable contingencies, specificities and 'othernesses' which geographers encountered could be (and often were) regarded by geographers as fundamentally undermining (dare I say 'deconstructing') of all forms of social scientific metatheory. The prime source of this difficulty is not hard to spot. None of us can choose our moment in time and, being determinate, time is more easily open to theories of determination. But we do have a range of choices as to location and such choices matter because the potential fixity of spatial configuration (a building, a city) permits that choice to have the apparent effect of freezing time (if only for a moment). The effect is to fragment and shatter the more easily specified processes of temporal change. These sorts of arguments have recently entered into literary theory. Kristin Ross (1988), for example, follows Feuerbach in suggesting that 'time is the privileged category of the dialectician, because it excludes and subordinates where space tolerates and coordinates'. The inference, of course, is that geography is not open to universal theory and *is* the realm of specificity and particularity. My own view, however, is that while too much can be made of the universal at the expense of understanding particularity, there is no sense in blindly cantering off in the other direction into that opaque world of supposedly unfathomable differences in which geographers have for so long wallowed. The problem is to rewrite the metatheory, to specify dialectical processes in time–space, rather than to abandon the whole project. An account of the role of place in social life should prove helpful in this regard.

The first step down that road is to insist that place in whatever guise is, like space and time (see Harvey 1990) a social construct. The only interesting question that can be asked is: by what social process(es) is place constructed? I shall try to get a fix on that problem by looking at two quite different answers and then triangulate in to suggest a conceptual resolution of the problem.

THE POLITICAL ECONOMY OF PLACE AND CONSTRUCTION UNDER CAPITALISM

I begin with a consideration of capitalism's historical trajectory of geographical expansion through the construction of actual places. Since I have written extensively on this topic elsewhere (Harvey 1982, 1985), I shall here offer a very abbreviated account.

Capitalism is necessarily growth oriented, technologically dynamic, and crisis prone. It can temporarily and in part surmount crises of overaccumulation of capital (idle productive capacity plus unemployed labour power) through geographical expansion. There are two facets to this process. First, excess capital can be exported from one place (region, nation) to build another place within an existing set of space relations (e.g. the recent history of Japanese investment of capital surpluses in overseas real estate development). Second, space relations may be revolutionized through technological and organizational shifts that 'annihilate space through time'. Such revolutions (the impact of turnpikes, canals, railways, automobiles, containerization, air transport and telecommunications) alter the character of places (if only in relation to each other) and thereby interact with the activities of place construction.

In either case, new networks of places (constituted as fixed capital embedded in the land) arise, around which new territorial divisions of labour and concentrations of people and labour power, new resource extraction activities and markets form. The geographical landscape that results is not evenly developed but strongly differentiated. 'Difference' and 'otherness' is *produced* in space through the simple logic of uneven capital investment and a proliferating geographical division of labour. There are tensions within this process. To begin with, it is necessarily speculative (like all forms of capitalist development). Place construction ventures often go wrong or become mired down in speculative swindles. Charles Dickens used the history of a mythical New Eden in *Martin Chuzzlewit* as a witty denunciation of a process which continues to this day as pensioners head down to their retirement plot in sunny Florida to find it is in the middle of a swamp. Thorsten Veblen (1967) argued, and I think he was basically correct, that the whole settlement pattern of the United States should be understood as one vast venture in real estate speculation. To say, therefore, that place construction is a given in the logic of capitalism's production of space is not to argue that the geographical pattern is determined in advance. It is largely worked out a posteriori through competition between places.

The second difficulty arises out of the inevitable tension between speculative investment in land development and the geographical mobility of other forms of capital. Those who have invested in the former have to ensure that activities arise that render their investments profitable. Coalitions of entrepreneurs actively try to shape activities in places for this purpose. Hence the significance of local 'growth-machine' politics of the sort that Logan and Molotch (1987) describe and of local class alliances to promote economic development in places. The 'social networking' which occurs in and through places to procure economic advantage may be intricate in the extreme but at the end of the day some sort of coalition, however shifting, is always in evidence. But such coalitions cannot always

succeed. Competition between places produces winners and losers. The differences between places to some degree become antagonistic.

The tension between fixity and mobility erupts into generalized crises, however, when the landscape shaped in relation to a certain phase of development (capitalist or precapitalist) becomes a barrier to further accumulation. The landscape must then be reshaped around new transport and communications systems and physical infrastructures, new centres and styles of production and consumption, new agglomerations of labour power and modified social infrastructures (including, for example, systems of governance and regulation of places). Old places have to be devalued, destroyed and redeveloped while new places are created. The cathedral city becomes a heritage centre; the mining community becomes a ghost town; the old industrial centre is deindustrialized; speculative boom towns or gentrified neighbourhoods arise on the frontiers of capitalist development or out of the ashes of deindustrialized communities. The history of capitalism is punctuated by intense phases of spatial reorganization. There has been, as I sought to show in *The Condition of Postmodernity* a powerful surge of this from about 1970, creating considerable insecurity within and between places.

I can now venture a first cut at explaining why it is that place has become more rather than less important over the past two decades:

1 Space relations have been radically restructured since around 1970 and this has altered the relative locations of places within the global patterning of capital accumulation. Urban places that once had a secure status find themselves vulnerable (think of Detroit, Sheffield, Liverpool and Lille); residents find themselves forced to ask what kind of place can be remade that will survive within the new matrix of space relations and capital accumulation. We worry about the meaning of place in general when the security of actual places becomes generally threatened.

2 Diminished transport costs have made production, merchanting, marketing and particularly finance capital much more geographically mobile than heretofore. This allows a much freer choice of location which, in turn, permits capitalists to take more rather than less advantage of small differences in resource qualities, quantities and costs between places. Multinational capital, for example, has become much more sensitive to the qualities of places in its search for more profitable accumulation.

3 Those who reside in a place (or who hold the fixed assets in place) become acutely aware that they are in competition with other places for highly mobile capital. The particular mix of physical and social infrastructures, of labour qualities, of social and political regulation, of cultural and social life on offer (all of which are open to construction) can be more or less attractive to, for example, multinational capital.

Residents worry about what package they can offer that will bring development while satisfying their own wants and needs. Places therefore differentiate themselves from other places and become more competitive (and perhaps antagonistic and exclusionary with respect to each other) in order to capture or retain capital investment. Within this process, the selling of place, using all the artifices of advertising and image construction that can be mustered, has become of considerable importance. 'Someday we all go to a better place', announces a vast hoarding in Croydon, advertising for relocation in Milton Keynes.

4 Profitable projects to absorb excess capital have been hard to find in these last two decades, and a considerable proportion of the surplus has found its way into speculative place construction. The lack of wisdom in much of this is now becoming clear in the massive default of savings and loan institutions in the United States ($500bn – larger than the combined Third World debt) and the shaky position of many of the world's largest banks (including the Japanese) through overinvestment in real estate development. The selling of places and the highlighting of their particular qualities (retirement or tourist resorts, communities with new lifestyles, etc.) become even more frenetic.

The upshot has been to render the coercive power of competition between places for capitalist development more rather than less emphatic and so provide less leeway for projects of place construction that lie outside of capitalist norms. The concern to preserve a good business environment or to realize a profit from speculative development dominates. Interplace competition is not simply about attracting production, however. It is also about attracting consumers through the creation of a cultural centre, a pleasing urban or regional landscape, and the like. Investment in consumption spectacles, the selling of images of places, competition over the definition of cultural and symbolic capital, the revival of vernacular traditions associated with places, all become conflated in interplace competition. I note in passing that much of postmodern production in, for example, the realms of architecture and urban design, is precisely about the selling of place as part and parcel of an ever-deepening commodity culture. The result is that places that seek to differentiate themselves end up creating a kind of serial replication of homogeneity (Boyer 1988).

The question immediately arises as to why people accede to the construction of their places by such a process. The short answer, of course, is that often they don't. The historical geography of place construction is full of examples of struggles fought for socially just reinvestment (to meet community needs); for the development of 'community', expressive of values other than those of money and exchange; or against deindustrialization, or the despoliation of cities through highway construction (even the upper classes organize against the destruction of their neighbourhoods by

the activities of some crass developer). Henri Lefebvre (1991) is quite right, therefore, to insist that class struggle is everywhere inscribed in space through the uneven development of the qualities of places. Yet it is also the case that such resistances have not checked the overall process (speculative capital when denied the option to despoil one city has the habit of quickly finding somewhere else to go).

But instances of popular complicity with speculative activities are also plentiful. These typically arise out of a mixture of coercion and co-optation into support of capitalist projects of place construction. Co-optation is largely organized around

1 dispersed property ownership which provides a mass base for specu-
 lative activity (no one wants to see the value of their house tumbling);
2 the benefits supposedly to be had from expansion (bringing new
 employment and economic activities into town); and
3 the sheer power of pro-capitalist techniques of persuasion (growth is
 inevitable as well as good for you).

For these reasons, labour organizations often join rather than oppose local growth coalitions. Coercion arises either through interplace competition for capital investment and employment (accede to the capitalist's demands or go out of business; create a 'good business climate' or lose jobs) or, more simply, through the direct political repression and oppression of dissident voices (from cutting off media access to the more violent tactics of the construction mafias in many of the world's cities).

But I doubt that the purchase of place over our thinking and our politics can simply be attributed to these trends, powerful and persuasive as they may be in many instances. The generalization of civic boosterism, of growth-machine politics, of cultural homogenization through diversifi-cation, hardly provides what many would regard as an authentic basis for place-bound identities and it cannot account for the strength of political attachments which people manifest in relation to particular places. So where can we look for other explanations?

HEIDEGGER AND PLACE AS THE LOCUS OF BEING

'Place', said Heidegger, 'is the locale of the truth of Being.' Many writers – particularly those within the phenomenological tradition – have drawn heavily from him and it is useful to see how his argument unfolds. The following quotation contextualizes his argument:

All distances in time and space are shrinking. . . . Yet the frantic abolition of all distances brings no nearness; for nearness does not consist in shortness of distance. What is least remote from us in point of distance, by virtue of its picture on film or its sound on radio, can remain

far from us. What is incalculably far from us in point of distance can be near to us. . . . Everything gets lumped together into uniform distance-lessness. . . . What is it that unsettles and thus terrifies? It shows itself and hides itself in the *way* in which everything presences, namely, in the fact that despite all conquest of distances the nearness of things remains absent.

(Heidegger 1971: 165)

Notice the sense of terror at the elimination of spatial barriers (cf. the 'terror of time–space compression' which I have commented on else-where). This terror is ineluctably present in daily life because all mortals 'persist through space by virtue of their stay among things' and are there-fore perpetually threatened by changing space relations among things. Physical nearness does not necessarily bring with it understanding or an ability to appreciate or even appropriate a thing properly. Heidegger recognizes that the achieved shifts in space relations are a product of commodification and market exchange and he invokes an argument close to Marx's:

the object-character of technological dominion spreads itself over the earth ever more quickly, ruthlessly, and completely. Not only does it establish all things as producible in the process of production; it also delivers the products of production by means of the market. In self-assertive production, the humanness of man and the thingness of things dissolve into the calculated market value of a market which not only spans the whole earth as a world market, but also, as the will to will, trades in the nature of Being and thus subjects all beings to the trade of a calculation that dominates most tenaciously in those areas where there is no need of numbers.

(Heidegger 1971: 114–15)

Heidegger, however, reacts to all this in a very particular way. He with-draws from the world market and seeks ways to uncover the truths of human existence and meaning through meditation and contemplation. The concept that he focuses on is that of 'dwelling'. He illustrates it with a description of a Black Forest farmhouse:

Here the self-sufficiency of the power to let earth and heaven, divinities and mortals enter in simple oneness into things, ordered the house. It places the farm on the wind-sheltered mountain slope looking south, among the meadows close to the spring. It gave it the wide overhanging shingle roof whose proper slope bears up under the burden of snow, and which, reaching deep down, shields the chambers against the storms of the long winter nights. It did not forget the altar corner behind the community table; it made room in its chamber for the hallowed places of childbed and the 'tree of the dead' – for that is what they call a coffin

there; the Totenbaum – and in this way it designed for the different generations under one roof the character of their journey through time. A craft which, itself sprung from dwelling, still uses its tools and frames as things, built the farmhouse.

(Heidegger 1971: 160)

Dwelling is the capacity to achieve a spiritual unity between humans and things. From this it follows that 'only if we are capable of dwelling, only then can we build'. Indeed, buildings 'may even deny dwelling its own nature when they are pursued and acquired purely for their own sake' (ibid.: 156). Although there is a narrow sense of homelessness which can perhaps be alleviated simply by building shelter, there is a much deeper crisis of homelessness to be found in the modern world; many people have lost their roots, their connection to homeland. Even those who physically stay in place may become homeless (rootless) through the inroads of modern means of communication (such as radio and television). 'The rootedness, the autochthony, of man is threatened today at its core.' If we lose the capacity to dwell, then we lose our roots and find ourselves cut off from all sources of spiritual nourishment. The impoverishment of existence is incalculable. The flourishing of any genuine work of art, Heidegger insists (1966: 47–8), depends upon its roots in a native soil. 'We are plants which – whether we like to admit it to ourselves or not – must with our roots rise out of the earth in order to bloom in the ether and bear fruit.' Deprived of such roots, art is reduced to a meaningless caricature of its former self. The problem, therefore, is to recover a viable homeland in which meaningful roots can be established. Place construction should be about the recovery of roots, the recovery of the art of dwelling.

Heidegger's 'ontological excavations' have inspired a particular approach to understanding the social processes of place construction. He focuses our attention on the way in which places 'are constructed in our memories and affections through repeated encounters and complex associations' (Relph 1989: 26). He emphasizes how 'place experiences are necessarily time-deepened and memory-qualified'. He provides, it is said, 'a new way to speak about and care for our human nature and environment', so that 'love of place and the earth are scarcely sentimental extras to be indulged only when all technical and material problems have been resolved. They are part of being in the world and prior, therefore, to all technical matters' (ibid.: 27–9). There are, however, some difficulties. Like most great philosophers, Heidegger remained extraordinarily vague in his prescriptions, and his commentators have had a field day elaborating on what all this might mean. For example, what might the conditions of 'dwelling' be in a highly industrialized, modernist and capitalist world? He recognizes explicitly that we cannot turn back to the Black Forest farmhouse, but what is it that we might turn to? The issue of authenticity

(rootedness) of the experience of place is, for example, a difficult one. To begin with, as Dovey (1989: 43) observes, the problem of authenticity is itself peculiarly modern. Only as modern industrialization separates us from the process of production and we encounter the environment as a finished commodity does it emerge. Being rooted in place, Tuan argues, is a different kind of experience from having and cultivating a sense of place: 'A truly rooted community may have shrines and monuments, but it is unlikely to have museums and societies for the preservation of the past' (Tuan 1977: 198). The effort to evoke a sense of place and of the past is now often deliberate and conscious. But herein lies a danger. The quest for authenticity, a modern value, stands to be subverted by the market provision of constructed authenticity, invented traditions and a commercialized heritage culture. The final victory of modernity, MacCannell (1976: 8) suggests, is not the disappearance of the non-modern world but its artificial preservation and reconstruction.

Nevertheless, there seems to be a widespread acceptance of Heidegger's claim that the authenticity of dwelling and of rootedness is being destroyed by the modern spread of technology, rationalism, mass production and mass values. Place is being destroyed, says Relph (1976), rendered 'inauthentic' or even 'placeless' by the sheer organizational power and depth of penetration of the market. The response is to construct a politics of place which is then held up as the political way forward to the promised land of an authentic existence. Here, for example, is Kirkpatrick Sale, writing in a left-wing journal *The Nation* (22 October 1990): 'The only political vision that offers any hope of salvation is one based on an understanding of, a rootedness in, a deep commitment to, and a resecralization of, *place*.'

This, then, permits a second cut at the initial question. Place is becoming more important to the degree that the authenticity of dwelling is being undermined by political–economic processes of spatial transformation and place construction. What Heidegger holds out, and what many subsequent writers have drawn from him, is the possibility of some kind of resistance to or rejection of that simple capitalist (or modernist) logic. It would then follow that the increasing penetration of technological rationality, of commodification and market values, and capital accumulation into social life (or into what many writers, including Habermas, call 'the life world'), together with time–space compression, will likely provoke increasing resistances that focus on alternative constructions of place (understood in the broadest sense of that word). The search for an authentic sense of community and of an authentic relation to nature among many radical and ecological movements is the cutting edge of exactly such a sensibility. Even such a trenchant socialist critic as Raymond Williams saw place as more than 'just the site of an event . . . but the materialization of a history which is often quite extensively retracted' (Williams 1979a: 276) and wrote a series of novels on the border country of Wales to explore its political and

affective meaning. There is certainly enough credibility in the Heideg-gerian argument to make it worthy of careful consideration, even if, as I hope to show, there are strong grounds for its rejection in its pure Heideg-gerian manifestation.

TOWARDS A RESOLUTION OF DIFFERENCE

The differences between the Marxist and Heideggerian traditions highlight some of the supposed oppositions between modernist and postmodernist ways of thinking and feeling. For Marx, analysis of the world of money and commodity production, with all its intricate social relations and universal qualities, defines an equally universal sphere of moral, economic and political responsibility which, though characterized by alienation and exploitation, has to be rescued by a global, political–economic strategy. This does not imply that the daily experiential world, which lies, as it were, within the confines of market fetishism, is irrelevant. Indeed, it is precisely Marx's point that this experience is so authentic as to tempt us permanently to regard it as all there is and so ground our sense of being, of moral responsibility and of political commitments entirely within its frame. Marx (1964) seeks to go beyond that frame and try, as he puts it in his early work, to construct a sense of 'species being' by a politics in which indi-viduals realize their full individuality only through free association with others across the surface of the earth. This is notoriously vague and uncertain rhetoric. But it suggests that we cannot go back; that we cannot reject the world of sociality which has been achieved by the interlinking of all peoples into a global economy; that we should somehow build upon this achievement and seek to transform it into an unalienated experience. The network of places constructed through the logic of capitalist development, for example, has to be transformed and used for progressive purposes rather than be rejected or destroyed.

The more progressive side of the modernist impulse drew much from this sentiment (though the concern with place transformation has been pecu-liarly muted in the Marxist revolutionary tradition). But it is also not hard to see how modernism could become complicitous with the universalisms of money, commodity, capital and exchange without in any way challenging the alienation. It cosied up to a corporate bureaucratic and state capitalist view of the world, and imposed a common language (in the construction of Hilton hotels, for example) of a sort that inhibited any response to aliena-tion. Internationalist, working-class politics that abstracted from the im-mediate experiential world of daily life in particular places could likewise lose its purchase and credibility.

Heidegger, on the other hand, totally rejects any sense of moral respon-sibility beyond the world of immediate sensuous and contemplative experi-ence. He rejects any dealings with the world of commodity, money,

technology and production via any international division of labour. He contracts his field of vision to a much narrower, experiential world to ask questions about the innate and immanent qualities of experience of things. He insists upon the irreducibility of the experience of dwelling and specificities of place and environment. In so doing, he evokes a sense of loss of community, of roots and of dwelling in modern life which evidently strikes a potent chord with many people.

> If places are indeed a fundamental aspect of man's existence in the world, if they are sources of security and identity for individuals and for groups of people, then it is important that the means of experiencing, creating and maintaining significant places are not lost.
>
> (Relph 1976: 96)

The problem is that such sentiments easily lend themselves to an interpretation and a politics that is both exclusionary and parochialist, communitarian if not intensely nationalist (hence Heidegger's respect for Nazism). Heidegger refuses to see mediated social relationships (via the market or any other medium) with others (things or people) as in any way expressive of any kind of authenticity. Indeed, mediated relationships of this sort are felt as threatening to identity and any true sense of self, while anything that contributes to or smacks of rootlessness is rejected outright (does this explain his antagonism to the diaspora and rootlessness of the Jews?). Experience, furthermore, becomes incommunicable beyond certain bounds precisely because authentic art and genuine aesthetic sense can spring only out of strong rootedness in place. This exclusionary vision becomes even more emphatic given his views on the power of language over social life. Places become the sites of incommunicable othernesses. There can be no interlinkage in the world of aesthetics or of communicable meanings of the sort that modernism often sought, even in a context of strong interlinkage in the material world of production and exchange.

From this standpoint, it is not hard to see how Heidegger figures so often in postmodern thinking as a precursor of ideas concerning the creation of 'interpretive communities', fragmented language games, and the like. And it is not hard to see how the crass and commercial side of postmodernism could play upon these sentiments and market the vernacular; simulate the authentic; and invent heritage, tradition and even commercialized roots. Yet, oddly, there persists another commonality with Marx. Heidegger persists in seeing authentic communities as materially and physically rooted in particular places through dwelling, rather than as being constructed solely, as so frequently happens in postmodernist rhetoric, in the realms of discourse.

But if I am correct, and modernism (as it is now generally interpreted) and postmodernism are dialectically organized oppositions within the long history of modernity (Harvey 1989: 339), then we should start to think of

these arguments not as mutually exclusive but as oppositions that contain the other. Marx regards experience within the fetishism as authentic enough but surficial and misleading, while Heidegger views that same world of commodity exchange and technological rationality as at the root of an inauthenticity in daily life that has to be repudiated. This commonality of perception of the root of the problem – though specified as peculiarly capitalist by Marx and as modernist (i.e. both capitalist and socialist) by Heidegger – provides a common base from which to reconstruct a better understanding of place. What happens, then, when we see the differences as dialectical oppositions inherent in the condition of both modernity and postmodernity rather than as irreconcilable contradictions?

The simple answer is that we live in a world of universal tension between sensuous and interpersonal contact in place (with intense awareness of the qualities of that place within which temporal experiences unfold) and another dimension of awareness in which we more or less recognize the obligation and material connection that exists between us and the millions of other people who had, for example, a direct and indirect role in putting our breakfast on the table this morning. Put more formally, what goes on in a place cannot be understood outside of the space relations that support that place any more than the space relations can be understood independently of what goes on in particular places. While that may sound banal or trivially true, the manner of its conception has major ramifications for political thinking and practice.

Consider, for example, a recent essay by Young (1990). She begins with a criticism of some dominant strains of feminism that have focused on the ideal of community. The 'desire for unity or wholeness in discourse', she complains, 'generates borders, dichotomies, and exclusions'. In political theory, furthermore, the concept of community 'often implies a denial of time and space distancing' and an insistence on 'face-to-face interaction among members within a plurality of contexts'. Yet there are 'no conceptual grounds for considering face-to-face relations more pure, authentic social relations than relations mediated across time and distance'. This is a crucial issue. For while it may be true that 'in modern society the primary structures creating alienation and domination are bureaucracy and commodification', it does not follow that all mediated relations are alienating. By positing 'a society of immediate face-to-face relations as ideal, community theorists generate a dichotomy between the "authentic" society of the future and the "inauthentic" society we live in, which is characterized only by alienation, bureaucratization and degradation'. Her criticism of the Heideggerian tradition is strong. 'Racism, ethnic chauvinism, and class devaluation . . . grow partly from the desire for community, that is, from the desire to understand others as they understand themselves and from the desire to be understood as I understand myself.' In the United States today, she argues, 'the positive identification of some groups is often

achieved by first defining other groups as the other, the devalued semihuman'.

Young's solution to this is to replace the ideal of face-to-face community with that of an 'unoppressive city', by building upon those positive experiences of city life in which differences of all sorts are embodied, negotiated and tolerated in the midst of all sorts of mediated relations in time and space. The 'unoppressive city' is defined as 'openness to unassimilated otherness'. While this solution is rather naïvely specified in relation to the actual dynamics of urban experience, the direction to which it points – the celebration of difference and diversity within some overarching unity – is of interest. It presupposes the possibility of somehow bridging the Marxian and Heideggerian conceptions within a new kind of radical politics. There is, however, one other major issue to be considered. Young cites Sandel:

> Insofar as our constitutive self-understandings comprehend a wider subject than the individual alone, whether a family or a tribe or a city or a class or nation or people, to this extent they define a community in the constitutive sense. And what makes such a community is not merely a spirit of benevolence, or the prevalence of communitarian values, or even certain 'shared final ends' alone, but a common vocabulary of discourse and a background of implicit practices and understandings within which the opacity of persons is reduced if never finally dissolved.
> (Sandel 1982: 172–3)

One of the major preoccupations of postmodernist thinking is the discursive construction of identity and 'places' in the social order in ways that have little or nothing to do, except coincidentally, with physical location or territorial expression. This complicates the argument only if an uncompromising break is inserted between how communities and places are represented and imagined on the one hand and how they are actually constituted through material social practices on the other. Yet the insistence upon the roles of both imagination and language has the signal virtue of demonstrating, as Anderson (1983) points out, that communities and places cannot be distinguished in the realms of discourse 'by their falsity/genuineness, but [only] by the style in which they are imagined'. This conclusion is fundamentally at odds with the idea of some easily definable distinction between 'authentic' and 'inauthentic' communities or places. If Marx (1967: 177–8) is right and imagination and representation always precede production, then Heidegger's view becomes just one possible imagined kind of place awaiting a material embodiment. Heidegger may have invoked a long deep past and the seemingly deep permanence of a pristine language, but he also recognized that it was impossible to go back to a world made up of Black Forest farmsteads and that it was necessary to press forward, in ways which national socialism then seemed to promise, to

construct a new kind of 'authentic' community appropriate to that time and place.

Yet it is, paradoxically, the very conditions against which Heidegger revolts which permit the search for an imagined authentic community to become a practical proposition. The long historical geography of capitalism has so liberated us from spatial constraints that we can imagine communities independently of existing places and set about the construction of new places to house such communities in ways that were impossible before. The history of utopian thinking, from Thomas More and Francis Bacon onwards, is illustrative of the discursive point: the penchant for constructing and developing new towns from Welwyn Garden City to Chandigarh, Brazilia or the much talked-about Japanese plan for Multifunctionopolis in Australia testifies to the frequent attempt to materialize such ideas through actual place construction. The difficulty, however, is to reconcile such transformative practices with the desire to retain familiarity, security and the deep sense of belonging that attachment to place can generate.

THE CONSTRUCTION OF PLACES THROUGH SPATIAL PRACTICES

The material practices and experiences entailed in the construction and experiential qualities of place must be dialectically interrelated with the way places are both represented and imagined. This leads me back to the 'Lefebvrian matrix' described in *The Condition of Postmodernity* (Harvey 1989: 220–1) as a way to think through how places are constructed and experienced as material artefacts; how they are represented in discourse; and how they are used in turn as representations, as 'symbolic places', in contemporary culture (Lefebvre 1991). The dialectical interplay between experience, perception and imagination in place construction then becomes the focus of attention. But we also need to work simultaneously across the relations between distanciation (presence/absence and spatial scale), appropriation, domination and production of places. This may all seem rather daunting, especially when coupled with the fact that the matrix provides a mere framework across which social relations of class, gender, community, ethnicity or race operate. But this seems to me the only way to attack the rich complexity of social processes of place construction in a coherent way, while finding some sort of bridge between the concerns expressed in the Marxian and Heideggerian approaches. Let me illustrate.

Times Square in New York City was built up as a pure piece of real-estate and business speculation around the creation of a new entertainment district in the 1890s. In the early 1900s, the name was pushed through by the *New York Times* which had just relocated in the square (after all, the *New York Herald*, its big rival, was located in Herald Square further downtown). The *Times* organized the grand New Year's Eve celebration of

fireworks and, ultimately, the celebratory lowering of the ball, as a promotional gimmick. Thousands came not only on that day but throughout the year to sample the entertainments, watch people, eat out, survey the latest fashions and pick up gossip or information on anything from business and real estate deals to latest trends in entertainment and the private lives of eminent people. Soon the square became the centre of an advertising spectacle which in itself drew in the crowds. Times Square was, in short, created as a representation of everything that could be commercial, gaudy, promotional and speculative in the political economy of place construction. It was a far cry from that authentic dwelling in the Black Forest and, on the surface at least, it surely ought to qualify as the most *ersatz*, or as cultural critics might prefer to call it, 'pseudo-place' on earth. Yet it soon became the symbolic heart of New York City and, until its decline (largely under the impact of television) from the 1950s onwards, it was the focus of a sense of togetherness and community for many New Yorkers. Times Square became *the* place where everyone congregated to celebrate, mourn or express their collective anger, joy or fear. Produced and dominated in the mode of political economy, it was appropriated by the populace in an entirely different fashion. It became an authentic place of representation with a distinctive hold on the imagination, even though as a space of material social practices it had all the character of a purely speculative and commodified spectacle. How could this happen?

Times Square rose to prominence as the modern metropolitan New York of five boroughs and sprawling suburbs began to take shape. Its rise coincided with an extraordinary boom in real-estate speculation; with the coming of mass-transit systems which changed the whole nature of space relations between people within the city (the subway came to Times Square in 1901); with the maturing of new systems of international and national communication (the radio in particular), of information and money flow, of commercialism and the marketing of fashion and entertainment as mass-consumption goods. This was a phase of rapid 'time–space compression', as Kern (1983) records, and even many New Yorkers seemed to lose their sense of identity. The stresses of rapid urban growth kept New Yorkers 'on the run', as it were, perpetually undermining the fragile immigrant and neighbourhood institutions which from time to time gave some sense of security and permanence in the midst of rapid change. What seems to have been so special about Times Square in its halcyon days was that it was a public space in which all classes of society could intermingle: as a classless (or rather a multiclass) place, it had the potential to be the focus of a sense of community which recognized difference but which also celebrated unity. The demi-monde rubbed shoulders with the aristocracy; immigrants of all sorts could share the spectacle; and the democracy of money appeared to be in charge. But community in this instance was not shaped by face-to-face interaction: it was achieved by the act of a common presence in the

face of the spectacle, a spectacle which was shamelessly about the community of money and the commodification of everything. New York's Times Square certainly represented the community of money, but it also became a representation of a quite different notion of community in the minds and affections of millions of New Yorkers who, to this day, will contest plans to transform and redevelop this particular public space precisely because of its unique symbolic meaning and place in the collective memory.

This same sort of story can be told from an exactly opposite direction. The search for authentic community, and in particular a form of community which is expressive of values outside of those typically found in a capitalist, materialist and highly monetized culture, has frequently led to direct attempts at community and place construction according to alternative visions. Yet all those that have survived (and that is a very small proportion) have almost without exception done so by an accommodation to the power of money, to commodification and capital accumulation, and to modern technologies. The survivors have also exhibited a capacity to insert and reinsert themselves into changing space relations. This is as true for such massive upheavals as the fundamentalist Islamic revolution in Iran (which is now walking the tightrope of how to reinsert itself into the world capitalist economy without appearing too overtly to accommodate to Satan) as it was for the innumerable communitarian movements which hived off from capitalism to become, in many instances, the cutting edge of further capitalist development – such as the French Icarians who settled in the United States (see Johnson 1974); the extraordinary wave of communalism and place building (including the Mormons, the Shakers and the early feminists) that had its origins in Western New York State in the first half of the nineteenth century; the anarchist and syndicalist movements which spawned dispersed settlements as far apart as Patagonia and Siberia and which even inspired the New Towns movement of Geddes and Ebenezer Howard. This whole history of place building suggests that a cultural politics has just as frequently been at the root of the inspiration of place construction as has a simple desire for profit and speculative gain. Yet the intertwining of the two is omnipresent and, in some instances, the cultural politics seems more like a means to a political–economic end than an end in itself.

Fitzgerald (1986) in *Cities on a Hill*, provides a fascinating picture of precisely this intersection in the US context. The studies of the gay community's appropriation and subsequent domination of the Castro district of San Francisco, of Jerry Falwell's religious empire in Lynchburg, and of Sun City (a retirement community in Florida), all illustrate the cultural politics of capital accumulation in different ways. By far the oddest of Fitzgerald's studies is, however, that of Rajneeshpuram. Founded in 1981 in a sparsely populated and semi-arid ranching area of Oregon as a 'self-sufficient' commune of the disciples of Bhagwan Shree Rajneesh, it

had all the trappings of a new-age community from the standpoint of lifestyle, yet it also was characterized by a powerful use of money, by high technology and a worldwide internationalism founded on the network of disciples that Rajneesh had cultivated over the years. The ranch cost $1.5m and within two years the Rajneeshis had spent more than £60m in Oregon, by Fitzgerald's account, and had gone a long way towards building a whole new settlement, replete with airstrip, large reservoir, power station, irrigated fields, housing and a whole range of facilities which could support more than 3,000 people permanently and offer temporary accommodation for many thousands more. Rajneesh looked down upon Ghandi and Mother Teresa because of their interest in the poor. Money became the means to the good life. 'Religion is a luxury of the rich', he argued and had twenty-one Rolls-Royces to prove it. Yet the commune demanded at least twelve hours' hard labour a day from its residents and pulled together some highly educated and often technically talented people who set to work in an atmosphere of overtly non-hierarchical social relations and with seeming joy and relish to create a place within which the human potential for personal growth might be realizable. Yet the exclusionary politics of the commune were so strong as to lead it to be represented internally as an island in a sea of spiritual and material decay, and externally as a cancerous foreign body inserted into the heart of rural America. The dissolution of the commune, the deportation of Rajneesh, and the arrest of some of the leading luminaries who, within a few years, had turned the commune from a mecca of personal liberation and human growth into an armed camp (engaging in all kinds of violent acts such as poisoning various officials and introducing salmonella into a neighbouring community's water supply), detracted little, according to Fitzgerald, from the intense feelings of affection felt by many who had passed through the commune. It had provided a home, however temporary, and a range of personal experiences for which people felt grateful. It had met a need, it had fulfilled desires, had allowed fantasies to be lived out in ways that were unforgettable. Yet it had also exhibited all of the intolerance of internal difference, all the subtle hierarchy and exclusionary politics which Young correctly fears is the inevitable end-product of communitarian politics. And for the brief moment of its success, it had all the attributes of a low-wage workcamp sustained out of moral fervour and delivering Rolls-Royces by the score to the guru of the establishment. This was not the first, nor will it be the last time that a cultural politics striving to produce an authenticity of place was to be co-opted and used for narrow financial gain.

The lesson is simple enough. Everyone who moves to establish difference in the contemporary world has to do so through social practices that necessarily engage with the mediating power of money. The latter is, after all, global and universal social power that can be appropriated by individual persons (hence it grounds bourgeois individualism) and any 'inter-

pretive' or 'political' community which seeks to forge a distinctive identity has to accommodate to it. Indeed, in many instances (such as all of those that Fitzgerald investigated), possession of sufficient money power is a necessary condition for exploring difference through place construction. Rajneesh's comment that 'religion is a luxury of the rich' is, in this regard, rather too close for comfort. It is, in short, precisely the universality and sociality of money power that allows all kinds of othernesses to take on an independent existence and to survive. There is nothing in itself particularly wrong with that (if we have the resources, why not be as eclectic as Jencks or Lyotard suggest we should?), but it does force us to consider the relation between the production of difference and otherness in the contemporary world and the organization and distribution of political–economic power. The examples illustrate how cultural politics in general (and the search for affective community in particular) and political–economic power intertwine in the social processes of place construction. It is, we may conclude, inadmissible to try to examine the one without the other.

PLACE AND POWER

To write of 'the power of place', as if places (localities, regions, neighbourhoods, states, etc.) possess causal powers, is to engage in the grossest of fetishisms; unless, that is, we confine ourselves rigorously to the definition of place as a social process. In the latter case, the questions to be posed can be rendered more explicit: why and by what means do social beings invest places (localities, regions, states, communities, or whatever) with social power; and how and for what purposes is that power then deployed and used across a highly differentiated system of interlinked places?

The production and reproduction of power differentiations is central to the operations of any capitalist economy. There is not only that great divide between the proletariat (reified as 'human resources', as if they were more or less substitutable by oil or firewood) and the capitalist class, but there are also the multiple and more nuanced hierarchical divisions which inevitably arise within the detail, social and territorial divisions of labour (between, for example, line workers, overseers, managers, service workers, designers, etc.) as well as those that factionalize the bourgeoisie (different interests in finance, land, production, merchanting, administration, law, science, military and police powers). Differences that preceded the capitalist order – of gender, race, language, ethnicity, religion and pre-capitalist social class – have been absorbed, transformed and reconstructed by a social system in which the accumulation of capital is assured through the domination of nature and control over wage labour. The manner of such reconstitutions deserves scrutiny. The connection between the rise of 'print capitalism', as Anderson (1983) calls it, and the transformation of linguistic diversity into 'imagined communities' of

nations that ground the modern state, is one such case in point. Similarly, the bourgeois tactic of depicting some segment of humanity (women or 'the natives') as a part of nature, the repository of affectivity and as inevitably chaotic and unruly, allowed those segments to be subsumed within the general capitalistic project of the rational and orderly domination and exploitation of nature. The effect was to transform gender and racial oppression into forms not hitherto experienced. Furthermore, the revolutionary dynamic of capitalism ensures that such transformations are not once-and-for-all events, but continuous and often contradictory movements within the historical geography of capitalist development, even in the absence of explicit struggle on the part of the oppressed or active engagement in the politics of place construction on the part of disempowered social groups (in, for example, the long history of decolonization or the attempts by women (see Hayden 1981) to construct alternative kinds of living and working spaces).

It is in such a context that we have to interpret the changing meaning of the production of place amongst all realms of the social order. And if I revert, once more, to the Lefebvrian matrix, it is because it permits a rapid reconnaisance of the intricacies of such a process. For we need to understand not merely how places acquire material qualities (as, for example, constellations of productive forces open to capitalistic use or as bundles of use values available to sustain particular ways and qualities of life). The evaluation and hierarchical ranking of places occurs, for example, largely through activities of representation. Our understanding of places here gets organized through the elaboration of some kind of mental map of the world which can be invested with all manner of personal or collective hopes and fears. The wrong side of the tracks and skid row are hardly parallel places in our mind to the gold coasts of Miami Beach. Psychoanalytic theory teaches, of course, that the field of representation is not necessarily all that it seems; that there are all manner of (mis)representations to which places are prone. If individual identity is constituted by fantasy, then can the identity human beings give to place be far behind?

Representations of places have material consequences in so far as fantasies, desires, fears and longings are expressed in actual behaviour. Evaluative schemata of places, for example, become grist to all sorts of policy-makers' mills. Places in the city get red-lined for mortgage finance; the people who live in them get written off by city hall as worthless, in the same way that much of Africa gets depicted as a basket-case. The material activities of place construction may then fulfil the prophecies of degradation and dereliction. Similarly, places in the city are dubbed as 'dubious' or 'dangerous', again leading to patterns of behaviour, both public and private, that turn fantasy into reality. The political–economic possibilities of place (re)construction are, in short, highly coloured by the evaluative manner of place representation.

Struggles over representation are, as a consequence, as fiercely fought and as fundamental to the activities of place construction as bricks and mortar (see, for example, Rose's (1990) discussion of the clash of ideologies in the definition of Poplar in the 1920s). And there is much that is negative as well as positive here. The denigration of others' places provides a way to assert the viability and incipient power of one's own place. The fierce contest over images and counter-images of places is an arena in which the cultural politics of places, the political economy of their development, and the accumulation of a sense of social power in place frequently fuse in indistinguishable ways.

By the same token, the creation of symbolic places is not given in the stars but painstakingly nurtured and fought over, precisely because of the hold that place can have over the imagination. I think it correct to argue that the social preservation of religion as a major institution within secular societies has been in part won through the successful creation, protection and nurturing of symbolic places. But imaginations are not easily manipulated or tamed to specific political–economic purposes. People can and do define monuments in ways that relate to their own experience and tradition. The places where martyrs fell (like the famous Mur-des-Fédérés in Père Lachaise cemetery) have long gripped the imagination of working-class movements. Yet no amount of formal monument construction (the extraordinary monumental palace that Ceauşescu had constructed in Bucharest, for example) can make a hated dictator beloved.

The strength of the Lefebvrian construction, however, is precisely that it refuses to see materiality, representation and imagination as separate worlds and that it denies the particular privileging of any one realm over the other, while simultaneously insisting that it is only in the social practices of daily life that the ultimate significance of all forms of activity is registered. It permits, therefore, an examination of the processes of place construction in which the material grounding still retains its force and salience. But in the process, we also understand that political mobilization through processes of place construction owes as much to activities in the representational and symbolic realms as to material activities, and that disjunctions frequently occur between them. Loyalty to place can and does have political meaning, even under circumstances where the daily practices of people in that place show little commonality. There was an element of that in the uprising of the Paris Commune, for example; while the fact that a category like 'New Yorkers' can make sense to the polyglot millions who occupy that place testifies precisely to the political power that can be mobilized and exercised through activities of place construction in the mind as well as on the ground.

There is, then, a politics to place construction ranging dialectically across material, representational and symbolic activities which find their hallmark in the way in which individuals invest in places and thereby empower

themselves collectively by virtue of that investment. The investment can be of blood, sweat, tears and labour (the kind of building of affection through working to build the tangible product of place). Or it can be the discursive construction of affective loyalties through preservation of particular qualities of place and vernacular traditions; or new works of art which celebrate or (as with artefacts in the built environment) become symbolic of place. And it is precisely in this realm that the intertwining with place of all those other political values of community, of nation and the like, begins its work.

Yet this activity continues in a world in which the objective of 'accumulation for accumulation's sake', no matter what the political, social or ecological consequences, has remained unchallenged and unchecked. And while there are innumerable signs of decentralization of power to places, there is simultaneously a powerful movement towards a reconcentration of power in multinational corporations and financial institutions (Harvey 1989). The exercise of this latter power has meant the destruction, invasion and restructuring of places on an unprecedented scale. The viability of actual places has been powerfully threatened through changing material practices of production, consumption, information flow and communication, coupled with the radical reorganization of space relations and of time horizons within capitalist development.

The necessity of place reconstruction has created dilemmas for spatial practices as well as for the way places get represented and themselves become representations. It is in such a context that the febrile attempt to reconstruct places in terms of imagined communities, replete, even, with the building of places of representation (the new monumentalities of spectacle and consumerism, for example) or the forging of imagined communities as a defence against these new material and social practices, becomes more readily understandable. But the building of exclusionary walls implicit in the new communitarian politics (a leitmotif among many postmodernist thinkers such as Rorty and Unger), although it may intervene in relations of production, consumption, exchange and reproduction, is always porous with respect to the universalizing power of money, while simultaneously becoming increasingly exclusionary and hence disempowered of collective capacity to control that money.

This brings me back to the rule that I spelled out in *The Condition of Postmodernity* (Harvey 1989). Oppositional movements are generally better at organizing in and dominating place than they are at commanding space. The 'othernesses' and 'regional resistances' that postmodernist politics emphasize can flourish in a particular place. But they are easily dominated by the power of capital to co-ordinate accumulation across universal fragmented space. Place-bound politics appeals even though such a politics is doomed to failure.

This, interestingly, is the central problem with which Raymond Williams

wrestles in his trilogy on *Border Country*. As one of the characters in *The Fight for Manod* puts it:

> The whole of public policy . . . is an attempt to reconstitute a culture, a social system, an economic order, that have in fact reached their end, reached their limits of viability. And then I sit here and look at this double inevitability: that this imperial, exporting and divided order is ending, and that all its residual social forces, all its political formations, will fight to the end to reconstruct it, to re-establish it, moving deeper all the time through crisis after crisis in an impossible attempt to regain a familiar world. So then a double inevitability: that they will fail, and that they will try nothing else.
>
> <div align="right">(Williams 1979b: 181)</div>

Is there, then, no way to break out of that inevitability?

CONCLUSION

Places, like space and time, are social constructs and have to be read and understood as such. There are ways to provide a materialist history of this literal and metaphorical geography of the human condition and to do it so as to shed light on the production of a spatially differentiated otherness as well as upon the chimerical ideals of an isolationist communitarian politics and the dilemmas of a non-exclusionary and hence universal emancipatory politics.

I have, however, considered the significance of place with scarcely a mention of modernism and postmodernism. In part, that tactic was deliberate because I think the way that opposition has evolved is obscuring rather than revealing of fundamental issues. Besides, the fight over such concepts is largely confined within the 'cultural mass' (a term I borrow from Daniel Bell (1979) to refer to those working in broadcast media, films, theatre, the plastic and graphic arts, painting, universities, publishing houses, cultural institutions, advertising and communications industries, etc.). Postmodernism is hardly of concern to trade unionists, social workers, health providers, the unemployed or the homeless. Like Rajneesh's religion, postmodernism appears to be the preoccupation of a segment of the privileged classes. Yet the cultural mass, in part under the banner of postmodernism, has internalized a whole host of political and ideological struggles that do have general significance – anti-racism, feminism, ethnic identity, religious tolerance, cultural decolonization and the like. Postmodernism within the cultural mass can be viewed from this standpoint as a welcome catching-up and coming-to-terms with the facts of fragmentation, difference and otherness, which have long been a central feature of capitalist political economy and culture. Yet the preoccupation with 'discourses' and 'representations' within the cultural mass has added a

new dimension to how repression, oppression and exploitation can be received – a dimension which, when taken by itself, threatens to lose contact with any other forms of social practice but which, when put solidly back into the Lefebvrian formulation, has much to teach. And I think it true to say, furthermore, that more has been done to highlight various forms of oppression and repression within the cultural mass than in many other spheres of social life.

From this latter standpoint it is possible to view the cultural mass as home to some kind of democratized and mass-based avant-garde of the politics of the future. Even if there were no truth in this argument, the politics of the cultural mass are still important since they define and circumscribe symbolic orders, imaginative realms, and forms of representation in crucial ways. Postmodernist claims to be a liberatory and deconstructive force within the cultural mass must therefore be taken seriously. But there are two problems to this. First, struggles for power *within* the cultural mass have inevitably led to the use of postmodern or deconstructionist rhetoric in an entirely *ad hoc* way, and not a little of the argument has all the flavour of intellectual and political opportunism (quite a few rather second-rate white male Anglos have risen to stardom within their professions on the postmodern bandwagon). The second problem is that the fight is being waged within a relatively homogeneous and privileged class configuration, so that issues of class oppression, while always on the agenda, are by no means as strongly and personally felt as would be the case with, say, women factory operatives in the Philippines or Mexico.

Consideration of the class positioning of the whole debate on modernism and postmodernism leads to even deeper objections to postmodernist claims. The cultural mass, by virtue of its own class position, has many of the characteristics of those white-collar workers that Speier (1986) studied in the 1930s. Collectively, we 'tend to lack the reassuring support of a moral tradition that [we] can call our own'. We tend, therefore, to be 'value parasites', drawing our values from association with other dominant interests in society. In the 1960s, the cultural mass drew much inspiration from an association with working-class movements, but the political attack on and decline of the latter cut loose the cultural mass to shape its own concerns around money power, individualism, entrepreneurialism and the like (Harvey 1989: 347–9). And its own concerns are limited by its own product – representations, symbolic forms, images, etc.

All of which brings me back to the problem of place. One of the most powerful strands of independent politics within the cultural mass is to focus rather strongly on the meaning and qualities of community, nation and place. The shaping of place identity and local tradition is very much within the purview of workers within the cultural mass (from the writers of novels and makers of films to the writers of tourist brochures), and there are strong institutional forms taken by that shaping (everything from univers-

ities that keep local languages and the sense of local history alive to museums, cultural events, etc.). The more the cultural mass explores its own interior values, the more it tends to align itself with a political economy and a cultural politics of place. Hence the outpouring of books on precisely that topic over the past twenty years (see, for example, recent works by Agnew and Duncan 1989; Davis *et al*. 1990; Lilburne 1989; Pred 1990; Probyn 1990; Tindall 1991) and the rise of a whole set of supportive political activities within the cultural mass for place-bound cultural movements (including the extraordinary role of cultural figures like Havel in the revolutions in Eastern Europe). As the cultural mass has dropped its association with proletarian movements and has sought to avoid a directly subservient position to capitalist bourgeois culture, it has become more closely identified with a cultural politics of place.

Not all of this must be cast in a positive light, however. The stereotyping of other places is one of the more vicious forms of bloodletting within the media (one only has to read the *Sun*'s descriptions of the French to get the point). Defining the other in an exclusionary and stereotypical way is the first step towards self-definition. The rediscovery of place, as the case of Heidegger shows, poses as many dangers as opportunities for the construction of any kind of progressive politics. Deconstruction and the post-modern impulse, as Said demonstrates in his study of *Orientalism* (Said 1978), certainly provide a means to attack the appalling stereotyping of other places, but there is a huge problem of public perspectives, representation and politics within the overall work of the cultural mass in this regard that desperately needs to be confronted.

Yet place is hardly a discovery of postmodernity. The politics of place and of turf, of local identity and nation, of regions and cities, has been there all along and been of great importance within the uneven geographical development of capitalism. The rediscovery of place, with all its multi-layered meaning, within the rhetoric of the cultural mass and, through that, within the rhetoric of politics, is what is significant here rather than the fact that the world has changed in some way to make the political economy or cultural politics of place more important now than in the past. Yet there is indeed a sense in which the latter proposition is also true, because it is in the face of a fierce bout of time–space compression, and of all the restructurings to which we have been exposed these last few years, that the security of place has been threatened and the map of the world rejigged as part of a desperate speculative gamble to keep the accumulation of capital on track.

Such loss of security promotes a search for alternatives, one of which lies in the creation of both imagined and tangible communities in place. The issue of how to create what sort of place becomes imperative for economic as well as political survival. Talk to the mayors of Baltimore, Sheffield and Lille and you will find that this has been their precise preoccupation over

the last few years. And it is here, too, that the politics of the cultural mass can take on considerable importance. For if, as Marx insisted, we get at the end of every labour process a result that is the product of our imaginations at the beginning, then how we imagine communities and places of the future becomes part of the jigsaw of what our future can be. Rajneeshpuram existed in someone's imagination and captured the imaginations of many caught up in the human potential movement who worked so hard to make it the temporary place it was. And even if, as in this case, there is many a slip between imagination and realization, and a whole host of unintended consequences to be countered and discounted on the path, the question of how we imagine the future and with what seriousness we invest in it is always on the agenda.

From that standpoint, the conflict between modernism and postmodernism, as also between the political–economic and cultural politics of place, has much to teach about the problems of place creation. But the whole game becomes worthwhile only if we are prepared to learn and act upon the lessons. And one of those lessons must surely be that all attempts to construct places and build imagined communities should, as Eric Wolf so cogently puts it, 'take cognizance of processes that transcend separable cases, moving through and beyond them and transforming them as they proceed' (Wolf 1982: 17).

REFERENCES

Agnew, J. and Duncan, J. (eds) (1989) *The Power of Place: Bringing Together the Geographical and Sociological Imaginations*, Boston: Unwin Hyman.
Anderson, B. (1983) *Imagined Communities: Reflections on the Origin and Spread of Nationalism*, London: Verso.
Bell, D. (1979) *The Cultural Contradictions of Capitalism*, New York: Harper & Row.
Boyer, C. (1988) 'The return of aesthetics to city planning', *Society*, 25 (4): 49–56.
Davies, M., Hiatt, S., Kennedy, M., Ruddick, S. and Sprinker, M. (eds) (1990), *Fire in the Hearth: The Radical Political Economy of Place in America*, London: Verso.
Dovey, K. (1989) 'The quest for authenticity and the replication of environmental meaning', in D. Seamon and R. Mugerauer (eds), *Dwelling, Place and Environment: Towards a Phenomenology of Person and World*, New York: Columbia University Press.
Fitzgerald, F. (1986) *Cities on a Hill: A Journey through Contemporary American Cultures*, New York: Simon & Schuster.
Harvey, D. (1982) *The Limits to Capital*, Oxford: Basil Blackwell.
—— (1985) *The Urbanization of Capital*, Oxford: Basil Blackwell.
—— (1989) *The Condition of Postmodernity*, Oxford: Basil Blackwell.
—— (1990) 'Between space and time: reflection on the geographic imagination', *Annals, Association of American Geographers* 80: 418–34.
Hayden, D. (1981) *The Grand Domestic Revolution: A History of Feminist Designs for American Homes, Neighborhoods and Cities*, Cambridge, MA: Massachusetts Institute of Technology Press.

Heidegger, M. (1966) *Discourse on Thinking*, New York: Harper & Row.
—— (1971) *Poetry, Language, Thought*, New York: Harper & Row.
Johnson, C. (1974) *Utopian Communism in France: Cabet and the Icarians*, Ithaca: Cornell University Press.
Kern, S. (1983) *The Culture of Time and Space, 1880–1918*, London: Weidenfeld & Nicolson.
Lefebvre, H. (1991) *The Production of Space*, Oxford: Basil Blackwell.
Lilburne, G. (1989) *A Sense of Place: A Christian Theology of the Land*, Nashville: Abingdon Press.
Logan, J. and Molotch, H. (1987) *Urban Fortunes: The Political Economy of Place*, Berkeley, CA: University of California Press.
MacCannell, D. (1976) *The Tourist: A New Theory of the Leisure Class*, New York: Schocken.
Marx, K. (1964) *Economic and Philosophic Manuscripts of 1844*, New York: International Publishers.
—— (1967) *Capital*, vol. 1, New York: International Publishers.
Pred, A. (1990) *Making Histories and Constructing Human Geographies: The Local Transformation of Practice, Power Relations, and Consciousness*, Boulder, CO: Westview Press.
Probyn, E. (1990) 'Travels in the postmodern: making sense of the local', in L. Nicholson (ed.) *Feminism/Postmodernism*, New York: Routledge.
Relph, E. (1976) *Place and Placelessness*, London: Pion.
—— (1989) 'Geographical experiences and being-in-the-world: the phenomenological origins of geography', in D. Seamon and R. Mugerauer (eds) *Dwelling, Place and Environment: Towards a Phenomenology of Person and World*, New York: Columbia University Press.
Rose, G. (1990) 'Imagining Poplar in the 1920s: contested concepts of community', *Journal of Historical Geography* 16: 425–37.
Ross, K. (1988) *The Emergence of Social Space: Rimbaud and the Paris Commune*, Minneapolis: University of Minnesota Press.
Said, E. (1978) *Orientalism*, New York: Columbia University Press.
Sale, K. (1990) 'What Columbus discovered', *The Nation*, 22 October, pp. 444–6.
Sandel, M. (1982) *Liberalism and the Limits of Justice*, Cambridge: Cambridge University Press.
Speier, H. (1986) *German White Collar Workers and the Rise of Hitler*, New Haven, CT: Yale University Press.
Tindall, G. (1991) *Countries of the Mind: The Meaning of Place to Writers*, London: Hogarth Press.
Tuan, Y.-F. (1977) *Space and Place: The Perspective of Experience*, Minneapolis: University of Minnesota Press.
Veblen, T. (1967) *Absentee Ownership*, Boston: Beacon Press.
Williams, R. (1960) *Border Country*, London: Chatto & Windus.
—— (1979a) *Politics and Letters*, London: New Left Books.
—— (1979b) *The Fight for Manod*, London: Chatto & Windus.
Wolf, E. (1982) *Europe and the People without History*, Berkeley, CA: University of California Press.
Young, I. (1990) 'The ideal of community and the politics of difference', in L. Nicholson (ed.) *Feminism/Postmodernism*, New York: Routledge.

Chapter 2

Future fear

Meaghan Morris

One of the things I learned at the 'Futures' conference is that loose talk about globalization can be intensely parochial. Never again will I try to convince people working in Britain that 'postmodernism' is not a rhetoric of crisis and fragmentation. I think this *is* a British rather than a 'European' reading (the French-influenced work on heterology often conscripted to postmodernism has a different, and to my mind more positive, inflection), and I am always puzzled by it. For example, after reading *A Thousand Plateaus*, – with its passages explicitly rejecting the modernist theme of 'the fragment' – I am baffled when I see the work of Deleuze and Guattari assimilated by some critics to a postmodernism of fragmentation; I would read it as dealing instead (in a spirit more classical than 'postmodern') with heterogeneity. But as I listened to speakers and many participants at the conference reiterating those themes of crisis and fragmentation (even if only to criticize someone else's presumed concerns), I had a new sense of how strongly these can articulate here something crucial to people's experience – something that makes that model of postmodernism both powerful and truthful for them.

In a small way, this kind of learning experience is for me one of the rewards of having cross-cultural as well as cross-disciplinary loose talk about general tendencies in culture; there is nothing like a close encounter with an alien idea of the global to shake one's faith in common sense. In future, I will only be able to claim that postmodernism is not *globally* a rhetoric of crisis and fragmentation. However, since this small qualification must complicate my panel task of speculating on 'globalization and the future of cultural politics', I want to begin by considering why I don't find such rhetoric useful in my present as a white and, as Australians say, Anglo-Celtic, feminist intellectual. For, to speak plainly, I don't really have a strung-out (as opposed to momentary) sense of crisis – although I certainly do feel *fear*. Nor do I feel especially fragmented, although I do identify strongly with Angela McRobbie's account of women's time, and of the shattering pressures involved in doing multiple 'part-time' labours. But I don't thereby come to imagine that I'm living through an aftermath, or

caught in a chronically 'post' condition, or scrabbling round looking for fragments to shore against someone else's ruin.

Only occasionally do I think in general terms of past and present and future (mostly when watching television) and then I have a fairly cohesive sense of living, cheerfully as well as fearfully, in a 'whole new era' of history. This is, of course, a media construction of public events and of time: I do not think that there has been a 'break' or a rupture with the past, and I do not at all suppose that this sense of newness bears equally for everyone, or for me, on all aspects of social experience. Media discourse is inflationary: to claim to be living in a 'whole new era' is merely to say that some radical changes have occurred in the past ten years, that the Australia of my childhood has vanished (and I'm mostly glad that it has), and that the future now seems more unpredictable than it ever has before. It is to say that the present is being represented, and may also be experienced, as turbulent, conflictual, and above all *transitional* to a future which is already an object of speculation and struggle. Since a major referent now of most such speculation and struggle is what our politicians call the 'international- ization' of the Australian economy, I can try to relate my local sense of the future to the conference themes by means of what will have to be a mythic anecdote about its origins.

Someone said to me during the conference, 'I suppose people have stopped talking about postmodernism in Australia?' I never know how to answer that sort of question: factitious distinctions forming in my head ('arts and media people have, literary and social theory people haven't; magazine people have, academics and journalists haven't . . .'), I heard myself say glibly – magazine person that I am – 'Well, yes: it's very 1984'. Wondering later what on earth this meant, I decided that something about that year *was* important. It was certainly a year for postmodernism in architectural polemic, and Jean Baudrillard caused a frenzy in inner-city art schools by visiting about then. But it was also a strange year for citizenship, a euphoric 'crisis' phase in which some of the more apocalyptic art-burble doing the rounds could and did resonate with serious talk about modernization and globalization that was drifting through our current affairs TV. The year 1984, let's say, was a transitional period between the end of the domestic Cold War, and the beginning of what media discourse now represents to us as our 'new era' – perhaps also a time in which the themes of a *critical* postmodernism (that is, of a critique of modernity as well as 'modernism', and thus of all white Australian history) began to have a certain public currency. So let me describe two moments that schematically define that period.

The local Cold War ended for me on the evening of 22 February 1983. After seven grim years of conservative Coalition government, charisma was pouring through the networks for Bob Hawke, the new Labor leader. Faced with a bad recession, a drought, and now with fighting an election

against the most popular man in Australia, the Prime Minister, Malcolm Fraser, panicked: he warned that if Labor came to power, our savings would be safer under the bed than in the banks. On television that night, Bob Hawke threw back his head and laughed, and then he said: 'They can't put them under the bed because that's where the Commies are'. That was one of the most emancipatory moments of my life. I knew then that it was *over*: never again would that deadly fantasy of Red Menace/Yellow Peril (Australians, you must remember, associated 'Commies' with Asia) have the power to shape Australian political culture as it had since before I was born.

I really hated Malcolm Fraser. He was the direct beneficiary of the 'constitutional coup' that in 1975 overthrew the only Federal Labor government that I, born in 1950, had ever known. Now, here he was (after blowing out the budget himself in 1982), trying to revive Labor's image from the 1970s as a party of economic mismanagement. Hawke's riposte was wonderful. It swept away the Whitlam government's failings by mocking an older scare technique ('kicking the communist can') which had worked almost unfailingly for conservatives since 1949 and which, by exploiting even older racist fears, had helped to involve Australia deeply in the war in Vietnam. The moment in which a leader of the Australian Labor Party could joke about 'Commies' on prime-time TV was a moment in which *everything*, it seemed, had already begun to change.

Of course, the experience of Labor in power soon led some people to talk about crisis and fragmentation. Hawke could laugh so easily because he personally could never be accused of having 'Commie' inclinations, or even of social idealism. His would be a pragmatic regime of *economic* reform: its keywords were restructuring, consensus, neo-corporatism, wage restraint, privatization, deregulation, modernization, spending cuts, tariff reductions, end-of-ideology and export competitiveness. At first, many people in 'cultural politics' on the non-labour left did not know what this meant; thirty years of Liberal–Country Party Coalition rule had taken their toll of our ability to relate in any active way to the process of national government. So had an education system still reticent in the 1970s about the history and structure of our distinctive institutions, like 'labourism' – the 1904 social contract exchanging trade protection and currency controls for a state-regulated, wage-fixing system and compulsory arbitration. When the Hawke government floated the exchange rate and partially deregulated banking at the end of 1983, we knew that it meant *something* serious, but I was not alone in being uncertain exactly what that was.

The mist began to clear towards the end of 1984. Another election loomed: there on TV, mixed in with the opinion shows and the party-political advertising, were the interviews with money men in Tokyo and Chicago saying, unbelievably, 'Vote Labor for the good of your currency'. Now *here* was a 'whole new' era – and not only because Labor was figuring

as the favourite of finance capital. This was also the beginning of an intensive media campaign for what Labor leaders like to call 'economic literacy' – in fact, a training of the public in the jargon and the assumptions of economic rationalism.[1] During this period, too, the government began to legitimize its actions by referring not to party principles or ideals of social justice, but to a dystopian narrative of economic necessity and the *telos* of crisis-management: 'crisis' suddenly became, in fact, the governing rhetoric of state. By 1986, as the Treasurer began to warn of our 'banana republic' tendencies and burgeoning foreign debt, viewers were, in the words of one angry critic, 'treated nightly to the spectacle of *economic* commentators pronouncing on the government's *political* performance. . . . It was as though foreign traders, rather than Australian voters, had become the arbiters of political taste in this country.'[2]

But as this almost excessive emphasis on the *foreign* may suggest (as though a displacement of 'voters' by 'traders' were not already a problem), the passion for global economics that seized the media in those years also helped to put an end to the vintage 'protectionist' forms of nationalism in Australia. In a federation of former British colonies that had next become an American client state, the values of 'independence' and 'sovereignty' were commonly construed by most nationalist discourses as goals to achieve in *future*. They could not signify a long-lost mythic past, but rather a utopian programme which had a strong, sometimes dominant, cultural–political component (the 1970s state-funded film revival, for example, was legitimized along these lines). So the glittering business programmes, the charismatic foreign traders, and the economist-studded news shows on TV in the mid-1980s probably did for old dreams of national *autonomy* what Bob Hawke's mockery had done for the rhetoric of socialism. Both shifted from the scenario of the future to the archive of the past.

I think that this shift is probably irreversible, although autonomist nationalism may have a future in reaction to severe economic distress. At the moment, however, it has no more anchorage in the institutions governing the real of Australian *social* life than 'socialism' has had since the turn of the century. When Australia finally slid into the worst recession since the 1930s after eight years of Labor 'Accord', some critics suggested that Fraser had been right after all about those savings under the bed. But most did so wryly: few could claim with confidence that the outcome of all that credit-binging by the banks and big business would have been better under a Coalition policy differing from Labor's version of economic rationalism only in its extremism – and, in one crucial departure, promising to deregulate the labour market and confront the unions as well. In the immediate future, Australia may follow New Zealand in essaying this extremism. If so, we could experience, with masochistic deliberation, a kind of civil war about our basic social institutions and values: postmodernism, indeed.[3] However, the only alternative on the horizon is a tempered version of

Labor's present policies – with, if 'the markets' allow it, a bit of industry policy and public spending thrown in.

At this point, I feel some pressure to turn around the mood of these remarks by saying that the ideals once represented by dreams of 'socialism' and self-determination will, of course, survive to be reinvented more powerfully in the future. I do think that the desire for a better world and the will to achieve it are irrepressible under capitalism, and that both are thriving in everyday life, in public agencies, and also in a plethora of non-governmental organizations which are these days little attended to by the culture-critical left. But I want to confront (in my own work in future) the resistance that I also feel not only towards the grand old forms of visionary left futurology,[4] but towards those little leftist *genre* rules that give me that sinking feeling that I should 'signify optimism *here*'. I prefer to articulate optimism by exploring precisely the questions that such rules have served to foreclose.

As a *citizen*, for example, I know perfectly well that I do not greatly regret the passing of the often quite repressive 'socialist' and 'nationalist' marginal milieux that I experienced in the 1970s. Nor do I share the 'politics' of an ultra-leftist critique dismissing actual efforts at social change as inadequate to, or even subversive of, an infinitely greater, and ever-receding future task. So, as an *intellectual* committed to the collective project of producing anti-racist, feminist knowledge of Australian cultural history (and to making that knowledge 'mainstream'), I also want to learn more about the forces constituting my ambiguous and, in part, class-specific, citizenly knowledge. These are tasks that I can perform, that I can share with others, and that may even allow me to contribute on particular points to public debate in my society. This sort of modest proposal is always open to the unanswerable charge of doing nothing to stop the Antarctic melting or to mend the hole in the ozone layer. True. I none the less feel that I am more usefully employed in using as much imagination as I possibly can to change the cultural climate in which ideas for doing so are formulated and in which they circulate than I would be in elaborating 'whole new' futures with – at least in my case – rather dubious practical value. These days, we have think-tanks for that.

Moreover, we *need* think-tanks. If there is a certain fatuity haunting the scene of 'the intellectual' designing 'the future', it is not just because of the complexity and scale of the problems facing the world today, or because of the collapsing time–space frames of action under electronic capitalism. Future thinking about the future also has to take material as well as moral account of the heterogeneity (not 'fragmentation') of the human aspirations that are shaping now the future of mixed societies.[5] No doubt it is, as David Harvey and others have suggested, all too easy for cultural theorists to fetishize 'difference' while ignoring the power relations defining some differences as more different than others. The social facts remain that the

population of Australia has doubled by immigration since the Second World War; that a quarter of this population now comes from a non-English-speaking background; and that substantial numbers of these people do not refer their historical experience, their cultural identity or their political dreams to western European traditions. Any political 'future' which is not open to radical change by those for whom the historic values of Australian socialism or nationalism may hold no obvious appeal is a future which already has no future.

For this reason, I suspect that a common basis for constructive thinking shared between people with differing and conflicting dreams of what 'a better world' might mean is now emerging precisely from the experience of living oddly and awkwardly together in a country which is economically on the cusp of three powerful sets of *relations* among competing global powers – Europe, the United States and Japan (our major trading partner) – who are hovering on the edge of trade war, and to whom Australia's gruesome fate in such a war is insignificant. 'Fragmentation' doesn't even come close to describing for me the terrifying but also exhilarating experience of being buffeted about between what can quite reasonably be called these 'new' historical forces.

I do not mean to suggest here that the displacement of Social Darwinism by multiculturalism as a unifying state ideology (a project now twenty years old in Australia) in some way mirrors the more recent structural changes in the national economy to which it is connected, although I do think that the de-Anglifying effect of postwar immigration has helped to make it easier for Australian *cultural* critics to admit to their thinking (as few British critics to my knowledge have done) the global implications of the fact of Asian capitalism. However, my point is that in this situation the need for critical thought to be relational, *as well as* differential, in impulse, is less a 'theory' or fashion imperative than it is basic common sense. I still find post-structuralist thinking most useful in this respect, just as I find post-modernism useful as a discourse on history, and I am unconvinced by apocalyptic leftist talk about their supposed reactionary effects. 'Theory', I must say, is not what I fear when I am afraid of the future.

So, in listening to the various conference papers, I was buffeted between two ways of thinking the future which appealed to me equally (not 'schizo-phrenically') at different moments. I have a strong sympathy with Francis Mulhern's vision of a history inexorably moving by its 'bad side'. When I said that I felt *fear* rather than a sense of crisis, I was thinking of the immediate future in global politics (the Gulf War was looming at the time of the conference); the longer-term prospects for massive ecological breakdown; nuclear proliferation among regional powers; population overload; spreading poverty; famine and epidemic; repressive, even fascist, government in many parts of the world. I was also thinking of 'Europe'. Europe – with all its nationalisms, particularisms, traditionalisms and fundamentalisms so long

repressed 'at home' and so freely projected (not least by the internationalist socialist left) on to movements in 'the rest of the world' – scares me profoundly.

But the world is not European. European events and experiences are not indicative of 'global' tendencies, although they do, alas, have global effects. I think it is crucial to the future of the ideals represented by those old socialist dreams for theorists of cultural politics to begin to understand that historically European discourses that deploy, as universals, certain power-saturated and generative oppositions like 'modernity' and 'tradition' (as I think David Harvey does with his use of Marx and Heidegger in *The Condition of Postmodernity*) are actually *limited* – or 'place-based', even parochial – in their descriptive, let alone their predictive, value; they help to produce, from a particular position, the phenomena they claim to describe. For this reason, I have a very strong sympathy for Dick Hebdige's satire on the 'bound to happen' syndrome. The danger of thinking about the future in that mode was foregrounded in the build-up to the Gulf War by the use in the media of the precedent of Chamberlain's appeasement of Hitler to secure consent to military action by binding a fear of 'fundamentalism' – a convenient media reading then of what can more plausibly be called Saddam Hussein's fascist modernism – to the idea that, without a terrible war, a terrible war was 'bound to happen'. Which, of course, it did.

One 'bound to happen' scenario circulating in Australia at present involves a convergence of environmental doomsaying with a form of white supremacist racism that I had thought to be extinct in Australian public life. Symbolically laid to rest in 1965 when the words 'White Australia' were removed from the Labor Party platform, the ghost of white Australia at long last seemed to die in 1987, when the Coalition – seeking ways to differentiate themselves from a government that had stolen most of their policies – cynically tried to suggest that they might restore some form of racial discrimination to immigration policy. They called this 'One Australia'. Australia lost a fortune in investment from South-East Asia in about two months. The media consensus was that even if life does get tricky for immigrants in some (un)working-class suburbs, an anti-Asian racist *policy* is simply bad for business. Business agreed, and 'One Australia' disappeared.

Now, however, we have a development popularly known as the 'green and red-neck alliance'. Some scientists suggest that the Australian continent, inhabited at present by 17 million people, can viably support only 10 million people indulging even a modified version of our current lifestyle. Given the rate of soil degradation, salination, desert expansion, forest destruction, water pollution and species extinction achieved since the British invasion, this is not hard to believe. In November 1990, the Bureau for Immigration Research held a conference to discuss, among other

things, this issue. Remarkably, members of what one journalist called 'the previously internationalist left-liberal class' claimed that the best way to reduce the population would be to eliminate immigrants who 'grew up in the crowded cities of other countries, and have yet to appreciate a lifestyle intrinsically related to open space; or . . . have little knowledge, national pride or concern for the unique landscape, flora and fauna in Australia.'[6]

A century ago, this same exclusionary logic – invoking class struggle rather than 'lifestyle', and wages and conditions for white male workers rather than the fate of flora and fauna – was used to make white Australia the lynchpin of the Labor and trade union ethos. This logic assumes not only that the other, unlike 'us', is eternally the same ('impossible to unionize'), but that we in 'our' national (racial) difference have a monopoly on knowledge, pride and concern. The economic and cultural costs to Australia of those six decades of insular, even idiot homogeneity imposed by policies of exclusion are now reasonably well known; even in the ruthlessly pragmatic terms that catastrophism can impose, it seems fantastic to consider making the same mistake twice in the name of a manifest absurdity like 'ecology in one country'. However, the weird historical recurrences shaping environmentalist racism today exceed even the old dialectic of 'white' and 'Asian' in 1890s *fin de siècle* discourse, reaching back for rhetorical sustenance to the primal colonial scene. In a relay of conflicts between some environmentalists and indigenous people in the United States and Canada, it has been argued recently that what remains of Australia's 'unique landscape' after 200 years of white settlement now needs to be protected from *Aboriginal* people – 'modern' Aborigines, with guns, jeeps and land rights over areas where protected species roam free.

I do not wish to decry the sense of urgency enabling these debates. Real dilemmas are emerging, some of which will make it much more difficult in future for the old 'left-liberal' and leftist cultures to maintain their political imaginary by identifying with a spectrum of causes once smoothly construed as coherent – feminism; anti-racism; gay activism; land rights; environmentalism; opposition to uranium mining. When, for example, a sector of Aboriginal opinion argues *in favour* of a multinational uranium mine on Aboriginal land (a possibility glimpsed in recent negotiations with the Jawoyn people over mining Coronation Hill in the Northern Territory), then the grammar of what Americans call 'political correctness', and Australians of my generation used to call, sardonically, 'ideological soundness', begins to collapse. Of course, this can be a good thing: simplistic as well as romantic projections of unity between idealized causes may have little to offer beyond perpetuating self-referring signs of political *attitude*.

But it is also a difficult and dangerous thing for cultural politics. Successful coalitions have been built on such projections, and, in the past, these offered people the political experience that makes it possible to leave projection behind. An atomized or openly sectarian *version* of 'issue' or

'identity' politics (both projects which, in general, I support) is no replacement for this experience, fostering as it can a construction more paranoid than romantic of whatever must count as other – 'whites' and 'males' for some, 'immigrants' and 'Asians' for others – to the primary struggle. Coalitions then form by default. In this respect, the resurgence of racism on the fringes of the environmental movement finds its precursor in the moves by feminists earlier in the 1980s to join forces not only with the homophobic and gynophobic Christian right on issues to do with censorship, but more recently with those neoconservatives who support the extension of the power of the state over women's bodies (by banning, for example, surrogate mothering) – while acclaiming its withdrawal from the 'public' economic sphere.

Of course, catastrophists will say that environmental imperatives must now take precedence over others, that the future depends on the planet's capacity to keep on sustaining human life, and that there is *no time* left to work slowly; choices, they will say, must be made. As a citizen whose support for land rights and Aboriginal self-determination is (if I am forced to choose) more absolute than my opposition to uranium mining or to hunting, I am aware of a hiatus in my thinking at this point. I can easily believe that massive ecological breakdown is not only probable but imminent. In fact, in those moments when I am watching the Kuwaiti oilfields burn on television, hearing about the 1,200-kilometre, toxic blue-green algal bloom killing the Murray–Darling River system that waters a third of Australia, or just watching my frangipani tree forget to lose its leaves in winter, I do fear that most speculation about the future to which I could ever have access is 'academic' in the sense that society as I know it will likely collapse, or be transformed unimaginably, within my lifetime. On the other hand, I choose to act on an everyday basis as though my fear has no real value.

As an intellectual influenced by materialist philosophies, I have several ways of displacing this fear. For example, I can call it 'millenarian'; I can (and do) support those environmentalists who work to negotiate outcomes to particular disputes and problems; I can help to draw attention to the damage done by intensive agricultural methods and tourist resort development (rather than by 'immigrants'), and to the efforts of people proposing alternative technologies; I can show how 'choices' are socially structured, economically invested and historically inflected, and consequently open to change; I can work to promote more constructive modes of public political debate. Yet the hiatus still remains: what good does it do (I wonder at times, observing my frangipani) to write a cultural history of the racially and sexually saturated discourse on 'unique landscape' deployed in our media today? But when I see a man on television objecting to a proposal to drain a creek in the desert to bring the grass on a Japanese golf course in Western Australia up to 'international' standard, I know what cultural

history can aspire to do precisely at the moment when I hear him veer ('I'm not racist, but . . .'), into ranting about '*the* Japanese' who are 'taking over the country'.

This is why I think it important to my work as a cultural critic not to deny my citizenly spasms of white suburban fear, or to displace them too easily with an academicism that programmatically dismisses incorrect emotions about the future, like helplessness, doubt or anxiety. Criticism of that sort – whether Marxist or 'postmodern' in inspiration, whether haunted still by the Five-Year Plan or imposing a disciplined cheerfulness about 'resistance' in popular culture – seems to me to restrict the scope and perhaps the *audience* of its work by defensively ignoring the tensions most people are subject to in forming their *own* sense of agency. For me, there is something tinny about theories 'of' agency, and demands for theories 'of' agency, that enunciatively erase a sense of the *messiness* of living and acting in the mediated world today. One broad social consequence of what David Harvey calls time–space compression is not, I think, the much-vaunted fading or 'fragmenting' of a (European) sense of history, but rather a proliferation of heterogeneous temporalities between and in terms of which a global struggling over 'history' is more intense than ever before.

So, in between sharing the fears that Francis Mulhern expressed (without centring my sense of history on Europe in quite the way that Francis does), and sharing Dick Hebdige's mistrust of catastrophism, I was particularly impressed by what Ruth Levitas had to say about 'the future' as a problem of conceptualizing agency in the present, and by Stuart Hall's comments about temporality and the need for a more complex sense of the historical scale as well as the stakes of some of the problems now so wildly represented as symptomatic of a 'whole new era'. It is in this in-between, I think, that it is possible for cultural critics to make their modest proposals for action.

Environmental catastrophism, for example, tells us persuasively *why* we should stake all future time on action in the next few years, but the immediate 'how' of such massive action remains (as in all proposals still vaguely entailing an 'overthrow' of capitalism) unclear. Political pragmatism offers the medium-term temporality of the committee, the report, the arduous labour of inter/national, regional and local negotiations between competing, even incommensurable economic interests, political programmes, and historical visions in underdeveloped, developing and overdeveloped countries. As a citizen, I am usually more sympathetic to the relative realism of the latter than to the absolute realism of the former, because I think pragmatism in the Australian social-democratic (not the American liberal) sense is a practice on balance more capable, if not of the 'resolution of difference' that David Harvey would like to see – since difference can never be *resolved* without repression – then of working in a

productive way through precisely that dialectic that Harvey calls 'place' and 'space'.

But I see the temporality of cultural politics in other terms again – terms that lead me to dissent on most major issues from the pragmatists I vote for. This is why I have insisted a little schematically on the connection but non-identity between my thinking as a citizen and as an intellectual: I do not take my subjectivity to be 'split', 'decentred' or 'schizophrenic' (terms which in my view act as metonyms of myths about poststructuralism produced by careless commentary), but I do think that Catherine Gallagher is right to argue, as Ruth Levitas did in discussion, that 'professionalism, critical intellectualism, and political activity are all overlapping but nonetheless separable aspects of a complex public identity'.[7]

Cultural critics, I think, work primarily as mediators – writers, readers, image producers, teachers – in a socially as well as theoretically obscure zone of values, opinion, ideology, belief and emotion. If much of our theorizing is devoted to debating what these terms can mean and why they now seem so important, and if in the process we can and should become involved in, as well as informed about, broader social and economic struggles, whatever *political* effectivity we might claim for critical work can only be registered, most of the time, by gradual shifts in what people take to be thinkable and do-able in relation to particular circumstances constructed in place *and* space. In more peaceful or settled times, this can be cast by its enthusiasts as an intrinsically splendid endeavour. In fearful or turbulent times, it is easily denounced as trivial. In between, I agree with Margaret Morse when she says that:

> Changes in shared fictions, values and beliefs occur over the long term, slowly and incrementally, not merely because once shared values are discredited or may no longer be viable, but because alternative values and their constituencies have labored to mark themselves in discourse. I believe the criticism of television can serve cultural change when it keeps such long-term goals in mind.[8]

To undertake such positive labour, it is necessary to gamble, I think, on the *openness* of the future, as well as to make a commitment to creating in the present some sense of continuity and solidarity with those who have laboured in the past.

For this reason, I am unmoved by what twenty years of changes in feminism have taught me to think of as conference bombast about the dire political failings of this or that critical statement; I do not believe, for example, that the future hangs on whether a group of people emphasize 'difference' or 'equality' (carefully as I would want to distinguish between these terms) over two days in the Tate Gallery. On the other hand, I am sceptical of ritual breast-beating about the futility of it all ('the world is falling apart and we sit here . . .', etc.). Most people with a more than

careerist investment in critical practice experience doubt, even anguish, about the purpose and the value of their work, and often this helps us to think. But there is also a time-honoured leftist practice of self-lacerating anti-intellectualism which, by fearlessly revealing that a paper in popular aesthetics cannot dismantle the military–industrial complex, only functions to deflate the significance of *other* people's labour.

Ian Hunter has written a book about the history of this and other related critical practices called *Culture and Government: The Emergence of Literary Education*.[9] It is not yet widely cited in debates about the future of cultural politics, perhaps because it is still (to take a term from Michèle Le Doeuff) *atopian* – unplaceably unplaced – in relation to most current debates that are not directly concerned with the question of cultural policy.[10] In this book, and in an article on 'Setting limits to culture', Hunter argues that the romantic imperative of reconciling divided ethical substance is still maintained, via Marxism, in cultural criticism today, and that this imperative works repetitively to create a 'fraught space' of debate where massive, world-historical problems are invoked on such a level of generality that they cannot possibly be solved, and are posed in ways which simply do not connect to agencies by which 'actual social futures' may be given 'definite shape'.[11]

I think that Hunter may be right about this, although I disagree with many aspects of his thesis.[12] It certainly does seem hard for cultural studies to throw off the megalomaniacal idea inherited from literary criticism that a training in 'reading' can and should form a caste of total subjects (or, as Hunter might say, 'whole persons') fit to rule, or at least to administer, the nation, or even the globe. This absurd and anachronistic expectation still marks our practice intimately in those moments when – as after Dick Hebdige's moving presentation of the grounds for hoping, indeed for *knowing*, that change will come – we ask of a discourse that has manifestly just inspired and strengthened people, 'Yes, but what *else* can this do?' I suspect that a cultural politics interested in influencing the future will benefit greatly from understanding better than in the past what it is that such a discourse – in inspiring and strengthening its audience – actually does.

I do not mean to suggest that cultural criticism is a neatly autonomous activity, still less that it can be described as just a form of innocent 'fun'. The *politics* of cultural criticism are in any given instance produced relationally as well as provisionally. This is obvious when we consider how intellectual work that can circulate inter/nationally (if not 'globally') is never universal or consistent in its political import or impact. In a small way, it was amazing for me to discover that my own work on the idea of 'banality' (a complex concept, which I take to include a strongly affirmative aspect) can be read in Britain as arguing that popular culture *is* 'banal' in the negative sense that subtends (and in my view spoils) the work of Jean

Baudrillard.[13] Conversely, a book like *New Times* – surely an attempt to generate a series of concrete possible futures from the left of British politics – came highly recommended in the Australian press as sensible and inventive (in comparison to the gloomy nonsense written by Australians confronting the reality of 'post-Fordist' Labor government) by the economically hyper-'rational' far right.[14]

One consequence of the mundane globalization immediately affecting intellectuals – an easier, wider circulation of *selected* cultural goods and personnel – is that this productive but sometimes destructive kind of mutation will happen more frequently and even more intensely than it has in the past. Cultural trade does not occur in a social, political or historical vacuum: as Gayatri Spivak pointed out some time ago, the circulation of Western 'theory' in post-colonial networks of power and influence has radically altered the significance of its uses – not only in 'other worlds' but, through the movement of work by diasporic intellectuals, in Europe and the United States as well.[15] If these movements intensify, it will become more difficult in some ways, as well as easier in others, to talk to and learn from each other, and the indignant parochialism of assuming that you always already *know* the political import of this or that product or practice will not be very helpful in future. Perhaps more seriously, the intellectual fantasy of total control historically invested in certain vanguardist forms of 'thinking about the future' – the manifesto, the utopian programme, that great book to change the course of human history – may itself become obsolete.

I quite like that idea. Classical utopian writing depresses me profoundly, and my idea of an empowering vision of the future is the ending of *Terminator 2*. But I doubt that the future is quite as open as that wonderful film suggests with its affirmation that freedom and responsibility are possible, not only in the fantasy futures by which we dream our opposition to regimes of grim necessity, but as real practices in the present of an indeterminate and unpredictable historical time. In reality, however, the *past* now seems even more terrifying than the future did under the old Cold War dispensation (and at the end of *The Terminator 1*). As the sense of a history moving with grim necessity into bloody repetition circulates insistently in the discourse of global media, I can understand the frustration of those people at the conference who were longing for the more benign, familiar closure of that stirring manifesto, that singular avant-garde gesture, that great book to initiate for us another 'whole new era'.

However, I have more faith in Margaret Morse's model of cultural politics because it does not require that we sacrifice to fear and 'crisis' the possibility of drawing on a *different past*, a past in which real practices of freedom and responsibility have been possible because 'alternative values and their constituencies have labored to mark themselves in discourse'. I do not share the belief of some speakers that vision and imagination are

lacking in the present, any more than I believe that TV and postmodern architectural styles are able to terminate history. I think it more plausible to suggest that there is amongst cultural critics a certain commodity boredom with the vision, the imagination, and the historical sense created by the labour that Morse invokes, and with the slow, incremental temporality endured by any struggle with serious designs on the future. My response to this boredom is – that's tough for cultural critics. Alternative values and their constituencies may perhaps be obliterated in an apocalyptic event, but they are not about to disappear by the decree of some jaded *culturati*.

On the same basis, I would also disagree with the view cited by David Harvey that the value-parasitic 'cultural mass' necessarily tends to 'lack the reassuring support of a moral tradition that (we) can call our own' (ch. 1, p. 26), and with his comment that this 'mass' has now 'internalized' struggles such as feminism under 'the banner of postmodernism'. I do know what he means by this, but I am uneasy with that '(we)' for the historical reason that, long before I was aware of any such thing as a 'banner of postmodernism', feminist politics taught me the value of doing cultural work and not the other way around. Alternative *histories* matter too, and the labour of marking and remarking them in discourse is, it seems, never-ending.

For example, if we must construct – for heuristic purposes – bipolar models in order to generate and 'resolve' a set of relations between modern and postmodern ways of conceptualizing 'space' and 'place', then the present as well as the future could look quite different if we began with a different past. Instead of starting out, once again, from Marx and Heidegger (thus staying firmly rooted in that Black Forest farmhouse called modern European social theory), we could stage a debate between Marx and Frantz Fanon, or one between Alexandra Kollantai and C. L. R. James, or another between Judah Waten (a Russian-born Jewish Australian Marxist) and Emma Goldman. I have argued elsewhere that the use of the figure of Heidegger to organize the concept of 'place' in *The Condition of Postmodernity* entails a serious misunderstanding of the varying politics of contemporary social movements concerned with identity and difference, in part because many *begin* their labours with a historical critique of what Harvey calls 'authenticity'.[16] In the context of the *Futures* conference, I think the problem is rather that Harvey's discourse on place is itself a little mired in theoretical nostalgia, and that we might better be able to realize the generous programme that he outlines by making use of other critical work already available.

My preference, really, would be to abandon the bipolar model. I would like to see a discussion of space and place (as well as of 'globalization and cultural politics') begin with Jamaica Kincaid's *A Small Place*, an essay on Antigua with plenty to teach about making connections between the global economy of tourism, colonial history, and the politics of cultural identity;

with Sally Morgan's *My Place*, a text about Morgan's experience of finding at the age of 30 that she was an Aboriginal not an Indian Australian, and of discovering what her history had to with the racial and sexual politics underpinning the economic success of the cattle industry in Australia; with Cynthia Enloe's *Bananas, Beaches and Bases: Making Feminist Sense of International Politics*, an economic and cultural study of the gender politics of the 'place construction' – army bases, embassies, brothels, servants' quarters – indispensable to global military space; with the late Eric Michaels' book about the cultural politics of television invented by the Warlpiri people in Central Australia, *For A Cultural Future: Francis Jupurrurla Makes TV at Yuendumu.*[17]

In this way, we might well have access to a political as well a moral tradition which could not be, in the possessive self-identical sense, 'our own', but which can powerfully shape and sustain our future labours. We could also see that place-based movements need by no means be place-*bound*, and may well provide in future more concrete ways of articulating and practising a politics of 'space' than those traditions of theorizing that think themselves universal have so far been able to achieve. One thing that such movements can certainly offer to the project of historical–geographical materialism outlined by David Harvey is their decades of experience in just how hard it can really be to build international movements – and their knowledge that it is, sometimes, possible to do so.

In Eric Michaels' last book, *Unbecoming: An AIDS Diary* (another text about globalization, 'place' construction and the stakes of personal identity), a text is included that he probably wrote in 1982 about a moment of decline, as he saw it, in gay politics. This text seems to me to have some pertinence to the concerns of the *Futures* conference. As a Jewish American who had spent years learning from the electronic and mixed-media strategies of traditional, if not especially Heideggerian, Aboriginal societies in Australia, Michaels wrote this about place, survival and the future for gay men:

> For starters, we need to take some responsibility for our own history, for conveying it to our young. It is not nostalgia. If one is going to go to all the trouble to be gay, one ought to do a more interesting and useful job of it. Models exist in our very recent past. They should be recalled.[18]

So should they all, I think, in future debates about the future of cultural politics.

NOTES

1 See Michael Pusey, *Economic Rationalism in Canberra: A Nation Building State Changes its Mind*, Cambridge and Melbourne, Cambridge University Press, 1991.

2 Graham Maddox, *The Hawke Government and Labor Tradition*, Ringwood, Penguin Books Australia, 1989, p. 108.

3 The future promised in 1991 by the Coalition is not exactly belated Thatcherism, although it is certainly influenced by Thatcher's (and Reagan's) policy *stance* – opposing 'smaller government', for example, to the 'welfare state'. But Australia already has small government and, because of its historic reliance on labourism to redistribute national income (as well as cuts to public spending under the Hawke regime), a 'lean' welfare system. In 1988 the total government sector accounted for 33 per cent of gross domestic product against an OECD average of 45 per cent, placing Australia 22nd out of 24 member nations (ahead only of Japan and Turkey), while social security transfers accounted for 8 per cent of GDP compared to the OECD average of 15.9 per cent – making Australia's spending the *lowest* of member nations reporting in that year (only Spain did not report). The aim of the Coalition plan, therefore, is 'to reduce the total public sector . . . to a much, much smaller proportion of the total economy than in any country with which we are accustomed to comparing ourselves' (Max Walsh, 'Fightback is a declaration of war against unions', *The Sydney Morning Herald*, 2 December 1991).

4 These forms are more often *invoked* (rather than practised) as though it somehow just ought to be possible for *other* people to practise them; and as though some moral failing is at work when they do not. See, for example, Andrew Milner's lament that:

> The generation of radical intellectuals which reached young adulthood in the 1960s . . . now lives in the shadow of its own failed revolution. In such circumstances Milton wrote *Paradise Lost*, Trotsky founded the Fourth International, and Henry Lawson drank himself to death. We, however, have discovered the politics of the transgressive sign.

It remains unclear in this passage why any 'radical' intellectual today would want to resort to the Great Man syndrome, just as it remains obscure why an incapacity to drink oneself to death should attest to political failure (Andrew Milner, 'The politics of the transgressive sign', *Thesis Eleven* 27 (1990), p. 201).

5 In Australian society – economically 'neo', as well as historically 'post', colonial, immigrant-based, racially and ethnically mixed to the point where only 10 per cent of third-generation Australians now claim a single ethnic background – this distinction really matters. *Fragmentation* is understood colloquially as a process by which a unity ideally defined by sameness undergoes a shattering event, while *heterogeneity* is a condition involving a mixture of radically different things (including 'fragments') which may, or may not, have had a shattering event in common. Colonized and displaced people experience fragmentation; they remake their memories, traditions and cultural identities in heterogeneity.

6 Demographer Christobel Young, cited by Michael Stutchbury, 'The bizarre anti-migration coalition', *The Australian Financial Review*, 14 November 1990.

7 Catherine Gallagher, 'Politics, the profession, and the critic', *Diacritics*, vol. 15 no. 2 (summer 1985), p. 41.

8 Margaret Morse, 'An ontology of everyday distraction: the freeway, the mall and television', in *Logics of Television: Essays in Cultural Criticism*, ed. Patricia Mellencamp, London, BFI Publishing, 1990, p. 215.

9 Ian Hunter, *Culture and Government: The Emergence of Literary Education*, London, Macmillan, 1988.

10 Michèle Le Doeuff, *Recherches sur l'imaginaire philosophique*, Paris, Payot, 1980, pp. 35–45.

11 Ian Hunter, 'Setting limits to culture', *New Formations* 4, spring 1988, pp. 103–25.

12 In particular, by constituting cultural criticism as an *ethical* project aimed at 'forming the self', Hunter's work tends to dismiss as without foundation such criticism's claims to engage in cultural *politics*. I discuss this in more detail in 'On the beach', in *Cultural Studies*, ed. Lawrence Grossberg, Cary Nelson and Paula Treichler, New York, Routledge, 1991.

13 Meaghan Morris, 'Banality in cultural studies', in *Logics of Television: Essays in Cultural Criticism*, ed. Patricia Mellencamp, London, BFI Publishing, 1990, pp. 14–43. Reprinted in *BLOCK* 14, 1988.

14 Stuart Hall and Martin Jacques (eds) *New Times: The Changing Face of Politics in the 1990s*, London, Lawrence & Wishart, 1989.

15 Gayatri Chakravorty Spivak, *In Other Worlds: Essays in Cultural Politics*, New York and London, Methuen, 1987.

16 Meaghan Morris, 'The man in the mirror: David Harvey's "Condition" of postmodernity', *Theory Culture & Society*, February 1992, pp. 253–79.

17 Cynthia Enloe, *Bananas, Beaches and Bases: Making Feminist Sense of International Politics*, Berkeley and Los Angeles, University of California Press, 1989; Jamaica Kincaid, *A Small Place*, London, Virago, 1988; Eric Michaels, *For A Cultural Future: Francis Jupurrurla Makes TV at Yuendumu*, Sydney, Artspace, 1987; Sally Morgan, *My Place*, Fremantle, Fremantle Arts Centre Press, 1987.

18 Eric Michaels, *Unbecoming: An AIDS Diary*, Sydney, Empress Publishing, 1990.

Chapter 3

Space as an arena of represented practices: An interlocutor's response to David Harvey's 'From space to place and back again'

Ashraf Ghani

RULES OF ENGAGEMENT

I will discuss David Harvey's essay from the position of an interlocutor, not that of a critic or a disciple. Karl Marx drew a clear distinction between the position occupied by a disciple and a critic:

> With the master what is new and significant develops vigorously amid the 'manure' of contradictions out of contradictory phenomena. The underlying contradictions themselves testify to the richness of the living foundation from which the theory itself developed. It is different with the disciple. His raw material is no longer reality, but the new theoretical form in which the master had sublimated it. It is in part the *theoretical disagreement of opponents of the new theory* and in part the *often paradoxical relationship of this theory to reality* which drive him to seek to *refute* his opponents and to *explain away* reality. In doing so, he entangles himself in contradictions and with his attempt to solve these, he demonstrates the beginning *disintegration of the theory* which he dogmatically espouses.
>
> (Marx 1971, Part III: 84–5; emphasis in the original)

In my reading, Marx touches on seven central issues pertaining to the production and reproduction of social theory. First, social theories are not discursive formations succeeding each other like geological epochs, but rather universes of discourse articulated in fields of agreements and disagreements with other theories. Second, as contradiction is an inherent aspect of any social theory, it is best to conceive of theories as open sets of arguments rather than as closed systems. Third, production and reproduction of a discursive rhetoric through which 'reality' is interpreted is a central aspect of the production of theories. Fourth, whereas the rhetorical strategy of a critic is based on exposing the silences and contradictions of a theory, the rhetorical strategy of a disciple is based upon using language games to explain away rather than deal with the objections of the critics. Fifth, as master and disciple are separated by differences of historical and

discursive contexts, the attempts of the disciple to remain faithful to the language of the master, instead of its simple reproduction, result in a new interpretation of the theory. Sixth, the resort to language games as the dominant rhetorical strategy of adherents of a theory is a symptom of the disintegration of a social theory. Seventh, as theories are produced and reproduced in the context of multiple fields of discourses, disagreement is the key mechanism in the production of new theories, viewed as novel if contradictory delineations of intersecting universes of discourse.

Despite its rich insights, Marx's sketch fails to account for repeated returns to the texts of theorists, such as himself or Freud, whom Michel Foucault calls 'founders of discursivity' – authors who have produced the 'possibilities and the rules for the formation of other texts' (Foucault 1984: 114). As the work of founders of discursivity establishes the primary co-ordinates of reference for a discursive universe, transformations of discursive practices take the form of re-examination of the texts of the founders. Thus, 'reexamining Freud's texts modifies psychoanalysis itself, just as reexamination of Marx's would modify Marxism' (ibid.: 116).

Foucault, however, neither discusses why the need for re-examination of these texts arises nor considers the possibility of how some types of readings might fundamentally differ from other types. I will argue that engaging Freud or Marx as an interlocutor is significantly different from engaging them as a founder, for the encounter takes place within discursive universes constituted by different questions, possibilities and rules. The examination of texts of Marx or Freud by an anthropologist, for instance, may result either in producing a Marxist or Freudian anthropology or in questioning the unstated cultural assumptions of theories of Marx and Freud that are premised on the historical experience of western Europe. In either case, the texts are produced in terms of possibilities different from those delineated by Freud or Marx. Whereas a critic questions the very founding assumptions of a theory on the basis of adherence to another set of founding assumptions, an interlocutor makes different theories inter-sect, thereby changing the character of coordinates for the production of discursive universes.

It is the activity of interlocutors that forces the adherents of a theory to undertake the re-examination of the texts of a 'founder of discursivity'. When Perry Anderson singles out the most striking single trait of Western Marxism as 'the constant presence and influence on it of successive types of European idealism' (P. Anderson 1976: 56), he is acknowledging the impact of interlocutors on 'Western Marxism'. Rather than viewing 'Western Marxism' as a closed system, it would be best to view it as an intersection of fields of discourse undergoing constant change and restatement.

The appeal of David Harvey's four-point agenda at the end of *The Condition of Postmodernity* (Harvey 1989) and at the beginning of his

present essay (see Chapter 1) is that he self-consciously undertakes his reconstruction of historical–geographical materialism in relation to the intersection of fields of discourse in which all producers and consumers of social theory are currently placed, if not caught. Not having the space to discuss whether Marx is still one of the central interlocutors for social theory, which I feel he is, I will now proceed to interrogate some of Harvey's conceptions of space in relation to his proclaimed agenda, but on the basis of questions made relevant by virtue of my formation as an anthropologist.

SPACE, DIFFERENCE AND UNEVEN DEVELOPMENT

I will respond to Harvey's call for looking at places in 'terms of material as well as in terms of discursive and symbolic practices' by taking two examples from England. Viewing the public world of men in London from the angle of the threshold of the private house, Virginia Woolf argued, in 1938, that

> within quite a small distance are crowded together St. Paul's, the Bank of England, the Mansion House, the massive if funereal battlements of the Law Courts; and on the other side, Westminster Abbey and the Houses of Parliament. There, we say to ourselves . . . our fathers and brothers have spent their lives. All these hundreds of years they have been mounting those steps, passing in and out of those doors, ascending those pulpits, preaching, money-making, administering justice. It is from this world that the private house (somewhere, roughly speaking, in the West End) has derived its creeds, its laws, its clothes and carpets, its beef and mutton.
>
> (Woolf 1966: 18–19)

The procession of men through these spaces has caused women, Woolf stated:

> to ask ourselves certain questions. But now, for the past twenty years or so, it is no longer a sight merely, a photograph, or fresco scrawled upon the walls of time, at which we can look with merely an esthetic appreciation. For there, trapesing along the tail end of the procession, we go ourselves. And that makes a difference. We who have looked so long at the pageant in books, or from a curtained window watched educated men leaving the house at about nine-thirty to go to an office, returning to the house at about six-thirty from an office, need look passively no longer. We too can leave the house, can mount those steps, pass in and out of those doors, wear wigs and gowns, make money, administer justice.
>
> (ibid.: 61)

The second example deals with the question commonly posed by Harvey to his students: where does their food come from? As John Hammond wrote:

> Before 1850, England could only obtain wheat from Odessa, or from Poland and Prussia via the Danzig. In 1905 she had cargoes from all parts of the world: in January from the Pacific coast of America, in February and March from Argentina, in April from Australia, in May and June and July from India, in July and August winter wheat from America, in September and October spring wheat from America and Russia, in November from Canada. The effect of the revolution [in transport] is that wheat, whether produced in England, Russia, Germany or the United States, fetches approximately the same price on the London or the Mannheim Corn Exchange. For corn, cotton, rubber, tea, sugar, the world is one market.
>
> (Hammond 1931: 10–11)

Why do I group such seemingly disparate passages together? To pose the question of examination of space as an arena for the production, reproduction and contestation of routinized spatio-temporal practices resulting in uneven development. Money, especially in the form of capital, occupies a central role in the process of production and reproduction of uneven development. But to understand the mechanisms of this uneven development, capital must be examined as a social process where differences are discursively formulated through a cultural system. These formulations of difference, according to Mary Poovey, are uneven 'both in the sense of being experienced differently by individuals [who are] positioned differently within a social formation (by sex, class or race, for example) and in the sense of being articulated differently by different institutions, discourses, and practices' (Poovey 1988: 3). Considering issues that are interpreted as 'problems' in binary ideological formulations of relationships to be particularly important in marking the limits of ideological certainty, Poovey provides not only a subtle analysis of how representatives of gender were produced, used and contested but also how the ideological work entailed in the constructions of gender in mid-Victorian England entailed the reciprocal construction of ideologies of class, race and nationality that defined 'Englishness' in the period. Therefore the failure of Marx, the most important theorist in Harvey's view, to grapple with these reciprocal constructions can best be understood in the light of his own remark on how people do not notice contradictions in their own society: 'A complete contradiction offers not the least mystery to them. They feel as much at home as fish in water among manifestations which are separated from their internal connections and absurd when isolated by themselves' (Marx 1967b: 779).

If Harvey's call for the omnipresence of difference and otherness is to be responded to, the reciprocal constructions between gender and other

categories of difference must be then made central foci of investigation in social theory. Focusing on gender is, of course, different from focusing solely on women; for rather than accepting the difference between men and women as 'natural', the analyst begins with how gender is socially constructed and politically sanctioned. To be compelling, such an analysis must follow Poovey's strategy of exploring the reciprocal construction of other categories of difference. The challenge posed by Harvey's silence on gender is then not merely to explain away the silence by reference to his social identity as a white English male, but to show how the incorporation of gender will result in a fundamental modification of his analysis.

If space were to be examined as a constitutive arena of socio-cultural practices and as a site constituted in the process of contestation over the reproduction of such practices, an analysis of the processes of production and representations of space over time will be central to the understanding of processes of uneven development. Woolf explicitly focuses on space as an arena of differentiating practices of power. Hammond, however, describes the increasingly central place of England in the global circuits of production and circulation of commodities without any attention to how the process was premised on the production of global uneven development. To explore the reciprocal constructions of gender, class and race entailed in the grouping of two passages, I will move from a reading of Woolf's passage to the exploration of global uneven development.

The distinction between the private space of the house and the public space of the office, to begin with, is a distinction that is culturally constructed and politically sanctioned by the state, and results in a pronounced gendering of space. The pervasive masculinity of the state is revealed with particular clarity by the monopoly of spaces of power by men. The uneven access of men and women to formal power is clearly revealed in the routinization of differences in their daily spatio-temporal routines, with women staying home but educated men spending the period from 9.30am to 6.30pm at the office. The uneven positioning of men and women in terms of spatio-temporal routines is clearly revealed in their unequal access to money. The public relation of brother and sister from the inception of English law up to 1919, Woolf argued, was set to the harsh tone of 'shall not': 'You shall not learn; you shall not earn; you shall not own; you shall not – such was the society relationship of brother to sister over many centuries' (Woolf 1966: 105). Uneven positioning in relationship to spaces of power results in significant differences in the perception of space. When access to these spaces changes, however, a shift in the perception of space is noticeable on the part of daughters of educated women.

Woolf does not dwell on the reciprocal constructions of gender and class, but she does discuss why English women were for empire and war.

So profound was her unconscious loathing for the education of the

private house with its cruelty, its poverty, its hypocrisy, its immorality, its insanity that she would undertake any task however menial. Thus, consciously she desired 'our splendid Empire'; unconsciously she desired 'our splendid war.'

(ibid.: 39)

In her analysis of social construction of Florence Nightingale, Poovey explores the reciprocal construction of gender, class and race. To mask the subversive character of her campaign against medical men, Nightingale foregrounded her campaign in terms of class. Her object was 'to bring the poor and their environment under the salutary sway of their middle-class betters' (Poovey 1988: 188). An embracing of the empire soon followed, for she produced an image of the empire as the government of love. This image was 'produced and reproduced as England's empire grew, because it legitimated middle-class England's domestic and colonial imperialism while disguising the profoundly and violently racist and classist bases of these campaigns' (ibid.: 197).

Direct representations of the domination of non-Europeans by Europeans, in terms of a heterosexual act, were prevalent. Prosper Enfantin, a member of the French delegation that arrived in Egypt in 1833, explicated the symbolism of the piercing of the Suez Canal by writing that 'Suez is the Centre of our life work. We shall carry out the act for which the world is willing to proclaim that we are male!' (quoted in Bernal 1987: 269). Enfantin, a St Simonian, was thus clearly articulating that discourse on uneven development called Orientalism, which Edward Said has aptly described 'as a Western style for dominating, restructuring, and having authority over the Orient' (Said 1978: 3).

The contours of this process of domination can best be captured by what Marx called the 'annihilation of space by time' (Marx 1973: 539). The phrase, as Harvey has argued, poses the 'question of how and by what means space can be used, organized, created, and dominated to fit the rather strict temporal requirements of the circulation of capital' (Harvey 1985: 37).

A measure of how Britain achieved its central role in the global synchronization of space and time that took place between 1850 and 1907 is provided by the expenditure of £8,986,150,000, of mainly British capital, on the construction of 601,808 miles of railway across the world (*Encyclopaedia Britannica* 1911: 822–4). Changes in the organization of space in India made possible shipments to Britain of cargoes of wheat in May, June and July of 1905 – a telling example of the role played by capital in subordinating geography to political economy. In 1833 the British conquerors had built only 16 miles of roads in India (*Imperial Gazetteer of India* 1908, vol. 3: 404). In 1853 Lord Dalhousie (Governor-General of India between 1848 and 1856) articulated the need for investing in a transport

network. Holding out the prospect of great tracts in India 'teeming with produce of which they cannot dispose' to British capitalists, he went on to declare that 'England is calling aloud for the cotton which India does already produce in some degree, and would produce sufficient in quality and plentiful in quantity, if only there were provided the fitting means of conveyance for it' (quoted in Jenks 1927: 211–12).

Judging by the investment of £14m in the following four years, the response of capital to Dalhousie's call was enthusiastic. But the real spurt came in the wake of the bloody suppression of the Indian revolt of 1857, as the London money market invested £67,610,000 between 1858 and 1869 in railways in India (Jenks 1927: 207, 219). With the opening of the Suez Canal in 1869, the distance between Bombay and Liverpool was reduced from 11,560 to 5,777 nautical miles, diminishing the time of travel between the two cities from in excess of one hundred days to between twenty-one and twenty-five days (*Imperial Gazetteer of India* 1908, vol. 3: 262).

The implications of these changes in the relationship between space and time for the commodification of the time of labourers in India and the products of their work can be illustrated by two examples. 'Thousands', wrote a British official, 'now travel annually to the jute-fields and tea gardens of Eastern Bengal and Assam, the rice-swamps of Burma, and other parts of the country; and distance no longer hinders the movement of the people' (ibid.: 386). Nor did distance hinder the movement of commodities. According to a British official estimate, it would have taken 220,000 carts using 750,000 men and bullocks to carry the volume of grain carried by one loaded train in one day (*Great Britain, Parliamentary Papers* (1884), vol. 11: 456).

With the export of 25.5 million cwt of wheat in 1904, India was the largest supplier of wheat to the United Kingdom. The *Encyclopaedia Britannica* (1911: 390) could proudly declare the transformation of India into one of the 'great grain-fields of the British empire'. The change, however, could also be measured by other indicators. More than a million people in India lost their lives as a result of a famine during the year of transition from the nineteenth to the twentieth century (*Imperial Gazetteer of India* 1908, vol. 3: 492). Uneven development was not confined to the production of commodities for the world market economy, for consumption in Great Britain was also premised on unequal development. In analysing the transformation of sugar from a luxury to a necessity, Sidney Mintz not only explores the class differences in consumption but argues that within the British working class, 'wives and children were systematically undernourished because of a culturally conventionalized stress upon adequate food for the "breadwinner" ' (Mintz 1985: 214).

Thus, differential positioning within the emergent global economy was not merely an indication of unequal access to money but also a sign that the relationship to money was a critical index of the place occupied by

persons and groups situated in relationships of uneven development. The corollary to be drawn from this discussion of the emergent phase of the globalization of capital for the current phase of space and time compression that Harvey has identified is that the consequences of shifts from Fordism to the flexible mode of accumulation of capital are, indeed, felt unevenly by different groups of people. It may, however, be equally true that the difference in experience constitutes an indication of the correctness of Harvey's analysis, for production of uneven development has been a hallmark of the process of capital accumulation.

But let us return to the discussion of the role of capital in the production of space and time in India. British power in India was not realized through the agency of faceless capital, destroying every barrier, dissolving every social bond, tearing down the fabric of the old society and replacing it with a society where capital and labour faced each other as antagonistic classes. It was realized through the agency of a colonial state, imposing its racist system of classification where the categories of 'martial races' and 'agricultural tribes' were to designate social groups that were considered 'naturally' endowed to fight or to own land. As befitting binary classifications, the other terms of the opposition were to be pinned on groups considered incapable of fighting or unworthy of owning land.

The determination of boundaries between religion and politics, obedience and sedition, the publicly permitted and forbidden in writing and speaking, became the business of the colonial state. But the range of the system of classification was not limited to the 'big' questions, for the archives of the colonial power bear witness to their equal zeal in discussing recruitment for the army and the determination of categories of 'natives' who were entitled to wear shoes or sit in the presence of government functionaries. If spaces of power for Woolf were the arena where the masculinity of the state was visible to the naked eye, spaces of power in the colonial situation were the arena where the reciprocal constructions of race, caste, class, gender and religion as discourses and practices were equally inscribed on places and bodies of subjects.

In his *Raj Quartet*, Paul Scott (1979) made these reciprocal constructions familiar to readers, representations brought to television viewers through the series called *The Jewel in the Crown*. The role assigned to women in this symbolic economy of power is best revealed in those rare moments when European women were taken prisoners by non-Europeans. Hearing of the destruction of the British army of conquest in Afghanistan, the Duke of Wellington articulated the issue clearly in his letter of 31 March 1842 to the Prime Minister of Britain.

> There is not a Muslim heart from Peking to Constantinople which will not vibrate when reflecting upon the fact that the European ladies and other females attached to the troops at Kabul were made over to the

tender mercies of the Muslim [chiefs]. . . . It is impossible that the fact should not produce a moral effect injurious to British Influence and Power throughout the whole of Asia, and particularly among Muslim population of the British Dominions in the Peninsula of India and the Dependencies thereof.

<div align="right">(Quoted in Norris 1967: 396)</div>

As far as the women of the dominated people were concerned, the attitude of the colonial establishment is best expressed by the proverb: 'Necessity is the mother of invention and the father of the Eurasian' (Fraser-Tytler 1967).

SPACE, TEMPORALITY AND POWER

George Orwell wrote in narrating his experience as a tramp in London:

It is curious how ones does not notice things. I had been in London innumerable times, and yet till that day I had never noticed one of the worst things about London – the fact that it costs money even to sit down. In Paris, if you had no money and could not find a public bench, you would sit on the pavement. Heaven knows what sitting on the pavement would lead to in London – prison, probably.

<div align="right">(Orwell 1933/1961: 154)</div>

Not noticing the cultural genealogy of routinized spatio-temporal representations and practices has been crucial to conferring upon historically constructed relationships qualities of timeless naturalness. As Harvey's analysis of experience of space and time in *The Condition of Postmodernity* (Harvey 1989) are among the most original contributions to the discussion of the subject, I will raise some questions pertaining to the reciprocal construction of space, temporality and power.

If space and time are to be analysed as socially constructed processes, then one may ask: what are the spatial and temporal co-ordinates of reference for Europe in historical time and geographical space? How have such co-ordinates of reference changed and how are they changing right now? When and how have the space and time represented as European been endowed with a superior essence and a progressive direction? How did shifts in the positioning of Europeans in fields of power in relation to adherents of other cultures affect the representations of the origins of Europe and other societies and how have representations of Europeans as different from other people affected and continue to affect the development of uneven development?

Constraints of space confine me to posing questions rather than attempting to answer them. I would, however, like to indicate that Martin Bernal, in

his account of fabrication of ancient Greece, has provided a bold examination of how representations of Europe's past have been forged in terms of the changing needs of the present. Showing that 'no one before 1600 seriously questioned either the belief that Greek civilization and philosophy derived from Egypt, or that the chief ways in which they had been transmitted were through Egyptian colonizations of Greece and later Greek study in Egypt' (Bernal 1987: 120), Bernal convincingly argues that it can be assumed 'that *after the rise of black slavery and racism, European thinkers were concerned to keep Africans as far as possible from European civilization*' (ibid.: 30; emphasis in the original). Hence the representations of Greece as the childhood of Europe and the place where philosophy originated.

The connection made by Bernal between changes in representations of the past and the practices of the present allows us to pose the question of space as an arena of production both of temporal representations and practices and of politics and movement. Benedict Anderson's conception of nation as 'an imagined political community – and imagined as both inherently limited and sovereign' (Anderson 1985: 15) is indeed the necessary point of departure. But if the analysis he initiated is to be made to intersect with the agenda delineated by Harvey, the concept of national economy as representation and practice needs to be explored.

Uneven development formed the historical context of the discursive move from the principles of English cosmopolitical economy to the formulation in 1841 by Frederic List of the doctrine of national economy. Rejecting the principles of free international trade as serving the interests of Britain, List argued for the protection of nascent industries in Germany on grounds of national interest (Austin 1842: 515–56). But opposition to the dominance of other nations was premised on the suppression of differences within the nation. Showing that translation of these doctrines into practices 'conciliated the business classes with the state', Moritz Bonn went on to argue that

> these business groups continued, however, to insist on a policy of non-intervention so far as labor conditions were concerned. They argued that no efforts should be made to shorten hours or to protect women or children; nor should the combination of workers to raise wages be permitted, since this would make labor a monopoly and endanger the accumulation of capital.
>
> (Bonn 1931: 340)

Construction of the national economy thus entailed the reciprocal construction of age, class, gender, capital and state. If political economy in France provided 'the terms by which relations of production and sexual division of labor were established and contested' (Scott 1988: 163), national economy in Germany provided the terms by which struggles over the uses and

representations of time and space in relation to the process of accumulation of capital as a national goal were established and contested.

Analysis of the working day as the site of contestation of labour has been among the enduring contributions of Marx to social theory (Marx 1967a: 231–302). He also made a cursory attempt to analyse the 'bloody legislation against vagabondage' enacted throughout Europe at the end of the fifteenth and throughout the sixteenth centuries (ibid.: 734–44). But despite his quoting Cairnes's observation that the most effective economy in slave-importing countries was to take 'out of the human chattel in the shortest space of time the utmost amount of exertion it is capable of putting forth' (ibid.: 266), Marx failed to analyse the reciprocal constructions of race, class and state in the process of accumulation of capital. But to ignore the forced migration of millions of Africans to the Americas is not only to fail to analyse the process of accumulation of capital as a historical process but also to ignore the place of race and other forms of difference in the historical present.

If forced migration is one side of the coin of the politics of movement, the use of differences to exclude certain groups from immigration is its other side. Race, again, has been a central category of reference in this regard. Exclusion of the Chinese from entry into the United States in 1882 was followed by the passage of similar measures in Canada in 1885 and in Australia in 1905. People from southern and eastern Europe became the targets of discriminatory measures in the United States in 1924. The effect of such measures, argued Caroline Ware, 'has been to change the character of immigration from a haphazard movement to a carefully regulated one, severely to cut down its volume and largely to deflect the direction of its flow' (Ware 1932: 594).

As in the case of other differences expressing uneven development, space is the arena where the political nature of movement is visible to the naked eye. Are not airports, ports and borders the sites supposed to facilitate movement, the very spaces dreaded by those people classified as undesirable by the powers that be? Is it not the case that the countries most vociferous in demanding the removal of the Iron Curtain for forty-five years are now engaged in the construction of an Iron Curtain of their own against migrants from the former members of the Warsaw Pact? And was the control over the future uses of the resources of the Middle East not greatly determined by the Gulf War?

The future, therefore, cannot be separated from the historical present, for the past in the present is the precondition of the reproduction of the present as future. If the future is to be different from the present, it has to be produced under different sets of preconditions than those on which the reproduction of the present in the past has been premised. It is the hope of overcoming historical distinctions masquerading as natural distinctions that I have adopted the position of Harvey's interlocutor. Were space available,

I would have engaged in a fuller discussion of spatiality and temporality. But then the richness of Harvey's contribution is such that this paper is only another step in an ongoing dialogue began long ago at Johns Hopkins.

REFERENCES

Anderson, B. (1983) *Imagined Communities: Reflections on the Origin and Spread of Nationalism*, London and New York: Verso.

Anderson, P. (1976) *Considerations on Western Marxism*, London: New Left Books.

Austin, J. (1842) 'On national system of political economy', *Edinburgh Review*, pp. 515–56.

Bernal, M. (1987) *Black Athena*, vol. 1, New Brunswick: Rutgers University Press.

Bonn, M. (1931) 'Economic policy', *Encyclopedia of the Social Sciences*, vol. 5, New York: Macmillan, pp. 333–44.

Foucault, M. (1984) 'What is an author?', in *The Foucault Reader*, ed. P. Rabinow, New York: Pantheon Books, pp. 101–20.

Fraser-Tytler, W. (1967) *Afghanistan: A Study of Political Developments in Central and Southern Asia*, London: Oxford University Press.

Hammond, J. (1931) 'Commerce', in *Encyclopedia of Social Sciences*, vol. 4, New York: Macmillan, pp. 1–13.

Harvey, D. (1985) *Consciousness and the Urban Experience: Studies in the Theory of Capitalist Urbanization*, Baltimore, MD: Johns Hopkins University Press.

—— 1989: *The Condition of Postmodernity: An Inquiry into the Origins of Cultural Change*, Oxford: Basil Blackwell.

Imperial Gazetteer of India (1908) vol. 3, Oxford: Clarendon Press.

Jenks, L. (1927) *Migration of British Capital*, New York: Alfred A. Knopf.

Marx, K. (1967a) *Capital*, vol. 1, ed. Frederick Engels, New York: International Publishers.

—— (1967b) *Capital*, vol. 3, ed. Frederick Engels, New York: International Publishers.

—— (1971) *Theories of Surplus-Value: Part III*, Moscow: Progress Publishers.

—— (1973) *Grundrisse: Foundations of the Critique of Political Economy*, trans. Martin Nicolaus, New York: Vintage Books.

Mintz, S. (1985) *Sweetness and Power: The Place of Sugar in Modern History*, New York: Penguin Books.

Norris, J. (1967) *The First Afghan War: 1838–1842*, Cambridge: Cambridge University Press.

Orwell, G. (1933) *Down and Out in Paris and London*, San Diego, CA: Harcourt, Brace Jovanovich.

Poovey, M. (1988) *Uneven Developments: The Ideological Work of Gender in Mid-Victorian England*, Chicago: University of Chicago Press.

Said, E. (1978) *Orientalism*, New York: Vintage Books.

Scott, J. (1988) *Gender and the Politics of History*, New York: Columbia University Press.

Scott, P. (1979) *Raj Quartet*, New York: Avon Books.

Ware, C. (1932) 'Immigration', in *Encyclopedia of the Social Sciences*, New York: Macmillan, pp. 587–94.

Woolf, V. (1966) (1st edn 1938) *Three Guineas*, San Diego, CA: Harcourt Brace Jovanovich.

Power-geometry and a progressive sense of place

Doreen Massey

TIME – SPACE COMPRESSION AND THE GEOMETRIES OF POWER

Much of what is written about space, place and postmodern times emphasizes a new phase in what Marx once called 'the annihilation of space by time'. The process is argued, or more usually asserted, to have gained a new momentum, to have reached a new stage. It is a phenomenon which Harvey (1989) has termed 'time–space compression'. And the general acceptance that something of the sort is going on is marked by the almost obligatory use in the literature of terms and phrases such as speed-up, global village, overcoming spatial barriers, the disruption of horizons and so forth.

Yet the concept of time–space compression remains curiously unexamined. In particular, it is a concept which often remains without much social content, or with only a very restricted, one-sided, social content. There are many aspects to this. One is, of course, the question of to what extent its current characterization represents very much a Western, colonizer's view. The sense of dislocation which so many writers on the subject apparently feel at the sight of a once well-known local street now lined with a succession of cultural imports – the pizzeria, the kebab house, the branch of the middle-eastern bank – must have been felt for centuries, though from a very different point of view, by colonized peoples all over the world as they watched the importation of, maybe even used, the products of, first, European colonization, maybe British (from new forms of transport to liver salts and custard powder); later US products, as they learned to eat wheat instead of rice or corn, to drink Coca–Cola, just as today we try out enchiladas.

But there are just two points which it seems particularly important to raise in the current context. The first concerns causality. Time–space compression is a term which refers to movement and communication across space. It is a phenomenon which implies the geographical stretching-out of social relations (referred to by Giddens (1984) as time–

space distanciation), and to our experience of all this. However, those who argue that we are currently undergoing a new phase of accelerated time–space compression usually do so from a very particular view of its determination. For Jameson and for Harvey these things are determined overwhelmingly by the actions of capital (Jameson 1984; Harvey 1989). For Harvey it is, in his own terms, time space and money which make the world go round, and us go round (or not) the world. It is capitalism and its developments which are argued to determine our understanding and our experience of space. This is, however, clearly insufficient. There are many other things that clearly influence that experience, for instance, ethnicity and gender. The degree to which we can move between countries, or walk about the streets at night, or take public transport, or venture out of hotels in foreign cities, is not influenced simply by 'capital'. Harvey describes how Frédéric Moreau, hero of Flaubert's *L'Éducation Sentimentale*,

> glides in and out of the differentiated spaces of the city, with the same sort of ease that money and commodities change hands. The whole narrative structure of the book likewise gets lost in perpetual postponements of decisions precisely because Frédéric has enough inherited money to enjoy the luxury of not deciding.

Reflecting on this, Harvey argues that

> it was the possession of money that allowed the present to slip through Frédéric's grasp, while opening social spaces to casual penetration. Evidently, time, space and money could be invested with rather different significances, depending upon the conditions and possibilities of trade-off between them.
>
> (Harvey 1989: 263–4)

Time, space and *money*? Did not Frédéric, as he 'casually penetrated' these social spaces, have another little advantage in life, too (see also Massey 1991b)? Or again Birkett, reviewing books on women adventurers and travellers in the nineteenth and twentieth centuries, suggests that 'it is far, far more demanding for a woman to wander now than ever before' (Birkett 1990: 41). The reasons for this, she argues, are a complex mix of colonialism, ex-colonialism, racism, changing gender relations, and relative wealth. Harvey's simple resort to 'money' alone could not begin to get to grips with the issue. (Incidentally, of course, the example also indicates that 'time–space compression' has not been happening for everyone in all spheres of activity.) In other words, and simply put, there is a lot more determining how we experience space than what 'capital' gets up to. Most of the arguments so far around time–space compression do not recognize this. Moreover, to argue for this greater complexity is not in any way to be anti-materialist, it is simply not to reduce materialism to economism.

The second point about the inadequacy of the notion of time–space

compression as it is currently used is that it needs differentiating socially. This is not just a moral or political point about inequality, although that would be sufficient reason to mention it: it is also a conceptual point. Imagine for a moment that you are on a satellite, further out and beyond all actual satellites; you can see 'planet earth' from a distance and, rare for someone with only peaceful intentions, you are equipped with the kind of technology that allows you to see the colours of people's eyes and the number on their number-plates. You can see all the movement and tune-in to all the communication that is going on. Furthest out are the satellites, then aeroplanes, the long haul between London and Tokyo and the hop from San Salvador to Guatemala City. Some of this is people moving, some of it is physical trade, some is media broadcasting. There are faxes, e-mail, film-distribution networks, financial flows and transactions. Look in closer and there are ships and trains, steam trains slogging laboriously up hills somewhere in Asia. Look in closer still and there are lorries and cars and buses and on down further and somewhere in sub-Saharan Africa there's a woman on foot who still spends hours a day collecting water.

Now, I want to make one simple point here, and that is about what one might call the *power-geometry* of it all; the power-geometry of time–space compression. For different social groups and different individuals are placed in very distinct ways in relation to these flows and interconnections. This point concerns not merely the issue of who moves and who doesn't, although that is an important element of it; it is also about power in relation *to* the flows and the movement. Different social groups have distinct relationships to this anyway-differentiated mobility: some are more in charge of it than others; some initiate flows and movement, others don't; some are more on the receiving end of it than others; some are effectively imprisoned by it.

In a sense, at the end of all the spectra are those who are both doing the moving and the communicating and who are in some way in a position of control in relation to it. These are the jet-setters, the ones sending and receiving the faxes and the e-mail, holding the international conference calls, the ones distributing the films, controlling the news, organizing the investments and the international currency transactions. These are the groups who are really, in a sense, in charge of time–space compression; who can effectively use it and turn it to advantage; whose power and influence it very definitely increases. On its more prosaic fringes this group probably includes a fair number of Western academics.

But there are groups who, although doing a lot of physical moving, are not 'in charge' of the process in the same way. The refugees from El Salvador or Guatemala and the undocumented migrant workers from Michoacán in Mexico crowding into Tijuana to make perhaps a fatal dash for it across the border into the USA to grab a chance of a new life. Here the experience of movement, and indeed of a confusing plurality of cultures,

is very different. And there are those from India, Pakistan, Bangladesh and the Caribbean, who come halfway round the world only to get held up in an interrogation room at Heathrow.

Or again, there are those who are simply on the receiving end of time–space compression. The pensioner in a bedsit in any inner city in this country, eating British working-class-style fish and chips from a Chinese take-away, watching a US film on a Japanese television, and not daring to go out after dark. And anyway, the public transport's been cut.

Or – one final example to illustrate a different kind of complexity – there are the people who live in the favelas of Rio; who know global football like the back of their hand, and have produced some of its players; who have contributed massively to global music; who gave us the samba and produced the lambada that everyone was dancing to a few years ago in the clubs of Paris and London; and who have never, or hardly ever, been to downtown Rio. At one level they have been tremendous contributors to what we call time–space compression; and at another level they are imprisoned in it.

This is, in other words, a highly complex social differentiation. There is the dimension of the degree of movement and communication, but also the dimensions of control and of initiation. The ways in which people are inserted into and placed within 'time–space compression' are highly complicated and extremely varied. It is necessary to think through with a bit more conceptual depth, a bit more analytical rigour, quite how these positions are differentiated. Moreover, recognition of this complexity raises the important issue of *which* condition of postmodernity we are talking about – *whose* condition of postmodernity?

More immediately, two points arise from these considerations. The first raises more directly questions of politics. If time–space compression can be imagined in that more socially formed, socially evaluative and differentiated way, then there may be the possibility of developing a politics of mobility and access. For it does seem that mobility and control over mobility both reflect and reinforce power. It is not simply a question of unequal distribution, that some people move more than others, some have more control than others. It is that the mobility and control of some groups can actively weaken other people. Differential mobility can weaken the leverage of the already weak. The time–space compression of some groups can undermine the power of others. This is well established and often noted in the relationship between capital and labour. Capital's ability to roam the world further strengthens it in relation to relatively immobile workers, enables it to play off the plant at Genk against the plant at Halewood. It also strengthens its hand against struggling local economies the world over as they compete for the favour of some investment. But also, every time someone uses a car, and thereby increases their personal mobility, they reduce both the social rationale and the financial viability of the public transport system – and thereby also potentially reduce the mobility of those

who rely on that system. Every time you drive to that out-of-town shopping centre you contribute to the rising prices, even hasten the demise, of the corner shop. And the 'time–space compression' which is involved in producing and reproducing the daily lives of the comfortably-off in first-world societies – not just their own travel but the resources they draw on, from all over the world, to feed their lives – may entail environmental consequences, or hit constraints, that will limit the lives of others before their own. We need to ask, in other words, whether our relative mobility and power over mobility and communication entrenches the spatial imprisonment of other groups.

A politics of mobility might range over issues as broad as wheelchair access, reclaiming the night and the streets of cities for women and for older people, through issues of international migration, to the whole gamut of transport policy itself. Conceptualizing space, mobility and access in a more socially imaginative way, and abandoning easy and excited notions of generalized and undifferentiated time–space compression, might enable us to confront some of these issues rather more inventively.

The second point is simply a question. Why is it that for so many of the academics who write about time–space compression, who are in relative control of their new mobility and means of communication, who jet off to (or from) Los Angeles to give a paper on it, does it generate such feelings of insecurity? Harvey (1989), for instance, constantly writes of vulnerability, insecurity and the unsettling impact of time–space compression. This question is important less in itself than because, as will be argued in the next part of this chapter, it seems also to have generated in them, as a counter to all this insecurity, a very particular (and unprogressive) sense of place.

A PROGRESSIVE SENSE OF PLACE

Those writers who interpret the current phase of time–space compression as primarily generating insecurity also frequently go on to argue that, in the middle of all this flux, one desperately needs a bit of peace and quiet; and 'place' is posed as a source of stability and an unproblematical identity. In that guise, place and the spatially local are rejected by these writers as almost necessarily reactionary. Space/place is characterized, after Heidegger, as Being; and, as such, as a diversion from the progressive dimension of Time as Becoming (see Harvey (1989); and Massey (1991a) for a critique of this position).

There are a number of serious inadequacies in this argument, ranging from the question of why it is assumed that time–space compression will produce insecurity, through the need to face up to – rather than simply deny – people's need for attachment of some sort, whether through place or anything else. It is also problematical that so often this debate, as in the

case of Harvey, starts off from Heidegger, for if it had not started off from there, perhaps it would never have found itself in this conceptual tangle in the first place.

None the less, it is certainly the case that there is at the moment a recrudescence of some problematical senses of place, from reactionary nationalisms to competitive localisms, to sanitized, introverted obsessions with 'heritage'. Instead of refusing to deal with this, however, it is necessary to recognize it and to try to understand what it represents. Perhaps it is most important to think through what might be an adequately progressive sense of place, one which would fit in with the current global–local times and the feelings and relations they give rise to, *and* one which would be useful in what are, after all, our often inevitably place-based political struggles. The question is how to hold on to that notion of spatial difference, of uniqueness, even of rootedness if people want that, without it being reactionary.

There are a number of distinct ways in which the notion of place which is derived from Heidegger is problematical. One is the idea that places have single essential identities. Another is the idea that the identity of place – the sense of place – is constructed out of an introverted, inward-looking history based on delving into the past for internalized origins, translating the name from the Domesday Book. Wright (1985) confronts both these issues. He recounts the construction and appropriation of Stoke Newington and its past by the arriving middle class (the Domesday Book registers the place as 'Newtowne': 'There is land for two ploughs and a half. . . .There are four villanes and thirty seven cottagers with ten acres' (ibid.: 227, 231)), and he contrasts this version with that of other groups – the white working class and the large number of important minority communities.

Another problem with the conception of place which derives from Heidegger is that it seems to require the drawing of boundaries. Geographers have long been exercised by the problem of defining regions, and this question of 'definition' has almost always been reduced to drawing lines around a place. I remember some of my most painful times as a geographer have been spent unwillingly struggling to think how one could draw a boundary around somewhere like 'the East Midlands'. Within cultural studies, some of the notions of 'cultural area' sometimes seem equally to entail this problematical necessity of a boundary: a frame in the sense of a concave line around some area, the inside of which is defined in one way and the outside in another. It is yet another form of the construction of a counterposition between us and them.

And yet if one considers almost any real place, and certainly one not defined primarily by administrative or political boundaries, these supposed characteristics have little real purchase. Take, for instance, a walk down Kilburn High Road, my local shopping centre. It is a pretty ordinary place,

north-west of the centre of London. Under the railway bridge the newspaper-stand sells papers from every county of what my neighbours, many of whom come from there, still often call the Irish Free State. The postboxes down the High Road, and many an empty space on a wall, are adorned with the letters IRA. The bottle and waste-paper banks are plastered this week with posters for a Bloody Sunday commemoration. Thread your way through the often almost stationary traffic diagonally across the road from the newsstand and there's a shop which, for as long as I can remember, has displayed saris in the window. Four life-sized models of Indian women, and reams of cloth. In another newsagent I chat with the man who keeps it, a Muslim unutterably depressed by the war in the Gulf, silently chafing at having to sell the *Sun*. Overhead there is always at least one aeroplane – we seem to be on a flight-path to Heathrow and by the time they're over Kilburn you can see them clearly enough to discern the airline and wonder as you struggle with your shopping where they're coming from. Below, the reason the traffic is snarled up (another odd effect of time–space compression!) is in part because this is one of the main entrances to and escape-routes from London, the road to Staples Corner and the beginning of the M1 to the north. These are just the beginnings of a sketch from immediate impressions but a proper analysis could be done, of the links between Kilburn and the world. And so it could for almost any place.

Kilburn is a place for which I have a great affection; I have lived here many years. It certainly has 'a character of its own'. But it is possible to feel all this without subscribing to any of the Heideggerian notions of 'place' which were referred to above. First, while Kilburn may have a character of its own, it is absolutely not a seamless, coherent identity, a single sense of place which everyone shares. It could hardly be less so. People's routes through the place, their favourite haunts within it, the connections they make (physically, or by phone or post, or in memory and imagination) between here and the rest of the world vary enormously. If it is now recognized that people have multiple identities, then the same point can be made in relation to places. Moreover, such multiple identities can be either, or both, a source of richness or a source of conflict. Second, it is (or ought to be) impossible even to begin thinking about Kilburn High Road without bringing into play half the world and a considerable amount of British imperialist history. Imagining it this way provokes in you (or at least in me) a really global sense of place. Third, and finally, I certainly could not begin to, nor would I want to, define it by drawing its enclosing boundaries.

So, at this point in the argument, get back in your mind's eye on a satellite; go right out again and look back at the globe. This time, however, imagine not just all the physical movement, nor even all the often invisible communications, but also and especially all the social relations. For as

time–space compression proceeds, in all its complexity, so the geography of social relations changes. In many cases, such relations are increasingly stretched out over space. Economic, political and cultural social relations, each full of power and with internal structures of domination and subordination, stretched out over the planet at every different level, from the household to the local area to the international.

It is from that perspective that it is possible to envisage an alternative interpretation of place. In this interpretation, what gives a place its specificity is not some long internalized history but the fact that it is constructed out of a particular constellation of relations, articulated together at a particular locus. If one moves in from the satellite towards the globe, holding all those networks of social relations and movements and communications in one's head, then each place can be seen as a particular, unique point of their intersection. The uniqueness of a place, or a locality, in other words is constructed out of particular interactions and mutual articulations of social relations, social processes, experiences and understandings, in a situation of co-presence, but where a large proportion of those relations, experiences and understandings are actually constructed on a far larger scale than what we happen to define for that moment as the place itself, whether that be a street, a region or even a continent. Instead then, of thinking of places as areas with boundaries around, they can be imagined as articulated moments in networks of social relations and understandings. And this in turn allows a sense of place which is extra-verted, which includes a consciousness of its links with the wider world, which integrates in a positive way the global and the local.

This is not a question of making the ritualistic connections to 'the wider system' – the people in the local meeting who bring up international capitalism every time you try to have a discussion about rubbish-collection – the point is that there are real relations with real content, economic, political, cultural, between any local place and the wider world in which it is set. In economic geography, the argument has long been accepted that it is not possible to understand the 'inner city', for instance its loss of jobs, the decline of manufacturing employment there, by looking only at the inner city. Any adequate explanation has to set the inner city in its wider geographical context. Perhaps it is appropriate to think how that kind of understanding could be extended to the notion of a sense of place.

These arguments, then, highlight a number of ways in which a progressive concept of place might be developed. First of all, it is absolutely not static and in no way relates to the Heideggerian view of Space/Place as Being. If places can be conceptualized in terms of the social interactions which they tie together, then it is also the case that these interactions themselves are not static. They are processes. One of the great one-liners in Marxist exchanges has for long been 'ah, but capital is not a thing, it's a process'. Perhaps this should be said also about places; that places are

processes, too. One of the problematical aspects of the Heideggerian approach, and one which from the point of view of the physical sciences now looks out of date, is the strict dichotomization of time and space. In the current debate around molecular biology and theories of evolution we find this other one-liner, from an article with the subtitle 'The integration of science with human experience', and completely apposite to the discussion here: 'form is dynamic through and through' (Ho 1988). In other words, form *is* process. It is invalid in that sense simply to dichotomize between diachronic and synchronic, between time and space. And on the other side of the academic disciplines, here we have an argument about Rimbaud, who invites us

> to conceive of space not as a static reality, but as active, generative, to experience space as created by an interaction, as something that our bodies reactivate, and that through this reactivation, in turn modifies and transforms us. . . . [T]he poem [*Rêvé pour l'hiver*] creates a 'non-passive' spatiality – space as a specific form of operations and interactions
>
> (Ross 1988, cited in Gregory 1990: 9).

Second, places do not have to have boundaries in the sense of divisions which frame simple enclosures. 'Boundaries' may, of course, be necessary – for the purposes of certain types of studies for instance – but they are not necessary for the conceptualization of a place itself. Definition in this sense does not have to be through simple counterposition to the outside; it can come, in part, precisely through the particularity of linkage *to* that 'outside' which is therefore itself part of what constitutes the place. This therefore gets away from that association between penetrability and vulnerability. Mumford (1961: 5) has characterized human life as swinging between two poles, 'movement and settlement'. As Robins argues, 'these two poles have been at the heart of urban development – the city as container and the city as flow' (Robins 1991: 11). But why, then, does settlement so often have to be characterized as 'enclosure' (Robins 1991: 12; Emberley 1989: 756)? For it is this kind of characterization that makes invasion by newcomers so threatening. A notion of places as social relations, on the other hand, facilitates the conceptualization of the relation between the centre and the periphery, and the arrival of the previously marginal in the (first-world-city) centre (although it should be pointed out, since it is usually forgotten, that some alien others – women – have been living there for a long time).

Third, clearly places do not have single, unique 'identities'; they are full of internal differences and conflicts (Massey 1991a). Davis (1985) captures this in his studies of Los Angeles. It is exemplified too by London's Docklands, a place currently quite clearly defined by conflict: a conflict

over what its past has been (the nature of its 'heritage'); conflict over what should be its present development; conflict over what could be its future.

Fourth, and finally, none of this denies place nor the importance of the specificity of place. The specificity of place is continually reproduced, but it is not a specificity which results from some long, internalized history. There are a number of sources of this specificity – the uniqueness of place (Massey 1984). There is the fact that the wider relations in which places are set are themselves spatially internally differentiated. *Contra* some of the debate within cultural studies, globalization does not entail simply homogenization. Indeed, the globalization of social relations is yet another source of (the reproduction of) geographical uneven development, and thus of the specificity of place. An approach which focused on cultural relations or flows (see, for instance, Appadurai 1990) rather than, or as well as, culture areas might make this point easier to appreciate since individual 'places' are precisely located differentially in the global network of such relations. Further, the specificity of place also derives from the fact that each place is the focus of a distinct *mixture* of wider and more local social relations and, further again, that the juxtaposition of these relations may produce effects that would not have happened otherwise. And, finally, all these relations interact with and take a further element of specificity from the accumulated history of a place, with that history itself conceptualized as the product of layer upon layer of different sets of linkages both local and to the wider world. In her portrait of Corsica, *Granite Island*, Dorothy Carrington (1984) travels the island seeking out the roots of its character. All the different layers of peoples and cultures are explored: the long tumultuous relationship with France, with Genoa and Aragon in the thirteenth, fourteenth and fifteenth centuries; back through the much earlier incorporation into the Byzantine Empire; and before that domination by the Vandals; before that being part of the Roman Empire; before that the colonization and settlements of the Carthaginians and the Greeks . . .; until we find that even the megalith builders had come to Corsica from somewhere else.

It is a sense of place, an understanding of 'its character', which can only be constructed by linking that place to places beyond. A progressive sense of place would recognize that, without being threatened by it: it would be precisely about the *relationship* between place and space. What we need, it seems to me, is a global sense of the local, a global sense of place.

REFERENCES

Appadurai, A. (1990) 'Disjuncture and difference in the global cultural economy', *Theory Culture & Society* 7: 295–310.
Birkett, D. (1990) 'Have guilt, will travel', *New Statesman and Society*, 13 June, pp. 41–2.

Carrington, D. (1984) *Granite Island: a portrait of Corsica*, Penguin Travel Library, London: Penguin Books.

Davis, M. (1985) 'Urban renaissance and the spirit of postmodernism', *New Left Review* 151: 106–13.

Emberley, P. (1989) 'Places and stories: the challenge of technology', *Social Research* 56 (3): 741–85.

Giddens, A. (1984) *The Constitution of Society*, Cambridge: Polity Press.

Gregory, D. (1990) 'Chinatown, part three? Soja and the missing spaces of social theory', *Strategies* 3.

Harvey, D. (1989) *The Condition of Postmodernity*, Oxford: Basil Blackwell.

Ho, M.-W. (1988) 'Reanimating nature: the integration of science with human experience', *Beshara*, pp. 16–25.

Jameson, F. (1984) 'Postmodernism, or the cultural logic of late capitalism', *New Left Review* 146: 53–92.

Massey, D. (1984) *Spatial Divisions of Labour: Social Structures and the Geography of Production*, Basingstoke: Macmillan.

—— (1991a) 'The political place of locality studies', *Environment and Planning A*, 23: 267–81.

—— (1991b) 'Flexible sexism', *Environment and Planning D: Society and Space* 9 (1): 31–57.

Mumford, L. (1961) *The City in History*, London: Secker & Warburg.

Robins, K. (1991) 'Prisoners of the city: whatever could a postmodern city be?', *New Formations* 15: 1–22.

Ross, K. (1988) *The Emergence of Social Space: Rimbaud and the Paris Commune*, Minneapolis: University of Minnesota Press.

Wright, P. (1985) *On Living in an Old Country: the National Past in Contemporary Britain*, London: Verso.

Chapter 5

Some notes towards thinking about the spaces of the future

Gillian Rose

Among the social sciences, geography has been unusually reluctant to admit women and women's experiences into its disciplinary imagination. In this chapter, I want to suggest that one of the reasons for this continuing marginalization of women is the structure of knowledge which the discipline accepts as legitimate. In particular, the chapter explores the privileged role given to the visual as a means of accessing knowledge and, more especially, the particular interpretation of space that results. It is often noted that geography is by far the most visual of the social sciences, and this is in part because of its long tradition of fieldwork and exploration. As a past president of the Association of American Geographers commented: 'Many of us are in geography because it involves using our eyes, and for the latitude it allows for wonderment at the world around us'.[1] But, of course, 'the visual is more than the domain of simple recognition',[2] and the geographer's gaze at the landscape, for example, has been characterized as 'an endless effort to bridge the gap between raw data and penetrating comprehensive knowledge':[3] an endless effort to understand fully by looking. This particular kind of visuality is also used in a much more general way in the discipline, as a metaphor for knowing the world, for seeing it as it really is. Geographers look in order to know, and what this entails is a particular notion of space. When geographers gaze at social space, the space economy, urban space and so on, their claim to know and to understand rests on a notion of space as completely transparent, unmediated and therefore utterly knowable. This is what Lefebvre calls the 'illusion of transparency', such that 'within the spatial realm the known and the transparent are one and the same thing'.[4] The geographical imagination thinks space can always be known and mapped, and that's what its transparency, its innocence, signifies: that it's infinitely knowable; that there are no obscure corners into which geographical vision cannot penetrate.

The penetrating gaze, the strong claim to knowledge, and transparent space are deeply bound together in geographical knowledges, and many feminists have argued that a particular masculinity structures this conflation.[5] The claim to see all and therefore to know all depends on assuming a

vantage point far removed from the embodied social world, and this transcendent, distanced gaze reinforces the dominant Western masculine subjectivity in all its fear of embodied attachment and in all its universal pretensions. To adapt slightly Haraway's description of this 'conquering gaze from nowhere', in geography it lets 'fabulous objects come to us simultaneously as indubitable recordings of what is simply there and as heroic feats of [social-] scientific production'.[6] My argument is concerned with a strategy for challenging this notion of transparent space knowable only through a certain masculinity.

Following Lebfebvre, it is possible to suggest that, like the masculine subjectivity on which it relies, transparent space hides what it depends on for its meaning: an other. In this dualistic structure of meaning, masculine knowledge of lucid transparent space is made sense of only in contrast to a notion of 'place' as an unknowable. Geographers represent place as the location of direct experience, a sensuous swirl of emotions and perceptions and myths, which rational analysis can only ignore or destroy. In that sense, as the other of space, place is 'a spatial paradox, a territory defined by its lack of definition': what Dejean has called a no man's land.[7] Her gendered metaphor is no coincidence. Place, perceived as an enigma, is very often characterized in geography through images of the domestic, maternal home. This evaluation can be negative. Harvey, for example, claims place is a fundamentally ambiguous concept, too ambiguous to be adequately known and fully perceived, and worries about its possible expression as a passionate and fascistic nationalism.[8] In a different geographical tradition, the humanistic one, place is seen as the very source of (hu)man(ity).[9] But it is always associated, I would argue, with 'the timeless, infinite vanishing-point of the maternal'.[10] If women are overtly missing from much of this geography, then, the feminine certainly is not.

And since femininity is meant in some way to be central to my identity, as a woman I'm not completely excluded from this structure of knowledge. If this is a discourse which works through a dualism of subject positions, then I am implicated in the geographical imagination in some way. As Braidotti says, ' "I, woman", am affected directly and in my everyday life by what has been made of the subject of woman; I have paid in my very body for all the metaphors and images that our culture has deemed fit to produce of woman.'[11] Moreover, in part I think through this kind of geographical discourse. I was first introduced to the powers and the pleasures of theory by tutors, lecturers, supervisors – almost all men – and listening to their arguments I desperately wanted to be able to join in. I still do. They perform and I was and am a willing audience and participant – here I am writing now.[12] This is what Miller has described as the seduction of theory for women; she says, 'I was, and still am, seduced by men's systematic and exhaustive claims on our meanings and our realities through their occupation of everything which is thought of as not male, but simply

as human.'[13] And she argues that this seduction is unavoidable: 'women can no more escape being adulterated than they can escape being adulteresses'.[14] Her metaphor of seduction feels especially evocative of a particular kind of social relations in the academy, implying both the sexuality of knowledge and of institutions, and the politics of that sexuality (Miller says seduction is rape annulled by consent).

But Miller also suggests that women are 'irritatingly unabsorbable'.[15] For me, my unabsorbability takes the form of a refusal to integrate the kind of feminism I'm making sense of my life through at the moment into the geography of transparent space, a geography which doesn't seem spoken with women in mind as its audience. Its innocent space isn't one I recognize; I feel excluded from its imagining. Neither central nor marginal, I'm included in the discourse, in the institution, but not on terms I'm easy with. From conversations with women postgraduates struggling to write academically, I don't think this feeling is mine alone. Women participate in the academy but never wholly; we master theory 'and if we don't actually enjoy it, at least we can fake it'.[16] Some women are ambivalent academics.

What this means is that while I feel it's vitally necessary to imagine a different geography of the future, to imagine spaces of which women can claim knowledge, in all their diversity and complexity, I also feel too complicit with my discipline's forms of and claims to knowledge to be able to map any such new spaces. Moreover, mapping is itself a representation which contains its own exclusions. There is no language untainted by the relations of power and knowledge; the language we have is the one we must use. What I think I may be able to do, though, following Kamuf's claim that 'forces opposing phallocentrism are not systematically opposed to it, but connive with what ruins it from within',[17] is to challenge the transparent space of geography by placing in it an image of its other: the domestic, maternal places of women. This is the strategy of this chapter.

Now, this is *not* to imply that all women everywhere are best characterized by their role as mothers. Although, as I've suggested, I think there is some connection between women and representations of the other as feminine in certain claims to knowledge, the elaboration and qualification of any such connections is an issue this chapter is not going to address directly. My use of representations of the figure of the mother here is strategic. For me, engaged in my discipline in the Western academy, it is a strategy which allows me to work with something which seems highly likely to subvert its masculinist structures of knowledge. So the next section briefly explores some feminist interpretations of woman as mother. The discussion focuses on a particular kind of white, Western feminism in the main, because this is where many discussions of mothering have taken place: an indication of that kind of feminism's own cultural specificity and complicity, and its ability to speak to other Western discourses. What the section suggests, though, is that it is not so much the image of maternal

woman which is disruptive, as the different ways in which these particular feminists have thought about mothering. It is these differences that I find particularly subversive, and their elaboration, which enables this chapter to avoid merely confirming masculinist claims that women are really mothers.

THE MATERNAL BODY

The feminine as maternal immediately emphasizes the importance of 'the body' as a key signifier of sexual difference. Recent feminist work on the body points out, of course, that there is no one body, and much of it elaborates the processes through which male and female bodies are distinguished. The argument emerging is that in modern Western culture, while the white male could transcend his embodiment by seeing his body as a simple container for the pure consciousness it held inside, this was not allowed for the female or the black.[18] So in our masculinist culture there is a contradictory attitude towards the body: what Wolff has described as its *re*pression and *po*ssession.[19] Fundamental to its construction and *po*ssession of other bodies is the masculinist *re*pression and denial of the male body; others are trapped in their brute materiality by the rational minds of white men. Riley, for example, has argued that from the seventeenth century the diversity of physical bodies was understood in the West more and more in terms of a polarity of two sexes; 'female persons become held to be virtually saturated with their sex which then invades their rational and spiritual faculties'.[20] The body was represented as the site of women's passion, lust and emotion. Women were seen as incapable of rational or ethical thought, and this meant they were not permitted to participate in the polity because 'women's bodies symbolise everything opposed to political order'.[21] Medical discourses were especially important to the development of these arguments. In the eighteenth century, medical men searched for the natural laws which they thought structured women's physiology and thus their psychology, and by the mid-nineteenth century women's spontaneous ovulation and maternal instinct had been 'discovered'. Because women became fertile automatically, it was argued that their mothering was not under their conscious control: women were understood as instinctive, natural mothers.[22] Women's place was therefore argued to be in the privacy of the domestic home.

Histories of the body like the one I've just very schematically sketched take what has been called a constructionist approach: the meaning of bodies is understood as socially and culturally constructed.[23] This claim is made in order to challenge the naturalization of sexual difference which grounds that difference in 'natural' bodily differences. For Western constructionist feminists, the power of the discourses that trap women by setting biological limits to their capabilities means that any attempt to explain anything by referring to the body, or to the biological, or to the

natural is impossible politically. Any such reference would only legitimate patriarchal claims that women were naturally incapable of certain kinds of action. These constructionist feminists argue that a central cause of white, Euro-American women's oppression is the ideological construction of femininity as domestic, caring, relational and maternal, because of the labour this identity makes such women perform in the family. So, in certain Western feminisms, there has developed a very clear distinction between sex (the brutely biological and irrelevant to understanding women's position in society) and gender (the social construction of feminine and masculine identity), and it is gender which is seen important for feminist understanding. More recently, in a rather different kind of feminism, the body has been represented as a purely discursive field: 'bodies are maps of power and identity', says Haraway.[24] But both these feminisms agree that reference to the physical body can only serve to naturalize what is in fact social difference.

Other feminists, however, have hesitated before this denial of the body, for the same reason as constructionist feminists have developed their arguments: in order to avoid reflecting and reinforcing those of masculinism. They suggest that to deny the body is to echo the masculinist repression of the bodily and to keep 'our lives out of our knowledge'.[25] The task as they see it is not to ignore the differentiated embodiment of subjectivity, but to start from it. These kind of arguments which return to the body can be called essentialist. This is the position of many ecofeminists, and also of Adrienne Rich in her 'Notes towards a politics of location':

> Begin, though, not with a continent or a country or a house, but with the geography closest in – the body . . . the politics of pregnability and motherhood. The politics of orgasm. The politics of rape and incest, of abortion, birth control, forcible sterilization. Of prostitution and marital sex. Of what had been named sexual liberation. Of prescriptive heterosexuality. Of lesbian existence. . . . Not to transcend this body, but to reclaim it.[26]

From now on, she says, the specific and differentiated subjection of women, through a woman's location in a particular scarred, pigmented, aged female body, has to be addressed.[27]

If Western masculinism has repressed and possessed bodies – different bodies – it seems then that Western feminisms have echoed both the repression and possession. Trying to adjudicate between constructionist and essentialist feminisms in general terms thus seems a bit beside the point, since one can hardly claim to be more 'feminist', more 'different' from masculinism, than the other, and in any case Fuss has suggested that the ontological distinction between the two may not be as clear as is often assumed.[28] This is particularly important for my argument. For I want to

suggest that these aren't always two different kinds of feminisms adopted by two (or more) different schools of feminist thought, although that is often the case; as Snitow has pointed out, these two positions are often taken by the same feminist, in responding to different political contexts.[29] Precisely because Western masculinist discourse is complex and differentiated, feminists need different positions from which to critique it. Perhaps, then, essentialism and constructionism are politically, ontologically, necessarily intertwined in Western feminism; and there is some evidence, historical and contemporary, to support this.[30] Ambivalence may be a central, if painful and often unacknowledged, part of much Western feminism.

I now want to return to the transparent space of geography, the space seen by the disembodied geographer, and to place into it this ambivalence about the maternal body.

FEMINIST GEOGRAPHERS, GEOGRAPHERS' SPACE AND MATERNAL BODIES

Anglo-American feminist geographers work with the constructionist notion of gender. They have explicitly rejected essentialist positions, and argue instead that the most important part of the ideology of femininity is the assumption that women will be mothers.[31] So mothers have been one focus of their research, a focus which raises questions about women's spatial mobility, about their access to resources, and about the power relations which constrain these.[32] Feminist geographers have used time-geography to detail these processes, because of its sensitivity to the routines of women's domestic, everyday lives. Time-geography traces the routinized paths of individuals in time-space, and is especially interested in the physical, technological, economic and social constraints on such movement. It claims to demonstrate how society as a whole is constituted by the unintended consequences of the repetitive acts of individuals (see Figure 5.1). Feminist geographers have used time-geography for its focus on the everyday and, less explicitly, for its emphasis on the reproduction of the social. In this sense, time-geography focuses on what has been associated with women's lives. But I now want to suggest that such a focus on such a possible difference between women's and men's lives is repressed within the transparent space of geography.

Geographers have rarely considered what kind of space constitutes time-geography. But an exceptional essay by Gould emphasizes its infinitude and unboundedness, its transparency; it's simply everywhere.[33] And what is stressed is the liberty possible in this space, in a most celebratory way: 'it is freedom to run, to leap, to stretch and reach out without bounds'.[34] These claims of power over space in time-geography suggest to me that its space is that of hegemonic masculinity. Only white heterosexual men can

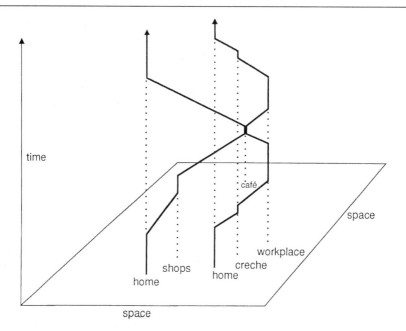

Figure 5.1 A time-geographic representation of the paths of two individuals over a 24-hour period.

usually enjoy such a feeling of spatial freedom. Women know that spaces are not necessarily without constraint; sexual attacks warn them that their bodies are not meant to be in public spaces, and racist and homophobic violence delimits the spaces of black and lesbian and gay communities. Transparent space then mimics the public space of Western empowered men, its violence repressed. This space is also the 'total geography of comprehension' which Riley associates with the social reform movements and the emerging social sciences of the late nineteenth century, and which the geographical imagination still assumes.[35] In an act of epistemic violence, this space claims transparency and universality, and represses any difference from itself.

In the face of this masculinism, it is important to argue that not everyone shares the same vision of space; there are other spaces, mapped on difference grids from that of empowered men. 'How is it for you, there, out in space, near me? Different, I know.'[36] The geographer Dyck argues that women's routine sociability constructs their gender identities and this affects the way women understand spaces.[37] Space for women changes its meaning through the diverse discourses of women's constructed subjectivity. Constructionist feminism implies then that space too is constructed. It isn't unproblematic in the way its masculinist representation in time-geography would have use believe. I've said that I'm not quite sure how to

specify these different spaces: only that the spaces that I feel are women's are very different from the notion of space which time-geography works with.[38] So I want to mention two impenetrable spaces, spaces the masculine imagination cannot enter, to represent all the different spaces transparent space denies: the space of the mother and pre-Oedipal child which Kristeva has explored, and the geography of women's fear in which women suffocatingly can't dare to think what might happen.[39]

What these two examples demonstrate, though, is that if I have contextualized space by asserting the constructed identity of women as mothers, then insisting on women's (constructed) difference evokes for me (as for other western feminist geographers with their interest in mothers) the maternal, sexual body. I now want to explore implications of placing the maternal body of essentialist feminism into time-geography, and to suggest that feminist geographers' accounts of mothers and their time-space zoning, with their stories of childbirth and love, offer a challenge to the strange absence of the body in time-geography. For what time-geography traces are paths. Bodies become their paths. I think this absence can be associated with the denial of the masculine body, and it suggests that the agency which these paths purport to represent is masculine too.

These paths are merely lines – what could be more innocent? But their very lack of defining characteristics begins to specify them. They are literally colourless, for example; the trace they leave does not tell whether the body is white or black. Skin does matter to these bodies though, since a corporeal boundary is assumed by time-geographers in their claim that external social relations are internalized by human agents in the course of their life-path.[40] This sense of a bounded body has implications for its biology. This biology is a peculiarly selective one, since bodily processes which transgress the boundary between inside and outside the body – childbirth say, or menstruation – are ignored as characteristics of the body when it is reduced to its path.[41] The agency of time-geography is clearly delimited; its paths mesh but never merge. So in whose image is the embodiment of human agency made?

White bourgeois men. The history of the white masculine bourgeois body in Euro-America can be told in terms of a series of exclusions, culminating in what Bakhtin called the 'classical body'. Bakhtin and Elias have traced that body's loss of vulgar and feminine orifices and excretions from the seventeenth century onwards; the civilized body was one with limited and carefully controlled passages between its inside and outside.[42] The enlightened masculine mind was one clearly separate from and untainted by its body. This bounded body and its role as the simple container of rationality both contribute to the idea that we are socialized by internalizing lessons which the 'outside' world teaches us when we act in it, and also produce a lack of interest in the unconscious, in dreams and fantasies. This is the model of socialization used in time-geography.

Further, in racist discourse, 'the body could not be separated from its colour';[43] colour becomes a key signifier of difference, but only those seen as different from 'white' are designated 'coloured'. Whiteness retains its hegemonic position by denying its own colour and so becoming transparent to the critical gaze.[44] Critiques of whiteness stress the importance of absence to the representation of the white body, an absence of colour. Yet in time-geography we have apparently colourless bodies. This white masculinist self-representation as a number of denials of its own embodiment accounts for the minimalism of time-geography's account of embodied agency; it is an effort to be limited in as few ways as possible by corporeality. Like the space it moves through, it is white, Western and masculine. Putting women's paths in this framework reveals the absences in it with precision because it raises the question of the body and what work its absence performs in geography. As Butler suggests, 'the denial of the body . . . reveals itself as nothing other than the embodiment of denial'.[45]

Feminists using time-geography then disrupt its coherence and reveal its repressions by drawing on both essentialist and constructionist arguments. Their ambivalence allows different kinds of critique.

SPEAKING AS AN AMBIVALENT FEMINIST

So, I'm ambivalent about my place in the geographical imagination, I've made an ambivalent argument about the body, and I've suggested that retaining such ambivalences is severely disruptive to one of masculinist geography's most basic conceptual claims to truth, namely transparent space. The final equivocation I want to register is my own about this essay.

I have reservations about representing ambiguity and ambivalence because of the way masculinist geographical knowledge represents the alien, the unknown, the uncertain, the unspeakable, as feminine. According to Michèle Le Doeuff, this is the condition of Western philosophy because 'rational discourse can only know itself by positing some irrational *outside* excluded from its own territory'.[46] Take Harvey on postmodernism.[47] In his language, the modern is heroic, rational, progressive, universal, seminal, thrusting and armed; the postmodern is frothy, seductive, fecund, disruptive, charismatic, local, passionate, titillating, bound into places and blind to the global gaze. Harvey seems able to make sense – or to fail to make it – of postmodernism only by constituting it as a feminine other. However, so-called postmodernist geographers have followed the same pattern of making the feminine stand in for uncertainty. Olsson's essay on ambiguity, for example, says that the ultimate example of the slipperiness and ambiguity of language is 'the dialectic of Duchamp's bride stripped bare by her bachelors only to discover that what *we* see [we the readers are positioned as masculine here] is nothing but ourselves looking'.[48] In this discourse of knowledge which represents the unknowable as feminine, it

matters that I'm a woman advocating ambivalence, able only to say, with Kristeva, 'that's not it, that's still not it' and having nothing more certain, more prescriptive, to add.[49] In that sense, this chapter becomes another enactment of the phallocentrism of geographical knowledge, in which masculinity is the known and the enigmatic other is feminine.

This is in part a consequence of my own complicity. But it might also have more radical consequences. For that feminine other is also fascinating for masculinity. Harvey, for example, rejects his feminine postmodern utterly, even seems rather scared of it – it is 'unsettling', a 'trauma', a 'maelstrom' – but none the less he writes a whole book on it.[50] This suggests to me that the seduced must also always be seductive. Perhaps then it is important to insist on speaking and listening from the feminine positions available, because a voice heard as 'feminine' can be powerfully compelling, as well as disruptive, in certain contexts. Its elusiveness fascinates, and it is vital it should, because an ambivalent refusal to settle, a sense of mobility, has been advocated by some feminists as a form of the accountability and specificity which the penetrating masculine gaze through transparent space denies. If a woman writes as a particular kind of feminist, she should account for her specific position, for what she is saying, to her specific audience at one moment. As the realities of the complexity, the contradictions and the power of hegemonic discourses shift, as well as resistances to them, so too must interpretation and critique move. Haraway, for example, insists that 'one cannot relocate in any possible vantage point without being accountable for that movement' while also demanding 'a commitment to mobile positioning'.[51] In her discussion of the politics of position, bell hooks begins by talking about transgression and says that in 'moving, we confront the realities of choice and location'.[52] And Rich says she can't write any more than notes towards a politics of location because of 'the struggle to keep moving, a struggle for accountability'.[53] Critique must settle, but settle *contingently*, make *arbitrary* closures, endorse *strategic* essentialism, make *provisional* gestures.[54]

My vantage point in this essay has been one of a white, lower-middle-class woman in the academy, both part of its powerful discursive structures and apart from them, trying to challenge their exclusions from a position hopelessly within them. So this chapter has tried to define its own limits, and to show some of the limits of the geographical spatial imagination from inside. If this chapter has been strategically ambivalent, then, in trying to intrigue one audience and account for itself to another, maybe overlapping, audience, it has also been inevitably divided between constructionism and essentialism: aware (to some extent) of the conditions of its own making, but trying also to assert the importance of what might lie outside them.

Acknowledgements

I would like to thank Michael Keith, Linda McDowell, Steve Pile, Nigel Thrift and especially Sarah Radcliffe for comments on an earlier version of this chapter. I remain responsible for the final version.

NOTES

1 J. J. Parsons, 'Geography as exploration and discovery', *Annals of the Association of American Geographers* 1977, vol. 67, no. 1, p. 2. For the importance of the visual to geography, see D. Cosgrove, 'Prospect, perspective, and the evolution of the landscape idea', *Transactions of the Institute of British Geographers*, 1985, vol. 10, no. 1, pp. 45–62. The pleasure which Parsons mentions is explored more fully in G. Rose, 'Geography as a science of observation: the gaze, the landscape and masculinity', in F. Driver and G. Rose (eds), *Nature and Science: Essays in the History of Geographical Knowledge*, London, Historical Geography Research Group of the Institute of British Geographers, 1992.

2 J. Rose, *Sexuality in the Field of Vision*, London, Verso, 1986, p. 231.

3 R. S. Platt, *Field Study in American Geography*, University of Chicago, Geography Department, Research Paper no. 6, 1959, p. 1.

4 H. Lefebvre, *The Production of Space*, Oxford, Basil Blackwell, 1991, p. 28.

5 See, for example, the arguments of R. Deutsche, 'Boys town', *Environment and Planning D: Society and Space*, 1991, vol. 9, no. 1, pp. 5–30; E. Grosz, *Jacques Lacan: A Feminist Introduction*, London, Routledge, 1990; E. Fox Keller and C. Grontkowski, 'The mind's eye', in S. Harding and M. B. Hintikka (eds), *Discovering Reality*, Dordrecht, Reidel, 1983, pp. 207–24; L. Irigaray, *Speculum of the Other Woman*, Ithaca, NY, Cornell University Press, 1985; L. Mulvey, *Visual and Other Pleasures*, London, Macmillan, 1989; J. Rose, op. cit. There is some debate in this literature as to whether to look is inevitably to be distanced from the object of the gaze; I follow Haraway in wanting to specify different kinds of looking which make different claims to knowing. See D. J. Haraway, *Simians, Cyborgs and Women: The Reinvention of Nature*, London, Free Association Books, 1991, pp. 188–201.

6 Haraway, op. cit., pp. 188, 189.

7 J. Dejean, 'No man's land: the novel's first geography', *Yale French Studies*, 1987, vol. 73, p. 179.

8 D. Harvey, 'Between space and time: reflections on the geographical imagination', *Annals of the Association of American Geographers*, 1990, vol. 80, no. 3, pp. 418–34. His concern is of course entirely correct. Harvey is also well aware of the historico-geographical specificity of different conceptions of space, a sense of specificity which he, like so many other geographers, unfortunately does not apply to his own gaze at global or urban space; see Deutsche, op. cit.

9 In two classics of humanistic geography, Tuan claimed that 'hearth, shelter, home or home base are intimate places to human beings everywhere', while Relph suggested that the home is 'an irreplaceable centre of significance' (Y. F. Tuan, *Space and Place: The Perspective of Experience*, London, Edward Arnold, 1977, p. 147; E. Relph, *Place and Placelessness*, London, Pion, 1976, p. 39).

10 C. Crosby, *The Ends of History: Victorians and 'The Woman Question'*, London, Routledge, 1991, p. 90. Heidegger's image of home haunts both

evaluations of place by geographers.

11 R. Braidotti, 'The politics of ontological difference', in T. Brennan (ed.) *Between Feminism and Psychoanalysis*, London, Routledge, 1989, p. 101.

12 bell hooks notes the difficulty that white women have in admitting their privilege in M. Childers and b. hooks, 'A conversation about race and class', in M. Hirsch and E. F. Keller (eds), *Conflicts in Feminism*, London, Routledge, 1990, pp. 60–81.

13 J. Miller, *Seductions: Studies in Reading and Culture*, London, Virago, 1990, p. 1.

14 ibid., p. 3.

15 ibid., p. 8.

16 L. Jardine, 'The politics of impenetrability', in Brennan, op. cit., p. 63.

17 P. Kamuf and N. K. Miller, 'Parisian letters: between feminism and deconstruction', in Hirsch and Keller, op. cit., p. 132. Toril Moi has commented similarly that 'the deconstructive move is not to abolish oppositions, or to deny that such signifiers exist, but rather to trace the way in which each signifier contaminates and subverts the meaning of others' (T. Moi, 'Patriarchal thought and the drive for knowledge', in Brennan, op. cit., p. 194).

18 S. L. Gilman, 'Black bodies, white bodies: toward an iconography of female sexuality in late nineteenth-century art, medicine and literature', *Critical Inquiry*, vol. 12, pp. 204–42; J. de Groot, ' "Sex" and "race": the construction of language and image in the nineteenth century', in S. Mendus and J. Rendall (eds), *Sexuality and Subordination*, London, Routledge, 1989, pp. 89–128.

19 J. Wolff, *Feminine Sentences: Essays on Women and Culture*, Cambridge, Polity Press, 1990, p. 121.

20 D. Riley, *'Am I That Name?' Feminism and the Category of 'Women' in History*, Basingstoke, Macmillan, 1988, p. 8. For a study of the contemporary desire to designate bodies as male or female, see S. J. Kessler, 'The medical construction of gender: case management of intersexed infants', *Signs*, 1990, vol. 16, no. 1, pp. 3–26.

21 C. Pateman, *The Disorder of Women: Democracy, Feminism and Political Theory*, Cambridge, Polity Press, 1989, p. 4. See also J. B. Elshtain, *Public Man, Private Woman: Women in Social and Political Thought*, Oxford, Martin Robertson, 1981; G. Lloyd, *The Man of Reason: 'Male' and 'Female' in Western Philosophy*, London, Methuen, 1984; V. Seidler, *Rediscovering Masculinity: Reason, Language and Sexuality*, London, Routledge, 1989.

22 L. Jordanova, 'Natural facts: a historical perspective on science and sexuality', in C. MacCormack and M. Strathern (eds), *Nature, Culture and Gender*, Cambridge, Cambridge University Press, 1980, pp. 42–69. See also M. Bloch and J. H. Bloch, 'Women and the dialectics of nature in eighteenth century French thought', in MacCormack and Strathern, op. cit., pp. 25–41; O. Moscucci, *The Science of Woman: Gynaecology and Gender in England 1800–1929*, Cambridge, Cambridge University Press, 1990; M. Poovey, *Uneven Developments: The Ideological Work of Gender in Mid-Victorian England*, London, Virago, 1989. Poovey is especially good at pointing out the instabilities and contradictions in this distinction between masculine and feminine.

23 The distinction between constructionist and essentialist feminisms is taken from D. Fuss, *Essentially Speaking: Feminism, Nature and Difference*, London, Routledge, 1989.

24 D. Haraway, 'A manifesto for cyborgs', in L. Nicholson (ed.), *Feminism/Postmodernism*, London, Routledge, 1990, p. 222.

25 J. Gallop, *Thinking through the Body*, New York, Columbia University Press,

1988, p. 4.

26 A. Rich, *Blood, Bread and Poetry*, London, Virago, pp. 212–13.

27 ibid., p. 214.

28 Fuss, op. cit.

29 A. Snitow, 'A gender diary', in Hirsch and Keller, op. cit., pp. 9–43.

30 For the historical evidence, see P. Hollis, *Ladies Elect: Women in English Local Government 1865–1914*, Oxford, Clarendon Press, 1987, p. 7; S. Holton, *Feminism and Democracy: Women's Suffrage and Reform Politics in Britain 1900–1918*, Cambridge, Cambridge University Press, 1986, pp. 17, 28; J. Lewis, *Women in Social Action in Victorian and Edwardian England*, Aldershot, Edward Elgar, 1991, p. 7; J. Rendall (ed.), *Equal or Different: Women's Politics 1800–1914*, Oxford, Basil Blackwell, 1987, p. 13; G. Rose, 'The struggle for political democracy: emancipation, gender, and geography', *Environment and Planning D: Society and Space*, 1990, vol. 8, no. 4, pp. 395–408. For contemporary arguments, see Hirsch and Keller, op. cit.

31 Women and Geography Study Group, *Geography and Gender*, London, Hutchinson, 1984.

32 I. Dyck, 'Space, time and renegotiating motherhood: an exploration of the domestic workplace', *Environment and Planning D: Society and Space*, 1990, vol. 8, no. 4, pp. 459–84; J. D. Fortuijn and L. Karsten, 'Daily activity patterns of working parents in the Netherlands', *Area*, 1989, vol. 21, no. 4, pp. 365–76; R. Miller, 'The Hoover in the garden: middle-class women and suburbanisation, 1850–1920', *Environment and Planning D: Society and Space*, 1983, vol. 1, no. 1, pp. 73–87; R. Palm and A. Pred, *A Time-Geographic Perspective on Problems of Inequality for Women*, Berkeley, Institute of Urban and Regional Development, University of California, Working Paper no. 236, 1974; J. Tivers, *Women Attached: The Daily Lives of Women with Young Children*, London, Croom Helm, 1985.

33 P. Gould, 'Space and rum: an English note on espacien and rumian meaning', *Geografiska Annaler*, 1981, vol. 63B, no. 1, pp. 1–3.

34 ibid., p. 2. Gould notes that these connotations of the word 'space' are peculiar to the English language, and this suggests that other interpretations of time-geography other than the version critiqued here are possible.

35 Riley, op. cit., p. 50. See also C. Stansell, *City of Women: Sex and Class in New York, 1789–1860*, New York, Alfred Knopf, 1986.

36 Snitow, op. cit., p. 37.

37 Dyck, op. cit., p. 466.

38 Dejean (op. cit.) suggests that such unrepresentability was a feminine space in the early modern novel.

39 G. Valentine, 'The geography of women's fear', *Area*, 1989, vol. 21, no. 4, pp. 385–90; E. Grosz, *Sexual Subversions: Three French Feminists*, Sydney, Allen & Unwin, 1989, pp. 44–9.

40 N. Thrift, 'On the determination of social action in space and time', *Environment and Planning D: Society and Space*, 1983, vol. 1, no. 1, pp. 23–57; A. Pred, 'Social reproduction and the time-geography of everyday life', in P. Gould and G. Olsson (eds), *A Search for Common Ground*, London, Pion, 1982, pp. 157–86.

41 The less-gendered phrase 'biological reproduction' is occasionally used: see Pred, op. cit., p. 159.

42 N. Elias, *The Civilising Process: Volume 1, The History of Manners*, Oxford, Basil Blackwell, 1978.

43 B. Omolade, 'Hearts of darkness', in A. Snitow, C. Stansell and S. Thompson

(eds), *Desire: The Politics of Sexuality*, London, Virago, 1984, p. 365.

44 R. Dyer, 'White', *Screen*, 1988, vol. 29, no. 4, pp. 44–64.

45 J. Butler, 'Variations on sex and gender: Beauvoir, Wittig and Foucault', in S. Benhabib and D. Cornell (eds), *Feminism as Critique: On the Politics of Gender*, Minneapolis, University of Minnesota, 1988, p. 133.

46 Moi, op. cit., p. 195.

47 D. Harvey, *The Condition of Postmodernity*, Oxford, Basil Blackwell, 1989.

48 It is rather hard to know what to make of Olsson's essay, other than to note that in its playful exploration of the ambiguity of language, figures of women recur as symbols of that ambiguity; G. Olsson, 'Of ambiguity or far cries from a memorializing mamafesta', in D. Ley and M. S. Samuels (eds), *Humanistic Geography: Prospects and Problems*, London, Croom Helm, 1978, p. 118, my emphasis.

49 J. Kristeva, 'Woman can never be defined', in E. Marks and I. de Courtivron (eds), *New French Feminisms*, Brighton, Harvester, 1981, p. 137.

50 D. Harvey, *The Condition of Postmodernity*, op. cit., pp. ix, 286, 292.

51 D. J. Haraway, *Simians, Cyborgs and Women*, op. cit. p. 192.

52 b. hooks, *Yearning: Race, Gender and Cultural Politics*, London, Turnaround, 1991, p. 145.

53 Rich, op. cit., p. 211.

54 These are phrases from S. Hall, 'Minimal selves', in L. Annignanesi (ed.) *Identity: The Real Me*, London, Institute of Contemporary Arts, 1987, p. 45; G. C. Spivak, *In Other Worlds*, London, Routledge, 1988, pp. 205–6; and Fuss, op. cit., p. 31.

Part II

Changing places

Homeless/global: Scaling places

Neil Smith

The Homeless Vehicle is a jarring intervention in the landscapes of the evicted. Designed by Krzysztof Wodiczko, a New York artist, the vehicle was first exhibited in 1988. The prototype was constructed in consultation with homeless men and subsequently women; it was first tested in the streets of New York's Lower East Side, then elsewhere in the city and in Philadelphia. An ongoing project, it has undergone continual revision and modification, and there are now four variants of the Homeless Vehicle. Its design and development has been funded by several art galleries and public art councils as well as by the artist himself. But more than simply a critical artwork heavy with symbolic irony, the Homeless Vehicle is deliberately practical: indeed, it works as critical art only to the extent that it is simultaneously functional.[1]

The Homeless Vehicle builds on the vernacular architecture of the supermarket trolley, and facilitates some basic needs: transport, sitting, sleeping, shelter, washing. Spatial mobility is a central problem for people evicted from the private spaces of the real estate market. Without a home, or anywhere else to store possessions, it is difficult to move around the city because you have to carry all your belongings with you. In the late 1980s in New York City, with homelessness estimated at between 70,000 and 100,000 people – between 1 and 1.5 per cent of the city's population – many evictees took to using supermarket trolleys or canvas postal carts for ferrying their belongings around, and for scavenging cans and bottles that could be redeemed for their nickel deposit.[2] Wodiczko elaborates on this appropriation. The lower compartment of the vehicle is designed to carry belongings – bags, clothes, blankets, food, water, empty cans.

Finding a place to sleep is also a major problem, and so the top compartment, which can be used to carry things by day, can also be pulled out into its three sections. Each section is draped with heavy plastic tarpaulin, and when expanded this upper compartment forms a sleeping space. Thus Wodiczko has also referred to it as a 'shelter vehicle'.[3] Daily ablutions too are a problem for the evicted: the vehicle's aluminium nose-cone, satirically redolent of a rocket or some other high-tech military

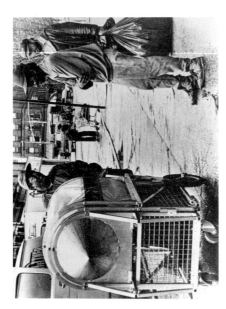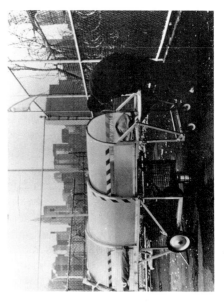

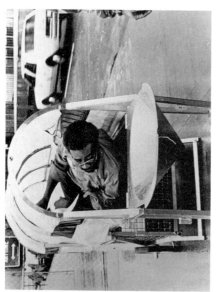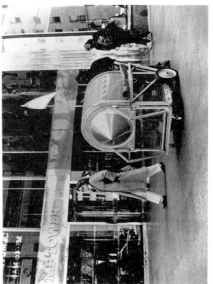

Figure 6.1 The Homeless Vehicle designed by Krzysztof Wodiczko.

device, folds down to become a wash-basin. In one model, Wodiczko tried to design a biochemical toilet on the rear of the vehicle but this proved impractical.

An appropriately extreme response to mass social eviction, the Homeless Vehicle neither is nor is meant to be a solution. It 'is not a home but illegal real estate', according to Papo Colo; it is an 'architecture provoked by poverty, a missile, the indication of flight, of retreat, or invasion and attack'.[4] With the appearance of a high-precision, military–industrial instrument, it expresses the social absurdity and obscenity of widespread homelessness in the capitalist heartland, but it does so only to the extent that the vehicle is rigorously functional. The prosaic usefulness of the nose-cone for everyday needs contrasts abruptly with the pathological waste of a $300bn defence budget, as if to point out that there is more social use in a single wash-basin than in the entire national armoury of high-tech junk. The supermarket trolley, a softer symbol, but nevertheless an icon of aggressive, expansive consumerism, becomes a means of production as well as consumption, a basic technology for conducting daily life. The vehicle's absurdity depends on its practicality. It expresses and exposes the relations of empowerment and disempowerment defining homelessness.

Evicted from the private spaces of the real estate market, homeless people occupy the public spaces, but their consequent presence in the urban landscape is fiercely contested. Their visibility is consistently erased by institutional efforts to move them elsewhere – to shelters, out of buildings and parks, to poor neighbourhoods, out of the city, to other marginal spaces. Evicted people are also erased by the desperate personal campaigns of the housed to see no homeless, even as they step over bodies in the street. This ongoing erasure from the public gaze is reinforced by media stereotypes that either blame the victim and thereby justify their studied invisibility or else drown them in such lugubrious sentimentality that they are rendered helpless puppets, the pathetic other, excused from active civic responsibility and denied personhood.

The Homeless Vehicle is an impertinent invention that empowers the evicted to erase their own erasure. It 'retaliates' by making homeless people visible and enhancing their identities, and it 'dramatizes the right of the poor not to be isolated and excluded'. Disrupting the ruling coherence of the urban landscape, it perpetrates a 'socially created scandal'; it becomes 'a vehicle for organizing the interests of the dominated classes into a group expression, employs design to illuminate social reality, supporting the right of these groups to refuse marginalization'.[5] The Homeless Vehicle provides a potential means by which evictees can challenge and in part overcome the social dislocation imposed on them by homelessness. Emphatically not a solution, it works only partly and unevenly; it addresses

most explicitly the needs of single male evictees and is less responsive to women's security needs or the needs of homeless families.

The tension between absurdity and functionality is expressed not simply through the vehicle's design, but through its practical revelation of the politics of daily life as inherently spatial. The Homeless Vehicle expresses a strategic political geography of the city. Evictees' immobility traps them in space, or rather traps them in the interstices of an urban geography produced and reproduced in such a way as to exclude them.[6] The Homeless Vehicle, by contrast, is simultaneously a means of production and reproduction, allowing evictees to make and remake space in a way that enhances their means of survival. It is a means to carve a more sympathetic, geographical politics in a city of exclusionary spaces. By allowing wider spatial mobility, it opens up the possibilities for scavenging and panhandling; it puts more distant can and bottle redemption centres within reach; makes new places accessible for sleeping; enables speedier and more effective escape in the face of police harassment and assaults; in general, it streamlines the routine of daily life. 'It facilitates the seizing of space by homeless subjects rather than containing them in prescribed locations'. Operators of the Homeless Vehicle 'possess space by their obligation to invent it'.[7] And enhanced mobility enhances the opportunity for public gathering and public organizing; it renders 'the homeless' more dangerous to the brittle coherence of the ruling political geographies of the city.

If the Homeless Vehicle provides an oppositional means for reinscribing and reorganizing the urban geography of the city, it does so in very specific way. It opens new spaces of interaction but does not do so randomly. Rather, it stretches the urban space of productive and reproductive activity, fractures previous boundaries of daily intercourse, and establishes new ones. It converts other spaces, previously excluded, into the known, the made, the constructed. In short, it redefines the scale of everyday life for homeless people. The liberatory intent of the Homeless Vehicle, the political empowerment it facilitates, the sharpness of the contradiction between absurdity and functionality, all these hinge on this reinscription of geographical scale. It promises not just the production of space in the abstract, but the concrete *production and reproduction of geographical scale* as a political strategy of resistance. As an instrument of political empowerment, the Homeless Vehicle works precisely to the extent that, symbolically and practically, it enables evicted people to 'jump scales' – to organize the production and reproduction of daily life and to resist oppression and exploitation at a higher scale – over a wider geographical field. Put differently, jumping scales allows evictees to dissolve spatial boundaries that are largely imposed from above and that contain rather than facilitate their production and reproduction of everyday life.

CONTEXT: TOMPKINS SQUARE PARK

On 6 August 1988, just about the time Wodiczko was preparing the first prototype of the Homeless Vehicle for exhibition at a downtown art gallery, New York City witnessed its largest riot since the 1960s. Homelessness and gentrification – the conversion of previously working-class neighbourhoods for middle-class consumption and the eviction of existing residents – defined both text and subtext of the police riot which took place in and around Tompkins Square Park in the Lower East Side. It was in Tompkins Square Park that Krzysztof Wodiczko had begun consulting with homeless men about the design of the Homeless Vehicle. Gentrification began pulsing through the area from west to east in the late 1970s and accelerated in the 1980s. Its causes were global as much as local: the rapid expansion of the world financial markets focused on Wall Street and the adjacent Financial District; national economic expansion following the recessions of 1973 to 1982; recovery from the city's fiscal crisis; the availability of a dramatically undervalued stock of tenement buildings, resulting from decades of disinvestment intensified since the 1950s; the planned as well as spontaneous centring of an alternative art industry in the area which became the cultural anchor around which reinvestment hype could be organized; and the active encouragement of myriad city and state programmes devoted to housing rehabilitation and redevelopment, anti-drug and anti-crime campaigns, and a park reconstruction programme.[8]

By the late 1980s, the costs of gentrification and the broader crisis in housing affordability were increasingly evident throughout the city but especially in Tompkins Square Park. By August 1988 between fifty and a hundred people were living in the park on a regular basis. A major symbol of political resistance and organization since the 1850s (the first in a series of police riots in the park came against a march of the unemployed in 1874), and located in an extraordinarily heterogeneous working-class and counter-culture neighbourhood that thrives on alternatives to white middle-class definitions of the mainstream, the park had become a growing focus for evictees from around the city.[9] As part of the Koch administration's active support for gentrification, its effort to reimpose that mainstream culture, and a related citywide effort to 'take back the parks' and other public spaces from appropriation by evictees, city police tried to invoke an old, forgotten law mandating a night-time curfew on all parks. The curfew would re-evict the evictees who had made the park their home. In 1988, a four-hour riot ensued that engulfed hundreds of onlookers and others who had simply wandered on to the scene. 'They'd taken a relatively small protest and fanned it out over the neighbourhood, inflaming hundreds of people who would have never gone near the park in the first place.' According to an eyewitness, 'the policemen were radiating hysteria'. They perpetrated 'isolated, insane beatings', according to

another. The police finally retreated and jubilant protestors retook the park. A group of activists attached the most hated symbol of gentrification in the neighbourhood, the Christadora Condominium. The Christadora, abandoned in the 1960s, unsuccessfully marketed in the 1970s, was eventually renovated by developers in the 1980s to yield $1.2 million penthouse apartments sold the year before the riot. When the *New York Times* covered the riot, it did so under the heading: 'Class struggle erupts along Avenue B'.[10]

If the Homeless Vehicle was developed in the context of emerging struggles over homelessness and gentrification in the Lower East Side, and with the active consultation of people living in the park, the political rhetoric of the riot and its aftermath mirrors the lessons of geographical scale highlighted by the Homeless Vehicle. Various slogans galvanized the anti-gentrification movement and the demonstrations up to and on 6 August 1988, some more nihilistic than others: 'Die Yuppie Scum'; 'Gentrification is Genocide'; 'End Spatial Deconcentration'; 'Class War'. But the slogan that came to define the struggle on the night of the police riot was: 'Whose park is it? It's our fucking park'.

This tight spatial definition and focus for a much broader struggle over housing and public space repeated unknowingly the script of 1874, when an Irish immigrant asked on the eve of the first Tompkins Square police riot: 'Is the Square private, police or public property? Has martial law been declared?' Spatial definition of the contested terrain was intermeshed with social vilification of the 1874 protestors. Both before and after the 1874 riot, the police sought to justify their intervention by branding rally organizers as 'communists', 'revolutionaries', 'atheists', and 'drunkards'. 'Communists, Internationalists and other social disturbers' bent on causing 'social anarchy', were responsible, added a union leader opposed to the march that precipitated the police riot.[11]

In the aftermath of the 1988 riot, the same language emerged. Much as the earlier police commissioner had done, Phil Caruso, President of the Patrolman's Benevolent Association (PBA) sought to defend his officers for instigating the riot, but unlike his predecessor, he had to contend with the results of late-twentieth-century technology and the democratization of surveillance – specifically a damning four-hour videotape of the riot by local videoartist Clayton Patterson which showed repeated police brutality by dozens of officers (some 121 civilian complaints were eventually filed against the police in connection with the riot). The videotape notwithstanding, in the eyes of Caruso, the riot was caused by the 'social parasites, druggies, skinheads' and 'communists' who used and inhabited the park. 'Anarchists', added Mayor Koch, who also described the park as a 'cesspool', while ordering that the curfew be suspended. Two years after the riot, in an exchange of letters in the *New York Times*, the city's Commissioner of Parks and Recreation was forced to concede that it still remained a contested question to 'whom the park belongs'.[12]

Tompkins Square expresses not just the spatialization of struggle in the abstract, but the social and political inscription of the geography of the city, through which urban space comes to represent and define the meanings of these struggles. In vilifying its denizens as they conceded the park, the city authorities in 1988 were forced to accept not just the liberation of the park but the geographical scale of the struggle set by the protestors. During early August 1988, it was understood as first and foremost a protest for the park, and the park's borders marked the firmest spatial boundaries of the struggle. The park was alternately scripted as a retreat from the wild city or as a symbol of the widest degeneration the city could offer,[13] but most of all it defined the scale of the struggle.

But the political ambition on different sides of this contest stretched far beyond the park borders. In the first days after the riot, there was an explosion of graffiti in the neighbourhood around the park, directly commenting on the riot, gentrification, displacement, financial crash of the year before, and the social purposes of art. Stencil artists specifically retaliated against the official definition of the park and its residents, and the implied confinement of struggle, by scripting the park's entire vicinity as an 'NYPD RIOT ZONE'. At the same time, hastily constructed links were built between park residents, squatters and housing activists and 'Whose park is it?' was replaced by the slogan: 'Tompkins Square Everywhere!' Some political connections were made at the citywide scale through the participation of squatters and evictee activists in housing and squatting struggles across the city, but it didn't jump scales so quickly or easily. At this stage, the focus of contest had expanded to the whole Lower East Side, but not yet to the city level.

The media establishment also participated in this escalation of the scale at which housing, eviction and homelessness were contested. Local television stations and newspapers began running periodic background stories depicting the whole Lower East Side, and not just the park, as 'non-traditional', 'bohemian', or endowed with a rich 'ambience' of danger and romance. While softer and more patronizing than the direct denunciations from the Mayor and police, these stories effectively identified and differentiated the whole neighbourhood as quite other than some vaguely implied white, middle-class, middle-American, mainstream normalcy. The whole Lower East Side, not just the park, had become 'Indian Country'.[14] In the media, this redefinition of the scale of the villain peaked with a local TV news series which, leaning heavily on police sources, depicted the riot as the work of a Lower East Side cult conspiracy led by the local rock group, Missing Foundation.

In the nine months after the riot, the number of squats increased to approximately forty buildings, with the number of squatters estimated at over 500. The population in the park also increased to perhaps 250, now a stronger magnet for evictees citywide. But by May 1989 the city was ready to resume the offensive; it used an arson fire and consequent damage at a

twenty-five-person squat at 319 East 8th Street, half a block from the park, to initiate a selective neighbourhood-wide campaign of demolition and eviction. Nearly 200 police in riot gear and thirty-five plainclothes police tried to enforce the demolition but an opposition of squatters, evictees and activists held them off for three days, during which 'for people in the neighborhood, it was like a state of siege'.[15] The night after the demolition was eventually accomplished, the doors of the Christadora were again smashed in.

In the short term, the alliance of evictees and squatters – whose presence in the neighbourhood was often resented by more conservative housing and community groups – was only enhanced. According to one witness and participant,

> [t]he current police clampdown has driven squatters and park crusaders into a closer and more militant alliance with the homeless than ever before. The homeless have picked up on the squatters' direct-action tactics, fighting for their turf with a sense of moral indignation they have not expressed before. And the homeless have given the squatters more credibility, making it difficult to dismiss them as just a bunch of white kids from the 'burbs who forgot the '60s are over.

As a squatter expressed the connection: 'In our case it's an abandoned building, in their case it's a park bench, but it's all a general squatting movement. The squatters and the homeless are on the front lines of the struggle against repression.'[16]

As the arena of struggle expanded to fill the Lower East Side, the park remained a contested zone. In the sharpest frost of the winter in December 1988, it hit the headlines again when an evictee froze to death on a park bench. Regular political rallies, speakouts, musical events, and spontaneous happenings secured the park's symbolism at the core of the loose housing, homeless and anti-gentrification coalition in the neighbourhood.

By July 1989, with a heightened police campaign against squatters now underway and meeting less organized resistance, the city felt emboldened enough to begin its own reconquest of Tompkins Square Park. Eleven months to the day after the riot, the main target was the forty to fifty structures comprising several shanty-towns and 'tent cities' in the park: 'the officers with riot equipment sealed off the park while park crews knocked down the shanties with sledgehammers and axes and threw debris, along with food, clothes and other belongings, into three garbage trucks'. More than 400 people, infiltrated by thirty plainclothes police who picked off thirty-one demonstrators for arrest, protested the destruction and eviction. Fearing a more violent response, the city allowed that evictees could sleep in the park as long as they did not construct any kind of shelter.[17]

The emerging housing coalition in the Lower East Side was at its peak in the summer of 1989. The growth of squatting in the neighbourhood had certainly encouraged squatting elsewhere in the city – Harlem, the South

Bronx, and some Brooklyn neighbourhoods – but the connections between them remained weak. Preoccupied with defending Tompkins Square Park and the squats in the Lower East Side against periodic assaults by police, parks officials, or the city's Housing and Preservation Department, neighbourhood activists did not move about sufficiently to other struggles around the city and did not forge lasting connections between different struggles. Nor were squatters and activists from other neighbourhoods able to make sufficient links to establish a functional, citywide movement as an alternative to more institutional organizations, such as the Metropolitan Council on Housing, that are committed to radicalizing housing legislation, but within the current legal and political structures. In the Lower East Side itself, activists in the emerging housing alliance only numbered in the hundreds at their peak – possibly a thousand.

Repeated police raids followed the July eviction. Some people filtered into local squats, themselves under heightened attack. A new tent city was established on a vacant lot on 4th Street across from an abandoned school, also squatted. But the park was also reoccupied, and as winter approached as many as 300 people lived there on a regular basis. Finally, in the early morning of 14 December 1989, one of the coldest days of winter, and with the blessing of incoming Mayor Dinkins – supposedly elected on a progressive platform and with widespread support from housing advocates – the police and Parks and Recreation Department workers carried out a second sortie against park dwellers. They destroyed more than ninety reconstructed shanties, tents and other structures. For the next year and a half, there was an uneasy stand-off between city agencies on one side and squatters and homeless people on the other. As a local resident put it in response to the neighbourhood's pro-gentrification lobby: 'whether one likes it or not, by living in the East Village, one is obligated to take a stand on one side or the other.'[18]

SPACE, DIFFERENCE AND METAPHOR

The reassertion of space in social discourse is now well documented and widely discussed, and it provides a vital theoretical and political context for the foregoing discussion of the Homeless Vehicle, Tompkins Square Park and the Lower East Side. I have chosen to tell these stories in a way that retrieves from a habitual invisibility the spatiality of local politics and especially the constitutive role of geographical scale. The reassertion of space in social discourse emanates from various sources: from geographers whose traditional concern with material space was dramatically enlivened and rendered social in the wake of the political uprisings of the 1960s and the spatial restructurings at all geographical scales that followed; from social theories of the 1970s and 1980s, for whom (in the context of the rigorously historicist tradition that has dominated social thought arguably since the eighteenth century) space is being rediscovered as a neglected

world of potentially novel and unexplored concepts; from literary and cultural theorists, especially but not exclusively feminists, for whom the language of space has yielded a reservoir of freshly revealing metaphors and new meanings.[19] These different expositions and rediscoveries of space have in their own ways been highly political projects, whether an effort to understand the constructed geographies of capitalism or to employ a spatial language for decentring previously dominant political concerns (e.g., class) and complementing or replacing them with new ones such as gender and race. Others would surely put it differently, but Jameson may be the most explicit – and he is certainly not alone – in coming to the conclusion that, further, 'a model of political culture appropriate to our own situation will necessarily have to raise spatial issues as its fundamental organizing concern'.[20]

A central obstacle, however, in this reassertion of space lies in the lack of any articulated language of spatial difference and differentiation. In so far as the grammar of social theory has been avowedly historicist, a language of temporal difference has been developed as a means to delineate different experiences. It is hardly that historians agree to some objective and universally applicable division of social history into formal eras and epochs; rather, the significant point is that the intensely political debates and struggles that go into the continual definition and redefinition of historical periods is not at all replicated vis-à-vis space. No such contentiousness has evolved over the categories and politics of spatial differentiation. Where are the political debates over the scale at which neighbourhoods are constructed, the boundaries of the urban, what makes a region of the nation state, or indeed what makes the global scale? It is not that such debates have never occurred – they have, although they have generally been obscure[21] – but that regardless, the division of the world into localities, regions, nations and so forth is essentially taken for granted.

In 'Western' social theory throughout the twentieth century, the subordination of space to time meant that spatial difference was usually either ignored or, conversely, treated as trivial: spatial difference pervaded social theory only to the extent that one could see different social processes and patterns in different places. Accordingly, space per se (as opposed to the social events that happened 'in' space or 'across' space) was treated as self-evident, therefore unproblematic and unrequiring of theory. Geographers who might have been expected to develop a language of spatial differentiation were indeed centrally concerned with spatial questions and not at all inclined to dismiss space during this period, but they harboured none the less a fatal reticence towards theory in general, and a complete reluctance to see geographical scale as socially constructed. With only rare exceptions, they too trivialized geographical scale as merely a question of methodological preference for the researcher. The clearest such trivialization came with the particularly conservative strain of regional geography that emanated from the US between the 1930s and the early 1960s, and

which based itself on the unexamined edifice of a peculiarly historicist neo-Kantianism still rooted in eighteenth-century idealism.[22] While it was certainly meritorious to have asked 'How are regions defined?', mid-century American geographers resorted to an anti-intellectual renunciation of the very real social processes of regionalization when they answered in virtual harmony: 'Any way you want them to be defined'.

In this context, the significance of the two stories with which I began will, I hope, be more sharply evident. I have recounted the struggle for Tompkins Square Park and for the Lower East Side not just as histories of the production of space, nor simply as examples of the making of place, but rather as political contests over the production of scale. I have been trying to suggest several things. First, that the construction of geographical scale is a primary means through which spatial differentiation 'takes place'. Second, that an investigation of geographical scale might therefore provide us with a more plausible language of spatial difference. Third, that the construction of scale is a social process, i.e., scale is produced in and through societal activity which, in turn, produces and is produced by geographical structures of social interaction. Fourth, and finally, the production of geographical scale is the site of potentially intense political struggle.

If these propositions have even partial validity, then a theoretical exploration of the production of scale may help to provide both a language and a set of connections for dealing with spatial difference. But before pursuing such an enquiry, it is important to clarify the language of space and scale I intend here; for quite different conceptions are invoked in this broader rediscovery of space and it is vital they be made explicit. As Foucault once suggested, it is a task of 'making the space in question precise'.[23] In particular, the metaphorical uses of space that have become so fashionable in literary and cultural discourse seem increasingly divergent from the more material conceptions of space that have dominated the 'new' geographies of the last two decades. This is not as simple as a mere semantic contest between supposedly real and ideal conceptions of space, but a quite contested *rapprochement* between multiple political visions. It was also Foucault, of course, who argued that while temporal metaphors tapped questions of individual consciousness, the effort 'to decipher discourse through the use of spatial, strategic metaphors enables one to grasp precisely the points at which discourses are transformed in, through and on the basis of relations of power'.[24] Not only is the production of space an inherently political process, then, but the use of spatial metaphors, far from providing just an innocent if evocative imagery, actually taps directly into questions of social power.

Much social and cultural theory in the last two decades has depended heavily on spatial metaphors.[25] The myriad 'decentrings' of modernism and of reputedly modern agents (e.g., the working class), the displacement

of political economy by cultural discourse, and a host of other 'moves' have been facilitated by a very fertile lexicon of spatial metaphors: subject positionality, locality, mapping, grounding, travel, (de/re)centring, theoretical space, ideological space, symbolic space, conceptual space, space of signification and so forth. If such metaphors functioned initially in a very positive way to challenge, aerate, even discard a lot of stodgy thinking, they may have now taken on a much more independent existence that discourages as much as it allows fresh political insight. It may be too soon to suggest that these spatial metaphors are out of control,[26] but they are headed that way, and a little timely reflection may not be a bad idea. Foucault's fleeting reflection on the purpose of spatial metaphor is rare; for the most part they are employed unselfconsciously.

First, the distinction between material and metaphoric conceptions of space is almost certainly overstated as I have laid it out here. The material and metaphorical are by definition mutually implicated and no clear boundary separates the one discretely from the other. Metaphors greatly enhance our understanding of material space – physical space, territory – just as our conceptions of material space are fecund raw material for metaphor. Neither is there a crude dualism working here; I am not somehow trying to discard metaphor – that would be an absurd project. Instead, I think that it is necessary to articulate the connections between material and metaphorical conceptions of space in order to understand the sources and potential of metaphorical power. Only in this way are we likely to be able to prevent the meanings from following the metaphors out of control.

The central danger in an unreflective use of spatial metaphors is that it implicitly repeats the asymmetries of power inherent in traditional social theory. Foucault again gives the most vivid description: 'Space was treated as the dead, the fixed, the undialectical, the immobile. Time, on the contrary, was richness, fecundity, life, dialectic.'[27] This asymmetrical relationship between time and space assumes history as the independent variable, the actor, and geography as the dependent – the ground on which events 'take place', the field within which history unfolds. Where geography is self-evidently given – it simply is – history hides all the secrets of social complexity. If the blossoming of spatial metaphors seems at first sight to represent an enervation of history and the championing of a re-energized space, things are not always what they seem. In fact, spatial metaphors tend to reinforce precisely this deadness of space. Metaphor works in many different ways but it always involves an assertion of otherness. Some truth or insight is revealed by asserting that an incompletely understood object, event or situation *is* another, where the other is assumed known: social definition (by race, for example) is called 'location' because it reveals the connection between social experience and place in the social structure; emerging ideas are said to occupy a distinct 'theoreti-

cal space' because such an imagery puts the clutter of existing and competing ideas at some remove – in another 'space'. In all such spatial metaphors, space is assumed as the unproblematic other, already known, and this suggests the Janus face of metaphor. To the extent that metaphor continually appeals to some other assumed reality as known, it systematically disguises the need to investigate the known.

Spatial metaphors evoke a very specific and contested representation of space. They assume as given what geographers, physicists and philosophers all recognize as 'absolute space'. In its absolute conception, space is represented as a field or container, within which the location of all objects and events can be fixed using a simple coordinate system. It is the dead, fixed and immobile space of which Foucault talked, and it presents itself for metaphorical service today precisely because, with all other rigidities rendered fluid in poststructuralist social theory, the fixity of absolute space provides the anchor that tethers otherwise free-floating ideas to material experience. Refracted against the mirror of a highly rigid, absolute space, metaphorical space carves out 'room to move', the space in which to be fecund, dialectical, life-giving. It is in this way that metaphorical space gains its richness – at the expense of material space, the impoverishment of which it reinforces. Indeed, the metaphors succeed only by retaining the most traditional and most totalizing of modernist spatial concepts. In so far as they problematize the universal assumption of absolute space, notions such as Henri Lefebvre's 'production' also render problematic the whole range of spatial metaphors grounded in the assumption of absolute space. Absolute space can no longer be equated with 'real space' even for the purpose of grounding alternative metaphors.

In providing a language of spatial differentiation, a more formal discussion of geographical scale may provide some clues for connecting material and metaphorical conceptions of space.

PRODUCTION OF SCALE: ICONOGRAPHY OF PLACE

It is possible to conceive of scale as the geographical resolution of contradictory processes of competition and co-operation. The continual production and reproduction of scale expresses the social as much as the geographical contest to establish boundaries between different places, locations and sites of experience. The making of place implies the production of scale in so far as places are made different from each other; scale is the criterion of difference not so much between places as between different *kinds* of places. When I first began to think of scale in this way, I conceived it in strictly political economic terms.[28] To take an obvious example, it is possible to see the scale of the nation state as a territorial compromise between differing needs of the capitalist class. On the one hand, competition between producers is a basic requirement of the

capitalist economy but, on the other, unrestrained competition threatens anarchy. The capitalist class also co-operates internally in order to create the appropriate conditions for capital accumulation and social reproduction, and to deal with challenges to its power. If hardly thought out with quite such explicit or detached voluntarism amidst national formation, the nation state represents an enduring but ultimately temporary and historically specific territorial resolution of this contradiction between competition and co-operation. Within the geographical boundaries of the nation state, the national ruling class co-operates broadly over such questions as the conditions for reproducing labour power, legal constitution of the economy, provision of infrastructures of production and circulation, and certain ideological institutions – even as separate capitals compete for markets, capital, labour, technology and land. Between different national markets there is also co-operation, but it is economic competition that prevails.

The resolution of this particular contradiction pivots on the structure of the nation state. That there is no abrupt and clearly demarcated boundary between competition and co-operation – producers of similar products and services compete within the nation state while nations can also co-operate – does not belie such a conceptualization of the nation state but rather confirms it. The territorial boundaries of the national scale elicit a (sometimes weakly, sometimes strongly) ordered alignment of co-operative and competitive economic relations. If the consequent territorialization of conflict resolution takes on a certain fixity in the landscape – national boundaries, for example – it is also marked by long-term fluidity. As the scale of economic accumulation expands, and with it the necessary scale of competition and co-operation, the territorially institutionalized form of resolution becomes increasingly obsolete, and alternative spatial forms are developed. This is the significance of the United Nations, of international trading co-operatives such as ASEAN or COMECON, or a unified Western Europe, all of which provide alternative (higher) geographical scales at which this particular contradiction is resolved – again presumably temporarily.

At the other end of the hierarchy of scales, the Homeless Vehicle highlights the way in which the scale of the community is constructed. While there is obviously an economic dimension to the functionality of the Homeless Vehicle, its significance is much broader, involving political and cultural access to, and production of, the space of the community: it challenges the ideological definition of community. The Homeless Vehicle highlights the connection between the everyday details of social reproduction and the construction of space at different scales. As Herod points out, a much wider array of social processes is involved in the production of scale than the political economic.[29] Feminist work has long focused on the home and community as a means to understand the relationship between

social production and reproduction, and more recent feminist writing has explored the scale of the body. Grounded more in metaphorical appropriations of space, and emphasizing social and cultural processes, this theoretical work on the body none the less connects in many different ways to the more geographical focus of, for example, discussions of the nation state. A coherent, spatialized politics will have to find a way of exposing these connections.

The construction of scale is not simply a spatial solidification or materialization of contested social forces and processes; the corollary also holds. Scale is an active progenitor of specific social processes. In a literal as much as metaphorical way, scale both *contains* social activity and at the same time provides an already partitioned geography within which social activity *takes place*. Scale demarcates the sites of social contest, the object as well as the resolution of contest. Viewed this way, the production of scale can begin to provide the language that makes possible a more substantive and tangible spatialized politics. 'The orderliness of respectability', says Iris Young, 'means things are under control, everything in its place, not crossing the borders.'[30] It is geographical scale that defines the boundaries and bounds the identities around which control is exerted *and* contested.

I would like to explore this further by examining a sequence of specific scales: body, home, community, urban, region, nation, global. I want to focus loosely on at least four aspects of each scale: identity, or the characteristics that render each scale coherent; internal differences; borders with other scales; and political possibilities for resistance inherent in the production of specific scales, the abrogation of boundaries, the 'jumping of scales'.

A few caveats are necessary before broaching such a schematic and exploratory discussion. With this typology of discretely different scales, I am not implying some rigid separation of spatial spheres. As the Homeless Vehicle suggests, it is precisely the active social connectedness of scales that is vital, yet we have no coherent, critically thought-out language for different scales. The strategic bias in what follows is therefore towards differences rather than homologies of scale. Second, the hierarchical character of this typology is deliberate, and reflects a practical rather than philosophical judgement. I am in no way proposing some ontological system of scales; rather I argue that geographical scale is hierarchically produced as part of the social and cultural, economic and political landscapes of contemporary capitalism and patriarchy. Put differently, the point is not to 'freeze' a set of scales as building blocks of a spatialized politics, but to understand the social means and political purposes through and for which such freezing of scales is none the less accomplished – albeit fleetingly. Such a hierarchical order of scales is certainly a candidate for abolition in a revolutionized social geography: by discussing challenges to and political contests over specific scales, I hope to indicate ways in which

...ght be accomplished, places from which it could be made to happen. Finally, although it stretches from the scale of the body to the global, this typology is inherently incomplete and open-ended. It could hardly be otherwise if, as I have claimed, scale is actively produced. At best, this typology provides a framework for organizing a more coherently thought-out analysis of spatial scale.

The body

The primary physical site of personal identity, the scale of the body is socially constructed. The place of the body marks the boundary between self and other in a social as much as physical sense, and involves the construction of a 'personal space' in addition to a literally defined physio-logical space. The body is also a 'cultural locus of gender meanings', according to Judith Butler,[31] and this suggests that more than most scales, the identity of the body *per se* is closely intertwined with bodily differences. The dialectic of identity and difference is central to the definition of scale but nowhere more important than with the body. Indeed, Simone de Beauvoir argued that masculine culture identifies women with the sphere of the body while reserving for men the privilege of disembodiment, a non-corporeal identity.[32] Not just gender, obviously, but other forms of social differences are constructed around the identity of the body. Young, in particular, argues that 'the scaling of bodies', as she puts it, appropriates a variety of corporeal differences in addition to sex – most obviously race, but also age and ability – as the putative bases for social oppression and 'cultural imperialism'.[33]

As the site of biological reproduction, the body has specific needs that are equally social in definition and delivery. As the site of pleasure and pain, it also has wants, desires and fears, and it is the biological organ around which social definitions of sickness and health are constructed. Care for the body, physical access to and by the body, and control over the body are the central avenues of contest at this scale. If women do not necessarily monopolize the scale of the body, as Beauvoir suggests, con-tests at this scale are none the less dominated by gender. The politics of abortion, rape, prostitution, reproduction and bodycare (the provision and preparation of food, clothing shelter, warmth) focus on access to women's bodies, work women do with their bodies, and the boundary between individual and state control over the body. The manual, *Our Bodies Ourselves*,[34] helped galvanize an emerging feminist movement in the early 1970s precisely because it enabled women to reclaim their bodies and control the conquest of the scale of the body; it affirmed the body as a site of struggle over which feminists staked a powerful claim. The same bound-ary between individual and state control of the body is contested in the politics of abortion and of sexual preference. The politics of the body are

not delineated by gender alone, of course, no matter how dominant gender is at this scale. Bodily style and clothing mediate personal constructions of identity with regional, national and global cultures and provide access to the body by the international fashion industry. Gendered as it is, bodily style is also a class question.

The impudence of the Homeless Vehicle demonstrates the importance of access *by* the body to wider spaces – bodily access as a means of jumping scales – but history reveals less cryptic examples. The feminist geographer Marston interprets the turn-of-the-century 'voluntary motherhood' movement in a parallel way. Determined to control fertility and the number of births, women activists transformed the norms of their own sexuality and, in the process of constructing a movement for 'domestic feminism', challenged a variety of assumptions and ideals about the wider social roles of women. Marston asks succinctly:

> How did women construct the various scales of resistance from the body to the home to the community, the state and the nation-state *and* how was knowledge and meaning translated between and among scales . . . leading eventually to transformations of the boundaries of difference with the wider male dominated social world?[35]

Since the emergence of AIDS at the beginning of the 1980s, the most unprecedented contest for the body has been played out on a global scale. First labelled GRID (Gay-Related Immune Deficiency) by the medical profession, and traced to Central Africa and Haiti, AIDS is still generally vilified as the result of voluntary mistreatment of one's own body. The political and professional response to AIDS has involved a hardening of spatial boundaries at all spatial scales. The United States refuses to admit non-citizens who test HIV-positive; national governments advocate compulsory AIDS testing; Cuba isolates AIDS victims, while many other national governments wish ruefully they could do likewise; communities expel HIV-positive students from local schools; police forces are issued surgical gloves for use in gay and lesbian demonstrations; physical attacks against gays and lesbians burgeon along with the moral cacophony against drugs and for sexual abstinence. The containment of AIDS is a highly spatial strategy which, by policing the boundaries of different scales, reinforces differences as spatial ones. The boundaries – not just of the body but of all other places the body might go – are subject to heightened surveillance. The response from AIDS activists such as Act-Up (AIDS Coalition To Unleash Power) and from gay and lesbian organizations such as Queer Nation has been to refuse, at all scales, social containment on the pretext of medical control. The most symbolic refusal of containment may have come with Douglas Crimp's defiant appeal for principled promiscuity.[36]

The home

The site of personal and familial reproduction, the home is a physical location and perhaps a structure – permanent or temporary. Routine acts of social reproduction – eating, sleeping, sex, cleansing, child-rearing – are based (but not exclusively practised) in and around the home. If the size of the home, its external appearance and location are largely a function of class difference, and in some societies of racial difference, the home *per se* is a heavily gendered site in many societies and is viewed as the locus of female activity, contrasting with a wider masculine realm. The form taken by this gendering differs widely, in part as a result of very different definitions of 'family' and the household. Internally, the differentiation of the home can vary from a single inside/outside dichotomy to more elaborate division; it represents a spatialization of different social experiences, activities and functions or combinations thereof, and is furnished accordingly. The interrelatedness of class and gender differences is suggested by Witold Rybczynski's study of the formation and identity of the bourgeois home: 'The feminization of the home in seventeenth-century Holland', which pioneered bourgeois domesticity, he argues, 'was one of the most important events in the evolution of the domestic interior'.[37] Age and social function also divide the home into different uses and places – bedroom, kitchen, bathroom, dining room, smoking room, study, playroom – which usually none the less retain the markings of class and gender difference in contemporary Euro-American culture. The differentiation of the home might also take on the simpler geometrical polarities of front/back or upstairs/downstairs.[38]

The borders of the home may be sharply defined, as in the walls of a structure or the markers of private property that include other private space such as garden or courtyard – a relatively recent and geographically specific invention – or they may be more fluidly defined as the space of the home fades into community space. Internally, the home is a contested zone, especially in gender terms, with the wider, socially sanctioned authority of men pitted, in numerous cultures, against the authority of women rooted in the routine of the home. If the interest of men lies largely in containing women within the home, the interest of women lies more in extending the power and pride experienced in the home to higher geographical scales. Both castle and prisonhouse, the home is socially if not always physically walled, and access out as well as in is controlled in various ways. As a means to control access to women's bodies, for example, the scope especially of young women's mobility can be severely restricted to the environs of the home, whether formally in many Islamic cultures with the tradition of purdah, or less formally as in many inner cities in the US.[39]

Although it was suggested that the scale of the body defines the site of

personal identity, the scale of the home provides the most immediate context within which this takes place. Homelessness is a dramatic loss of power over the way in which one's identity is constructed, since the home no longer shields from the public gaze. Squatting reasserts rights to social privacy against the dictates of economic privacy protected in the real estate market. The home itself is defined within a larger context, and no matter how sharp the physical boundary separating homes from one another, these borders always retain some porosity. Economic change, neighbourhood-wide disinvestment in the housing stock, or the expansion or contraction of local transport systems, for example, can severely affect the property values of individual homeowners, regardless of their own actions in and on the home. Porosity is equally marked in the opposite direction in so far as the home becomes the geographical basis for political struggle and mobilization. In a case study of working-class housing activities in Harlem, Leavitt and Saegert find that women predominate in tenants and neighbourhood organizations largely because they refuse to recognize the physical boundaries of the home but instead treat the community as a virtually borderless extension of the home.[40]

Community

The community is properly conceived as the site of social reproduction, but the activities involved in social reproduction are so pervasive that the identity and spatial boundaries of community are often indistinct. In addition to a grouping of homes, the community incorporates myriad intertwined social and cultural institutions – educational, religious, recreational – themselves intertwined with the local state. It also includes places of work, from the home to the factory, the office to the store. To the extent that such institutions take a fixed form, they become distinct places within the community. Community is therefore the least specifically defined of spatial scales, and the consequent vague yet generally affirmative nurturing meaning attached to 'community' makes it one of the most ideologically appropriated metaphors in contemporary public discourse. From 'the community of nations' fighting a murderous war against Iraq, to 'the business community' attempting to justify class-based exploitation, the idea of community is appropriated to rescript less salubrious realities. Identities established at other scales are easily rolled into struggles over community.

Communities are socially defined and can take very different spatial forms. Working-class communities in contemporary, advanced, capitalist cities may be broadly homologous with the spatial confines of a neighbourhood. The identity of the neighbourhood and community may significantly overlap, based on intraclass characteristics such as type of work, ethnicity, race, national origin, or some vaguer continuity of tradition, social propinquity, or identification of property with place. This certainly describes

many rural communities but also New York's Lower East Side: Herbert Gans's 'urban village' in Boston's North End is perhaps the classic exemplar. The upper middle class, meanwhile, construct and live in a very different kind of community, usually more diffusely defined, with a far wider spatial reach, and rarely coterminous with any spatially contiguous neighbourhood: the Kennedys hardly live in and Irish neighbourhood. In addition to the environs of the home, it may include the locale of a summer home hundreds or even thousands of miles away; the private school where the kids are sent; and a whole orbit of non-contiguous but habitually visited places.[41] It is not just that the rich express their freedom by their ability to overcome space while the poor are more likely to be trapped in space; differential access to space leads to differential power in constructing the spatial scale of daily, weekly and seasonal life.

The spatialization of struggles at this scale is central to the social identity of the community. In the summer of 1989, Yusef K. Hawkins, a black teenager, went to buy a car in Bensonhurst, a virtually all-white, heavily Italian part of Brooklyn. A mob of white male teenagers, claiming he was the new boyfriend of a neighbourhood girl, attacked and murdered him. Defence of community here involved not just reactionary violence but the conflation of several scales at which identity is constructed, a 'defence' of the neighbourhood against non-whites, but also a patriarchal defence of 'community property' – the woman's body. But place-based struggles can also galvanize a more progressive response as previously fragmented social groups coalesce into a politically defined community. Thus, in many British cities in 1981, amidst tumultuous uprisings sparked by unemployment, police brutality, and racist attacks on blacks and Asians, many young Asians, who had traditionally seen themselves as quite separate from even superior British blacks and Afro-Caribbeans, began to call themselves 'black', in a clear act of solidarity that expressed their own experience of racism. As the scale of black identity was thereby expanded, this had the effect of unifying and expanding the scale of struggle against racism. If the body is the immediate source of corporeal difference appropriated in the construction of racism, it is at the scale of the community that racism and, indeed, every form of localism is most firmly rooted.

Community-based struggles that are not simply defensive develop as political recognition of social identity – class, race, national origin, environmental vulnerability – is emancipated from parochial, spatial constraint. Spatial definition is not abandoned, but as the examples of Tompkins Square Park and the Lower East Side suggest, the re-spatialization of community and consequent definition of scale can become a means of constraining struggles within fixed borders or expanding them into new spaces. Thus, it was primarily the scale of the community that Harvey had in mind when he argued that 'working-class movements are . . . generally

better at organizing in and dominating *place* than they are at commanding *space*.'[42]

Urban

The urban represents the daily sphere of the labour market. It involves the most accomplished centralization of capital and social resources devoted to social production, consumption and administration. Manuel Castells defines 'the specificity of the urban' as the field of 'collective consumption', the realm of reproduction, as opposed to the regional which he sees as the scale of production.[43] While this distinction is suggestive, Castells falsely equates consumption and reproduction, and confuses the definition of the spatial limits of the urban with the processes and forces that constitute the urban scale.

Urban space is divided according to different activities and functions. In contemporary capitalist cities, the allocation of different land uses to different spaces is largely mediated through the land market with its system of differential ground rent. Differential levels of ground rent facilitate a spatial sorting of commercial, industrial, residential, recreational and other activities. Within the city, the ground rent structure, government policy and private financial institutions structure a differentiation of residential space largely but not exclusively along class and race lines – a structural differentiation that is culturally constructed into a mosaic of neighbourhood enclaves. The most definitive spatial distinction in the advanced capitalist city has involved the separation of work and home, precipitating a gendered urban geography. But with the emergence of gentrification and the integration of the suburbs in recent decades, together with the resurgence of homeworking and the increasing percentage of women who work outside the home, the gendered geography of the city is being restructured.[44]

The unprecedented growth of cities over the last few centuries reflects both the dramatic centralization of capital and the development of the means of transport that allowed increasing geographical dispersion. Most urban areas are legally defined by administrative boundaries, but these only accidentally reflect the range of everyday social intercourse. The spatial extent of the urban scale is demarcated much more acutely by the field over which a daily journey to work is feasible.

The coherence of the urban scale is challenged in a series of ways. Internal to capital, ground rent is a periodically unreliable means of allocating land uses in so far as it also responds to larger signals in the economy and transmits wider economic disruptions to the urban scale. By contrast, rapid urban development can also disrupt the coherence of the urban scale in that escalating land values and the receding spatial boundaries of the suburban fringe force many of the working class to choose between a dilapidated neighbourhood and a several-hour commute. Either

way, urban development puts significant pressure on the value of labour. To the extent that larger conurbations incorporate larger and larger concentrations of oppressed and exploited people, often in distinct communities, and provide them too with the means of transport, the economic requirements of an expanded labour market also create the conditions for political organization of the oppressed. Urban fiscal crises, whether periodic or chronic, bring cutbacks in services (the means of reproduction) and employment around which citywide organization can emerge, while continued expansion endangers the very economic and environmental conditions that stimulated growth, provoking the emergence of no-growth movements.

Region

The site of economic production, the regional scale is closely bound up with the larger rhythms of the national and global economy, and regional identity is constructed disproportionately around the kinds of work performed there. The region can be conceived as a concentrated network of economic connections between producers, suppliers, distributors and myriad ancillary activities, all located in specific urban or rural locations – 'ensembles of production', as Scott has recently suggested.[45] Traditional regional geography identified agricultural and industrial regions on precisely this basis: for late nineteenth-century Britain, Lancashire meant cotton, Yorkshire was woollens and heavy engineering, the Clyde was shipbuilding, the West Midlands was electrical engineering. The same kind of regional mosaic could be identified in other national and international spaces, for example New England. This regional structure was specific to the early industrial stage of capitalist development, but the emergence of Fordism in the postwar world was accompanied by a radical change in regional structure and a dramatic expansion of the regional scale. New England, for example, ceased to be the mosaic of local regions it had been prior to the Depression, but by the late 1960s had become part of a larger coherent region incorporating the whole Northeast.[46]

If productive activities – specific forms of industry and agriculture, tourism and mining, for example – define the broad contours of regional identity, the rhythms of daily, weekly and seasonal life etch a distinctive cultural identity for some regions more than others. In arguing that what people are 'coincides with their production, both with *what* they produce and *how* they produce',[47] Marx and Engels should be read as proposing not some universal ontology of individual identity but a social theory connecting work and culture most applicable at the regional scale. If the emphasis here is increasingly on economic relationships, this does not imply a diminished social construction of geography. It does, however, imply that the social and cultural construction of the regional scale is less the result of

immediate, individual and local agency but mediated to a greater extent through more generalized cultural, political and especially economic structures.

The social division of labour is most sharply expressed in spatial terms at the regional scale. Different social conditions, means and levels of production characterize various urban and rural places. Much as it is internally constructed, the social economy of the region is also fashioned in the swirl of national and international economic processes, events and developments; and in so far as regions specialize in specific types and conditions of production, making commodities or selling services for a wider market, regional borders are highly porous and changeable. While postwar New England lost much of its traditional regional identity, merging into a larger Northeast, the deindustrialization of the 1960s and 1970s in turn eroded the territorial coherence of this larger Northeastern region. The Northeast fragmented into a mosaic of much smaller regions at the behest of larger economic and political shifts at the national and global scales. Conversely, new patterns of high-technology growth, a shift towards producer and consumer services, and a move towards flexible specialization in production processes and output began to establish very different regional ensembles, such as Silicon Valley, which reconstituted regional space at a diminished scale.[48]

In as much as regional identity focuses on productive activity, regional struggles are disproportionately class struggles, with work as the basis of political organization. Intraclass co-operation enhances interclass competition, and the spatial organization of class co-operation and competition contribute to the definition of regional boundaries. The fragmentation of the Northeast in recent decades was not simply the result of economic recession and absorption into the world market; in a series of givebacks, several powerful unions relinquished national and regional scale bargaining for myriad separate local agreements.[49] The restructured regional geographies of the 1980s were marked by fluidity and flexibility, and this applies equally to the scale of regional construction.

Regional political movements may be highly defensive, combating some perceived external invasion. This would apply to some anti-deindustrialization coalitions of recent years, which identified external capital or foreign nations as the villain, but it also describes some emerging environmental and antigrowth coalitions. Most defensive of all, politically very diverse and often the most volatile, are those regional movements based less directly on political economic demands than on historic, often romantic, cultural claims that seek to reinstate certain regions as separate nation states. Regional difference and chauvinism here work to contain class-based and other regional struggles within territorial bounds. At worst, regionalism can give vent to racism and other forms of localism generated at lower spatial scales. But regionalism and connected claims to

national sovereignty can also be a basis for progressive social movements, and these succeed to the extent that they continue to challenge not just regional but national containment of struggle – to the extent that their project is a global and not just a nationalist anti-imperialism.

Nation

If it represents a division of the world market, the national scale is none the less primarily a political construct, the site of state power. It was not always so. State power in earlier social formations was often vested at the urban scale (as in the city states of Athens or of West Africa) or at the regional scale with an array of duchies, fiefdoms, sheikhdoms and sultanates. By contrast, the nation state evolved as the dominant scale of state power with the emergence of capitalism, and it differs from past formations of the state in that citizenship is defined exclusively on the basis of a territorial rather than a kinship definition of the nation, as evidenced by the comparatively recent invention of passports and erection of fences, walls and custom posts. The more extensive scale of the nation state compared with its predecessors results largely from the increased scale of economic activity and accumulation attendant on an emergent capitalism, but the actual boundaries separating nation states are more usually the product of war, military conquest, political disputes and treaties.

If a territorial definition of the 'body politic' supersedes a genetic one, the localism inherent in the latter is not thereby vanquished. Ethnic, racial, religious or regional differences can divide the nation state internally, and citizenship confers foreign status as surely and as emotionally as it confers national identity. Nationalism is perhaps the most imporous of spatially based *ideologies* – in contrast to the increasing economic porosity of national *boundaries* – and challenges to state power only rarely question the basis of state power *per se* or the legitimacy of the national scale of social organization. The majority of challenges seek not to abolish the power of the nation state but to replace the leadership. But there are exceptions, and the nation state is today a peculiarly vulnerable scale of social organization. First, to the extent that capital organizes itself through the world market, global corporations may retain significant economic power over nation states. The working class too can outflank national ruling classes by organizing internationally, but despite the long-established ambition that 'Workers of the World Unite', the international working class is nowhere as organized as its adversary. Nationalism has largely contained class-based assaults on state power, from the shambles of the Second International in 1914 to the diversion of postcolonial struggles throughout Latin America, Africa and Asia into the reconstruction of separate national bourgeoisies. The same fate befell Poland's Solidarnosc.

State power is held not only by a minority ruling class, but generally by

men, and possibly too by a distinct racial, ethnic or religious group. To the extent that these social interests are systematically incorporated in the legal and ideological fabric of the state, exploitation and oppression on the basis of class, race, gender and other social differences are institutionalized in national structures of enfranchisement and property law. As such, the state also polices the borders of lower spatial scales, especially the body, home and community, and challenges to state power emanate from these and other sources of oppression even if they are rarely so neatly defined. It was the patriarchal state that Virginia Woolf sought to vault over when she declared: 'As a woman, I have no country. As a woman I want no country. As a woman, my country is the whole world.'[50]

Global

It might seem that the borders of the global scale are self-evidently given by the natural borders of the planet but, as with other scales, the global scale *per se* is socially produced. The world of the Roman Empire, to take an obvious example, covered only a small percentage of the planet's surface, while conversely, the realities of space travel strongly suggest the imminent expansion of the 'global' scale. Indeed, hundreds of billions of dollars devoted to space travel have already had a significant effect on the world economy over the last four decades. With the capitalist mode of production, the global scale is primarily a construct of the circulation of capital.

The conquest of the global scale is difficult to discuss except historically. Sub-planetary global worlds – whether highly localized (as with the various peoples of Amazonia, Central Africa or Borneo who were periodically 'discovered' by nineteenth-century European explorers) or the larger empires such as Ming Dynasty China – were constructed by various mixes of political, cultural, economic and ideological power. The economic construction of a unified global scale came only with the globalization of the world market in the early twentieth century. Since then, the global scale has been less demarcated by the political colonization of 'new' territories, previously outside the world market, by nationally based European capitals; rather, it is the internal dynamics of economically uneven development, structured according to the specific social and economic relations of capitalist society, that patterns the global scale. Accordingly, the global is divided not only according to the political divisions of the nation state, but according to the differential levels of development and underdevelopment experienced and achieved by these states in the world market.

The conquest of the global scale may seem like an impossible idea or set of events to grasp, but it is very real. In class terms, the capitalist class came to rule through a series of more or less recognizable national revolutions

between the seventeenth and twentieth centuries; some were violent political overthrows of previous ruling classes, others were quieter revolutions resulting from an accretion of power in the market. The important point is that they did not remain isolated in separate states but that through political as well as economic means the rising bourgeoisie actively coalesced different islands of national power into global hegemony. Integrally involved were not only projects of class domination but also those of oppression, especially but not exclusively on the basis of race and gender. These intertwined histories of conquest – enslavement, robbery, denial of property ownership, disenfranchisement – sought to contain incipient social struggles at a lower geographical scale, as struggles over the body or over nationalism for example, while asserting the global claims of capitalism.

The opposition to contemporary global power emerges out of a number of nationally as well as internationally based struggles: anti-imperialist and anti-war movements obviously, and post-colonial struggles, but also environmental and feminist movements that may have local inspiration but global potential. The ability of revolutionary socialism, rooted in a class analysis of capitalist society, to extract a whole nation state from global capitalism provoked an extraordinary global defence involving an economic embargo, placing sixteen national armies on Soviet soil in 1919, and leading eventually to the Cold War. Despite its avowed internationalism, however, and with the failed revolutions of 1919, the Soviet leadership did not manage to 'jump scales'. They were not only contained as a hostile island in the world economy by the capitalist embargo but, under Stalin, they succumbed to the disastrous belief in 'socialism in one country'. Socialism in the Soviet Union was stifled well before the events of 1989.

If the political connectedness of the bourgeois revolutions and their class, gender and racial agendas are today erased in the jingoistic celebration of separate national Independence Days and revolutionary wars, this ideological erasure comprises part of a perpetual policing of the global scale. In so far as the ruling class attempts to reproduce its own vision of the world, it also seeks to establish a definition of global alongside national citizenship. The erasure of difference implied in 'the universal subject' is one insinuation of such global citizenship, but it also takes more popular forms. 'The global' is very actively constructed. 'We do business in only one place', reads a Salomon Brothers ad for their financial services, beneath a dreamy spaceshot of spaceship earth.

The critique of the universal subject has itself become near universal, but the more difficult question is how a political subject or coalition of subjects can be reconstructed without on the one hand replicating the assumption of a white, male, ruling-class subject, and on the other reverting to a radical individualism. This familiar epistemological dilemma seems to require a negotiation of privilege based on different subject positionalities, and is

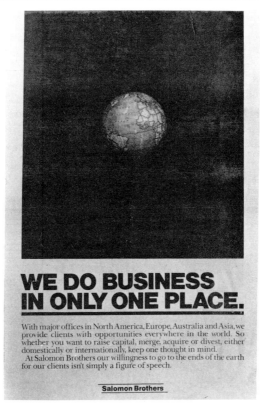

Figure 6.2 Salomon Brothers advertisement.

usually thereby seen as a quintessentially local project, but the reconstruction of the political subject(s) is at the same time intensely global. 'The personal', Cynthia Enloe reminds us, 'is international', and this can be denied only by bracketing off scales in a self-defeating way. To avert any dangers of academic idealism, the discussion about a reconstructed political subject(s) also needs to take place with greater attention to the *objects* of political conquest, and it is for that reason that I introduce it here in a discussion of the global scale. It was only eighteen years but a very long way from Jim Morrison's 1967 threat – 'We want the world and we want it *now*' – to the thoroughly idealistic Band Aid lament of the 1980s: 'We are the world'. 'We' are not the world, but there are many who still want it, and we will only find the internally differentiated identity of 'we' in so far as we also continue to want the world.[51]

CONCLUSION

Marx detected in capitalism a tendency towards what he called 'the annihilation of space by time'.[52] We can see this at all scales – from the global, where advances in communications and transport technology quite literally make for a smaller world, to the scale of the body, where the space of the body is erased in favour of temporal freedom, much as Beauvoir detected and indeed mirrored. A spatialized politics recovers space from this annihilation, much as Lefebvre's notion of the production of space seeks to recover social space from the abstractions constructed by the capitalist state or through the market. This suggests the double-edged nature of scale. By setting boundaries, scale can be constructed as a means of constraint and exclusion, a means of imposing identity, but a politics of scale can also become a weapon of expansion and inclusion, a means of enlarging identities. Scale offers guideposts in the recovery of space from annihilation.

In June 1991, Tompkins Square Park became the site of a swift, direct and officious annihilation of space. The preceding year had been comparatively quiet, but with homeless people filtering back to the park and as many as seventy shanties rebuilt since the second raid, the pro-gentrification lobby in the neighbourhood had become increasingly vocal. Many other residents who sympathized with the needs of evictees in the park none the less became increasingly frustrated with the lack of provision of services for the growing homeless population. On 28 May 1991, a memorial day concert celebrated 'Housing is a Human Right', and the park again became the venue for clashes between police and park users. In the aftermath, the local pro-gentrification lobby was bolstered by the *New York Times*, which has traditionally maintained close ties to real estate developers. In a now-familiar script, the newspaper blamed the riot on 'anarchists', and 'political extremists', and galvanized citywide support for closing the park. In a polemic that began by quoting *Webster's Dictionary* on the definition of a park, a *New York Times* editorial noted that 'A park is not a shantytown . . . unless it is Tompkins Square Park in Manhattan's East Village'. The park had come to 'symbolize governmental failure', it continued, ignoring any failures of the real estate market to provide affordable housing, and demanded that the city 'reclaim Tompkins Square Park' from the homeless people 'who have stolen it from the public'. Noting that many in the park were not 'legitimately homeless people' and that 'misplaced sympathy abounds', it demanded 'a clean sweep' and that the city then 'secure it with regular patrols'.[53]

The Dinkins administration closed Tompkins Square Park at 5am on 3 June 1991, evicting more than 200 park dwellers. Echoing the allegation that the park had been stolen from 'the community' by park evictees, Mayor Dinkins declared that 'The park is a park. It is not a place to live.'[54]

Militarization of the park was completed with the immediate construction of an 8-foot chainlink fence and, amidst a serious budget crisis, the delegation of over a hundred uniformed and plainclothes police officers together with a communications truck devoted to 'securing' the park. In the following days, the park was ripped up by earthmovers as a putative $2.3m reconstruction began. Actually, three park entrances were kept open and guarded by police: one, opposite the gentrified Christadora condominium on Avenue B, provided access to a dog run; the others accessed a children's playground and basketball courts.

Closure of the park marked 'the death knell' of an occupation that 'had come to symbolize the failure of the city to cope with its homeless population', concluded Sarah Ferguson of the *Village Voice*,[55] but it hardly ended the struggle for housing or indeed for control of land and buildings in the Lower East Side. No alternative housing was offered evictees except for the city's notoriously dangerous shelter system, and although some evictees again moved into local squats or filtered out into the city, the largest group moved a block and a half east to a new shanty-town on a vacant lot which, three weeks after the clean sweep, already included more than twenty structures and housed about 100 people. The park closure and reconstruction were challenged in court on the grounds that no plan actually existed and the requisite local consultation and impact studies had not been carried out. And continual demonstrations attracted small groups and large groups of protestors, including many Lower East Side residents who, while frustrated at the homeless encampment in the park, were far more angry that it was now closed. While the *New York Times*, presumably unwittingly, evoked Vietnam imagery as it celebrated 'barricading a public park to save it',[56] hundreds of neighbourhood residents, homeless people and protestors endured police harassment and linked hands around the park in a quietly defiant promise that the park would be reopened to the public. When the park did reopen fourteen months later, physically reconstructed, it was the immediate object of renewed protests to 'take back the park'.

NOTES

1 A somewhat different version of this paper appears in *Social Text* 33 (forthcoming). On the Homeless Vehicle, see David V. Lurie and Krzysztof Wodiczko, 'Homeless Vehicle Project', *October*, 1988, no. 47, pp. 53–67; Daniel, Krzysztof, Oscar and Victor, 'Conversations about a project for a Homeless Vehicle', *October*, 1988, no. 47, pp. 68–76; and the catalogue for Wodiczko's exhibit at Exit Art: *New York City Tableaux: Tompkins Square. The Homeless Vehicle Project*, New York, Exit Art, 1990.

2 The lower estimate of homelessness is from Peter Marcuse, 'Isolating homelessness from housing', in Carol Caton (ed.) *The Homeless in America*, New York, Oxford University Press, 1989. The higher figure was publicized by the Coalition for the Homeless in 1987, although they later revised this downward to 70,000. In

1986, the City of New York would admit at most only half of this figure, and as the number of homeless people clearly grew in the late 1980s, they simply stopped reporting any figures at all. The language of 'the evicted' is from Rosalyn Deutsche, who argues that it better elucidates 'the specific historical, rather than mythical reasons for the presence of today's homeless'. See Rosalyn Deutsche 'Uneven development: public art in New York City', *October*, 1988, no. 47, p. 8.

3 Krzysztof Wodiczko and David Lurie, 'The Homeless Vehicle', *New York City Tableaux: Tompkins Square. The Homeless Vehicle Project*, New York, Exit Art, p. 22.

4 Papo Colo, 'Living rights are human rights', *New York City Tableaux: Tompkins Square. The Homeless Vehicle Project*, New York, Exit Art, p. 2.

5 Deutsche, op. cit. pp. 47–52.

6 For an early discussion of the urban geography of homeless people, predating the burgeoning homelessness of the 1980s, see James Duncan, 'Men without property: the tramp's classification and use of urban space', *Antipode*, 1978, vol. 10, no. 1, pp. 24–34. More recently, see Susan Ruddick 'Heterotopias of the homeless: strategies and tactics of placemaking in Los Angeles', *Strategies*, 1990, no. 3, pp. 184–201.

7 Colo, op. cit., p. 2; Deutsche, op. cit., p. 50.

8 On gentrification in the Lower East Side, see Neil Smith, Betsy Duncan and Laura Reid, 'From disinvestment to reinvestment: tax arrears and turning points in the East Village', *Housing Studies*, 1989, vol. 4, pp. 238–52. For a broader theoretical discussion of gentrification, see Neil Smith, 'Towards a theory of gentrification: a back to the city movement by capital not people', *Journal of the American Planners Association*, 1979, vol. 45, pp. 535–45.

9 For a synoptic history of Tompkins Square Park, see Neil Smith, 'Tompkins Square Park Time Line', *New York City Tableaux: Tompkins Square. The Homeless Vehicle Project*, New York, Exit Art, 1990, pp. 14–20. On the first Tompkins Square riot, see Herbert G. Gutman, 'The Tompkins Square "Riot" in New York City on January 13, 1874: a re-examination of its causes and its aftermath', *Labour History*, 1965, vol. 6, pp. 44–70.

10 For direct reporting of the riot from which this account is drawn, see C. Carr, 'Night clubbing. Reports from the Tompkins Square Riot', *Village Voice*, 16 August 1988, p. 10; Sarah Ferguson, 'Boombox wars', *Village Voice*, 16 August 1988; Leslie Gervitz, 'Slam dancer at NYPD', *Village Voice*, 6 September 1988, p. 12; Michael Wines, 'Class struggle erupts on Avenue B', *New York Times*, 10 August 1988, p. B1; *The New Common Good*, September 1988. For a broader discussion, see Neil Smith, 'Tompkins Square: riots, rents and redskins', *Portable Lower East Side*, 1989, vol. 6, pp. 1–36.

11 Quoted in Gutman, op. cit., pp. 48, 50, 60.

12 *New York Times*, 13 October 1990; 3 November 1990; 1 December 1990. See also Girvitz, op. cit.

13 On the political geography of parks as recuperative social constructions of nature and their ideological construction *vis-à-vis* the reproduction of social relations, see Cindi Katz and Andrew Kirby, 'In the nature of things: the environment and everyday life', *Transactions of the Institute of British Geographers*, New Series, 1991, vol. 16, pp. 259–71.

14 Jerome Charyn, *War Cries Over Avenue C*, New York, Donald I. Fine, Inc., 1985, p. 7.

15 James C. McKinley Jr, 'Mêlée site quiet, but police stand guard', *New York Times*, 6 May 1989; Sarah Ferguson, 'Squatters' victory? Protestors piss off demolition crew – for now', *Village Voice*, 9 May 1989.

16 Quoted in Sarah Ferguson, 'Beyond Tompkins Square Park. Inside the squatters movement: occupied territories', *Village Voice*, 18 July 1989.
17 James C. McKinley Jr, 'City moves to clean up Tompkins Sq. after raid', *New York Times*, 7 July 1989.
18 Aaron Emke, letter to *New York Times*, 16 August 1989.
19 From geography, see especially the work of David Harvey: *Social Justice and the City*, London, Edward Arnold, 1973; *Limits to Capital*, Oxford, Basil Blackwell, 1982; *The Urbanization of Capital*, Baltimore, MD, Johns Hopkins University Press, 1985; and, most recently, *The Condition of Postmodernity. An Enquiry into the Origins of Cultural Change*, Oxford, Basil Blackwell, 1989. See also Derek Gregory, *Ideology, Science and Human Geography*, London, Hutchinson, 1978; Michael Watts, *Silent Violence*, Berkeley, University of California Press, 1983; Doreen Massey, *Spatial Divisions of Labour: Social Structures and the Geography of Production*, Basingstoke, Macmillan, 1984; Neil Smith, *Uneven Development: Nature, Capital and the Production of Space*, Oxford, Basil Blackwell, 1984; Edward Soja, *Postmodern Geographies: The Reassertion of Space in Critical Social Theory*, London, Verso, 1989; Richard Peet and Nigel Thrift (eds), *New Models in Geography. The Political Economy Perspective*, London, Unwin Hyman, 1989. From the side of social theory, the 'discovery' of space (and spatial concepts) has been advanced by Louis Althusser and Etienne Balibar, *Reading Capital*, New York, Monthly Review Press, 1977; Anthony Giddens, *A Contemporary Critique of Historical Materialism*, Basingstoke, Macmillan; Michel Foucault, 'Questions on Geography', in *Power/Knowledge: Selected Interviews and Other Writings 1972–1977*, ed. C. Gordon, New York, Pantheon, pp. 63–77; Marshall Berman, *All That is Solid Melts into Air*, New York, Simon & Schuster, 1982; Elspeth Probyn, 'Travels in the local: making sense of the local', in Linda J. Nicholson (ed.), *Feminism/Postmodernism*, New York, Routledge, 1990, pp. 176–89. For a more historical approach, see E. D. Genovese and L. Hochberg (eds), *Geographic Perspectives in History*, Oxford, Basil Blackwell, 1988. From literary criticism see Fredric Jameson, 'Postmodernism, or the cultural logic of capitalism', *New Left Review*, 1984, no. 146, pp. 71, 89; Edward Said, *Orientalism*, New York, Pantheon, 1978; Said, 'Narrative, geography and interpretation', *New Left Review*, 1990, no. 180, pp. 81–97; Kristin Ross, *The Emergence of Social Space: Rimbaud and the Paris Commune*, Minneapolis, University of Minnesota Press, 1988. Of course, these categories of geography, social theory and literary criticism are not discrete and involve considerable and growing overlap. This is nowhere better exemplified than in the pioneering work of Henri Lefebvre, 'Reflections on the politics of space', *Antipode*, 1976, vol. 8, pp. 30–7; *La Révolution Urbaine*, Paris, Maspero, 1970; *The Production of Space*, Oxford, Basil Blackwell, 1991.
20 Jameson, 'Postmodernism', pp. 71, 89.
21 But consider the debate over the legal and territorial constitution of the United States, where the different geographical scales of political organization were keenly contested as very different models of political power. See Alexander Hamilton, James Madison, John Jay, *The Federalist Papers*, New York, Bantam Books, 1982 edn.
22 See Neil Smith, 'Geography as museum: private history and conservative idealism in "The Nature of Geography" ', in J. Nicholas Entrikin and Stanley D. Brunn (eds) *Reflections on Richard Hartshorne's 'The Nature of Geography'*, Washington DC, occasional publication of the Association of American Geographers, pp. 91–120; Peter Gould, 'Reflections require a mirror', *Annals of the Association of American Geographers*, 1991, vol. 81, pp. 328–34.

23 Foucault, 'Questions on Geography', p. 68.
24 ibid., pp. 69–70.
25 For an earlier exploration of material and metaphorical space on which the present discussion builds, see 'Afterword: the beginning of geography', in Neil Smith, *Uneven Development* Oxford, Basil Blackwell, 2nd edition 1990, pp. 160–78.
26 See Dick Hebdige, 'Training some thoughts on the future', Chapter 19 in this volume.
27 Foucault, 'Questions on Geography', p. 70.
28 N. Smith, *Uneven Development*, pp. 135–47. For a more empirical analysis of the production of scale, see N. Smith and W. Dennis, 'The restructuring of geographical scale: coalescence and fragmentation of the northern core region', *Economic Geography*, 1987, vol. 63, pp. 160–82. The debate on scale has emerged mostly in the journal *Antipode* as part of the larger debate on localities and locality studies. See N. Smith, 'Dangers of the empirical turn: some comments on the CURS initiative', *Antipode*, 1987, vol. 19, pp. 59–68; K. Cox and A. Mair, 'Levels of abstraction in locality studies', *Antipode*, 1989, vol. 21, pp. 121–32; S. Duncan and M. Savage, 'Space, scale and locality', *Antipode*, 1989, vol. 21, pp. 179–206.
29 Andrew Herod, 'The production of scale in United States labour relations', *Area*, 1991, vol. 23, pp. 82–8.
30 Iris Marion Young, *Justice and the Politics of Difference*, Princeton, NJ, Princeton University Press, 1990, p. 136.
31 Judith Butler, 'Variations on sex and gender: Beauvoir, Wittig and Foucault', in Seyla Benhabib and Drucilla Cornell (eds) *Feminism as Critique. On the Politics of Gender*, Minneapolis, University of Minnesota Press, 1986, p. 129.
32 Simone de Beauvoir, *The Second Sex*, New York, Modern Library, 1952. There is of course considerable debate over Beauvoir's formulation, and this is not the place to elaborate. But see especially Monique Wittig's denial of any pre-social sexual difference underpinning the social construction of gender: *The Lesbian Body*, New York, Avon Press, 1975. Butler's criticism, that 'Beauvoir's dialectic of self and Other argues the limits of a Cartesian version of disembodied freedom' seems especially apt ('Variations on sex and gender', p. 133). Indeed, Beauvoir's dualism seems to resign women to entrapment in the body *vis-à-vis* the freedom of men in time.
33 Young, op. cit. pp. 122–55.
34 Boston Women's Health Collective, *Our Bodies Ourselves*, New York, Simon & Schuster, 1973.
35 Sallie A. Marston, 'Transforming the boundaries: power and resistance among turn of the century American women', paper presented at the Annual Conference of the Institute of British Geographers, Sheffield, 2–5 January 1991.
36 Douglas Crimp, *October*, 1987, no. 43, pp. 237–71.
37 Witold Rybczynski, *Home, A Short History of an Idea*, New York, Viking, 1986, p. 72.
38 Anthony Giddens's discovery of social space and time–space distanciation pivots upon a generalization of these most elementary divisions within the home. For no apparent reason, the home becomes the basis for a metaphorical 'regionalization' that elides all differences of spatial scale. See *The Constitution of Society*, Berkeley, University of California Press, 1984, pp. 110–44.
39 Cindi Katz, 'Growing girls, closing circles', in C. Katz and J. Monk (eds) *Full Circles. Geographies of Women Over the Life Course*, London, Routledge, forthcoming.

40 Jackie Leavitt and Susan Saegert, *From Abandonment to Hope*, New York, Columbia University Press, 1989.
41 Herbert Gans, *The Urban Villagers*, New York, Free Press of Glencoe, 1962. I present these contrasting relations of community and neighbourhood in an overly binary form. This is brought about by the abbreviated and highly schematic nature of this discussion and is not at all intended as an assertion of dual 'ideal types'.
42 David Harvey, *The Condition of Postmodernity*, Oxford, Basil Blackwell, 1989, p. 236.
43 Manuel Castells, *The Urban Question*, London, Edward Arnold, 1977, pp. 439–52.
44 David Harvey and Lata Chaterjee, 'Absolute rent and the structuring of space by financial institutions', *Antipode*, 1974, vol. 6.1, pp. 22–36; Ann Markusen, 'City spatial structure, women's household work, and national urban policy', *Signs*, 1980, vol. 5, pp. 23–44; Linda McDowell, 'Towards an understanding of the gender division of urban space', *Environment and Planning D*, 1983, vol. 1, pp. 59–72; Liz Bondi, 'Gender divisions and gentrification: a critique', *Transactions of the Institute of British Geographers*, New Series, 1991, vol. 16, pp. 190–8.
45 Allen, J. Scott, *New Industrial Spaces*, London, Pion, 1988.
46 Neil Smith and Ward Dennis, 'The restructuring of geographical scale: coalescence and fragmentation of the northern core region', *Economic Geography*, 1987, vol. 63, pp. 160–82.
47 Karl Marx and Frederick Engels, *The German Ideology*, New York, International Publishers, 1970, p. 42.
48 Smith and Dennis, op. cit.; Scott, op. cit.
49 Herod, op. cit.
50 Virginia Woolf, *Three Guineas*, London, Hogarth Press, 1952 edn.
51 Cynthia Enloe, *Bananas, Beaches and Bases. Making Feminist Sense of International Politics*, Berkeley, University of California Press, 1990, p. 195. See also Young, *Justice and the Politics of Difference*, for what I take to be a similar vision, and Donna Haraway, 'Situated knowledges: the science question in feminism and the privilege of partial perspective', in Haraway, *Simians, Cyborgs and Women: The Reinvention of Nature*, New York, Routledge, 1991, pp. 183–201.
52 Karl Marx, *Grundrisse*, Harmondsworth, Penguin, 1973, pp. 524, 539.
53 Alessandra Stanley, 'Tompkins Sq. Park, where politics again turns violent', *New York Times*, 30 May 1991; 'Make Tompkins Square a park again', *New York Times*, 31 May 1991.
54 John Kifner, 'New York closes park to homeless', *New York Times*, 4 June 1991.
55 Sarah Ferguson, 'Should Tompkins Square be like Gramercy?', *Village Voice*, 11 June 1991.
56 'Retaking Tompkins Square', *New York Times*, 5 June 1991.

Chapter 7

Dystopia on the Thames[1]

Jon Bird

The tidal current runs to and fro in its unceasing service, crowded with memories of men and ships it had borne to the rest of home or to the battles of the sea. It had known and served all the men of whom the nation is proud, from Sir Francis Drake to Sir John Franklin, knights all, titled and untitled – the great knight-errants of the sea. It had borne all the ships whose names are like jewels flashing in the night of time, from the Golden Hind returning with her round flanks full of treasure, to be visited by the Queen's Highness and thus pass out of the gigantic tale, to the Erobas and Terror, bound on other conquests – and that never returned. It had known the ships and the men. They had sailed from Deptford, from Greenwich, from Erith – the adventurers and the settlers; king's ships and the ships of men on 'charge'; captains, admirals, the dark 'interlopers' of the Eastern trade, and the commissioned 'generals' of East India fleets. Hunters for gold or pursuers of fame, they all had gone out on that stream, bearing the sword, and often the torch, messengers of the might within the land, bearers of a spark from the sacred fire. What greatness had not floated on the ebb of that river into the mystery of an unknown earth! . . . The dreams of men, the need of commonwealths, the germs of empires.

(Joseph Conrad, *Heart of Darkness*, 1902)

THE HERITAGE: London's bustling docks and busy river were the very evidence of the nation's development as the Empire grew and flourished; jewels in Britain's commercial crown. Products of engineering and industrial genius despatched around the world; exotic cargoes and evocative aromas from far-flung corners in return. But eventually new trading patterns emerged and modern cargo-handling techniques moved the tide of shipping away from those docks. Already, as the docks declined in commercial importance, so the neighbouring City of London was increasing in stature and importance – as *the* international centre for financial services. Strategically placed between the New and Old Worlds, spanning the globe, creating new opportunities, linking all

kinds of trade. New technology, new communications, new demands and new services reaffirmed the importance of London, with the greatest concentration of markets in Europe – and the innovative skills and experience that go with them.

(London Docklands Development Corporation, 1989)

City life in Britain has never conveyed the alluring resonances of the great centres of European modernism – Paris, Barcelona, Madrid, Milan, Hamburg, or the glittering but brittle spectacles of American urbanization. Neither the Left nor the Right has really laid claim to the city as a site for the construction of subjectivity and political identity other than as the backdrop for the enactment of ritual and tradition: the ceremonial commemoration of privilege, national identity, or loss. During the 1970s and early 1980s, various social and democratic movements, notably the Labour-controlled Metropolitan Councils, challenged the dominant meanings of city spaces and activities, only to be abolished by Conservative government legislation replacing the social infrastructure with privatized services and facilities. This process did not go unchallenged and the 1980s were marked by eruptions of the inner cities in anarchic refusal of the patterns of unemployment, repressive policing, and authoritarian government. Starting with violent clashes between police and rioters in Brixton in south-east London in 1981, this rapidly spread to depressed areas throughout the country, frequently as a result of years of racial harassment and social and economic neglect. Many of the tactics learnt by the police in combating urban unrest during this period were later successfully deployed against a fantasized 'enemy within' – the miners in their year-long strike of 1984/85, and against the print workers in the Wapping struggles as Murdoch shifted his production to East London.

These moments of civic upheaval have occurred against a continuing nostalgia for a mythical past of tranquillity and order running deep within the political and social fabric of Britain as a nation state, and manifested in the proliferating cultures of 'heritage' and 'enterprise' that so clearly characterized the last decade.

In London, the most public and visual expression of 1980s aggressive monetarism has been the changing skyline of East London's riverside redevelopment from the Tower of London to the Thames Barrier, spear-headed by the Toronto conglomerate Olympia & York's Canary Wharf scheme on the Isle of Dogs. This represents the single largest building project ever undertaken – a $7bn investment into 12 million square feet of office space, apartments, restaurants, shopping malls and riverside facilities, which includes the country's (and until recently, Europe's) highest single building at over 800 feet, designed by Cesar Peli, and on a scale totally disproportionate to the scale of the City, casting a permanent shadow over the immediate vicinity.

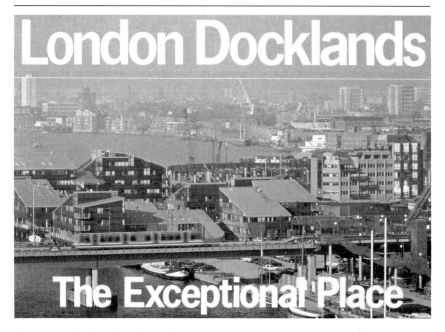

Figure 7.1 London Docklands Development.

Docklands has been made possible by the Thatcher government's estab-
lishment in 1981 of Urban Development Corporations (UDCs) – consortia
of business and property interests run by boards directly appointed by the
Secretary of State and able to grant planning permission free from local
authority investigation or sanction. Under the ideology of 'regeneration of
the inner cities', the UDCs can create companies, subsidize existing busi-
nesses, and develop or dispose of land and buildings. Although UDCs have
also been established in several areas of the north-east, it is the high-profile
London Docklands Development Corporation (LDDC) that has become
the testing ground for free-market intervention into what had previously
been the concerns and responsibilities of democratically elected local
councils and boroughs – in Docklands the three boroughs of Tower
Hamlets, Newham and Southwark. The almost unlimited powers of the
LDDC included the appropriation of publicly owned land, approximately
5,000 acres and 55 miles of waterfront property which could then be sold
off to private developers. Land prices leapt from £70,000 per acre in 1981
to £4m by 1987. Add to this the presence of the river, and the context is
created for a battle over representations in which the complex historical
and mythological connotations of the Thames and the City are played out
in the conflict between dominant and subordinate cultures and economies.
 If, in the modern period, the City signified the visual and tactile presence
of modernity, a liberatory image of anonymity and freedom, in the post-

modern period this has become a battleground of oppositions between the public and the private. The urban wasteland has been repositioned within the circuits of international finance capital and recoded as a site of consumption and the pursuit of leisure. Spatially, Docklands represents the principle of uneven development that is the hallmark of the geography of capitalism. The ideology of 'regeneration' (represented as a natural process of decay, death and rebirth) masks the economic and social relations that characteristically determine a history of neighbourhood decline and abandonment, followed by rediscovery and gentrification – a trajectory frequently initiated by the social migration of transitory groups of squatters, students and artists seeking affordable, temporary accommodation. This process can be traced across the maps of the modern and postmodern metropolises as localities and communities are included or excluded from the centres of wealth, decision-making and power.

The rationale behind Docklands as a redefined space has been the intended relocation of a proportion of the City's finance centre away from the overcrowded Square Mile to East London, with the inducement of rent reductions for office space from £70 to £20 per square foot. (Events are constantly overtaking my analysis. The recession has now more or less removed the disparity between the rents in Docklands and the Square Mile, where they have dropped by 30 per cent over the last year.) Besides the economic arguments, however, the developers have sought to construct a symbolic opposition between a myth of the waterfront – the Thames as the once-great artery of the capital, but allowed to silt up and become a sinister space of Dickensian dereliction and impoverishment – and a sparkling, utopian vision of a 'Metropolitan water city of the twenty-first century'. In this scenario, a history of government neglect is turned into a pathology of despair, a narrative of outmoded industries and regressive labour relations, parasitical local authorities and fragmented communities, a spectre of the inner city as a virus within the social body. This 'official' labour history of Docklands constructs a recalcitrant and militant workforce resistant to the inevitable dynamic of modernization, specifically the containerization of cargoes. Mechanization removed the requirement for a large dockside workforce available up-river in East London and shifted the transfer of cargo to the purpose-built container port of Tilbury at the mouth of the Thames. Some containerization took place in the Royal Docks but was discontinued in 1981 because of the greater profits available from the sale of the land. The shipping lines were able to avoid having to employ a strongly unionized workforce drawn from London's docklands in favour of the individualistic and collaborative support of the transport companies. The fabricated and selective history of the docks represents a systematic refusal of class history and struggle; of multicultural communities and democratic organization around demands over housing, education, and the preservation of traditional and local skills and industrial

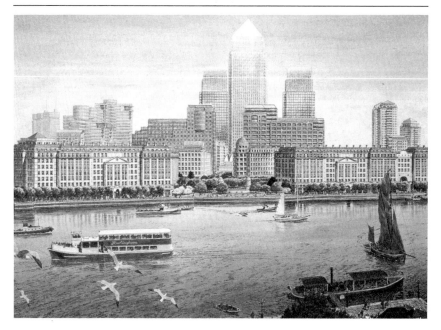

Figure 7.2 A utopian vision of a 'Metropolitan water city'.

experience. (Although, of course, it is important not simply to substitute one myth for another – there is also a history of anti-semitism, racism, sexual harassment – and their respective points of resistance.)

To take a ride through Docklands on the Light Railway is to experience the global postmodern as a building site. Here consortia and multinationals swallow up the generous offers of land that are made available in an enterprise zone and spew out varieties of architectural postmodernism and high-tech in paroxysms of construction that are as incoherent as they are unregulated. To cite just one example of the advantages available to potential developers: any proposals that fall within the zone benefit from a greatly simplified planning process, no rates payable until 1992, and the offsetting of building costs against income tax or corporation tax by 100 per cent for projects under construction by April 1992.

Olympia & York stepped in to rescue the financially ailing LDDC after the original American consortium (Crédit Suisse, First Boston, Morgan Stanley, and the Travelstead Group) had backed out of the Isle of Dogs schemes in 1987. Besides the monumental Canary Wharf development, Olympia & York are building 1,000 privately owned riverside apartments and a hotel across the water at Heron Quay; they own a third of the property group which has erected a vast shopping mall in the Royal Docks, and have bought into the Port East retail development at West India Dock. The magnanimity of their entrepreneurial activities (generally trumpeted

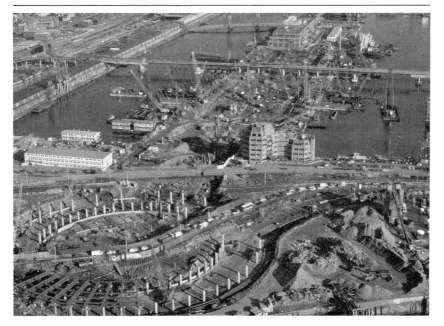

Figure 7.3 Aerial view of London Docklands Development.

as providing jobs, homes, etc.) is tempered by the conditions they made for their involvement. These included the initial land purchase at a fraction of the (then) market value, £500m from the government in capital allowances, and a further contribution of £550m to upgrade the transport facilities upon which Canary Wharf's financial viability depends. Much of this development centres around the 'politics of the view' – a battle over representations. This is not simply the desirability of the waterside, but the juxtaposition of private affluence with public deprivation – of luxury apartments facing high-rise council housing blocks. Recently the LDDC has provided the finance to screen off all the contradictory signifiers of uneven development through planting rows of trees, rebuilding picturesque dock walls, or renovating the facades of council estates which overlook expensive residential apartments.

Already the unoccupied low-rise development at Heron Quay is being demolished as the initial projections are redrawn and plans are revised upwards to accommodate an anticipated daily influx of 150,000 people by 1993, far in excess of the capacities of even the most ambitious transport scheme, a process described by the LDDC as 'second-wave regeneration'. The present deep recession and high interest rates have slowed development and forced a number of property companies out of business. Despite this, the proposed major extension to the Light Railway and the construction of the Docklands Highway are going ahead. The Highway will be a six-lane

motorway scything through the East End from the City, a plan agreed secretly between the LDDC and the Department of Transport, the first major road project since the war to be approved without any form of public inquiry. However, the building of the highway has become symptomatic of the general economic problems threatening the rate, if not the scale, of development, and symptomatic too of the crisis within the LDDC. The 1.1-mile Limehouse Link, now costed at over £300m, is set to become the most expensive stretch of road in the world. As the LDDC has been forced by the Treasury to cut costs, the schemes to be jettisoned are, predictably, those social projects that represented concessions to the needs and demands of the resident Docklands communities.

The publicity material produced by the LDDC and Olympia & York presents an image of harmony and coherence, a unity of places and functions not brutally differentiated into the respective spheres of work, home and leisure, but woven together by the meandering course of the river into a spectacular architectural myth of liberal *civitas*. Canary Wharf is indeed a fantasy of community: a city within the City populated by a migrant army of executive, managerial and office staff serving the productive signifiers of postmodernity – microelectronics, telecommunications and international capital – along with the relevant support structures and lifestyle accoutrements, from food to culture, an airport to shopping malls. These panoramic representations of the City characteristically adopt an elevated perspective that distances the viewer and creates an image of totality. We look from a distance across, or down upon, the river and adjacent buildings, each scene suffused with a gentle light which plays upon the towers and the water. Nothing is unharmonious or out of place – these are viewpoints that allow us to possess the City in imagination. Similarly, the estate agents' advertisements stress the desirability of a riverside lifestyle: windsurfing, cocktails in St Katherine's Yacht Club, a plethora of marinas, the proximity of other European capitals via the new Docklands airport, the jetfoil to the City or the West End, electronic surveillance and round-the-clock security systems – a familiar description of urban living cushioned by the privileges of wealth and power. As Michel de Certeau has argued, this voyeuristic gaze is in contrast to the everyday practices of inhabiting the street: the tactics of lived space. The voyeuristic gaze implies mastery and objectification, a distancing relationship of knowledge and power that is founded upon repression and desire. The politics of these postmodern utopias is to legitimize the actual processes of redevelopment and gentrification over and above the everyday needs and experiences of the people inhabiting Europe's largest building site. Indeed, the experience of visiting Docklands is one of exclusion and alienation. The monumental scale overpowers the street; corporate architecture dominates and privatizes every vista; the mirror-glass façades disorientate the relations of people, place and space whilst the physical combinations of height and

mass creates climatic conditions that, on anything other than the brightest and calmest of days, threaten to sweep the unwary into the river. There is also the question of the spatial mobilities and experiences that are constructed by these forms of urban geography; the directives and constraints upon movement, access and enclosure which serve to remind that the spaces of the city, modern or postmodern, are gendered spaces reinforcing relations of power and subjectivity.

Against these powerful myths and realities of power, the Docklands Consultative Committee – comprising the democratically elected representatives of the various Dockland boroughs, neighbourhoods and community groups – produced in 1988 their own report and assessment of the claims and progress of government and developers. Not surprisingly, they found that the real beneficiaries were service-sector industries and employees, with only a minimal proportion of jobs being made available to local residents, mostly on government training schemes and temporary and part-time servicing contracts: cleaners, caterers, chauffeurs, domestic labour, etc. Similarly, the commitment to provide rented accommodation and affordable housing had fallen short of all the original estimates: in fact, to date, over 90 per cent of all residential property has been sold on the open market. With excessive land values, even after the slump, and the redirection of government funding from the public to the private sector, the local authorities are unable to construct alternative, cheap accommodation, or create employment opportunities: a cycle of high unemployment and urgent welfare requirements in the context of inadequate resourcing producing the very conditions that are then used to justify market intervention and private investment.

Against the destructive impact of international capital, complicit government, and a culture of enterprise, the collaborative activities of the Docklands communities, founded upon a history of political activism and the proliferation of points of resistance across the divisions of class, gender and ethnicity, have provided more than a token refusal of market forces, winning crucial victories over land and housing projects, and forcing the LDDC to establish a Community Development Unit. In 1983 a number of local organizations combined to produce The People's Plan for the Royal Docks, a campaign initiated by the Borough of Newham Docklands Forum aided by the Joint Docklands Action Group and the Docklands Community Poster Project. The focus for this activity was a report then being prepared on the feasibility of building a light airport in the Royal Docks. At each stage in the development of the report and throughout the subsequent political campaign, antagonistic and contradictory versions of 'official' discourse were produced – as posters, banners, leaflets, flyers and press reports. Although the eventual outcome was the opening of the airport, the enabling process of collaboratively challenging the dominant

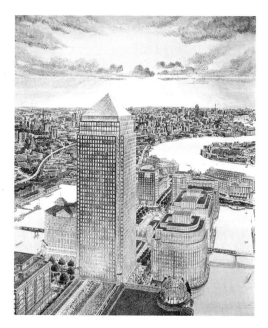

Figure 7.4 Canary Wharf – a fantasy of community.

Figure 7.5 The desirability of a riverside lifestyle.

meanings provided a vehicle for the expression of cultural identities and community interests.

Occupying a crucial position in this process has been the Docklands Community Poster Project (DCPP), founded in 1982 out of the practice of two artists: Peter Dunn and Loraine Leeson. The discursive nature of the DCPP, and the co-ordination of research and production through collaboration with an advisory steering committee representing the varied interests of Docklands residents, is a recognition of the multi-faceted and mobile aspect of cultural politics today. The DCPP has been involved in the production of posters, publications and banners for specific issues and campaigns; the establishment of a visual archive of the history of Docklands; the generation of a travelling exhibition which situates the narrative of the docks within a broader social history and acts as a model for other sites subject to riverside redevelopment; and, most recently, the establishment of a consultancy – Art For Change. The Project has also co-ordinated a number of highly theatrical street demonstrations, and between 1984 and 1986, it organized the People's Armada – flotillas of boats sailing up the Thames to the Houses of Parliament to protest against Docklands developments – events which attracted national press and media coverage. However, the central element of the DCPP has been an ongoing series of large-scale photomurals, initiated in 1981, charting the 'changing picture of Docklands'.

The photomurals are actually large billboards, each measuring 18 feet by 12 feet, containing photographic and drawn imagery in colour and black-and-white, that are located at key sites throughout the docklands boroughs. Each mural tells a story, an unfolding of collective history and lived experience, in selected moments of oppression and struggle as each successive scene represents a stage in a transformation from past memories, through present 'realities', towards a utopian resolution. The series *The Changing Picture of Docklands* consists of eight stages. Panels are changed at regular intervals until the original image representing the signs of urban dereliction – corrugated iron and graffiti-covered walls – has been transformed into a liberatory scenario of a schoolgirl leading a hetero-geneous and multi-racial community of local residents into *Our Future in Docklands*. Intermediate stages visualize an economy of privatization and exploitation: towers of money, tenement blocks, the scrapheap of social planning, the controlling hand of capital. The final images, although problematic in their utopian aspirations, are an attempt visually to invert power relations and to recognize the necessity for alternative visions of social reality, besides emphasizing the city as representation – a field of meanings that can be contested and changed.

In a recent series on housing, the posters invert the strategies of corporate advertising. Advertising conventionally erases all traces of the labour history of the product prior to its entry into the circuits of distribution and

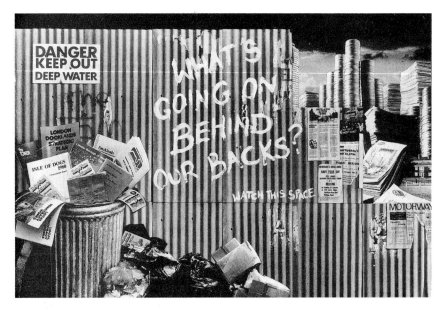

Figure 7.6 'What's going on behind our backs?' *The Changing Picture of Docklands*. London Docklands Community Poster Project.

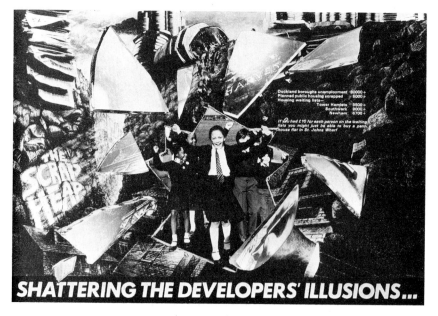

Figure 7.7 'Shattering the developers' illusions . . .' *The Changing Picture of Docklands*. London Docklands Community Poster Project.

consumption: its message is one of constant and immediate gratification. Like advertising, the official visual rhetoric of Docklands expresses the hallucinatory form of a wish, the voyeuristic gaze that involves subject and object in processes of fantasy and desire. The strategy of Dunn and Leeson in the various poster series is to confront the social and psychic construction of images through representing the specific histories, experiences and cultural practices that have formed individual and communal identities in this area of East London. The *Housing* series documents various moments and events in local history, connecting the home and the workplace in representations that make evident the gender politics that underlie the distinctions between the realms of the public and the private. Historically significant events in the labour history of Docklands are depicted using the dominant representational technologies of the period – social documentary photography to depict the Reformist movement of the late nineteenth century, and the techniques of the illustrated popular press to describe dock life in the 1920s. However, the apocalyptic imagery of industrialization, with its fascination with the sublime expressed as a tension between terror and awe, is here employed as a deconstructive device against the truth claims of the documentary tradition. The ideology of victimization and class passivity is challenged by examples of political and cultural production: the suffrage movement in East London and the organization of the Dockers' Union. The second half of the sequence takes the viewer through the labour disputes of the 1930s to the reconstruction of the postwar period, the slogan 'Homes for Heroes' reads as an ironic commentary as the widely deployed 'temporary' housing units (prefabs) are piled on top of each other to form a tower block. This symbol of postwar planning and social control bears the address Ronan Point, a reference to the collapse of a council housing block in 1968, an overdetermined moment in the crisis of welfarism and the bureaucratic state.

The visual rhetoric of the murals partly references the critical traditions of collage and montage within modernism, although Dunn and Leeson have deliberately constructed a deep spatial field as an analogue for the richness of social history. The montages are intended to produce narratives that accept the ultimate instability at the core of relations of representation, while also recognizing the necessity for points of stability. To subvert meaning, to place meanings *under erasure*, there have to be points of fixity against which ambiguities within the social formation, and the formation of subject identities, can be rearticulated to mean *otherwise*.

> Now without 'utopia', without the possibility of negating an order beyond the point that we are able to threaten it, there is no possibility at all of the constitution of a radical imaginary – whether democratic or of any other type.[2]

The DCPP represents the ways in which culture as a 'whole way of life' can

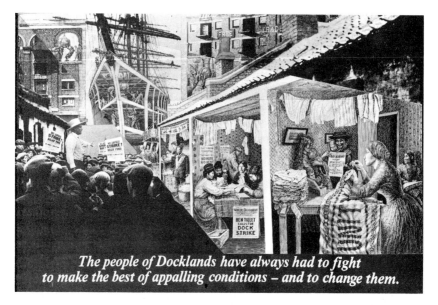

Figure 7.8 'The people of Docklands have always had to fight to make the best of appalling conditions – and to change them.' *The Changing Picture of Docklands*. London Docklands Community Poster Project.

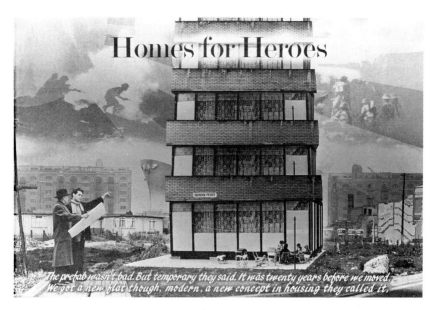

Figure 7.9 'Homes for Heroes.' *The Changing Picture of Docklands*. London Docklands Community Poster Project.

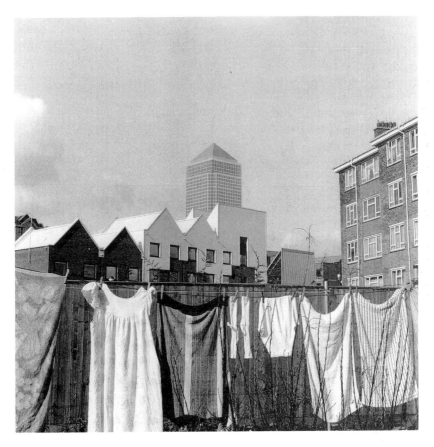

Figure 7.10 Photo: Bruce Thorndike.

be made to articulate the wishes and desires of 'ordinary' people, and the quality of everyday experience. Located, for the most part, outside the sanctioned spaces of high art, and representing the collaborative efforts and ideals of communities instead of celebrating individualism, Dunn and Leeson are involved in a project 'to develop a critical means of celebrating solidarity, strength and the ability to survive and win over oppression'. Obviously there have been failures – the combination of multinational capital and government complicity is hard to resist – but there have also been victories, not the least of which has been the use-value of a cultural organization in producing a coherent identity and focus for social and political campaigning.

Today the iconography of Docklands development prepares the regenerated public space for the postmodern, postindustrial, upwardly mobile, credit-wealthy, information-rich subject. This new occupant of the City

consumes and is consumed by the spectacle of an economic geography as satellite dishes and fibre-optic cables connect global marketeers to the universal data banks. As the architects and planners enfold the most technologically sophisticated products of the computer industries in the mantle of historicism and heritage, the confident beneficiaries of enterprise culture take their leisure at a waterside bar, stroll through the 'unique Georgian malls and arcades' of Docklands Shopping Village, or jet over to Paris from the Royal Docks City Airport.

Meanwhile, the bulldozed lots and boarded-up housing blocks testify to ghostly presences and forgotten histories. What East London – a neighbourhood of closely knit terraced housing, shops and pubs, riverside warehouses, schools and hospitals – used to mean was streets. Despite the contradictions and hardships concealed in memories of community (forms of nostalgia that have their own tendency to simulate 'heritage'), the street did provide a location for social gathering and for collective memory and shared forms of lived experience and resistance embedded in the very fabric of everyday life. It is, perhaps, too easy to slide into a melancholic discourse of loss, hopelessness and regret. Instead we can listen for the distinctive voices of challenge and resistance encoded in the rhythms of subcultural street life, the vibrancy of local and heterogeneous cultures redefining the relations of periphery to centre, the visible presence in the metropolitan world of alternative traditions of representation, the deconstructive strategies at work from street theatre to the combative rhetoric of the Poster Project's photomurals: all are elements contributing to an eclectic, postmodern culture of resistance.

In this uncertain moment of geocultural transformation, it is clearly hard to predict how this culture might grow and flourish. Although the recuperative and co-optive powers of global capital have effectively blunted the critical edge of the socialist tradition as a historical project – modernity's 'grand narratives' – it remains to be seen whether the vantage point of the *post* (as in postmodern, post-colonial, post-history, post-Marxism, etc.) leads to a productive reassessment of the values and means necessary for self-realization and cultural diversity. For the Left, the centrality of 'enterprise culture' as both economic dominant and symbolic order needs to be constantly questioned, from the marble halls and sanctioned spaces of official culture, to the shopping malls and urban geographies of cities and states as we approach the '*fin de millénium*'. We need a new 'politics of place', capable of recognizing and exploring the instabilities and contradictions present in all areas of social life and political formations, and we need practices that symbolize the bridging of individual experience, cultural difference and collective representations. Raymond Williams always recognized our responsibilities to the disenfranchised voices of past, present and future generations. For Williams, it was the commitment to reflect critically upon the complexity and diversity of social relationships

and to discover their determination upon ourselves as subjects that provided the justification and promise of freedom. Never likely to be a convenient or dominant expression, 'its sound is usually unmistakable; the sound of that voice which, in speaking as itself is speaking, necessarily, for more than itself. Whether we find such voices or not, it is worth committing ourselves to the attempt.'[3]

POSTSCRIPT

Events continue to overtake my analysis. Currently Canary Wharf is set to become the largest financial collapse of the post-war period with Olympia & York having total debts in the region of $20b. Only ten of Canary Wharf's fifty floors are actually occupied and the most optimistic forcasts project this will only rise to 60 per cent of leased space by 1993. One response to this is a round of applause at the prospect of another dramatic example of the crisis of capitalism. However, like most such crises previously, there are few beneficiaries from the fall-out from multi-billion dollar fiascos other than the bailiffs and official receivers. Certainly the impact upon the local communities is likely to be even more demoralizing than the last decade of unregulated speculation and 'regeneration': the spectre of the ghetto is once again haunting the docklands of East London.

Whatever happens, Canary Wharf stands as a material legacy of the Thatcherite dream of remaking Britain through private development and corporate finance under the combined ideologies of enterprise, regeneration and heritage. Docklands is the most spectacular example (or the most grotesque) of the interweaving of global capital, global information networks, transnational media, and complicit government. It provides evidence of the dramatic (and disastrous) effects of multinational grids of investment and marketing upon the redefinition of social space and the relations between the spheres of the public and the private – of the antagonisms between the culture of the market and the life and history of the community.

NOTES

1 An earlier version of this article was first published in *Art in America*, June/July 1990. The author and publishers are grateful for this opportunity to reprint this amended version.
2 Ernesto Laclau and Chantal Mouffe, *Hegemony and Socialist Strategy*, London, Verso, 1985, p. 190.
3 Raymond Williams, 'The writer: commitment and alignment', in *Resources of Hope*, London, Verso, 1989, p. 87.

Chapter 8

The Art of Change in Docklands

Peter Dunn and Loraine Leeson

Digital Highways are the corporate lines of communication that criss-cross the globe, spanning time zones, national boundaries and cultures. They link the financial centres of the world, dealing in electronic money transfer, carrying the information and value systems of multinational culture. Along these nodes of power come the technological hardware, the 'Fordist' business practices and the steel and concrete infrastructures that support them. In short, they have a profound impact upon the communities and work places that immediately surround their nexus points and have a ripple effect in terms of the development or under-development upon whole regions of the globe.

The perspectives of the Digital Highway are those of a minority, but a very powerful and increasingly internationalized one. They are undemocratic in their operations yet exert a major influence upon the democratic institutions and 'free markets' of many nations. There is no place for the needs and concerns of local identities, disenfranchised minorities (or majorities for that matter), for non-Western thinking, for difference of any kind. Its whole ethos is that of Western modernism. And far from being 'dead' as some postmodernists claim, it is currently engaged in major projects of *regeneration* in cities around the world. To paraphrase Habermas, modernism may be dead but, behind the façades of postmodernist architecture, it is certainly dominant.

At the mid-point in the time zone between New York and Tokyo stands Canary Wharf, which is the centre piece of an 8-square mile development in London's Docklands. This is the largest single redeve-lopment area in Europe, possibly the world. It directly affects a popu-lation of 50,000 people, mainly working-class communities, along a 9-mile stretch of the Thames running eastwards from 'The City' – the financial heartland of London. The area is under the control of a non-elected Development Corporation, effectively disenfranchising the local population – a situation further exacerbated by the abolition of the Greater London Council and the curtailing of powers of local authori-

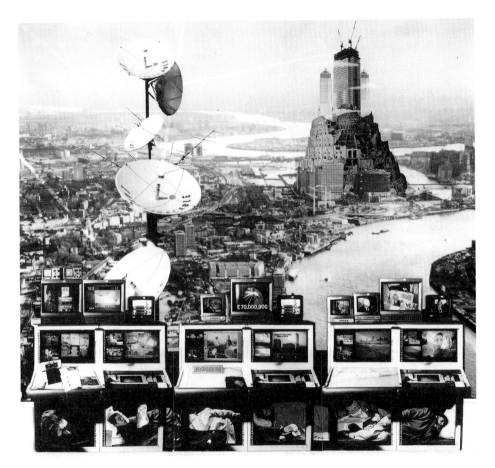

Figure 8.1 Digital Highway – London Terminal: 'The confusion of Tongues' (Peter Dunn and Loraine Leeson 1991). Montages produced by means of digital-imaging software on computer, enlarged photographically to 9ft × 12ft, hand coloured with acrylic glazes.[1]

ties. Docklands was created as the Thatcher government's showpiece, a model now being applied to all urban redevelopment programmes in Britain.

(Peter Dunn and Loraine Leeson, March 1991, from
the catalogue for 'Digital Highways' installation at the
Agnes Etherington Arts Centre, Kingston, Ontario, Canada)

The flow of information and cultural exchange has always been associated with trade routes and London's Docklands, from one perspective, has simply shifted from that of the pre-industrial age – the seaway – to the post-industrial 'Digital Highway'. The time zone is a crucial factor in the marketing of Docklands to multinational corporate interests, together with the 'Virgin Site' and 'New City' image free of the space and planning restrictions of the Square Mile. The people living in Docklands have always depended upon and been subject to the changing needs of trade routes. Major upheavals have resulted with each successive rebuilding and extension of the docks from the 1850s onwards. And just at the point where they thought that they had won some rights in security of employment and in decasualization of labour by the mid-1960s, the docks were closed. Once again they were at the mercy of the market. But this time their labour was not needed in the new 'port', moreover the physical presence of their communities was both an inconvenience and an embarrassment. It was not enough that they were dispossessed and politically disenfranchised but they had to be rendered *invisible* too. This was initially attempted by the Development Corporation's projection of Docklands as the 'Virgin Site': 'a blank canvas upon which we can paint the future'.[2] Later, as luxury housing became a prominent feature of the development, the politics of the view entered the frame – those who had spent vast amounts of money for their 'View of the River'[3] did not want it marred by the sight of crumbling tenement blocks and unsightly council estates. This was dealt with first by retaining the dock walls to screen off the new developments and, where possible, using gates and video surveillance to enhance their exclusivity. Strategic tree planting was also used to mask the unsightly. Finally, if all else failed, the Development Corporation provided money for the refurbishment of council properties *but only those that affected the view*.

AGAINST THE ODDS

When we were asked to work with the tenants and action groups in Docklands in 1981, the first problem they identified was that of visibility – something big and bold to say 'We're here and we're fighting back'. The next task was to help the activists in consciousness-raising and to unite the

different neighbourhoods, each with its own problems, needs and desires – in some cases quite distinct micro-cultures – into a coherent campaigning community. We were very fortunate in that there was already quite a developed network among the tenants and action groups and a wealth of campaigning experience. For example each area, such as Wapping, the Isle of Dogs or Newham Docklands, had umbrella organizations – the Association of Wapping Organizations, Association of Island Communities, Newham Docklands Forum – and these, in turn, were affiliated to Docklands-wide organizations: the Joint Docklands Action Groups and Docklands Forum. We began by creating a steering group of representatives drawn from these organizations, later formalizing this into a Community Co-op, The Docklands Community Poster Project, registered under the Friendly Societies Act. We became part of the network. Each of the organizations within the network had complementary specialities, ranging from the organization of direct action, through economic and planning research, through to our own visual skills. From the very beginning it was understood that we should draw upon each other's strengths; we did not presume to tell them how to organize people, how to draw up alternative plans and economic strategies for their area, and they did not dictate to us how we should visualize the issues. What we did discuss, however, were what issues to foreground, strategies to maximize visibility, and the *reading* of images – how the message was getting across, the main text and subtexts. And this was extremely stimulating and challenging. It was also, of course, a dynamic process which began with the majority of people in Docklands confused and on the defensive, to that of a substantial and cohesive community which began to seize the initiative in drawing up alternative plans and move on to the offensive in the public profile of Docklands. This culminated in a major river event called 'The People's Armada to Parliament', which involved over 2,000 people taking to the river in boats and at least an equal number involved in shore-side festivals. From the LDDC being projected as the 'great hope' of Docklands, the media began to refer to it as the 'controversial Development Corporation'. The role of cultural production in campaigning also changed during this process. When we began it was very much at the bottom of the agenda at action group meetings but, by the time of the Armada, campaigning had become primarily a cultural event, emphasizing visual spectacle, music, theatre; a fun day but with a hard-hitting message. It was far more effective both in recruiting people and in raising the profile.

From 1981 to 1986 the process for all involved was one of confidence-building and empowering. Most of the organizations were receiving some kind of funding or resources from the Greater London Council. With this institutional and political backing we were able to use our ingenuity and the invention born of necessity to compete on roughly equal terms with the

Corporation's PR department, not in financial and material resources but in our ability to influence the public perception of Docklands. The Communities of Docklands were visible, and, against massive odds, were winning some victories. The abolition of the GLC and the subsequent re-election of the Thatcher government changed all that. It was like going back to 1981: confusion reigned. Worse, people had glimpsed the possible but were left with no hope of realizing it. There was despondency, burn-out; funding dried up, some groups disappeared, others began to tear themselves apart, internalizing their sense of frustration and failure. And we were not immune to this. Attendance at Co-op meetings began to fall off; there were arguments about direction; there was personal friction; people left and could not be replaced as funding shrank. It was time to reassess what we had achieved and what we could achieve in the future.

The Docklands Community Poster Project had grown during expansion of funding in London during the 1980s by the GLC. We grew from two people, unpaid and working at home, to six people with a relatively large studio, owning six 18 feet by 12 feet billboards that we had built in strategic sites around Docklands with a rolling programme of changing images. We had been producing prolific amounts of posters, leaflets, publications, banners, and had been involved in organizing events and festivals. Suddenly we found ourselves working against larger odds, with fewer people and less resources, in an atmosphere of increased stress among activists, and an air of despair and resignation in the community at large. By 1989, we came to the painful conclusion that we had ceased to be effective. We were down to three people, all working part time, unable to put images on our billboards, and finding it difficult to meet even the reduced campaigning needs of the community. We had large overheads but little output to show for it. We faced the prospect of closing the project down, with dignity before the funding bodies closed us down, or of finding a way to expand in order to become effective again. With nothing to lose, we decided to go for the latter option.

In the short term, within a context of shrinking public funds, the only way forward was to find means of generating income. We examined our skills and resources and made some preliminary assessments about which of these could be used for income generation. Offering a design service was the most obvious. During the more productive period of The Docklands Community Poster Project we had been approached by various voluntary and campaign organizations outside Docklands but had turned them down because we had more than enough to do in Docklands. We knew there was at least the beginnings of a market there. We assessed that this would require taking on a designer who could pay for his or her own salary by doing 50 per cent of the work as income generation, with the aid of desktop publishing technology. We had the

Docklands Roadshow – a compilation of issue-based exhibitions and workshops – and there were other areas around the country facing similar kinds of developments, in fact, Docklands was being used as the model, so there was a potential market there. Using our skills and experience at creating exhibitions, we felt that we could offer that as a service more widely. Finally, if we could not use our billboards ourselves, then we could open them up for others to use. Not commercially but, by putting together funding packages that would include a fee for hire of facilities and technical support, we could offer it as a resource for other organizations, schools, etc. This would also enable applications to be made to bodies who would not fund us directly, either because of our overtly political stance or because they were already providing revenue support which they could not increase. So that became the basis of our survival package: we produced a three-year development plan and cashflow, including investment in digital-imaging technology, we employed new workers including a marketing person, we crossed our fingers and set to work. That was over a year ago, and we are managing to meet our income-generation targets by doing work for people we want to work for, such as Amnesty International, anti-racist and rights organizations, alternative planners and educationalists, making work and contacts with a whole new network of people who share an interest in similar issues.

The primary focus of our work had been specific and local, yet it received some national and international recognition on a number of different fronts. Initially this was within art contexts, as a model of particular forms of social practice, then later for our distinctive use of billboards in *The Changing Picture of Docklands* series. Through our Docklands Roadshow and because of the issues central to the work, it began to be used within urban planning contexts and, more recently, attracted the attention of a relatively new discipline – cultural geography – in dealing with the impact of urban renewal upon culture and identity. In short, the initial strength of the work – which was its specificity – began to be used in more generalized contexts either as art product, as instruments of planning polemic, or to visualize aspects of postmodern cultural theory. We always intended that the work should have a broader context than its initial specific use, so we were pleased that the work should have taken on this versatile, and sometimes unexpected, role. And the tenants and action groups saw this as a means of extending their struggles and the lessons they had learned. In looking to the future, therefore, we began to see the wider interest in our work as not merely incidental to our 'real work', which was specifically local. Rather, we saw it as an important and vital extension of both our work and the issues it engages into broader networks.

THE ART OF CHANGE

A new direction requires a new name. We were never just a poster project, and since we were no longer just operating in Docklands, a new name seemed long overdue. We decided on The Art of Change to reflect the experience and skills we had developed, both in the visual representation and the *issues* of change – a focus for using the specificity of the knowledge we have gained while extending it into other contexts.

Central to this theme of change is the transformation of the urban environment and its impact upon quality of life, 'community' and cultural identity. What we mean by 'community' here is important, since the word is often associated with nostalgic or highly romanticized images of 'place'. This, in our experience, is not very useful – indeed it is counterproductive within a dynamic of change. All communities are essentially communities of interest. The fact that this 'interest' may attach itself to a specific location in certain circumstances is not unimportant, since this may involve issues of identity, especially when an area is undergoing major demographic change as in Docklands. Nevertheless, we do not regard this as the primary factor in defining a community. Community – as its root *communis* implies – is inextricably linked to communication. It is an identifiable 'sphere of discourse', with codes of inclusion and exclusion – a microculture – which is, of necessity, meshed with other spheres of culture and society, and engaged actively with them in a continual dynamic of change. As Raymond Williams says,

> the process of communication is in fact the process of community: the sharing of common meanings, and thence common activities and purposes; the offering, reception and comparison of new meanings, leading to the tensions and achievements of growth and change.[4]

It is therefore this dynamic view of 'community', which may extend far beyond any particular location, engaging and interconnecting with other 'spheres of discourse', that we are concerned with developing in The Art of Change.

THE PROCESS OF ENGAGEMENT

In a society as complex as ours, however, it is clear we cannot address all 'communities', even if we wanted to, and expect them to share our meanings and goals. We have to make choices. Put simply, the process of engagement starts with

1 establishing what 'communities' we actually belong to and what the nature of that involvement is;
2 linking with those we we want to belong to, have connections with, or wish to ally ourselves to;

3 working outwards from there to make contact with others who may be interested in dialogue and exchange.

It is obviously more complex than a linear 1, 2, 3; these levels happen simultaneously and cross-refer. But putting it this way helps to clarify what our role might be at various moments in the process. As communicators, to help (as Raymond Williams puts it) 'the sharing of common meanings', to build the bonds of solidarity, that's our *sustaining* role, at times even a defensive role. And it's an important one, where there is a value in 'speaking to the converted', and an opportunity for *celebration*, which is vital. The other role – the *transformative* – is in 'the offering, reception and comparison of new meanings'. And this, the point of intervention, is obviously where we are most likely to engender conflict. Here again we have to make choices. *Vis-à-vis* those with whom we choose to ally ourselves, we have to be aware of, and sensitive to, the new directions that community wishes to take; to be part of its *becoming*. Against those whom we oppose – those who oppress – it is important to make our critique hard-hitting, not to convince *them*, because they are not interested in genuine dialogue or exchange: it would be against their interests both materially and subjectively. (There is a poster for the latest *Godfather* movie that says, 'Real power cannot be given, it must be taken'; there is some truth in that statement.) But there are many people who do not deliberately ally themselves with the minority interests of the powerful, who are nevertheless caught up, at varying levels, in the momentum of power. And if any real change is to be effected, they have to be reached. We also have to be aware that, in certain instances, the *they* in question might well be ourselves.

LOCAL NARRATIVES

In opposition to the seemingly viral-like spread of corporate culture[5] globally along its 'Digital Highways', the importance of 'local narratives' has become ever more critical. What do we mean by this? We mean 'local narratives' as opposed to the 'grand narrative' claims of international modernism in art, multinational economics and its corporate culture. 'Local narratives', not just defined by geography but as the *specificity* of what it is like to be working class in this society, to be a woman, to be black, to be gay, to be differently abled. 'Local Narratives', in other words, as the voices of all those suppressed and marginalized – defined as 'other' – by the arrogant claims and practices of the greatest and most pernicious cultural imperialism the world has ever seen. And it's not just the West which is responsible for this, though it has a lot to answer for; we are now witnessing the results of decades of suppressed 'local narratives' in the former Soviet Union, and

in many other parts of the world. Whether or not we are comfortable with what they have to say, we ignore them at our peril. Unless this arrogance is at the very least blunted, then it will not just be the many rich and diverse cultural narratives that will become extinct but the countless bio-logical narratives that sustain life on our planet. In short, opposition to the 'grand mono-narrative' mentality is not simply about the ideological differences or the opposing aesthetics of elite art movements, it could well turn out to be *the* crucial factor in a life-and-death struggle for the future of our planet.

We have chosen to use the term 'local narratives' (borrowed from Lyotard)[6] because some of the work that has previously attempted to address these issues has been lumped under various umbrellas such as 'community art', 'political art', 'women's art', 'black art', 'ethnic art' and so on. These terms – usually created by funding bodies or critics – are convenient labels for bureaucrats and have at times had short-term strategic uses for practitioners too in creating a profile for a previously marginalized activity. Let's face it, the marginalized and dispossessed have to be opportunistic. Nevertheless, in the long term, such phrases are both counterproductive and divisive. It divides the work falsely into ghettos or fashions. How many of us have heard galleries say, 'Women's Art [or any of the other of the above categories], we've done that, now we're into so and so'? It also limits the reading of the work to one level, the single issue, when clearly the most vital work in these areas – by its very nature – interconnects across many issues and addresses a number of spheres of discourse.

The interesting thing about this fragmentation of discourses that used to be fairly unitary 'disciplines', such as that of fine art, is that we are beginning to see new alignments, what Edward Said has described as 'interference' across what have become 'fiefdoms' for the initiated, and the creation of new agendas. For example, our work has drawn us into the areas of urban regeneration and planning. At The Art of Change we talk more to, and probably have more in common with, members of tenants and action groups, radical planners and cultural geographers, than we do with a lot of artists. Similarly, artists dealing with issues of gender or sexuality may have links with networks involved with those issues, and certain black artists may have more interest in the issue of racism and other matters affecting them and their communities directly than they have in the formalist discourses of other white artists. And so on. This, if you like, is a fragmentation of the art discourse, but in our opinion it is a very healthy one. It is not ignoring the art discourse, but it is not privileging it in the same way. It represents a fanning out, a moving away from the dusty museums of academia and the sterile intro-version of modernism; it is remaking networks and realigning narratives to make contact with the pulse of wider social and cultural change, not

just formal innovation. And yet this work has to make formal inno-
vations too. Its different contexts demand that. In our different ways and
different means, we believe it is vital that the grand narrative's monovi-
sion is opposed; in its material impositions and its subjective and cultural
hegemony – from the physical pollution of our environment to the per-
vasive 'memory screen'[7] of corporate culture which stains our percep-
tions. And rather than creating an equal and opposite monovision, we
believe, more than ever before, that we need to engage and extend our
'local narratives' to achieve a new consensus where it is needed – in
matters such as global warming, for example – but one which is capable
of embracing difference.

We also need to find ways of using some of the new technology of the
'Digital Highways' for ourselves. There are communications devices,
such as faxes and computer modems, to make connections outside of the
mainstream and, as yet, beyond the control of state authorities. 'Faxes
to China' during the recent repression is an example of this. This, of
course, is very limited and restricts the network to those who have the
resources, often excluding the very people it needs to reach. But we do
not have to think in terms of only one network. And digital-imaging
technology, still relatively in its infancy, is now moving into the areas of
remarkable sophistication. Putting aside for the moment the possibility
of major ecological catastrophe or the fall of capitalism, it is fairly safe
to predict that digital imaging will have at least as great an impact upon
our culture in the next century as optical imaging has had in this. This is
not a celebration of 'technological progress', but simply to point out that
this is a future we have to engage, like it or not, if we are to remain
visible within what amounts to a new visibility already under
construction.

There is a tendency, a pressure even, when you are critical of the
status quo, that people expect you to lay out an alternative 'vision for the
future', a blueprint for the way forward. Even if we were capable of
doing that, or arrogant enough to try, we think that too many have
already attempted that with disastrous consequences. What we have tried
to do here is to make a very simple point, but in looking at it from a
number of different angles we hope we have also conveyed something of
its complexity. In order to embrace that complexity creatively, we – not
only artists but our culture as a whole – need to become more responsive
to the specificity of context, to the *difference* embedded in 'local narra-
tives'. And we believe this is achieved, not by simply becoming more
tolerant, but by refining our critical faculties; so that we can understand
more about the nature of difference – where it comes from and how it
comes about. Uncritical tolerance is so often just another way of being
patronizing. And that is no good to anyone, least of all to those who are
being patronized. It also leads to a paralysing relativism. We need to be

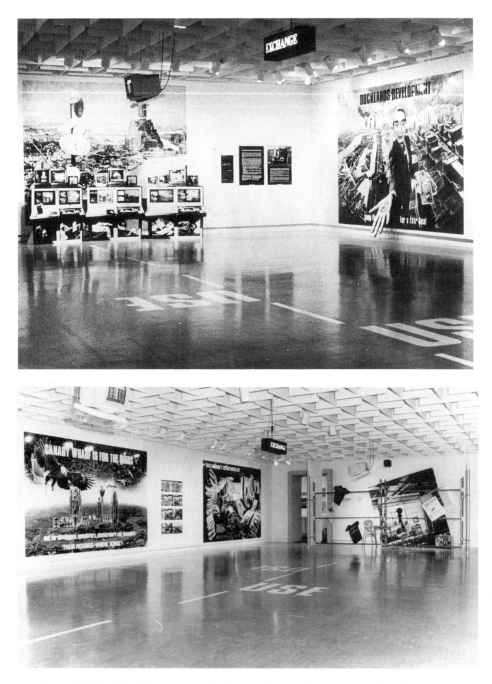

Figure 8.2 Digital Highways Installation: a collaboration between Peter Dunn and Loraine Leeson and Canadian artists Karl Berverage and Carole Conde, shown at the Agnes Etherington Gallery, Kingston, Ontario, Canada.[8]

clear about where the nodes of power are in the tangled web of forces that influence our lives. The most progressive Futures will surely be those that propagate the creative value of fragmented power – decentralized, democratized – and of a culture made rich and vital from the many strands and threads of difference that are currently excluded or marginalized.

NOTES

1 This work borrows its metaphor from Bruegel's *Tower of Babel*, and as Bruegel placed his tower within his own contemporary setting, so our tower is placed on the site of Canary Wharf. Today, the 'confusion of tongues' are the meta-languages of information technology, the social and economic stratification which means that different social groups have totally different terms of reference – they don't 'speak the same language' – and, of course, the continuous erasure of one partially grasped impression by another as the media rolls on to another 'current affair'. The thrust is not anti-technological, on the contrary – in keeping with the theme, the major part of this installation utilizes computer technology and represents an experiment in new digital photography techniques – rather it raises questions about its use. The Gulf War began when we were in the process of producing this work. As the differing practices of imperialism – the early twentieth-century model of military annexation, and the late twentieth-century one of economic domination – faced each other in the desert, we were reminded that the original Tower of Babel was sited on the banks of the Euphrates, yet its 'story' is communicated to us through the 'Western tradition'. And when some Tory politicians described the BBC as the Baghdad Broadcasting Corporation because they believed that we, the British public, were getting too much information about what was happening in Iraq, then this obviously became an important element of the work.

 The representational tradition of the Tower of Babel sites the tower itself in the background, emphasizing its scale against a dwarfed landscape with its uppermost reaches rising above the clouds. Its winding structure usually contains narratives of work. In the foreground you see the rulers and taskmasters, and the 'confusion of tongues' is dramatized here by a rhetoric of gestures among those surrounding them. In our interpretation, we split foreground and background into two sections. The backdrop contains the tower, foregrounded by a column of microwave dishes beaming their messages in all directions. In front of this stands a freestanding console of monitors and computers showing a selection of images from news broadcasts during the second week in February – the Gulf, Palestinians, advertisements for London's Docklands, the Birmingham Six, the bombing of London rail stations, the UN, and an array of prominent leaders currently on the 'world stage'. The sound that goes with this involved the weaving in and out of four simultaneous tracks, a 'babble', taken from these news broadcasts with the music of 'Mars' from Holst's *Planet Suite* anchoring the whole. Reclining under the tables of these 'consoles' are images of homeless people from Cardboard City. After six minutes the sound and lighting to this piece goes off and next to it slides are projected, compiled from events and demonstrations organized by local tenants and action groups in Docklands, notably the 'People's Armada

to Parliament'. This lasts for a further six minutes and then the cycle begins again.

 Credits: Original photograph of London cityscape with Canary Wharf was supplied by Olympia & York, Canary Wharf Limited. *The Tower of Babel* came from a reproduction of Bruegel's painting of 1563. Photographs of homeless people from 'cardboard city' in London (shown 'under the table') were supplied by David Hoffman and Philip Wolmouth. All other visual materials originated by The Art of Change/Docklands Community Posters.

2 Statement by Reg Ward, first Chief Executive of the LDDC, at a local meeting, 1982.

3 The 'View of the River' was the major marketing slogan for luxury housing inDocklands.

4 Raymond Williams, *Culture and Society*, London, Pelican.

5 See reference to the 'Image Block' in an interview with Paul Virilio in *BLOCK* no. 14, 1988.

6 *The Postmodern Condition*, J.-F. Lyotard, Manchester, Manchester University Press, 1984.

7 See 'Digital highways, local narratives', *AND*, no. 26, 1991. Virilio has referred to this process as an 'image block' and Baudrillard has described it as 'hyper-reality': see *BLOCK*, no. 14, 1988.

8 The installation ran the whole length of a 60ft × 40ft gallery, using the two end walls to represent 'terminals' in London and Toronto (previous works by Berverage, Conde, Dunn and Leeson were shown along the side walls). The 'terminals' were joined by a laser beam flanked by live TV monitors showing current stock market information and a pixel moving message board spelling out 'EXCHANGE'. Counterpointing this on the floor, like the SLOW signs on a road, were the words 'USE' and reversed out of white dashes across the floor were, alternately, 'resist' 'transform', 'transform' 'resist'.

REFERENCES

Baudrillard, J. (1983) *Simulations*, New York: Semiotext(e).

Cooke, P. (1990) *Back to the Future*, London: Unwin Hyman.

Foster, Hal (ed.) (1983) *Postmodern Culture*, Washington: Bay Press/Pluto.

Foucault, Michel (1967) *Madness and Civilisation*, London: Tavistock.

—— (1976) *The History of Sexuality*, London: Penguin.

Gorz, Andre (1982) *Farewell to the Working Class: an Essay on Post-Industrial Socialism*, trans. Michael Sonenscher, London: Pluto.

—— (1985) *Paths to Paradise*, London: Pluto.

Gramsci, Antonio (1971) *Selections from the Prison Notebooks*, London: Lawrence & Wishart.

Habermas, Jurgen (1985) *Habermas and Modernity*, ed. Richard Bernstein, Cambridge: Polity Press.

Lukacs, Giorgi (1973) *Marxism and Human Liberation*, New York: Dell Publishing.

Lyotard, Jean-François (1984) *The Postmodern Condition*, Manchester: Manchester University Press.

Nairn, T. (1981) *The Break-up of Britain*, London: Verso.

Orbach, Susie and Echenbaum, Luise (1987) *Bittersweet*, London: Century Hutchinson.

Said, Edward (1978) *Orientalism*, New York: Pantheon Books.
Williams, Raymond (1961) *Culture and Society*, London: Pelican.
—— (1980) *Materialism and Culture*, London: Verso.
—— (1983) *Towards 2000*, London: Chatto & Windus.

Chapter 9

Beyond the modern home:
Shifting the parameters of residence

Tim Putnam

Where – and what – is home in a postmodern geography? What do contemporary concerns with problems of 'identity', 'situation' and 'consumption' have to do with the process of making a home, and the work done by constructs of 'the home'? Reading across the dislocations in the discourses that impinge on the domestic, is it possible to characterize a shift in the parameters of residence?

Although the making of houses into homes is a paradigmatic form of emplacement, there may be a temptation to avoid enquiring too deeply into residence when addressing orientation in a global context. From their earliest existence, the discourses of political, economic and ideological determination surveyed their respective terrain with this 'private' sphere firmly behind them. Now that the world can no longer be represented as a federation of families, it has become commonplace to consider the domestic as dominated and decentred, a territory of 'consumption' and 'reproduction' rather than signifying or consequential action. The social sciences which have engaged with 'home' and 'family' have been bent on their regulation and reconstruction. Even in critical social and cultural studies, more accustomed to eliciting difference, subtle barriers exist to recognizing what transpires in this backstage sphere, associated with the dominated gender. In times favourable to 'local narratives', the domestic still connotes parochial interests, trivialized commitments, unacknowledged groundings. Those who would nevertheless speak about emplacement in 'the home' must steer their discourse between past reifications in a vortex of infinitely varied modes of living. Far easier, in conducting a discussion of 'being at home' in the contemporary world, to evade the vagaries of the domestic altogether.

However, it is impossible in a discussion of emplacement to neglect the principal site where material culture is appropriated in mutual relationships. In a postmodern context, the agency exercised in home-making becomes less trivial – and its qualities less readily apparent – than accounts of mass production and mass media would allow. In recent years, investigators of several kinds have become fascinated by the relations between

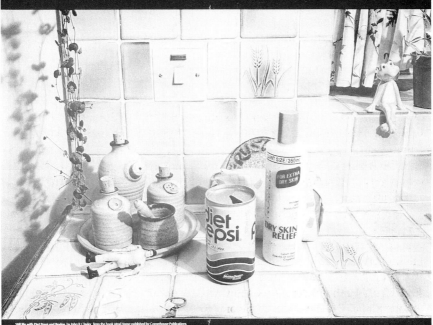

Household Choices
DESIGN IN DOMESTIC CONSUMPTION

Still life with Diet Pepsi and Revlon by John R J Taylor, from the book Ideal Home published by Cornerhouse Publications

"At the time I liked frogs...
it seemed to be the phase. I hate
real frogs but I like ceramic ones.
Behind there is my make-up bag.
It's in case I run out. I never go out
anywhere without a bit of lipstick
on. I'm a bit vain, I'm afraid."

28 February – 1 July 1990 VICTORIA AND ALBERT MUSEUM Henry Cole Wing

Figure 9.1 Poster for *Household Choices: Design in Domestic Consumption* exhibition.

these micro-mysteries and large-scale processes. England, France, Germany, Sweden and the US have seen major exhibitions in which 'domestic creation' is held up for contemplation (Putnam and Newton 1990; Segalen 1990; Pallowski 1988; Lofgren 1990; Galassi 1991). While this interest reflects the greater care in treating the relations between local narratives and global schemata of all kinds, it has also been fed by an awareness that both the ends and means of home-making have altered in our life time. We can now see that from the moment the dream of 'the modern home' began to be realized, domestic consumption practice departed in new directions, pointing, as Lefebvre suggested at the time, to a new epoch (Lefebvre 1971).

In one respect, this new home-making may be characterized as a problematic of discretionary consumption, where a stimulated individual agency contemplates an enhanced field of choice. The traditional autonomy of householders to establish common meanings through collaboration in fashioning and maintaining a shared environment, refracted by commoditization and eclipsed by the mass diffusion of the apparatus of modern living, appeared to take on renewed significance. Boundless bricolage laid to rest any notion of mass consumption as a passive relation, and forced attention on creative autonomy, even resistance and subversion, in the 'everyday' and the 'banal' (Goodall 1983; Saunders 1984; Forrest and Murie 1987; Tomlinson 1990; Putnam 1991; cf. Duncan 1981). But the symbiotic relation between these initiatives and the extensive new promotions of domestic design might still be judged as culturally arbitrary, not only lacking the complex local 'groundedness' of pre-industrial tradition (cf. Heidegger) but, like other phenomena of postmodern consumption, any secure referent whatsoever (cf. Baudrillard 1981). The cultural agency of householders might be considered as confined within a problematic of 'distinction' (cf. Bourdieu 1984). The adequacy of such perspectives has not, however, been tested against the diversity of lived relationships which produce contemporary homes and rely on them as supports. Those who have pondered dislocations in material culture have only recently come to recognize that they must deal with those who encounter, enact and envisage 'the home', and that the domestic sphere has witnessed such extensive renegotiations of generation and gender relations that the viability of this concept as the goal of a joint project has been brought into question.

Domestic happenings, then, have had enough vitality to escape the compass of discourses. The professions and industries that service and support the domestic, increasingly unsure of their object, have called for new lines of research. The initiatives of householders have surpassed and often surprised the calculations of architects and those who package domestic design for living. Feminism and critical self-awareness in the human sciences have exposed the bulk of what passes as 'knowledge' about actual homes as quasi-instrumental, constituted for the reconstruction and

regulation of such objects as 'housing', 'the family', 'hygiene', 'leisure' and 'consumption'. The authority of these reifications, reinforced by their conjuncture in the all-enveloping project to install the 'modern home', has waned with the achievement of that project and the disintegration of its constituent parts.

The current state of uncertainty can be read in this recent call for European collaboration in defining housing quality:

> Twenty years ago it was not very difficult to define housing quality. At that time it was a matter of dwelling size and sanitary standard. Later, the awareness grew that housing quality also included such aspects as architectural and landscaping qualities and maybe also the degree of public and commercial service facilities in the neighbourhood.
>
> Today it is much more difficult to come to grips with what constitutes housing quality. Instead of the quantitative aspects, should it rather be described in qualitative terms like community, participation, belonging and the home? Or still, is housing quality a mixture of the quantitative and qualitative aspects? In that case, how can housing quality be measured? And how can housing quality be compared between different segments of the population, and indeed, between different countries?
>
> Many European countries face hard work in upgrading the worst mistakes of the post-war housing production period. In this work what steps should be taken to turn the large scale housing projects of Modernism into livable environments? And what lessons are there to be learned from such projects for future housing production?
>
> (Gaunt 1989)

A recent attempt to reformulate a discourse about the domestic was made in *Home: a Short History of an Idea* (1986), by Witold Rybczynski. An architect reared on modernism, Rybczynski deplores the 'postmodern' packaging of lifestyle decor, but accepts the inadequacy of functionalism to give an adequate definition of home. He is wary in particular of functionalism's associations with a technological definition of domestic comforts (Brindley 1989). Like others emerging, willingly or not, into a postmodern awareness, Rybczynski realizes that 'home' embraces imaginative, social and material orders. He perceives that its effectiveness as a cultural category depends on local interpretation, but elevates personalization to the status of a universal principle. Looking out from his study across the centuries, he only manages to recognize the domestic arrangements and ideals that conform to the petty-bourgeois model in which domestic privacy is celebrated as a separate sphere for the creative achievements of the protected female.

The artful way in which Rybczynski historicizes his own sensibility as a resolution of the dilemmas of modernism and postmodernism has had

some resonance, particularly in North America, and may be taken as a 'sign of the times'. It also turns on a question which is embedded many recent approaches to the domestic: authenticity. Rybczynski juxtaposes the discriminating detritus of a busy life with lifestyle packaging. This effects a double disdain: first, manifestly, of the pretension of the commodity to set not only the standard, but tone of living, and second, implicitly, of the home-making lack in the consumer that this would fill. Like weightier cultural theorists, the author of *Home* is personally quite confident in his own aura of authenticity yet dubious as a spectator on a macro-scale.

This problem of authenticity has been around long enough to be regarded as a condition of modernity (Berman 1988). To the extent that we live in a world that permits diverse interaction and self-redefinition, that escapes the degree of closure accorded to the society of tradition, recirculates goods and reattaches signifiers, polyvalence of meaning becomes the norm (Appadurai 1986; Miller 1987). Extreme consequences have been extrapolated, for example, by Heidegger and Baudrillard. However, one has to ask for whom is authenticity what kind of problem? While contemplating the movement of images and objects in the abstract may pose epistemological dilemmas (Baudrillard 1981; Hebdige 1988), the problems of practical reason for those involved in making a home appear to be of a different order. Home-making establishes proximate relations between aspects of spatial and artefactual order, social practice, discourse and the imagination. Although the resulting order can be very sophisticated, it does not exhibit a high level of consistency either internally or in relation to external referents (Kaufman 1991). Households use commodities and general cultural resources in a fundamentally opportunistic way to carry out internal strategies which evolve relatively slowly. While the household's parameters must be secured to a tolerable degree, its object-world does not need to be grounded in the transcendental sense of which Heidegger speaks; nor is it undermined by the lack of ultimate referents (de Certeau 1984).

As Rybczynski recognizes, home-making in producing its own field of value generates an effective authenticity. And while the pursuit of external guarantees or tokens of authenticity for domestic consumption is bound to prove quixotic, this is beside the point so long as it serves to generate a range of satisfactions – hardly exhausted by Bourdieu's construction of social identity through discrimination. Those who would maintain that such emplacement is illusionistic, inauthentic, should 'take a holiday' (as Chambers suggests) at home. The work of framing 'the home' in a macro order is not the same as that of constituting meaning on a domestic scale. As we know little about how these local narratives serve to place people in the world and how their meanings are communicated and accumulated on a wider social scale in a variety of ways, the sovereignty of the discourse from which such 'talk' is assessed is not beyond question.

Attempts to recapture the domestic in discourse have attempted to produce a degree of convergence on a common complex object of study. The two main lines of policy research relevant to the domestic sphere – that which informs housing design and provision and that which monitors the family as a unit of social reproduction – customarily disregarded each other's domains, sometimes with comic or catastrophic results. However, domestic design research, which long ago invoked psychology in a search for universally valid solutions, has been forced to recognize social process and cultural difference. Family studies, having previously acknowledged the importance of external contexts, are beginning to take a greater interest in the immediate home environment. Policy myopia and established differences in disciplinary focal length have meant that the most productive encounters have often been interdisciplinary: where geographers' work on emplacement can cross the threshold and meet accounts of family processes, or recent attempts in psychology to deal with sociocultural difference (Altman and Low 1991; Bernard 1990).

The scope and texture of home-making agency and its relation to macro-processes has been most readily accommodated in that branch of ethnography focused on metropolitan milieux (Lofgren 1990; Miller 1987, 1990; Segalen 1990; Silverstone 1992). In an ethnographic perspective, the significance of 'home' as a cultural category depends primarily on how it is used by subjects to place themselves in both an elemental social nexus ('household', 'family') and a secure and malleable environment ('habitat', 'house'), comprising a spatial and artefactual order. The ethnographic ability to identify the immanence of cultural value in everyday spatial and temporal order, and spot homologies and supports between the orders of discourse, social process and material culture, have characterized the most notable recent research on the home. Although the articulation of the multiple relations between personal, social and material dimensions of home as locality have yet to be adequately explored, and its bearing on the inflection of domestic ideologies remains unspecified, it is now widely acknowledged that all work on the domestic must attempt to situate itself in this context. The ambiguity of the English word 'home' can no longer go unremarked: does the usage indicate an environment encountered, relationships enacted, an ideal envisaged, or an articulation of all three?

To remind ourselves of what is at play in home-making does not in itself give an account of the parameters of residence; the quality of the integration sought or achieved by home-makers must then be related to differentiated accounts of how the externally produced elements and supports of home-making are mediated. Here the ethnographic paradigm is at an apparent disadvantage by comparison with those disciplines that have focused on the macro-structures and processes that govern the transformation of the built environment, employment, the production and mediation of goods and representations, the formation of social fractions and the

instruments and legitimation of power. Little work has been done to reintegrate the pertinent findings from these relatively well-developed fields with the articulation of home as a cultural form (but see Putnam and Newton 1990).

Thus, quite different emphases can arise from privileging particular parameters of residence. It has been possible to assert, on the one hand, that the global connectedness brought by electronic technology has so eroded the boundaries of home as to attenuate any sense of own place, and, on the other, that increasing investment of time or elaboration of commodities produced for consumption in the domestic sphere constitutes a new privatism. Such apparently contradictory assertions may depict complementary, even interdependent, trends if brought to bear on each other. As part of such an encounter, it is incumbent upon each discourse to acknowledge its own history and, in particular, its implication in the project to create the modern home. Each needs to disentangle itself from the aftermath of this project and assess the extensive effects of its dis-integration – not least on the legitimation of the public realm, of technoc-racy, of mobility and the aspirations of classes, genders, nations and generations.

DECONSTRUCTING 'THE MODERN HOME'

In speaking of a modern home, we are talking about more than technolo-gized comforts. The modern home is inconceivable except as a terminal, affording the benefits of but also providing legitimating support to a vast infrastructure facilitating flows of energy, goods, people and messages. The near-completion today of great infrastructures of modern material culture: of hygiene, energy, transport and communication, has dramati-cally transformed what is possible and desirable in homes. The most obvious aspect has been a qualitative transformation of the technical specification of houses and their redefinition as terminals of networks. This infrastructure-building has had a strong public character even though, in most countries, it was largely carried by private investments of science-based industry, and it was linked to the diffusion of a new 'modern' standard of living through the cultivation of popular aspiration. Widening access to this standard and the means of its achievement was an important dimension of the new democratic politics. Proffered improvements to the material environment of the home figured in the agendas of all tendencies that aspired to mobilize support on a broad basis.

There is much to be done to disentangle the ideological aspirations and consequences of the extension of these networks, and their impact on the household as a social nexus. Some work has been done on the pro-grammes, proclamations and institutional politics of hygiene, energy pro-motion, and public housing provision, but relatively little on the reception

of these initiatives or their significance in a wider political context (aspects have been problematized – see Madigan and Munro 1990; Matrix 1984; Cowan 1989). It has been shown both that promotion of new infrastructure dependent appliances as labour-saving was strong, and that their adoption has led to a greater change in the quality than in the quantity of housework. The feminist critique of 'liberating consumption' has demonstrated the non-equivalence of technological possibility, recommended consumption, social practice and householders' ideals, and leaves open many questions about the relations between them. How, for example, should we understand the abandonment of labour-saving as a proffered rationale for appliance consumption since the 1950s in favour of rhetorics of leisure, pleasure and higher standards of consumption?

The rhetorics of appliance promotion remind us of the symbiotic relationship of the public and private sectors during this period of the consolidation of infrastructures and mass legitimation, and also of the close links with family policy, the politics of gender and generation. Here, connections could be made between existing research about the demobilization of women after the Second World War, infrastructural development, and housing policy and design. In some countries, Britain included, the qualitative improvement of the housing stock, in public discussion, has often been overshadowed by a politics of housing quantity. The outlines of postwar public housing programmes are relatively well known and certain aspects – comprehensive redevelopment, system building – have been the subject of extensive discussion. It is important not to overlook the fact that much of the demand for new housing units came from those who would otherwise have had to share with family or strangers, and that housing provision is thus linked with a change in the norm for the number of people per housing unit and especially with a decline in the number of generations sharing family accommodation (in Italy, this norm is currently in process, see Rullo 1990).

The aspiration of couples to have their 'own house' extended beyond public sector tenants, but public guarantees and incentives, backed by provision in the public sector, fundamentally changed the horizon of what it was legitimate to expect. This movement towards generational autonomy was consonant with the reduced role of intergenerational family contacts in transmitting occupational opportunity and life chances which followed industrial concentration and reorganization and the increasing importance of formal education as mediator of cultural resources and opportunities. The disruptive subordination of local communities to the new networks has been much discussed, as has the unreality of various attempts to synthesize substitutes. The neighbourhood aspect of residence has been transformed to the extent that the shared experience of work and home life within a local geographical scale has become a sign of social and economic marginality. This is not simply an effect of mobility, but of changes in the means

by which sociality and identity are established and cultural and economic resources can be accessed, which have altered the parameters within which meaningful lives can be made.

In the advanced countries, the installation of the infrastructures of modernity is fundamentally over, although restructuring and relocation continues. For the great majority, the modern home is no longer a dream but an unspoken premise – the conjuncture which linked diverse elements in a political programme has been broken by its own fulfilment and the exposure of its internal contradictions, perhaps crystallized in the universal 'happy housewife' of 1950s advertising. One can sense the transmutation of aspiration into structure in the shifting rhetoric of advertising and propaganda in the 1960s – as well as in the independent courses struck both by privileged social groups and youth, rediscovering the charms of the antique or rustic, and or a style self-consciously postmodern, disenchanted with the new housing estates, even as many were still struggling to realize the essential items of modern domestic consumption.

The disintegration of the project of the modern home brings to the fore some long-established features of discretionary, differentiating consumption, display and confirmation of status. In the present period, these have been fed by a conjunctural attenuation of egalitarian ideals, restructuring and increasing disparities of income. Nevertheless, the appearance of massive new domestic investment is misleading; there has been a shift in the typical objects of investment rather than an increase in the proportion of income invested in domestic consumption.

The infrastructures of modernity are, however, presumed in a permanently changed domestic environment. They afford vastly more choice in the use of the home, but the quality of life which can thus be achieved, accessed through the network in the broadest sense, depends on the cultural resources and modes of operation of the inhabitants. Otherwise the installed comforts are as bleak as the eviscerated neighbourhoods. Perceptions of residential satisfaction are very strongly related to confidence in accessibility of external support and opportunity (Bonvalet 1989; Feldman 1989; Franklin 1990). Communication and transport may vie for importance, but the resource to be accessed is crucial: family, friends, shopping, healthcare and leisure facilities, schooling and employment opportunities. So situation signifies first in this broader sense. The Kantian aestheticized contemplation of situation depends on the satisfaction of this range of needs' wider agenda.

HOME AS A PROJECT: A 'NEW CONJUGALITY'

Having been relocated culturally, socially and economically by participation in an external educational and employment system, more couples now enjoy and, in a sense, must create, living environments representing

their distinctive trajectories – rising from personal and familial histories to self-projection in social space. Greater confidence permits diversity and experiment. The question of the interrelation of projects within the household has gained a new importance. Several recent studies have argued for a relation between a 'new conjugality' and involvement in home improvements. As a sense of joint project is compatible with the maintenance of strong gender definitions in both space and activity patterns in the household, it is interesting to find that this 'new conjugality' has been linked with changes in the relation between generations, sense of neighbourhood and community, new patterns of alteration and a redefinition of gender and space in the home (Almquist 1989; Franklin 1990; Miller 1990). There are reasons to treat such findings with some scepticism.

First, the conjugal home project occurs principally as a story told by women (Segalen 1990; see also accounts by Almquist 1989, Lofgren 1990 and Morley 1990b). There is the possibility of a certain irony in these accounts, in that the hidden subject of the account is the woman's specific role both in creating the design of the home and, in a larger sense, taking responsibility for the relationship which is being celebrated (Swales 1988). As well as embodying a displacement, such accounts are also an idealization, for the self and for the visitor. In one sense, the ability to produce such accounts amounts to a kind of examination on social norms; in another sense it represents the necessity of a pole of orientation.

Second, the celebration of conjugality in the domestic interior is hardly new, and a number of 'new domesticity' revolutions have been discovered by historians: the shift of aristocratic family focus from lineage to couple in the eighteenth century (Trumbach 1977); the domestication of the early nineteenth-century bourgeoisie, associated with 'separate spheres' (Davidoff and Hall 1987); companionate marriage in the early twentieth century (Franklin 1989) and its extension in 'joint marriage' (Bott 1957; cf. Partington 1989 and Morley 1990a). One needs to disentangle the specificity of each from a tradition–modernity polarity.

The 'jointness' in current British discussions of conjugality refers principally to shared leisure time, both within and outside the home. In comparison with marriages of separate spheres, such partnerships typically involve paid employment for women outside the home, as well as more time spent by the man within it. However, as Franklin (1990) points out, the new conjugality may involve a strong complementarity of roles – the extent to which this may have been attenuated in the territory of housework has been the subject of some dispute (see Cowan 1989) – and there may also be a greater and more obvious domination of shared time and space by the male than in a segregated marriage.

Third, although contemporary conjugality is not one end of a tradition–modernity polarity, the long-term processes of centralization of economic life and formalization of knowledge which have instigated the installation

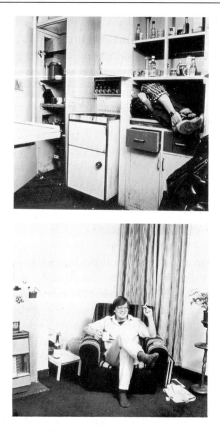

Figure 9.2 The home is a welter of improvisation.

of the modern home, have a differential impact both within and between households. Those forces that appear to enhance the autonomy of the couple may also challenge the previously defined unity of the conjugal household (Allen and Crow 1989). The home environment is not only able but expected to cater for individualized activities. One sign of this is the demand for dedicated personal space, and appropriate technologies, for all household members (Morley and Silverstone 1990).

Recent studies reveal two patterns in the new conjugality in home-making in Britain. The first pattern involves a general blurring of function-ally defined room boundaries and a weakening of the association of gender with particular spaces in the house. Instead there is a focus on particular pursuits – work or leisure – and their supports, which often involve new technologies. Where rooms are dedicated, this is more likely to be on a personal rather than a functional basis. The home is a welter of improvisa-tion and a base for activities. Received gender roles in the household have been transgressed to some extent. The socioeconomic position of this

household is likely to be in that part of the intermediate strata where cultural rather than economic capital is predominant.

The second pattern involves extensive DIY or bricolage which has not, however, blurred the functional boundaries of rooms, (Almquist's 'carpentry culture'). In this case, there appears to be a link between renovation work and gender complementarity (Miller's 'neo-traditionalism'). This redefined complementarity pervades domestic roles, although the man spends more time at home and the woman less than in a segregated marriage. The place of technologies in the home is likely to be constrained within these patterns. Overall, the home is a project to be realized as well as a centre for leisure and recuperation. The socioeconomic position of this household is likely to be of well-paid manual or clerical workers.

The two groups of couples have a few things in common. Both are likely to be house-owners, although each pattern can be sustained in rented accommodation and in flats. Both kinds of couple believe they occupy a social place and direction of movement somewhat different from that of their parents. Both possess a diverse network of chosen social contacts relating to work or leisure interests. In both kinds of household, domestic labour and responsibility is typically compulsory for women, and optional for men.

The statistical importance of each pattern in contemporary Britain is not known.[1] While the studies surveyed are neither fully comparable nor, taken together, comprehensive, the two patterns identified are sufficiently different to cast doubt on any generalizations which might be made about the temper of a 'new conjugality'. The first is oriented around the relationship between mutuality and individuality and moves towards the deconstruction of its own presuppositions. The second is oriented around the relationship between reciprocity and identity, and works towards the reconstruction of tradition.

These emphases are related to distinctive preoccupations in domestic design. The classic problem for the first group is the redefinition of the comforts and opportunities afforded by a large old house (Swales 1988). This provides endless opportunities for personal exploration and collective realignment; the adaptations of the house are a metaphor for the social process of the family group. The classic problem for the second group is room 'improvement or modernization' – especially of the kitchen, as in Miller (1990). Whereas a previous generation would have occupied separate spheres, now design and labour were being exchanged to demonstrate the complementarity of the genders within the household. Where, as in Miller's black households, gender division was not connected with room use, men took their own decorative initiatives in the kitchen.

The two groups produce their greatest impact on the home environment at different points in the life stage. The first pattern involves the redefinition of space and accumulation of objects as family, careers and avocational interests develop. The second pattern is an extension of the practice of 'setting-up home' before rearing children. The obligation of both partners

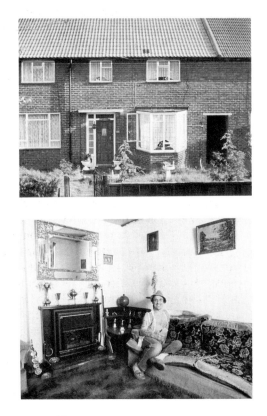

Figure 9.3 Home-ownership.

to work to acquire the requisites of contemporary comfort reinforces jointness in relaxation and in project-planning at home. The importance of role redefinition is dramatized by the juxtaposition of shared experience and internalized gender norms, reinforced by peer and family expectations. When children arrive, both resources for modification and symbolic tension are reduced, to re-emerge at a later stage when the children leave and the couple must redefine its internal dynamic, personal and conjugal goals and social identity.

These distinctive orientations towards home investment and domestic consumption characterize distinct social fractions in the process of formation. The first group crystallizes around educational investment and culture as a disciplined pleasure. The improvised quality of much of its home arrangement reflects both cultural capital and the capacity for further development, with the latter aspect receiving particular emphasis. The second group creates the home as a refuge and a mark of achievement, and its consumption reflects not so much investment in the socioeconomic

system as compensation for effort. Social goods are displayed as marks of achievement rather than as developmental means. Although this group's consumption goods may be more varied, its reference more current and 'ambitious' than among traditional segregated marriages, traditions persist in areas that are important to family role definition, such as the three-piece suite (Morley 1990a).

Role expectations for mothers in these studies carry the marks of class-differentiation in segregated marriages. Mother as educator is very different from mother as servant (Hunt 1989). In contemporary conjugality, both of these roles are reinforced by the kind of work which could be performed by the women concerned 'outside' the home (Franklin 1990). Child-rearing forces a prioritization which clarifies the extent and basis of jointness in practice. The ways in which gender categories are redefined also, however, leave their mark on the home environment.

These studies indicate something of how social relations are refashioned in the home-making matrix. Class-distinctive modes of consumption are evident beneath an apparent accession to a standard of living with global access. This difference in social practice implies differential modes of emplacement, appropriation of objects, and social encounter. Such differences revolve around the extent to which subjects see the world as transactable, with perhaps a greater emphasis on compensatory autonomy on the one hand and control of change on the other. These are hardly new themes in the sociology of class formation (Bernstein 1971; Bourdieu 1984); they underline the fact that the dream of the modern home has been realized to the extent that people have been able to make full use of resources of the network.

Much further work is needed on the contemporary home as a cultural site, especially on the dialectic of transmission between generations in a household. Modern infrastructures of education and communication, and an enhanced standard of accommodation would appear to have given greater autonomy to the young in relation to parental cultural practices while increasing their interaction with outside cultural influences. In this sense, 'the home' as an ideological category may come to have a less definite and fully specified signification, which is not to say that the area it designates has become less important in emplacement.

NOTES

1 Swales's (1988) survey in Birmingham's 'pink triangle' turned up only variants on the first pattern. Both groups appeared in Johnston's (1980) survey of Guildford, among which owner-occupiers predominated, along with a group influenced by feminism to aspire to the first pattern but who were unable to move their partners in this direction. Miller's 1984 (1990) survey of Islington council tenants and Wallman's (1984) survey in Battersea produced the second pattern in a sample which also included more segregated marriages. Segregated marriages were

dominant in the older London working-class samples interviewed by Morley (1990b) and Brain-Tyrrell (1990). Hunt's (1989) interviews with five middle-class and five working-class families in Stoke did not include an example of either pattern. (This discussion draws on these studies, together with those of Devine 1989, Segalen 1990 and Almquist 1989.)

REFERENCES

Allen, G. and Crow, G. (1989) *Home and Family*, London: Macmillan.
Almquist, A. (1989) 'Who wants to live in collective housing?', unpublished paper, Gavle, Swedish Institute for Building Research.
Altman, I. and Low, S. (eds) (1991) *Place Attachment*, New York: Plenum.
Appadurai, A. (ed.) (1986) *The Social Life of Things*, Cambridge: Cambridge University Press.
Baudrillard, J. (1981) *For a Critique of the Political Economy of the Sign*, London: Telos.
Berman, M. (1988) *All That is Solid Melts into Air*, New York: Penguin.
Bernard, Y. (1990) 'Life-style evolution and home use', unpublished paper, Paris, Laboratoire Psycologie D'Environnement.
Bernstein, B. (1971–7) *Class, Codes and Control* (3 vols), London: Routledge.
Bonvalet, C. (1989) 'Housing and the life cycle', unpublished paper, Paris, Institution Nationale d'Études Démographiques.
Bott, E. (1957) *Family and Social Network*, London: Tavistock.
Bourdieu, P. (1984) *Distinction*, London: Routledge.
Brain-Tyrrell, A. (1990) 'Objects of necessity', MA dissertation in the History of Design, Middlesex University.
Brindley, T. (1989) 'Social theory and architectural innovation in housing design', unpublished paper, Leicester Polytechnic.
Cowan, R. S. (1989) *More Work for Mother*, London: Free Associations.
Davidoff, L. and Hall, C. (1987) *Family Fortunes*, London: Hutchinson.
de Certeau, M. (1984) *The Practices of Everyday Life*, Berkeley: California University Press.
Deem, R. (1989) *All Work and No Play?*, Milton Keynes: Open University Press.
Devine, F. (1989) 'Privatised families and their homes', in G. Allen and G. Crow (eds) *Home and Family*, London: Macmillan.
Duncan, J. (ed.) (1981) *Housing and Identity*, London: Croom Helm.
Feldman, R. (1989) 'Psychological bonds with home places in a mobile society', unpublished paper, University of Illinois.
Forrest, R. and Murie, A. (1987) 'The affluent homeowner', in N. Thrift and P. Williams (eds) *Class and Space*, London: Routledge.
Franklin, A. (1989) 'Working class privatism: an historical case study of Bedminster, Bristol', *Society and Space* 7 (1).
—— (1990) 'Variations in marital relations and the implications for women's experience of the home', in T. Putnam and C. Newton (eds) *Household Choices*, London: Futures.
Galassi, P. (1991) *Pleasures and Terrors of Domestic Comfort*, New York: Museum of Modern Art.
Gaunt, L. N. (1989) 'Housing Quality', Lund: National Board for Housing, Building and Planning.
Goodall, P. (1983) 'Gender, design and the home', *BLOCK* 8.
Harris, C. (ed.) (1979) *The Sociology of the Family*, Keele: British Sociological Association.

Hebdige, R. (1988) *Hiding in the Light*, London: Comedia.

Heidegger, M. (1975) *Poetry, Language, Thought*, New York: Harper.

Hunt, P. (1989) 'Gender and the construction of home life', in Allen and Crow (eds) *Home and Family*, London: Macmillan.

Johnston, D. (1980) 'Women's attitudes towards the kitchen', unpublished PhD thesis, University of Surrey.

Kaufman, J. C. (1991) 'Les habitudes domestiques', in F. de Singly (ed.) *La Famille*, Paris: La Découverte.

Lefebvre, H. (1971) *Everyday Life in the Modern World*, London: Allen Lane.

Lofgren, O. (1990) 'Consuming interests', *Culture and History* 7.

Madigan, R. and Munro, M. (1990) 'Ideal homes: gender and domestic architecture', in T. Putnam and C. Newton (eds) *Household Choices*, London: Futures.

Marshall, G., Newby, H., Rose, D. and Vogler, C. (1988), *Social Class in Modern Britain*, London: Hutchinson.

Mass Observation (1944), *People's Homes*, London: Mass Observation.

Matrix (1984) *Making Space: Women and the Manmade Environment*, London: Pluto.

Miller, D. (1987) *Material Culture and Mass Consumption*, Oxford: Basil Blackwell.

—— (1990) 'Approaching the state on the council estate', in T. Putnam and C. Newton (eds) *Household Choices*, London: Futures.

Morley, C. (1990a) 'The three piece suite', MA dissertation in History of Design, Middlesex University.

—— (1990b) 'Homemakers and design advice in the postwar period', in T. Putnam and C. Newton (eds) *Household Choices*, London: Futures.

Morley, D. and Silverstone, R. (1990) 'Families and their technologies', in T. Putnam and C. Newton (eds), *Household Choices*, London: Futures.

Pahl, R. (1984) *Divisions of Labour*, Oxford: Basil Blackwell.

Pallowski, K. (1988) 'Die Schwierigkeit der Designer mit dem Geschmack der Leute', *Designactuel* 1: 26–43.

Partington, A. (1989) 'The designer housewife in the 1950s', in J. Attfield and P. Kirkham (eds), *A View From the Interior*, London: Women's Press.

Putnam, T. (1991) 'The aesthetics of the living room', *Issue* 7, London: Design Museum.

—— (1992) 'Regimes of closure and the representation of cultural process in the making of home', in R. Silverstone (ed.) *Consuming Technologies*, London: Routledge.

Putnam, T. and Newton, C. (eds) (1990) *Household Choices*, London: Futures.

Rullo, G. (1990) 'Experience of the home among young adults', unpublished paper, Rome, Instituto di Psicologia.

Rybczynski, W. (1986) *Home: A Short History of an Idea*, New York: Viking.

Saunders, P. (1984) 'Beyond housing classes', *International Journal of Urban and Regional Research*, pp. 201–27.

Saunders, P. and Williams, P. (1988) 'The constitution of the home: towards a research agenda', *Housing Studies* 3 (2).

Segalen, M. (1990) *Être bien dans ses meubles*, research report, Paris: Centre d'Ethnologie Française.

Silverstone, R. (ed.) (1992) *Consuming Technologies*, London: Routledge.

Swales, V. (1988) 'Personal space and room use in Moseley', MA research paper in History of Design, Middlesex University.

Tomlinson, A. (1990) *Consumption, Identity and Style*, London: Routledge.

Trumbach, R. (1977) *The Rise of the Egalitarian Family*, London: Academic Press.

Wallman, S. (1984) *Eight London Households*, London: Routledge.

Part III

Moving times

Chapter 10

Global and local cultures[1]

Mike Featherstone

Contextualism is heretofore spelled with a capital C; the living world appears only in the plural; ethics has taken the place of morality, the everyday that of theory, the particular that of the general.

(Habermas 1984, quoted in Schor 1987: 3)

The man who finds his country sweet is only a raw beginner; the man for whom each country is as his own is already strong; but only the man for whom the whole world is as a foreign country is perfect.

(Eric Auerbach, quoted in McGrane 1989: 129)

er lasst sich nicht lesen – 'it does not permit itself to be read'

(Edgar Allen Poe, *The Man of the Crowd*, 1840)

It has become a cliché that we live in one world. Here we think of a variety of images: the photographs of the planet earth taken in space by the returning Apollo astronauts after setting foot on the moon; the sense of impending global disaster through the greenhouse effect or some other man-made catastrophe; the ecumenical visions of various traditional and new religious movements to unite humanity; or the commercial use of this ecumenical sentiment which we find in the Coca-Cola advertisement which featured images of legions of bright-eyed young people from the nations of the world singing together 'We are the world'. Such images heighten the sense that we are interdependent; that the flows of information, knowledge, money, commodities, people and images have intensified to the extent that the sense of spatial distance which separated and insulated people from the need to take into account all the other people which make up what has become known as humanity has become eroded. In effect, we are all in each other's backyard. Hence one paradoxical consequence of the process of globalization, the awareness of the finitude and boundedness of the planet and humanity, is not to produce homogeneity but to familiarize us with greater diversity, the extensive range of local cultures.

THE GLOBALIZATION OF CULTURE

That the process of globalization leads to an increasing sensitivity to differences is by no means preordained. The possibility that we view the world through this particular lens, or form, must be placed alongside other historical possibilities. One perspective on the process of globalization which was accorded a good deal of credibility until recently was that of Americanization. Here a global culture was seen as being formed through the economic and political domination of the United States which thrust its hegemonic culture into all parts of the world. From this perspective the American way of life with its rapacious individualism and confident belief in progress, whether manifest in Hollywood film characters such as Donald Duck, Superman and Rambo or embodied in the lives of stars such as John Wayne, was regarded as a corrosive homogenizing force, as a threat to the integrity of all particularities.[2] The assumption that all particularities, local cultures, would eventually give way under the relentless modernizing force of American cultural imperialism, implied that all particularities were linked together in a symbolic hierarchy. Modernization theory set the model into motion, with the assumption that as each non-Western nation eventually became modernized it would move up the hierarchy and duplicate or absorb American culture, to the extent that ultimately every locality would display the cultural ideals, images and material artefacts of the American way of life. That people in a wide range of countries around the world were watching *Dallas* or *Sesame Street* and that Coca-Cola cans and ring-pulls were to be found all around the world, was taken as evidence of this process.

The separation of cultures in space was seen as reducible to a more fundamental separation in time. The prioritization of time over space has been a central feature of theories of modernity. A central concern of the major figures in social theory from the Enlightenment onwards such as Vico, Condorcet, Saint-Simon, Comte, Spencer, Hegel, Marx, Weber and Durkheim was to seek to understand social relationships and state–society units in developmental terms. The move from traditional to modern societies was seen as accountable in terms of a range of specific processes: industrialization, urbanization, commodification, rationalization, differentiation, bureaucratization and the expansion of the division of labour, the growth of individualism and state formation processes. It was generally assumed that these processes, which arose within what has increasingly been dubbed as Western modernity, had a universalizing force; that Western history was universal world history. Incorporated within these theories in varying degrees of explicitness was the assumption that history had an inner logic, or directional impetus, which was understood as progress. The idea of progress implies some direction to history and

suggests the finitude of history, the eventual deliverance into, or arrival at, a better or ideal social life or 'good society'.

It is this assumption of a destination for history which has been most strongly challenged by what have become known as postmodern theories. Vattimo (1988), for example, argues that we are taking leave of modernity in abandoning the notion of development. Postmodernity is not to be regarded as a new epoch, a new stage of development on from modernity, but as the awareness of the latter's flawed assumptions. The key assumption of modernity's account of Western history is progress. In fact, this is the secularization of Judaic–Christian notions of salvation and redemption which become transformed into the belief in progress through the development of science and technology to bring about the perfectibility of man and human society. Postmodernism is to be regarded as 'the end of history' in the sense of the end of the belief in the overcoming of the present in pursuit of the 'new'.[3] It does not, of course, refer to the end of the objective process of history, only the end of our awareness of history as a unitary process. This secularization of the notions of progress and the perfectibility of the world entails a greater awareness of the constructed nature of history, of the use of rhetorical devices and the capacity to deconstruct narratives (something that was discussed at great length by Simmel (1977) over a century ago; for a more recent account, see Bann 1984). It also points to a greater awareness of the plurality of history, the suppressed narratives within history that suggest that there is no unitary privileged history, only different histories.[4] From this perspective, there clearly are global developments and processes that increasingly bind together the individual histories of particular nation states and blocs, yet the confidence with which they could be incorporated into a single, explanatory, global historical narrative has been lost. In this sense, the attempts to construct a global history become immeasurably complicated as the value perspective from which such a construction takes place becomes contested and effectively relegates theories with universalistic pretensions to the status of local histories.

If one of the characteristics associated with postmodernism is the loss of a sense of a common historical past and the flattening and spatialization out of long-established symbolic hierarchies (see Featherstone 1991), then the process of globalization, the emergence of the sense that the world is a single place, may have directly contributed to this perspective through bringing about a greater interchange and clashing of different images of global order and historical narratives. The perception of history as an unending linear process of the unification of the world with Europe at the centre in the nineteenth century and the United States at the centre in the twentieth century, has become harder to sustain with the beginnings of a shift in the global balance of power away from the West. Hence, in the late twentieth century, there is increasingly the recognition that the

non-Western world has histories of its own. Particularly important in this process in the post-Second World War era has been the rise of Japan, not only because its economic success seemed to present it as outmodernizing the West, but because the Japanese began to articulate theories of world history that disputed the placing of Japan on the Western-formulated continuum of premodern, modern and postmodern societies (see Miyoshi and Harootunian 1989). Hence there has been a growing awareness that history is not only 'temporal or chronological but also spatial and relational' (Sakai 1989: 106), that our history is generated in relation to other spatially distinct, coexisting temporalities. If nations can maintain isolation from other nations, or possess as a bloc of nations the economic and political power to be able to ignore the challenges of others, there is every possibility that they will be able to sustain fantasy images of their own superiority. This may take on a number of forms. One of the best known is the image of the Orient as housing all the exotic differences and otherness which have been repressed and cast out by the West as it sought to construct a coherent identity (Said 1978). Alternatively, there is the assumption that in the last analysis, 'they are just like us' and that the West is consequently granted the moral right and duty to guide and educate them because of the necessity to civilize the totality.[5] In either case, the West understands itself as the guardian of universal values on behalf of a world formed in its own self-image. It is only when other nations acquire the power to speak back, to make the West have to listen and notice their resistance, that constructions such as 'the Orient' – which is given some vague sense of unity in terms of it being the construct which objectifies all that is left outside the West when it seeks to constitute its identity as progressive – becomes problematic (Sakai 1989: 117). It is only then that we begin to discover the complexity and range of oriental and other civilizations' images of the West as the 'other'.

The sense that there are plural histories to the world, that there are diverse cultures and particularities which were excluded from Western modernity's universalistic project, but now surface to the extent that they cast doubts on the viability of the project, is one particular outcome of the current phase of the process of globalization. It points to the more positive evaluation by the West of otherness and differences resulting from the shift in the balance of power between nations which find themselves progressively bound together in a global figuration from which it is increasingly difficult to opt out. This entails the sense that the world is one place, that the globe has been compressed into a locality, that others are neighbours with which we must necessarily interact, relate and listen. Here the assumption is that the density of contacts between nations will itself lead to a global culture. In this case the notion of a global culture must be distinguished from that of the nation state.

National cultures have usually emerged alongside state formation pro-

cesses in which cultural specialists have reinvented traditions and reshaped and refurbished the ethnic core of the people. As nation states became increasingly drawn together in a tighter figuration of competing nations, they faced strong pressures to develop a coherent cultural identity. The process of the homogenization of culture, the project of creating a common culture, must be understood as a process in the unification of culture of the need to ignore, or at best synthesize and blend, local differences.[6] It is the image of the completion of this process, to the extent that culture oils the wheels of the social relationships and institutions that make up society, which became dominant within sociology: culture regarded as an unproblematic, integrated pattern of common values. Yet the process of formation of such a culture cannot be understood merely as a response to forces within the nation state, but must also be seen in relation to forces outside of it: the potential for the development of national identity and cultural coherence as relationally determined by the structure of the shifting disequilibriums of power and interdependencies of the figuration of nation states within which a particular country was embedded.

It is clearly hard to stretch this conception of culture to the global level and in no way can a global culture be conceived as the culture of the nation state writ large. Not that this is a historical possibility which could automatically be ruled out. It is possible to conceive that one result of the elimination contest of power struggles between nations could have been the dominance of a single nation, which would be in a position to seek to develop a global common culture alongside its extended state formation process. This process of cultural formation would be much easier in the face of some external threat; here one would have to conceive the globe as subjected to some extraterrestrial or intergalactic threat. A further possibility would be the response to a perceived threat to the continued viability of life on the planet through some ecological disaster. In either case, the process of cultural formation and development of a common identity for the world as an 'in-group' is in response to the development of a mission to meet the challenge of an 'out-group'. There are clearly a range of other possibilities (such as a federation of nations, or the triumph of a particular religion or trading company) which could in theory have led to the formation of a global culture (see Robertson 1990a, 1991).

The ways in which different nations have been drawn together into a tighter figuration through closer financial and trade ties, through the increasing development of technology to produce more efficient and rapid means of communication (mass media, transport , telephone, fax, etc.), and through warfare has produced a higher density of interchanges. There has been an increase in a wide variety of cultural flows which increase transnational encounters. Appadurai (1990), for example, refers to the increasing flows of people (immigrants, workers, refugees, tourists, exiles), technology (machinery, plant, electronics), financial information (money,

shares), media images and information (from television, film, radio, news-papers, magazines) and ideologies and world views. While some might wish to see the motor force for these changes as the relentless progress of the capitalist economy towards a world system (Wallerstein 1974, 1980) or the movement towards a new, disorganized or 'post-Fordist' stage of capitalism (Lash and Urry 1987), for Appadurai there is a disjunction between the cultural flows. On the practical level, the intensification of flows results in the need to handle problems of intercultural communication. In some cases this leads to the development of 'third cultures' which have a mediating function, as in the case of legal disputes between persons from different national cultures (Gessner and Schade 1990). In addition, there is the further new category of professionals (lawyers, accountants, management consultants, financial advisers, etc.) who have come into prominence with the deregulation and globalization of financial markets with 24-hour stock market trading, plus the expanding numbers of 'design professionals' (specialists who work in the film, video, television, music, fashion, advertising and consumer culture industries) (King 1990). All these specialists have to become familiar with a number of national cultures as well as developing, and in some cases living in, third cultures. The majority of these third cultures will draw upon the culture of the parent country from which the organization originated. It is therefore evident that the cultures which are developing in many of the global financial firms have been dominated by American practices. The same situation applies with regard to many culture industries, such as television, film and advertising. Yet these third cultures do not simply reflect American values, their relative autonomy and global frame of reference necessitates that they take into account the particularities of local cultures and adopt organizational cultural practices and modes of orientation which are flexible enough to facilitate this. Hence the practical problems of dealing with intensified cultural flows between nations leads to the formation of a variety of third cultures which operate with relative independence from nation states.

Furthermore, this is not to imply that the increased cultural flows will necessarily produce a greater tolerance and cosmopolitanism. An increasing familiarity with 'the other', be it in face-to-face relations, or through images, or the representation of the other's world view or ideology, may equally lead to a disturbing sense of engulfment and immersion. This may lead to a retreat from the threat of cultural disorder into the security of ethnicity, traditionalism or fundamentalism, or the active assertion of the integrity of the national culture in global cultural prestige contests (e.g., the Olympic Games). To talk about a global culture is equally to include these forms of cultural contestation. The current phase of globalization is one in which nation states in the West have had to learn to tolerate a greater diversity within their boundaries which is manifest in greater multiculturalism and polyethnicity. This is also in part a consequence of

their inability to channel and manipulate global cultural flows successfully, especially those of people, information and images, which increases the demand for equal participation, citizenship rights and increased autonomy on the part of regional, ethnic and other minorities. Those who talk about such issues within nation states are also increasingly aware that they are talking to others outside the nation state. That there is something akin to the formation of global public opinion was evident in the unfolding of the independence struggles of Lithuania and other nationalities within the Soviet Union, as well as in the Kuwait Gulf crisis and war. Such incidents as they develop frequently involve appeals to notions of humanity, or the appropriate norms of behaviour within and between states, which while contested increase the awareness that there is a world stage and that the world is increasingly becoming one place. From the point of view of social science and sociology, in particular, this should make us aware that

> commitment to the idea of the culturally cohesive national society has blinded us to the various ways in which the world as a whole has been increasingly 'organized' around sets of shifting definitions of the global circumstance. In fact it would not be too much to say that the idea of a global culture is just as meaningful as the idea of national-societal, or local, culture.

> (Robertson 1991)

LOCAL CULTURE

It is striking that one of the effects of the process of globalization has been to make us aware that the world itself is a locality, a singular place. This is apparent not only in the images of the world as an isolated entity in space, which photographs of the earth from the moon provided, but also in the sense of its fragility, its finitude and openness to irreparable damage and destruction. While, as Durkheim argued, the sense of our common humanity might be expected to increase alongside our awareness of the sacredness of the human person as the only thing we all have in common in an increasingly differentiated world in which particularities become more evident, it is also possible to extend this argument to life, and the home of our life, the earth. Of course, this perspective is nothing if not limited and contested, but it does point to the localization of globality, the perception of the finite and limited nature of our world.

Usually, a local culture is perceived as being a particularity which is the opposite of the global. It is often taken to refer to the culture of a relatively small bounded space in which the individuals who live there engage in daily, face-to-face relationships. Here the emphasis is upon the taken-for-granted, habitual and repetitive nature of the everyday culture of which individuals have a practical mastery (Bourdieu 1977). The common stock

of knowledge at hand with respect to the group of people who are the inhabitants and the physical environment (organization of space, buildings, nature, etc.) is assumed to be relatively fixed; that is, has persisted over time and may incorporate rituals, symbols and ceremonies that link people to a place and a common sense of the past. This sense of belonging, the common sedimented experiences and cultural forms which are associated with a place, is crucial to the concept of a local culture. Yet, as our example of 'planet earth' as a locality shows, the concept of local culture is a relational concept. The drawing of a boundary around a particular space is a relational act which depends upon the figuration of significant other localities within which one seeks to situate it.[7]

For example, if I meet another European in China after spending a number of years there, it would be expected that we would find sufficient cultural forms in common from our experience of being European to revive collective memories which can constitute a temporary sense of common identity, or community, which demarcates 'us' from the 'them' of the host people. Alternatively, a similar sense of membership and belonging may be revived from meeting another Englishman while residing in France, or a Northern Englishman while spending a period of exile in London (a person who, incidentally, may come from a neighbouring town to mine and with whom I might normally have an intense rivalry). This symbolic aspect of community boundaries (Cohen 1985) is also evident when one considers relationships within a village in which those who define their localness in terms of length of residence may refuse membership to outsiders. Hence the 'we-images' and 'they-images', which are generated within local struggles to form an identity and exclude outsiders, cannot be detached from the density of the web of interdependencies between people. Such struggles between established and outsider groups (Elias and Scotson 1965), will therefore become more common with the extent of contact with others, which bring groups of outsiders more frequently into the province of local establishments.

In addition to this face-to-face dimension of direct contact with outsiders, which may under certain circumstances reinforce local cultural identity, there is also the perceived threat to this through the integration of the locality into wider regional, national and transnational networks via the development of a variety of media of communication. Here it is possible to point to the development of the various transcultural media of interchange of money, people, goods, information and images of which we have already spoken which have the capacity to compress the time–space geography of the world. This provides contact with other parts of the world which renders different local cultures more immediate and the need to make them practically intelligible more pressing. For example, given the spatial dispersal of corporations with the flexible specialization of post-Fordist industrial production, local people in Brazil, the north-east of

England or Malaysia will have to interpret the strategies of Japanese or American management and vice-versa. It also integrates localities into more impersonal structures in which the dictates of market or administrative rationalities maintained by national elites or transcultural professionals and experts have the capacity to override local decision-making processes and decide the fate of the locality. It is in this sense that the boundaries of local cultures are seen to have become more permeable and difficult to maintain, to the extent that some proclaim that 'everywhere is the same as everywhere else'. It is also often assumed that we live in localities where the flows of information and images have obliterated the sense of collective memory and tradition of the locality to the extent that there is 'no sense of place' (Meyrowitz 1985).

In terms of our earlier remarks about the deglobalizing reactions to global compression and the intensity of global flows, it would be expected that the generation of such nationalistic, ethnic and fundamentalist reactions to globalization could also entail a strong assertion of local cultures. These might take the form of reviving or simulating local traditions and ceremonies, or inventing new ones. Before proceeding to a discussion of these strategies, it would be useful to focus on the notion of a loss of a sense of place, or homelessness, in more detail. The condition of nostalgia is usually taken to refer to this loss of home in the sense of physical locale (Davis 1974). But in addition to this 'homesickness', it has also been used to point to a more general loss of a sense of wholeness, moral certainty, genuine social relationship, spontaneity and expressiveness (Turner 1987). While this sense of loss can motivate some to formulate romantic schemes or art forms to recreate some golden age or deliver some future utopia, it is worth enquiring into how a sense of home is generated.

It can be argued that a sense of home is sustained by collective memory, which itself depends upon ritual performances, bodily practices and commemorative ceremonies (Connerton 1989). The important point here is that our sense of the past does not primarily depend upon written sources, but rather on enacted ritual performances and the formalism of ritual language. This may entail commemorative rituals such as weddings, funerals, Christmas, New Year, and participation or involved spectatorship at local, regional and national rituals (e.g., royal weddings, nation days, etc.). These can be seen as the batteries which charge up the emotional bonds between people and renew the sense of the sacred. A sacred which can only rarely be regarded as operating as an integrating canopy for a nation state, yet this should not be taken to imply that the sacred has evaporated completely under the assault of the globalizing forces we have mentioned; rather it would be better to speak of the dissipation of the sacred, that it operates in a variety of ways amongst a wide range of groups of people (see Featherstone 1991; ch. 8; Alexander 1988).[8]

One of the ways it operates in localities is in the countless little rituals,

rites and ceremonies which take place in the embodied practices between friends, neighbours and associates. The little rituals entailed in buying a round of drinks in a particular way, or turning up to occupy the same seats in a pub each week, help formalize relationships which cement the social bonds between people. It is when we leave that place for some time and return that we seek out habits of home in which our body responds with ease as it falls into comforting, taken-for-granted routines – like a dog eager to perform its tricks for a returning master. It is the co-ordination of bodily gestures and movements which have never been verbalized or subject to reflection; the familiar smells and sounds; the ability to touch and look at things which have become charged with symbolism and affect. It is the apparent absence of such affective and symbolic sedimentation into the material fabric of the buildings and environment and the embodied practices of social life which prompt remarks such as Gertrude Stein made with reference to Oakland, California: 'there's no there there.' Of course, for the inhabitants of the town, there may have been a strong sense of place and local culture; what Stein was referring to was recognizable cultural capital.

One of the dangers of the 'no sense of place' type of arguments is that they seem to point to processes that are assumed to be universal in their impact and which do not vary historically. It may, for example, be possible to detect particular phases induced by changes in the process of globalization and relations between states which intensify or decrease the sense of homelessness and nostalgia. It has been argued that the phase of intense globalization which took place between 1880 and 1920 and which drew in more nations into a tightly structured, global figuration of interdependencies and power balances, produced an intense nationalism and 'wilful nostalgia' (Robertson 1990b: 45ff.). The efforts of nation states to produce homogeneous, integrated common cultures and standardized citizens loyal to the national ideal led to attempts to eliminate local ethnic and regional differences. This was a phase of the establishment of national symbols and ceremonies and the reinvention of traditions which were manifest in Royal Jubilees, Bastille Day, the Olympic Games, the Cup Final, the Tour de France, etc. Within societies that were rapidly modernizing and eliminating tradition, these rites created a desire to celebrate the past; they instituted forms of imitation and mythical identification which have persisted (Connerton 1989). The fact that such rites and ceremonies were invented should not be taken to mean they were invented *ex nihilo*: they drew upon traditions and ethnic cultures which possessed plausibility. The fact that they were spectacles which have become commodified and promoted to wider audiences need not be taken to imply that they have induced passivity amongst citizens who are essentially manipulated. As they became part of the popular culture of modern societies, they were often used by particular groups in ways different to that intended by their

originators, groups who effectively renegotiated meanings of symbols and the sacred. Here spectatorship should not be understood as passive, or remote from the bodily enacting of rituals. For those who watch on television major events such as the Cup Final or a Royal Wedding, the place of viewing may borrow some of the festive aura of the actual event, with people dressing up, singing, dancing, etc. as they watch together either at home or in public places like bars or hotels.

A second phase of nostalgia can be related to the late-twentieth-century phase of globalization which has taken place since the 1960s and is associated by many commentators with postmodernism (Robertson 1990b; see also Heller 1990). This second phase is in response to some of the globalizing processes we spoke of earlier, which in the current phase can be related to pressures (which for the large part are being successfully met in the West) for nation states to reconstitute their collective identities along pluralistic and multicultural lines which take into account regional and ethnic differences and diversity. In this present phase, the response to nostalgia in the recreation and invention of local, regional and subnational cultures (in Europe we think of the cultural assertiveness of the Welsh, Scots, Bretons, Basques, etc.) has also to be placed alongside the perceived destruction of locality through the globalization of the world economy, expansion of the mass media and consumer culture, but also can be understood as using these means to reconstitute a sense of locality. Hence the qualities of populism, syncretism, fragmentation and multi-coding, the collapse of symbolic hierarchies, the end of the sense of progress and historical 'new', and the positive attitude towards the excluded 'other' which are usually associated with postmodernism, can also be traced back to the emphasis upon these qualities that we find within the development of consumer culture (Featherstone 1991). In particular, those developments in architecture and the organization of space which are often referred to as postmodern, represent a movement beyond the abstract characterization of space with its emphasis upon pure form which we find in architectural modernism (Cooke 1990). With postmodernism, there is a re-emergence of the vernacular, of representational forms, with the use of pastiche and playful collaging of styles and traditions. In short, there is a return to local cultures, and the emphasis should be placed upon local cultures in the plural, the fact that they can be placed alongside each other without hierarchical distinction. The reconstruction of inner-city areas and docklands in the wake of the 1980s global financial boom produced a spate of such building in the form of new shopping centres, malls, museums, marinas, and theme parks. Localization is clearly evident in the processes of gentrification as the new middle class moved back into the city to restore old neighbourhoods or live within purpose-built simulations designed to recreate a certain ambience, whether it be a Mediterranean village in the docklands, or artistic bohemias in a warehouse district.

One characteristic frequently used to describe this type of architecture is 'playful'. Certainly, many of the spaces and façades have been designed to produce a sense of disorientation, wonder and amazement as one steps inside locations which simulate aspects of past traditions and futuristic and childhood fantasies. Theme parks, contemporary museums and the whole heritage industry play to this sense of recreating a home which takes one back to a past experienced in fictional form. Disney World is one of the best examples: there one can ride on Tom Sawyer's riverboat or climb up into the Swiss Family Robinson's tree house in which the combination of realistic film-set scenery, animatronics, sounds and smells are frequently sufficient to persuade adults to suspend disbelief and relive the fiction. If one is able to journey 'home' to childhood fantasies, then one is also persuaded to relive one's own and others' childhood memories through 'factions': the capacity to explore open-air and indoor industrial or every-day life museums, such as Beamish in the north-east of England (Urry 1990). Here the reconstruction of working coal-mines, trams, corner shops and trains can actually take people into the physical reconstruction of past localities where preservation of the real merge with simulations. For old people, this must provide an uncanny sense of the local cultures they lived in, when effectively they can step inside a typical room, handle the tin bath-tub or mangle for wringing clothes. Such postmodern spaces could be regarded as commemorative rituals which reinforce, or help regain, a lost sense of place. At the same time, they encourage the performance of rites, the watching of simulated performance or the participation in bodily practices which revive many aspects of the past cultural forms. They encourage a 'controlled decontrol of the emotions', a receptivity to, and experimentation with, emotional experiences and collective memories previously closed off from experience. They encourage the adult to be childlike again, and allow the child to play with simulated ranges of adult experiences.[9] Of course, not everyone experiences these sites in the same ways. It is the new middle class, especially those who have had higher education or work in the culture industries or the professions, who are most well disposed to experiment with the reconstitution of locality, the controlled decontrol of the emotions, and the construction of temporary aesthetic communities of the type to which Maffesoli (1988) refers. We therefore have a very uneven picture, the possibility of misreadings and misunderstandings as different class fractions, age and regional groupings mingle together in the same urban sites, consume the same television programmes and symbolic goods. Such groups possess different senses of affiliation to localities and the propriety of engaging in the construction of imagined communities. They utilize goods and experiences in a range of different ways, and a careful analysis of their everyday work and liminal practices is necessary if we are to discover the range of affiliations to locality which operate.

CONCLUDING REMARKS

It should by now be apparent that the notions of global and local cultures are relational. It is possible to refer to a range of different responses to the process of globalism, which could be heightened or diminished depending upon specific historical phases within the globalization process. First, we can point to the attitude of immersion in a local culture. This could take the form of remaining in a long-established locality and ignoring the efforts to be drawn into wider collectivities and to erect barriers to cultural flows. This, however, is difficult to achieve without military and economic power which are essential if one is to avoid being drawn into broader regional interdependencies and conflicts. Hence there is the problem of being left alone, of remaining undiscovered, or of controlling and regulating the flow of interchanges even when geographical reasons (e.g. the case of Japan) facilitate isolation. On a more mundane level, from the point of view of some tribes, this may come down to the question of the best strategies which can be used to resist or ignore those tourists who quest after some last authentic, untouched remnant of 'real culture' such as those who go to New Guinea on cannibal tours. This can be related to the problems faced by those in the West who in this context develop a sense of protective responsibility and seek to devise strategies to conserve what they take to be a genuine local culture without placing it in a protective reservation in which it becomes a simulation of itself, as it has been argued was the case when an allegedly unknown tribe was recently discovered in the Philippines (Baudrillard 1983).

Second, such communities which are increasingly becoming drawn to the global figuration, will also have to cope periodically with the refugees from modernization, those members of ethnic groups who are romantically attracted to the perceived authenticity of a simpler life and sense of 'home'. Here we think of the disparaging descriptions of them by their host groups which display their doubts about their capacity to acquire permanent membership with depictions such as 'red apples' (returning first nation North Americans, who are held to be red on the outside and white on the inside), and 'coconuts' (returning Hawaiians seen as brown on the outside and white inside) (Friedman 1990). While such groups can be seen as searching to live out their version of an 'imagined community', the caution on the part of the locals shows that a crucial dimension of the relationship between them can be understood in terms of established-outsider struggles.

Third, variants of the refurbished imagined community also exist in the rediscovery of ethnicity and regional cultures within the current phase of a number of Western nation states which seek to allow a greater recognition of regional and local diversity and multiculturalism. Within certain

contexts it may be appropriate to wear the mask of local affiliation, as in the case of dealing with tourists, or confronting local rivals (Scotsmen on meeting Englishmen). This can entail varying degrees of seriousness and playfulness. Here we can also point to the fact that this capacity to move backwards and forwards between various elements of national cultures which are manifest in everyday public and work situations and the local affiliation, may take the form of regular ritual re-enactments of the imagined community. This is clearly the case in societies which have been settled by Europeans such as the United States, Canada, Australia and New Zealand, in which various indigenous local affiliations as well the maintenance of imagined communities on the part of immigrant groups, has pushed the questions of multiculturalism and respect for local cultures onto the agenda.

Fourth, those locals who travel, such as expatriates, usually take their local cultures with them (Hannerz 1990). This is also the case with many tourists (especially those from the working class) whose expectation from the encounter with another culture is to remain on the level of sun, sea, sand plus 'Viva España' style stereotypes. In effect they seek 'home plus' and will do all they can to take comforting aspects of their local culture with them and limit the dangers of intercultural encounters to 'reservation-style' experiences (Bauman 1990).

Fifth, there are those whose local affiliation is limited, whose geographical mobility and professional culture is such that they display a cosmopolitan orientation. Here we have those who work and live in 'third cultures' who are happy to move between a variety of local cultures with which they develop a practical, working acquaintance and the bridging third culture which enables them to communicate with like persons from around the world.

Sixth, there are cosmopolitan intellectuals and cultural intermediaries, especially those from the post-Second World War generation, who do not seek to judge local cultures in terms of their progress towards some ideal derived from modernity, but are content to interpret them for growing audiences of those who have been through higher education within the new middle class and wider audiences within consumer culture (Bauman 1988). They are skilled at packaging and re-presenting the exotica of other cultures and 'amazing places' and different traditions to audiences eager for experience. They are able to work and live within third cultures, as well as seemingly able to present other local cultures from within, and 'tell it from the native's point of view'. This group can be regarded as post-nostalgic, and can relate to growing audiences in the middle classes who wish to experiment with cultural play, who have forgone the pursuit of the ultimate authentic and real, who are content to be 'post-tourists' and enjoy both the reproduction of the effect of the real, the immersion in it in controlled or playful ways, and the examination of the backstage areas on which it draws (Fiefer 1985).

At the same time it should be emphasized that this list of the range of possible affiliations to various forms of local and global cultures should not in any sense be understood as exhaustive. One of the tendencies often associated with postmodern theories is to assume that our present stage of development, or particular set of theoretical aporias, is somehow final and eternal. The current fascination with local cultures and the 'other', and the tendency for these to be broken down in a relentless search to discover yet more complex formulations of otherness, may not be sustained. Although this perception may be driven by the populist and egalitarian tendencies associated with postmodernism, it can be argued that the increasing quest to discover particularity and detail, the drive towards deconstruction and deconceptualization, may itself represent a phase in which a partial shift in the balance of power away from the Western nations may be represented as an indication of some present or future final levelling. Hence the discovery of the different voices of a wider and more complex range of localities and modes of otherness, may occur at particular phases of a process in which powerful establishments are forced to recognize and acknowledge the claims of outsider groups. This need not mean that a dramatic levelling has taken place, rather it may point more to a struggle to reconfigure the conceptual apparatus to take account of the implications of this shift: a reconfiguration in which notions of detail, particularity and otherness are used to point to the difficulty of conceptually handling a greater degree of cultural complexity. At the same time, these struggles, which are often driven by outsider groups within Western cultural establishments, may themselves be regarded as limited and patronizing by those they seek to represent under the blanket concept of otherness. Hence for some others who are denied or granted a very limited access to the global means of communication, there would seem little possibility of compelling those within the dominant cultural centres to take account of their views, in their own terms. In this situation a characteristic response to their self-appointed guardians in the West might be 'Don't other me!'

This would suggest that our present, so-called postmodern condition is best understood not as a condition, but as a process. It is possible to see the global balance of power shifting further away from the Western bloc in the future without profoundly benefiting those Third World others who may be the current cause for concern. Certainly, if the rise in the power potential of Japan and other East Asian nations continues, it is possible that these Third World nations may be confronted by a further source of globalizing and universalizing images which provoke a new range of problems and defensive strategies. Needless to say, such tendencies would also provoke further problems in the reconceptualization of a confident self-image in the West. In addition, if past world history is any guide to the future, while a benevolent world state which tolerates

diversity is one possible outcome of the present process, there are other alternatives. The possibility of an intensification of competition between nation states and blocs cannot be ruled out, something which could take the form of elimination contests involving trade wars and various forms of warfare. Under such conditions, one would expect a series of defensive reactions in the form of mobilization of nationalisms and common cultures, with strongly defined stereotyping 'we-images' and 'they-images' which have little time for more nuanced notions of otherness. It is evident that the current global circumstance already incorporates these and other possibilities and we must be careful to avoid perpetuating our own particular conceptions of global and local cultures, however compelling they may seem.

NOTES

1 An earlier version of this paper was presented at the Netherlands Leisure Studies Association meeting, Utrecht, January 1991. I would like to thank those who attended for their comments. I would also like to thank Hans Mommaas and Donald Levine for helpful suggestions for revising earlier versions of this paper.

2 See on this the work of Mattelart (1979), especially his *How to Read Donald Duck*, and Schiller (1985). (For critical disscusions of cultural imperialist theories see Smith 1990; Featherstone 1987; Tomlinson 1991). Although the notion of Americanization was something which became most explicit in the writings of critics of cultural imperialism, it was also an implicit assumption which could be detected in modernization theories. It is also worth noting that while Americanization was seldom made explicit in the modernization theories which became influential from the 1960s onwards, it was certainly an assumption of a good many American citizens that modernization entailed cultural Americanization.

3 The term 'the end of history' was first used by Cournot in 1861 to refer to the end of the historical dynamic with the perfection of civil society (see Kamper 1990). Arnold Gehlen adopted it in 1952 and it has been taken up more recently by Heidegger and Vattimo.

4 As we shall shortly see, the impetus for this does not only come from the West in terms of an inward-looking loss of confidence, but arises practically through the encounters with 'the other' who refuses to accept the Western version of history. One example of the construction of global culture is therefore the attempt to construct world histories. For a discussion of the difficulties involved in participating in the UNESCO project to bring together historians from various nations to construct a world history and the resultant conflicts and power struggles, see Burke (1989).

5 Needless to say, this is very different from the assumption that 'we are just like them' which lacks the assumption that they are subordinates who will eventually become educated to be like us. Rather to assume that 'we are just like them' is to assume that we can learn from them and are willing to identify with them.

6 It is important to stress that the process of the homogenization of culture is an image which the nation state represents to itself, which may take numerous forms such as rituals and ceremonies. It is not the actual elimination of differences, the

vestiges of regional, ethnic and local affiliations which is crucial, but the perception of the right of the state to do so, that such ties are backward and deviant and must be neutralized through education and civilizing processes.

7 For an interesting discussion of the spatial elasticity of the concept 'homeland' (*agar*) which in Ethiopian culture can mean anything from a local hamlet to the national state, see Levine (1965).

8 That the collective conscience and society-encompassing sense of the sacred might still be generated in modern societies was a preoccupation of Durkheim. Yet little did he and his 'heir', Marcel Mauss, realize that their conception of society would be actualized in the Nuremberg rallies of the Nazis. As Mauss commented, 'We ought to have expected this verification for evil rather than for good' (quoted in Moscovici 1990: 5).

9 It should also be mentioned that for some of the young people, the newer urban spaces of large cities (such as the Les Halles area of Paris) offer the opportunity to experiment with types of affiliation hitherto often denied. Hence Maffesoli (1988) refers to the emergence of postmodern 'affective tribes' in which young people momentarily come together to generate spontaneously a temporary sense of *Einfuhlung*, emotional oneness and intensity. These tribes are not attached to particular locales nor do they have the exclusivity of membership normally associated with tribes, yet they do suggest the capacity to generate collective emotional experiences in terms of the dissipation of the sacred we have spoken of. The same could be said for contemporary rock concerts which can generate an intense emotional sense of togetherness and an ethical concern for nature, the Third World, etc. This would suggest that the dangers to 'ontological security' which Giddens (1990) associates with our present phase of what he calls 'high modernity' may have been overestimated.

REFERENCES

Alexander, J. (ed.) (1988) *Durkheimian Sociology*, Cambridge: Cambridge University Press.

Appadurai, A. (1990) 'Disjunction and difference in the global cultural economy', *Theory Culture & Society* 7 (2–3).

Bann, S. (1984) *The Clothing of Clio: A Study of Representations of History in Nineteenth Century Britain and France*, Cambridge: Cambridge University Press.

Baudrillard, J. (1983) *Simulations*, New York: Semiotext(e).

Bauman, Z. (1988) 'Is there a postmodern sociology?' *Theory Culture & Society* 5 (2–3).

—— (1990) 'Modernity and ambivalence', *Theory Culture & Society* 7 (2–3).

Bourdieu, P. (1977) *Outline of a Theory of Practice*, Cambridge: Cambridge University Press.

Burke, P. (1989) 'New reflections on world history', *Culture and History* 5.

Cohen, A. K. (1985) *The Symbolic Construction of Community*, London: Tavistock.

Connerton, P. (1989) *How Society Remembers*, Cambridge: Cambridge University Press.

Cooke, P. (1990) *Back to the Future: Modernity, Postmodernity and Locality*, London: Unwin Hyman.

Davis, F. (1974) *Yearning for Yesterday: A Sociology of Nostalgia*, New York: Free Press.

Elias, N. and Scotson, J. L. (1965) *The Established and the Outsiders*, London: Cass.

Featherstone, M. (1987) 'Consumer culture, symbolic power and universalism', in G. Stauth and S. Zubaida (eds) *Mass Culture, Popular Culture and Social Life in the Middle East*, Boulder, Colorado: Westview Press.
—— (1991) *Consumer Culture and Postmodernism*, London: Sage.
Fiefer, M. (1985) *Going Places*, London: Macmillan.
Friedman, J. (1990) 'Being in the world: globalization and localization', *Theory Culture & Society* 7 (2–3).
Gessner, V. and Schade, A. (1990) 'Conflicts of culture in cross-border legal relations', *Theory Culture & Society* 7 (2–3).
Giddens, A. (1990) *The Consequences of Modernity*, Cambridge: Polity Press.
Habermas, J. (1984) 'Remettre le mobile en mouvement', *Le monde d'aujourd'hui*, 6 Aug.
Hannerz, U. (1990) 'Cosmopolitans and locals in world culture', *Theory Culture & Society* 7 (2–3).
Harvey, D. (1989) *The Condition of Postmodernity*, Oxford: Basil Blackwell.
Heller, A. (1990) *Can Modernity Survive*, Cambridge: Polity Press.
Kamper, D. (1990) 'After modernism: outline of an aesthetics of posthistory', *Theory Culture & Society* 7 (1).
King, A. (1990) 'Architecture, capital and the globalization of culture', *Theory Culture & Society* 7 (2–3).
Lash, S. and Urry, J. (1987) *The End of Organized Capitalism*, Cambridge: Polity Press.
Levine, D. (1965) *Wax and Gold: Tradition and Innovation in Ethiopian Culture*, Chicago: Chicago University Press.
McGrane, B. (1989) *Beyond Anthropology: Society and the Other*, New York: Columbia University Press.
Maffesoli, M. (1988) *Le temps des tribus*, Paris: Klincksieck.
Mattelart, A. (1979) *Multinational Corporations and the Control of Culture*, Brighton: Harvester.
Meyrowitz J. (1985) *No Sense of Place*, London: Oxford University Press.
Moscovici, S. (1990) 'Questions for the twenty-first century', *Theory Culture & Society* 7 (4).
Miyoshi, M. and Harootunian, H. (eds) (1989) *Postmodernism and Japan*, Durham, NC: Duke University Press.
Robertson, R. (1990a) 'Mapping the global condition: gobalization as the central concept, *Theory Culture & Society* 7 (2–3).
—— (1990b) 'After nostalgia? Wilful nostalgia and the phase of globalization', in B. S. Turner (ed.) *Theories of Modernity and Postmodernity*, London: Sage.
—— (1991) 'Social, theory, cultural relativity and the problem of globality', in A. D. King (ed.) *Culture, Globalization and the World System*, New York: Macmillan.
Sakai, N. (1989) 'Modernity and its critique: the problem of universalism and particularism', in M. Miyoshi and H. D. Harootunian (eds) *Postmodernism and Japan*, Durham, NC: Duke University Press.
Said, E. (1978) *Orientalism*, London: Routledge.
Schiller, H. I. (1985) 'Electronic information flows: new basis for global domination?', in P. Drummond and R. Patterson (eds) *Television in Transition*, London: British Film Institute.
Schor, N. (1987) *Reading in Detail: Aesthetics and the Feminine*, London: Methuen.
Simmel, G. (1977) *The Problem of a Philosophy of History*, trans. and ed. G. Oakes, New York: Free Press.
Smith, A. (1990) 'Towards a global culture?', *Theory Culture & Society* 7 (2–3).

Tomlinson, J. (1991) *Cultural Imperialism*, London: Pinter.
Turner, B. S. (1987) 'A note on nostalgia', *Theory Culture & Society* 4 (1).
Urry, J. (1990) *The Tourist Gaze*, London: Sage.
Vattimo, G. (1988) *The End of Modernity*, Cambridge: Polity Press.
Wallerstein, I. (1974) *The Modern World-System I*, London: Academic Press.
—— (1980) *The Modern World-System II*, London: Academic Press.

Chapter 11

Cities without maps

Iain Chambers

The city, the contemporary metropolis, is for many the chosen metaphor for the experience of the modern world. In its everyday details, its mixed histories, languages and cultures, its elaborate evidence of global tendencies and local distinctions, the figure of the city, as both a real and an imaginary place, apparently provides a ready map for reading, interpretation and comprehension. Yet the very idea of a map, with its implicit dependence upon the survey of a stable terrain, fixed referents and measurement, seems to contradict the palpable flux and fluidity of metropolitan life and cosmopolitan movement. Maps are full of references and indications, but they are not peopled. You often need a map to get around a city, its subway system, its streets. But that preliminary orientation hardly exhausts the reality in which you find yourself. The city plan is both a rationalization of space and of time; its streets, buildings, bridges and roads are also temporal indices. It permits us to grasp an outline, a shape, some sort of location, but not the contexts, cultures, histories, languages, experiences, desires and hopes that course through the urban body. The latter pierce the logic of topography and spill over the edges of the map.

Beyond those edges, and abstract, one-dimensional indications, we encounter the space of the vibrant, everyday world and its challenge of complexity. Here we find ourselves in the gendered city, the city of ethnicities, the territories of different social groups, shifting centres and peripheries; the city that is both a fixed object of design (architecture, commerce, urban planning, state administration) and simultaneously plastic and historical: the site of transitory events, movements, memories. This is also a significant space for analysis, critical thought and comprehension. I want to use this essay to reflect on this space and the opportunity it provides in reconsidering the scope and sense of cultural analysis today.

The idea of both lived and intellectual complexity, of Edgar Morin's '*la pensée complexe*', introduces us to a social ecology of being and knowledge. Here both thought and everyday activities move in the realm of uncertainty. Linear argument and certainty break down as we find ourselves orbiting in a perpetual paradox around the wheel of being: we

bestow sense, yet we can never be certain in our proclamations.[1] The idea of cultural complexity, most sharply on display in the arabesque patterns of the modern metropolis – and that includes Lagos as well as London, Beijing and Buenos Aires – weakens earlier schemata and paradigms; it destabilizes and decentres previous theories and sociologies. Here the narrow arrow of linear progress is replaced by the open spiral of hybrid cultures, contaminations, and what Edward Said has recently referred to as 'atonal ensembles'.[2] It is a reality that is multiformed, heterogeneous, diasporic. The city suggests a creative disorder, an instructive confusion, an interpolating space in which the imagination carries you in every direction, even towards the previously unthought.[3] Here, in the dissonance and interrogation that lie between what Donna Haraway calls 'situated' and 'disembodied knowledges', the very location of theory is disturbed.[4]

STARTING OUT FROM PARIS

> If initially the world market sterilizes local sources, in a second moment it revitalizes them.
>
> (Edgar Morin)[5]

Barbès is the traditional Arab immigrant quarter of Paris, the home of the sounds of Algerian raï, of Cheb Khaled. Here was born the statement '*Je suis un beur!*', where '*beur*' is the not exact inversion, but rather a deliberate mixing up, of the word '*arabe*'. The '*beurs*' (in Paris there is also Radio Beur, along with Radio Maghreb) are French born of Arab parents. '*Beur*' signifies a difference, a particular history and context, a cultural ambiguity.

There is also rap. BAB ('Bombe à Baiser') is a member of the Zulu nation of Rome who, with his white, Italian collaborator, produces electronic instrumentation over which he raps in French. There is the ABC Nation. Their members, aged between 17 and 20, come from the French Antilles, Cameroon and Mali. They sport wide jeans, baseball caps, basket-ball pumps, rectangular hair cuts: the 'Zulu look'. On the northern periphery of Paris, in areas such as St Denis, Aubervilliers and La Courneuve, all last stops on the Métro, is 'Zululand'. It is here, in the 'banlieue populaire', the 'popular suburbs' on the edges of the city, that sounds and stories from West Africa, from the Antilles, from the Maghreb, are mixed up and mixed down in reggae, raï and rap. The references are to Dr Martin Luther King, rebel chants against Babylon and the police, in praise of Malcolm X ('prophet of rage'). The raps are in French, with occasional phrases in English, and much in a subcultural slang. It is part of a melange that stretches from the Bronx to Brixton, to Barbès, to Brazzaville. Composed of connective rhythms and local inflections, it proposes instances of mixing, remixing, translating and transforming a shared tonality into particular voices and situations. It helps to articulate

the dissonance of the experiences of a particular time and place: to be Arab *and* French, to be black *and* Parisian.

Such examples, easily verified in similar but distinct histories in London or New York, do not suggest an integration with existing hegemony or the mainstream of metropolitan life, but rather with the shifting, mixing, contaminating, experimenting, revisiting and recomposing that the wider horizons and the inter/trans-cultural networks of the metropolis both permit and encourage. They offer us that 'magic in which the connection of certain social facts with certain sounds creates irresistible symbols of the transformation of social reality'.[6]

TO JOURNEY WITHOUT MAPS

> Ethics comes from *ethos* and Heidegger translates this Greek word not so much in the sense of 'the character that belongs to man', but as 'lodging', 'the place where one lives', 'the open region in which man dwells'.
>
> (Pier Aldo Rovatti)[7]

> To be simultaneously 'rooted and rootless'.
>
> (Trinh T. Minh-ha)[8]

The labyrinthine and contaminated quality of metropolitan life not only leads to new cultural and musical connections, it also undermines the presumed purity of thought. If critical thought can entertain this encounter, and abandon a distanced monologue for dialogue, it curves downwards into the everyday world and a different register. To travel in this zone, without maps and charts, is to experience the dislocation of the intellectual subject and his, the gender is deliberate, mastery of the word/world. The illusions of identity organized around the privileged voice and stable subjectivity of the 'external' observer are swept up and broken down in a movement that no longer permits the obvious institution of self-identity between thought and reality.

To inhabit this world, both intellectually and ethically, individually and socially, is, as Trinh T. Minh-ha puts it, to struggle to continue in its continuation.[9] Here the individual does not dominate, but rather lets go and loses him- or herself in order to explore and find parts of that self. This opens up the possibility of 'dislodging the inertia of the "I" '.[10] It leads to the release of diverse voices, an encounter with an 'other' side, an unfolding of the self, and negates the possibility of reducing diversity to the identical. Knowledge takes a holiday, a sabbatical, from the traditional ideas of truth and scholarship as unitary and transcendental entities. Against the virility of a self-assured, strong thought it proposes a weaker, but more extensive, mode of thinking that is contaminated, transgressive, multi-directional and transitive.[11]

The intellectual condemnation of mass culture and the mass media, although today more subdued, a little less self-assured, is still widespread. The Italian critic Franco Rella has recently pointed out that it is a line of argument based on principles that have yet to be demonstrated: 'the disappearance of the individual and the subject in the mass; the evil of technology. In the end the impression is not that of coming closer to the truth, but to a neurosis (or the diagnosis of a neurosis).'[12] Still, there remain many still willing to mouth the total critique of mass culture and to condemn it as 'ideology' or, more brutally, as mere propaganda. The most salient features of that critique are: that both art and the mass media are a commodity, what other values they may have or have had are now completely overdetermined by this fact, and the same applies to mass culture, and (at least Adorno argued this) to much of culture as a whole. Culture can no longer provide an alternative, only a diversion; it has been reduced to a technological display (records, radio, cinema, television, compact disks, video), blindly absorbed in the circuits of capital.

To this we can oppose some countervailing observations: technology is the web in which we are embedded and in which the sense, the truth, of our condition, is revealed (Heidegger).[13] The mechanical and, by now, electronic reproduction that is inherent in modern mass culture involves the shattering of tradition and the secularization of the image. This, in turn, leads to a distracted reception in which we all become 'experts' and learn to move around inside the languages of the mass media.[14] It leads to the suggestion of a 'metropolitan aesthetics', to a potential democratization of the use of signs and images, and the space for an unsuspected politics of everyday life.

Opposed to the abstractions of an ideological critique of mass culture – invariably presented as a homogeneous totality, without contradictions or room for subtle, subaltern or alternative voices – are the details and divergences that are historically revealed in how people go about using and constructing a sense inside this culture, usually in a manner unforeseen by the producers of the 'culture industry'.

The monolithic critique of contemporary culture as a homogeneous, ideological bloc (i.e., 'capitalist culture', 'bourgeois art'), is concerned with the philosophical fate of mankind (sic) and the alienation of MAN in the abstract. It has little to say about how real women and men get by and make sense of the conditions in which they find themselves. It cannot speak to the lives, fears, hopes, passions and expressions revealed in the immediate culture of the everyday world. But what if contradictions lie not between capital and an imagined alternative or utopia, but in the very conditions of capitalist society? This is what Marx seems to be saying when he insists that the new society will emerge out of the old, as internal contradictions lead to new developments, new possibilities and a widened intercourse between those caught up in the social relations of modern

capitalism.[15] This proposes a step away from the historical intellectual mission to maintain a clear distinction between culture and industry, art and commerce, and reflects an awareness that industry, commerce and urbanization are integral to the production of contemporary culture.

This debate, and its consequences, runs throughout the whole course of what we might call modernity. It is a central and often contradictory theme in Marshall Berman's influential book, *All That is Solid Melts into Air*. It was inaugurated by Romanticism around 1800, and its opposition to the mechanical body of industry (Dr Frankenstein and his monster), but itself also drew upon the distinctions, elaborated by Kant in the 1780s, between the rational and the aesthetic realm. It was such a distinction that allowed the sphere of culture to be treated as an autonomous reality, the source of eternal values, untouched by immediate history and the dirty hands of industry, commerce and the city.

From this debate we inherit a largely transcendental, or metaphysical, view of art and culture, an atemporal reality separate from the everyday world. Whereas the argument that comes from below, as it were, from inside the details and different histories of both popular culture and the changes induced in culture as a whole by industrialization, urbanization, globalization and commerce, suggests an opposed, secular view. Here culture, its values and aesthetics, are not timeless but, rather, inexorably caught up in time, in the restless movement and shifting tides of the world. Here there are no eternal values, no pure states: everything, including cultures of resistance and the oppositional arts, is destined to emerge, develop and die within this movement.

The classical 'subject' – the semantic centre and habitat of such a stable conception of knowledge and aesthetics – no longer holds the stage. We now confront the liberation of differences under the sign of 'homelessness'. Out of this emerges a significant critical shift in which the understanding and interpretation of our languages (artistic, political, cultural) are no longer tied to an epistemological reading that rests upon appeals to a unique and homogeneous truth that supposedly guarantees critical thought and 'distance'. Instead, there is the evocation of the idea of an ontological truth that comes to be inscribed in our being; in the continual becoming and mutation of our being in the languages in which we are cast (in the sense of being both formed and thrown). In such a manner, the critique of consumerism comes to be based on consumerism itself, on the rules of the game and its languages of identity. Just as the critique of technology is expressed through the deployment of technology, as, for example, in the Wim Wenders' film *Until the End of the World* (1991). Here nothing is fixed, our analyses are constantly forced to change focus and attention. There are no longer unambiguous positions that are eternally true, but shifting constellations of meaning, identities, openings and possibilities.

Such an enframing of our lives requires analyses attentive to the differ-

ent histories, nuances and narratives that combine in making up our present. Here the commonplace, and apparently homogeneous, material of popular tastes and cultures, reveals more complex stories and ways of making sense. It involves, as Michel de Certeau insisted, listening to and following this frequently overlooked activity. These are activities that, while drawing upon the vocabularies of established lexicons and languages – cinema, television, music, the supermarket, the newspaper – and remaining subject to those languages, nevertheless establish trajectories of interests and desires that are neither necessarily determined nor captured by the system in which they develop. In this sense, as de Certeau goes on suggestively to underline, we all become nomads, migrating across a system that is too vast to be our own, but in which we are fully involved, translating and transforming bits and elements into local instances of sense. It is this remaking, this transmutation, that makes such texts and languages – the city, cinema, music, culture and the contemporary world – habitable: as though they were a space borrowed for a moment by a transient, an immigrant, a nomad.

> The 'making' in question is a production, a *poiesis* – but a hidden one, because it is scattered over areas defined and occupied by systems of 'production' (television, urban development, commerce, etc.), and because the steadily increasing expansion of these systems no longer leaves 'consumers' any *place* in which they can indicate what they *make* or *do* with the products of these systems. To a rationalized, expansionist and at the same time centralized, clamorous and spectacular production corresponds *another* production, called 'consumption'. The latter is devious, it is dispersed, but it insinuates itself everywhere, silently and almost invisibly, because it does not manifest itself through its own products, but rather through its *ways of using* the products imposed by a dominant economic order.[16]

> And since one does not 'leave' this language, since one cannot find another place from which to interpret it, since there are therefore no separate groups of false interpretations and true interpretations, but only illusory interpretations, since in short there is no *way out*, the fact remains that we are *foreigners* on the inside – *but there is no outside*.[17]

If you lack your own space, you have to get along in the network of already established forces and representations. And it is in such historical details, in the often unobserved and overlooked everyday politics of her- and his-stories, that we can cut the older ideological knot between capital and culture and critically get beyond both the condemnation of everyday culture as ideology and its apologetic and merely populist defence.

This suggests that there is no exterior 'truth' to be salvaged from the immediate world of commerce and everyday popular culture; that somehow beneath the surface and inside the sign there lurks a deeper message.

The argument, central to both the Marxist and Baudrillardian critique of the sign (fetishism, simulacrum), is that surfaces and appearances are simply the deceptive, seductive and mystifying manifestations of an underlying reality: the alienation of the human condition. But this reduction to a hidden value – the values of 'authenticity' supposedly masked by false appearances – denies the ontological reality of signs, appearances and everyday life. It denies that they, too, are sites of sense, of meaning. To appreciate this opening, this particular possibility, means once again taking a sabbatical from the ideological critique that has traditionally directed our attention.

HOLIDAYS IN JAPAN

The idea of letting go, of taking a holiday from the languages that usually position us, of drifting free from domestic meanings, is how Roland Barthes prefaces his writings on Japan: *Empire of Signs*. He refers to that '*loss of meaning* that Zen calls a *satori*', and muses on the 'retreat of signs'. He uses his encounter with the 'other' not to presume to explain that alterity, but rather to go beyond himself, his own language and sign culture, and thereby disturb and question the presumed stability of the symbolic order of which he is a part. Here differences although recognized remain as differences, irreducible to the same, they exist as a supplement, an excess that causes 'knowledge, or the subject, to vacillate'.[18]

This idea of facing the other, of acknowledging differences, and with them the diverse descriptions that constitute our world, is not merely a geographical encounter typical of the metropolitan intellectual. It is also an encounter to be found within the internal territories of our own cultures, on the 'other' side of the city, culture and languages we inhabit.

'Japan' offers the possibility of undoing our own 'reality' and displaces the usual position, or topology, of the subject, together with her or his voice and authority. What has been taken for granted, considered 'natural', hence universal, is revealed to be local and historical.[19] This Barthesian awareness, to return to the earlier point, does not emerge from excavating beneath the surfaces of appearances so much as from putting surface to surface, sign to sign, and there in the lateral or horizontal plane registering the difference. These are the differences that Barthes discovers in appearances – what he calls the 'shimmer of the signifier' – as found in the ornamental and fragmented arrangement of food, in the ceremonial bow, in the painted ideogram, in the Pachinko players, in the disregard for the Western illusion of totality in the *Bunraku* theatre, in the transitory instance of the haiku and its temporary suspension of finality (what we in the West call 'meaning'): signs, as Barthes puts it, in describing Tokyo, that reminds us 'that the rational is merely one system among others'.[20]

So, for Barthes, the plenitude of haikus, of these minimal expressions of

the 'here and now' (*hic et nunc*), of these gestures of writing, provide a space of pure fragments in which it is language itself that is celebrated in an 'exemption from meaning'. Although Barthes then modifies the statement and goes on to say that what is 'abolished is not meaning but any trace of finality'. There remains just a trace, a designation of words, where meaning is 'only a flash, a slash of light'. Without a centre or direction to grasp, there is just 'a repetition without origin, an event without cause, a memory without person, a language without moorings'.[21]

Signs and language can be set free from immediate referents. This is what Barthes's particular 'Japan' permitted him to contemplate. But with this we are not necessarily condemned to joining Baudrillard and the cultural pessimists in announcing the end of meaning. What Barthes's text opens up is the opposite of a resigned nihilism: it proposes an excess of sense. We become aware that signs can be cast loose from their meanings in one system of thought, language, culture and history and acquire other, sometimes unrecognizable, perhaps incomprehensible, ones elsewhere. Such a semiotic movement, of setting sign to sign, and appearance to appearance, on the surfaces of language and culture, does not avoid the question of significance, but rather supplements, extends and complicates it.

THE RUINS OF MODERNITY

We could contrast this perspective with a project that is clearly intent on an opposed trajectory, determined to break through the appearances of the modern world and the arc of modernity. It results in analyses, certain in their description, that are prematurely foreclosed in their insistence on seeking an ultimate finality, an anchorage and shelter in the realm of 'authentic' being and its traditions.

Picking up some of the key words and concepts that Marshall Berman employs in *All That is Solid Melts into Air*, and running them against the grain of his own account, we might also consider what further sense emerges.

> the modern public expands, it shatters into a multitude of fragments, speaking incommensurable private languages: the idea of modernity, conceived in numerous fragmentary ways, loses much of its vividness, resonance and depth, and loses its capacity to organize and give meaning to people's lives. As a result of all this, we find ourselves today in the midst of a modern age that has lost touch with the roots of its own modernity.[22]

Berman's declared desire is to 'chart traditions to understand the ways in which they can nourish and enrich our own modernity.'[23] But what if modernity, as he himself elsewhere acknowledges, is not about continuity

but discontinuity? What if there is no uninterrupted inheritance that reaches into the present from the past, but instead bits and pieces that exist in our present as traces, as elements not of an unique tradition but of different histories that are continually being recomposed? What, in other words, if there has occurred a historical shift in the very understanding of 'tradition' and its identification with a unitary sense of belonging? There is, after all, a major difference between tradition defined by an uninterrupted faith in an imagined 'community' and the recognition of complex identities forged in discontinuous, heterogeneous histories in a contingent world. In the latter case, we are forcefully reminded of Walter Benjamin's observation that 'discontinuity is the foundation of an authentic tradition'.[24] Here, traditions and roots become less important in themselves, as though stable tokens of a vanished 'authenticity', and acquire significance as part of a flexible and composite inheritance that is drawn upon, rewritten and modified in assembling an effective passage through the present. 'Roots' become routes.

Berman wants to put modernity back on the right tracks. But if the Faustian double-bind – that is, the drive towards 'progress' and 'modernization' at whatever price – is integral to modernity, why is he so reluctant to put those terms, and the very idea of 'modernity' itself, in question? He leaves us with the impression that modernity was once a noble project that has now degenerated, and that in order to salvage it we need to get back to its sources, to its wellsprings. My suggestion is that we cannot go back. That genesis exists today only as traces in memory, elements that we can choose to reconstruct through historical and textual analysis; stories and accounts that we encounter, interpret, hence position, inscribe and locate, in our present. We can never return to the scene of our beginnings and their presumed 'origins'.[25]

The actors assembled by Berman in his epic account – the writer, the people, the crowd – are all abstract unities, unified (pre-Freudian) subjects. It is as though they were merely the (by)products of modernity, modernization and the capitalist mode of production, and not also its producers. The only producers that Berman's chronicle permits are those writers, thinkers, artists and architects capable of riding the storm of capitalist development. In a decidedly Romantic view of artistic expression and 'genius', attention is continually drawn to the voice, invariably male, that manages to rise above the maelstrom and cast it into the canon of significant expression.

Finally, there is the tragedy of modernity. For Berman this is played out on the world stage in the internal contradictions of progress, modernization and capitalism. Agreed, it is indeed a global process. All I would suggest is that when we look further into the particular histories that make up modernity, we will discover that the raging sickness of the times sets problems and proposals that permit us to move beyond the nostalgic

appeal for a lost unity, coherence and unified sense of tradition. They present us with heterogeneous subjectivities, with histories and languages intent on transforming the traces and fragmented inheritance of the past, together with other more immediate borrowings and suggestions, into a meaningful present. It is these particular histories that offer us the chance to consider further the contemporary sense of the city, its languages, cultures and possibilities. This means to put aside the intellectual comfort afforded by the rational clarity of 'negative dialectics' and abstract unities, and to take a walk in the city. It is there, paying attention to its multiple voices, its ethnographic details, diverse stories and not always commensurable realities, that we are drawn beyond ourselves and the critical world we once inhabited.

NO EQUATION . . .

modernity resides in its ambiguous status as a demand for external guarantees inside a culture that has erased the ontological preconditions for them.

(William E. Connolly)[26]

The discourse of radical democracy is no longer the discourse of the universal; the epistemological niche from which 'universal' classes and subjects spoke has been eradicated, and it has been replaced by a polyphony of voices, each of which constructs its own irreducible . . . identity. This point is decisive: there is no radical and plural democracy without renouncing the discourse of the universal and its implicit assumption of a privileged point of access to 'the truth'.

(Ernesto Laclau and Chantal Mouffe)[27]

Naturally, all this is a prelude, part of a reflection gathered from looking at the scene of contemporary cultural analyses, and at the histories, prospects and lives that frame such work. I have tried to unpack some of the analytical baggage that is still being carried around in this landscape, and which frequently passes for critical 'common sense'. To query that perspective is hopefully already to reveal in the undoing of its language other, more open, ways of formulating questions and prospects. To move through such ruins, and into the subsequent openings, is to enter into another type of dialogue with the possibilities of our present.

NOTES

I would like to thank the graduate students of the 'Communications and the City' class at Hunter College, CUNY, who in the spring of 1990 encouraged, and sometimes contested, the above remarks.

1 Edgar Morin, *La méthode. 1. La nature de la nature*, Paris, Éditions du Seuil, 1977.

2 Edward Said, 'Figures, configurations, transfigurations', in *Race and Class* 32 (1), 1990, p. 16.

3 Giacomo Leopardi, *Zibaldone*; see Franco Rella, *Asterischi*, Milan, Feltrinelli, 1989, p. 33.

4 Quoted in Lata Mani, 'Multiple mediations: feminist scholarship in the age of multinational reception', in *Inscriptions 5*, 1989. This latter essay contains an important discussion on the shifting location and subsequent disturbance of theory.

5 Edgar Morin, '1965: We don't know the song', in Edgar Morin, *Sociologie*, Paris, Fayard, 1984; Italian edition, Rome, Edizioni lavoro, 1987, p. 92.

6 Greil Marcus, *Lipstick Traces. A Secret History of the Twentieth Century*, London, Secker & Warburg, 1989, p. 2.

7 Pier Aldo Rovatti, in Alessandro Dal Lago and Pier Aldo Rovatti, *Elogio del pudore*, Milan, Feltrinelli, 1990, p. 39.

8 Trinh T. Minh-ha, 'Cotton and iron', in Russell Ferguson, Martha Gever, Trinh T. Minh-ha and Cornel West (eds), *Out There: Marginalization and Contemporary Cultures*, Cambridge, MA, MIT Press, 1990, p. 335.

9 Trinh T. Minh-ha, *Woman, Native, Other*, Bloomington and Indianapolis, Indiana University Press, 1989, p. 49.

10 Pier Aldo Rovatti, in Alessandro Dal Lago and Pier Aldo Rovatti, *Elogio del pudore*, Milan, Feltrinelli, 1990, p. 30.

11 This is to introduce the post-Nietzschean theme of 'weak thought', most widely associated with the work of the Italian philosopher Gianni Vattimo. See Gianni Vattimo, *The End of Modernity*, Cambridge, Polity Press, 1988. For a further exploration of this trope in the context of cultural analyses, see my *Border Dialogues. Journeys in Postmodernity*, London and New York, Routledge, 1990.

12 Franco Rella, *Asterischi*, Milan, Feltrinelli, 1989, p. 25.

13 Martin Heidegger, 'The question concerning technology', in Martin Heidegger, *The Question Concerning Technology and Other Essays*, New York, Harper, 1977.

14 Walter Benjamin, 'The work of art in the age of mechanical reproduction', in Walter Benjamin, *Illuminations*, New York, Schocken Books, 1969.

15 Karl Marx, *Grundrisse*, Harmondsworth, Penguin, 1973, pp. 541–2.

16 Michel de Certeau, *The Practice of Everday Life*, Berkeley, Los Angeles and London, University of California Press, 1988, p. xiii.

17 ibid., pp. 13–14.

18 Roland Barthes, *Empire of Signs*, New York, Hill & Wang, 1982, p. 4.

19 ibid., p. 6.

20 ibid., p. 33.

21 ibid., pp. 79–83.

22 Marshall Berman, *All That is Solid Melts into Air*, New York, Penguin, 1988, p. 17.

23 ibid., p. 16.

24 Quoted in Franco Rella, *Il silenzio e le parole*, Milan, Feltrinelli, 1981, p. 146.

25 For more on this 'impossibility', even for psychoanalysis, see my *Border Dialogues. Journeys in Postmodernity*, London and New York, Routledge, 1990.

26 William E. Connolly, *Political Theory and Modernity*, Oxford, Basil Blackwell, 1989, p. 11.

27 Ernesto Laclau and Chantal Mouffe, *Hegemony and Socialist Stratey*, London, Verso, 1985, pp. 191–2.

Chapter 12

A European home?

Francis Mulhern

The political maps of the present are systematic misprojections of its real social geographies. Such, in effect, was the thesis of Raymond Williams's *Towards 2000*.[1] Indeed, the idea of the world as a patchwork of singular societies is itself an anachronism: the real spaces of human activity expand or shrink according to perspective, purpose and occasion. And all *significant* societies are either larger or smaller than the nation state. The political institutions of a 'sustainable socialist future' would undo the false identification of social and territorial sovereignties, surpassing not merely the pattern of the nation state but the very principle of 'all-purpose' social boundaries. Societies, as the effective unities of collective life, would be 'variable' in extent, with decision-making practices to match.

This is a compelling prospectus. Tapping both classical Marxist resources and all that he intended in his critical appeal to 'community', Williams was seeking to affirm the necessarily international character of a new social order while refusing the brutalism of scale that has fixated too much practical socialist thinking, to affirm the value of local familiarities without concession to populist nostalgia, and to unite these considerations in a clarified political formula: 'variable socialism'. For now, however, his vision is compelling mainly as a negative reminder of the present, which anticipates it as travesty.

We need only think of a scenario like this. In London a transnational corporation publishes a controversial novel by a celebrated writer. The event is carefully planned and primed for maximum cultural-commercial effect, but soon escapes into a magical-realist life of its own. The book causes religious offence, and is denounced and publicly burned by outraged members of a religious – and ethnic – minority community: it *must* be suppressed. Here is a problem for official Britain – for its law enforcement and community relations agencies and for its half-formulated and largely untested cultural indifferentism – and it worsens by the day. These people are black, and thus conventional objects of liberal concern; but they are book burners, and thus stock characters in the liberal nightmare. The left is divided, and fascists opportunistically join the struggle for

freedom of expression. But the affair has already passed beyond the frontiers of British jurisdiction and debate. The opponents of the book express absolute commitment to the norms of an international religious faith, which in recent times has achieved a special authority within a still larger, though less quotable, community of sentiment – the once-colonized peoples of the world. 'Old' networks of belief and solidarity combine with the new telecommunications satellites to create a multi-million audience and a struggle across frontiers. Bookshops are torched, traitors executed, while others die in riots. And then the international status of the affair is confirmed and deadlocked in the plainest and most conventional terms, as another nation state, casting itself as the divinity's earthly executive, pronounces the author a planetary outlaw, to be put to the sword by any believer so privileged as to find the opportunity.

Improbabilities multiply. The author, in hiding, issues a public appeal on behalf of the imagination, which for now can be exercised only under the protection of the secret services. A prominent literary liberal discovers feminist reasons for judging the offended – or offending – Holy Book inferior to the locally preferred text of revelation. A year and a day go by, but without the usual release. More months pass, then the author an-nounces his coming to terms with the divinity and returns discreetly to the world; the death sentence is not rescinded; and that is or is not that. No one is vindicated, few are convinced or even relieved, unless perhaps the Special Branch. Resolutions are not part of the format of such stories, which indeed can be far more menacing that this one. Imagine what might ensue, immediately and over the longer run, if a not dissimilar ensemble of interests, authorities and sovereignties were called into play not over a mere book but, say, over the political status of a small but oil-rich state . . .

Contemporary history does indeed seem to bear out the thesis that the significant unities of today are either larger or smaller than the nation state – but with the critical qualification that the nation state persists, at once too weak and too strong, as their nearly exclusive field and means of action. In this way, contemporary history gives new life to a hackneyed phrase: it is, quite simply and quite lethally, out of control.

THE LOGIC OF EUROPEAN (DIS)INTEGRATION

Out of control, yet not chaotic. For this disorder is generated by a reality quite systematic in itself: the capitalist mode of production. The self-expansion of this system within and across national and continental bound-aries has been the leading force in world history for more than two centuries now. It continues, and, with the collapse of Stalinism, has entered a critical new phase. Liberals hailed this unfolding history as one that would also be universalist in politics and culture, and socialists, with all important qualifications made, began by agreeing. But it is now clear

that capitalist universalism coexists with and actually stimulates intensified particularism, in the familiar forms of national, religious and ethnic/racial chauvinisms.

The current condition of the European Community furnishes one pertinent illustration of this pattern. Here, perhaps the most ambitious planned reorganization in the history of capitalism is reaching a decisive point of advance. Following long-laid schemes, but galvanized now by the need to maximize West European advantage in the newly breached markets to the East, the EC is moving fast towards monetary and political union. At the same time, the zone is experiencing a new wave of militant chauvinism, expressed variously in a transnational upswing of racist terror and the emergence of new rightist electoral forces – Le Pen's party in France, the German Republicans, and in Italy the perhaps more equivocal Lega Nord. What must be emphasized here is that such developments are not merely atavistic reactions to the emergence of an assuredly more cosmopolitan European order. They are its natural counterpart. Both emerge from a single process: the active (or *radio*active) decay of the nation state as the principal means and field of political determination.

As superintendent of an economy, the nation state seeks to optimize the internal and external conditions of capital accumulation. But it does so specifically as representative of the *nation*, confirming its population in an identity in which the elements of territory and descent are dominant. The politico-cultural formula of the nation state tends to compose or recompose all prevailing discourse on social being in the language of nationality, so that any disturbance of the one is rendered spontaneously as a disturbance of the other. The move towards integrated markets and political federation, for all its upsets and rivalries, is consistent with the long-established functions of the state, but disrupts its politico-cultural formula. The nation state appears to abrogate its 'national' responsibilities, but the identitarian formula remains, and now offers a 'natural' code of discontent – to the natural advantage of the right. In the same process, the minorities who have been the oppressed 'others' of the dominant identity are newly exposed, and frequently driven to respond in the same communitarian terms – again, to the natural advantage of their most conservative members. The regional pennants of the Lega Nord are indeed antique, but the alienations they dignify and mobilize are thoroughly modern. Bourgeois cosmopolitanism is the progenitor of particularist identities. Margaret Thatcher was for years the nationalistic curmudgeon of EC politics, but few things are more truly 'European' than the self-destructive ambivalence that so largely contributed to her downfall. (The other ambivalence, true to the general pattern sketched here, was a dogmatic anti-statism that worked itself out in a centralist attack on the traditional discretions of local government.)

The theme of a new, 'European' identity is, of course, increasingly

current. But, in present conditions, there is little here that the left can hope to embrace. The real probabilities of such an identity are either weak or dangerous. Weak, because its main denominators are constitutional and market-based, and do little to recompose identities of descent and place, unless negatively. Dangerous, because in so far as a new 'Europe' does begin to form, it will be as a continental bloc in the new global pattern of economic rivalry now taking shape. And either way, for the growing populations of 'non-Europeans' living and working in EC territory (as also now, for the second-class Europeans from the East) the most cosmopolitan feature of the new order will be its transnational, multilingual racism.

Moscow's more generous visions of a 'European home' are hardly convincing. The *gemütlich* phrasing itself betrays the cold reality. It reminds us that in making a new 'home' in Europe, the Soviet Union would be withdrawing into a far smaller world, and probably relinquishing its traditional solidarities with a larger one. It reminds us too that the truly cosy 'homes' of Europe are smaller still – in the West and even more so in the East.

The process under way in the East of the continent is in important respects the opposite of that in the West. An interstate system has been dismantled. The East European states have been released from an oppressive overlordship, and the multinational 'USSR' is being dismembered. But the results to date appear familiar. The political and economic perspectives so far shaped in these countries are convergent with those of the West: constitutional norms of a bourgeois-democratic type and market-led economies ('led', that is, more or less briskly to capitalism). And the wider political culture of the area is more and more strongly patterned by ethnic particularism, sometimes democratic and pacific in its forms but at others bigoted and brutal. In the East as, less vividly, in the West, the past is reaching out to claim tomorrow. The new European home has already been squatted, looted and defiled by foreigners and unbelievers. Many in the old Eastern bloc see their future in a kind of Sweden; it may turn out a little more like Iran.

POSTMODERNISM AND SOCIALISM

So, here too are some salient postmodern phenomena: some more assertions of heterogeneity, some more initiatives in identity politics, some new others intervening in defiance of the grand narrative. And with every necessary and substantial qualification made, it must be said that they compromise any plausible prospect of human emancipation. Particularism and fundamentalism suppress dissent, confuse and divide working classes, subordinate women, oppress vulnerable minorities. They are, as a whole, reactionary. But they are not merely atavistic. If they have a shared motivation, it lies in the effort to assert some kind of collective control over

the common life, to establish basic securities in conditions where these things are denied or threatened. And their common, negative precondition is the frustration of socialism.

Capitalist development may be more or less planned and supervised here or there; it may be favoured by circumstance or not; but its central dynamic is in the end uncontrollable. For that reason it can never sustain a general social interest. Some eighty years of social-democratic governmental experience suggest that capitalism cannot be transformed gradually, or even held to a stable, socially 'corrected' course; the communist-governed countries suppressed capitalist economic relations only to create party dictatorships presiding voluntaristically over command economies. Both the social-democratic and communist traditions espoused values that might have framed a general popular interest capable of respecting inherited and emergent particular identities. But both, in effect, succumbed to official nationalism: social democracy through its strategic surrender to the bourgeois state; communism through the workings of the doctrine of 'socialism in one country'. In the one case, cultural pluralism meant indifference moderated by complacency; in the other, it was frequently repressed outright.

And now capitalism stands poised to claim the greatest single victory in its history: the reconquest of markets and spaces denied to it for a half-century and more, and the apparent elimination of its historic antagonist. The prospects for socialism seem bleak; but they can only be made bleaker if we accept the bland language of convergence in which the defeat of historical communism is rendered. A task force of strategic euphemisms and conflations has been mobilized – 'markets', 'democracy', 'freedom' and so on – to obliterate all critical knowledge of capitalism and socialism and of the qualitative difference between them. This is not the time for postmodern fascination with the postmodern scene. Even where fascination is critical, it remains contemplative, fulfilled in the timeless presence of its object. 'Difference' and 'discontinuity', valorized without regard for their specific contents and real conditions of existence, are the alibi of conformists and chastened doctrinaires. There will be a day for a Europe (and a world) of differences, lived as a history without closure, but its precondition is a general social transformation that will not come through the free (?) proliferation of particularities. The strong alternative to a flawed grand narrative is surely a critically revised one, not a winsome anthology of (very) short stories. Similar considerations apply to the superficially quite different political value of 'realism'. 'Realism' is habitually offered as meaning a lucid appraisal of probabilities: what can be done; where; how soon; and on what scale? But it also entails a judgement of *adequacy*. A solution that fails to deal with the problem in hand is not redeemed by the mere fact of its availability; inadequate solutions are, by definition, *not* 'realistic'. Thus, an appeal to 'realism' implies, against the

grain of its own usual motivation, an appeal to critical norms, and thence to a qualitative judgement on the existing order of things – on capitalist civilization.

This is the decisive reality of 'Europe', with its multiply-stressed politics and culture. Identities made out of 'these people in this place' belong to the romances of nationalism and imperialism. The attempt to make a European identity in such terms must prove self-defeating. In effect, the matter of a European identity will be settled 'elsewhere', by the answers given to another kind of question: what kind of social order can best sustain the general and particular interests of these changing populations in this shifting space? Capitalism as fact and socialism as concrete possibility are still the poles between which our history moves, and the task of enriching the critique of the one and the promise of the other is now more urgent than ever; for in the decades ahead, when capitalism seems likely, for the first time, to inherit the earth, the worst, the most truly hopeless of all 'European' identities would be one in which that comfortless critical knowledge has been forgotten.

February 1991

NOTE

1 Raymond Williams, *Towards 2000*, London, Chatto & Windus, 1983.

Part IV

Shifting values

Chapter 13

Towards a cultural politics of consumption[1]

Peter Jackson

INTRODUCTION

A range of new research opportunities has been opened up by the current convergence of social and cultural geography, blurring the distinctions between formerly separate subdisciplines and making new connections possible (Cosgrove and Jackson 1987). Traditional concepts like landscape and nature, space and place, have been criticized and recast, while newer concepts like locality, flexibility and postmodernity are bringing together human geographers from different branches of the discipline in the exploration of common theoretical concerns. As a result, human geography has been remodelled, remade and rethought, some authors encouraging the transgression of existing boundaries, others diagnosing the contemporary situation in terms of fragmentation and impending chaos.

Within the 'society and space' tradition, there has been an increasing recognition that understanding processes of uneven development, spatial divisions of labour, and the transition to more flexible modes of capital accumulation involves much more than a simple mapping of the contours of economic change, narrowly conceived. Whether the object of enquiry is the gentrification of urban neighbourhoods, the role of heritage in urban revitalization or changing divisions of labour, there is a growing realization of the extent to which these apparently rational 'economic' forces are culturally encoded.

One of the principal sources of social geography's current revitalization has been a growing sensitivity to feminist theory and practice. Within British geography, a feminist agenda was established as long ago as 1984 (Women and Geography Study Group 1984). Like feminism, social geography has also been exposed to the recent 'postmodern turn' in contemporary social theory, with varying degrees of enthusiasm (see, for example, Harvey 1989; Soja 1989; Cooke 1990). Geographers have much to learn here from the reservations that feminist authors have expressed concerning postmodernism's absorption with textuality, its reluctance to translate intellectual concern into political action, and its seeming inability to engage

in any kind of political or moral commitment (see, for example, Hutcheon 1989; Nicholson 1990; Deutsche 1990).

Feminists have also been wary of the unacknowledged appropriation in postmodern theory of their epistemological concerns regarding standpoint, perspective and position. These ideas have all now reappeared under the guise of a 'new' ethnography with little apparent awareness of earlier feminist debates about similar issues.[2] Geographers have compounded the error, showing an exaggerated deference towards the new ethnographers' dazzling displays of narrative self-consciousness and textual strategy, but little concern for the feminist debates that, in many cases, predate the current round of anthropological experimentation (see, among others, Gregory 1989; Sayer 1989).

The geographical literature on postmodernity is also unnecessarily fettered by its intellectual origins as a reaction to Marxist political economy. It has been concerned with identifying the limits of flexibility, with tracing the impact of time–space compression and mapping the simultaneous tendencies towards globalization and localization. Even observers like David Harvey (1989), who have stretched their canvas to include art and architecture, film and photography, are still preoccupied with probing the (economic) origins of cultural change. For Harvey, contemporary culture amounts to little more than art and artefacts; there is little discussion of culture as whole ways of life despite his approving references to Raymond Williams.[3] Is it possible to broaden the enquiry without losing the rigour of Harvey's materialist analysis? Can production-orientated theories of social change be adapted or transformed to deal with questions of consumption, or must we look elsewhere for theories that search for meaning rather than causation? These are the kind of questions that I want to raise in this chapter. To do so, I will employ a concept of cultural politics borrowed from the field of cultural studies.

CULTURAL POLITICS

'Cultural politics' is an ambiguous concept that lies at the heart of contemporary cultural studies (Jackson 1989). It refers to the view that 'cultural' questions of aesthetics, taste and style cannot be divorced from 'political' questions about power, inequality and oppression. Conversely, the concept refers to the way that contemporary politics have been 'aestheticized', with a whole range of new issues apparently replacing traditional class-based ones: issues around gender and sexuality, food and the environment, health and body-politics, ethnicity, nationalism and 'race'.

Rather than simply retracing the history of contemporary cultural studies, I want instead to draw on this literature to open up a debate about the question of consumption, too often conceptualized in narrow terms as a momentary act of purchase. Instead, I propose to treat consumption as a

process by which artefacts are not simply bought and 'consumed', but given meaning through their active incorporation in people's lives. How many times can we listen to a cassette tape or compact disk before it is fully 'consumed'? And how many different 'readings' is it capable of in the hands of different audiences or for the same listener in different times and places? Rather than limiting the discussion to the point of purchase, I will focus on the many acts of appropriation and transformation that may be performed on any single artefact before it is discarded, sometimes only to be reincorporated in new cycles of use. Before turning to some specific examples, a brief discussion of existing theories of consumption may be useful.

THEORIES OF CONSUMPTION

The most striking thing about the existing geographical literature on consumption is its relative paucity. Compared to the massive literature on geographies of production, consumption is much more poorly served. I concentrate here on some of the exceptions. Robert Sack has explored the way that places are created as contexts for consumption. His account is limited, though, by making the common reduction of consumption to advertising ('the language of consumption') and by conceptualizing the process in narrow terms as a single act of purchase: 'each statement in advertising contains a missing signified: the consumer. Each statement is incomplete unless you, the consumer, act: unless you purchase the product' (Sack 1988: 659). This leads him to view commercial environments like department stores and shopping malls as life-sized advertisements. Like many other commentators, he says little about how these environments are experienced by those who use them. As a result, we discover very little about how these 'place-advertisements' are actually 'read'. Even those who have attempted a semiotic reading of places like the West Edmonton mega-mall tend to *assume* a reading rather than exploring it empirically.[4] The effect has been to emphasize a dominant, hegemonic reading (from the producers' point of view) and to portray the consumer as a passive, hapless victim. The notion that people may be capable of diverse responses, including the possibility of subversive readings, is rarely discussed, much less the scope for consumer resistance.

A partial exception is the work of feminist authors like Meaghan Morris (1988) who argue that all shopping centres are minimally readable – that anyone who is literate in their use can uncover their basic rules of contiguity and association – but that they are also differentiated, striving to maintain a myth of identity, a unique and often localized sense of place. From this perspective there is no surprise that shopping centres can appear monolithic, monumental and solid while simultaneously tending towards

dissolution and indeterminism as they are subject to varied responses and multiple uses.

Roger Miller (1991) offers a rather different reading of the geography of consumption, concentrating on the relationship between mass-circulation magazine advertising and the emerging 'socio-spatial relations' of suburban America in the early decades of the twentieth century. He offers some valuable insights into the manipulation of class and gender relations in the marketing of vacuum cleaners ('Madam, you need never sweep nor dust again'), refrigerators ('Your children – is their food safe?'), washing machines ('An extra servant for two cents a week'), electric stoves ('What is this electric maid for modern mothers?') and automobiles ('Pride of ownership . . . the highest award'). But he says relatively little about how these new technologies were incorporated in people's lives; not just who bought them, but how they were used, valued and given meaning.

Probably the most successful attempt to sketch the geography of contemporary consumerism is a recent essay by David Clarke (1991). While the paper suffers from a density of theoretical reference that sometimes makes its argument hard to digest, it offers some original ideas on the spatiality of consumer society. Rejecting simple dichotomies between consumer sovereignty and consumers-as-dupes, Clarke draws on the work of Jean Baudrillard to advance a theory of consumption as a signifying practice in people's everyday lives. He uses Jacques Attali's work on the political economy of music to argue that advertising offers pleasure where denying satisfaction, and, less successfully, on Henri Lefebvre, to distinguish between 'spaces of representation' (such as shopping malls) and 'representations of space' (as in contemporary advertising). While he makes passing reference to the relevance of the cultural studies literature, he does not develop these points as I seek to do here.

I begin with the work of Dick Hebdige on subcultures, style and the meaning of material goods. In some of his early work, Hebdige (1979) offers an analysis of youth subcultures which focuses on 'the meaning of style', examining the relationship between material object and subcultural style: the punk rocker's safety-pin and bin-liner, the Mod's motor scooter, the Rasta's dreadlocks. He argues that these artefacts take on their special relevance in relation to the 'parent culture' from which they derive. The acquisition of meaning involves a dual process of appropriation (from the parent culture) and transformation (within its subcultural context). Short haircuts and Crombie overcoats can no longer be read as an unequivocal sign of middle-class respectability or of working-class aspirations for upward mobility. In the context of rising unemployment and inner-city decline, they can also signal youthful defiance and the potential for violent conflict (see also Hall and Jefferson 1976).

In his later work, Hebdige expands this argument into a wider discussion of the 'cartography of taste' (Hebdige 1988).[5] He criticizes the pessimistic

reading of consumption among commentators on the Left where the concept is weighed down with connotations of passivity and waste, digestion and disappearance. In place of this negative reading, he would substitute some other term:

> capable of conveying the *multi-accentuality* and *duration* over time and in different cultural-geographical contexts of commodified objects and forms as they move from one dislocated point to the next, from design, through production, packaging, mediation, and distribution/retail into use where they are appropriated, transformed, adapted, treated differently by different individuals, classes, genders, ethnic groupings, invested with different degrees and types of intensity.
>
> (Hebdige 1988: 211)

This opens up an exciting agenda, already being developed within cultural studies and with considerable potential too for social geography. Let me take just a couple of examples from areas which some might regard as excessively specialized, trivial or irrelevant, but whose general significance I hope to demonstrate.

My first example is taken from Angela McRobbie's (1989) fascinating work on the second-hand dress market in London. She shows how the market for second-hand dresses is class- and place-specific: popular among young, middle-class women (who can 'afford' to dress down), rather than among young working-class women who generally prefer to buy new, inexpensive clothing from high street chain stores. But any clear pattern of class distinctions is disrupted by a range of movements from one domain into another, some initiated by the consumer, some driven by the market. A style that begins with the individual 'entrepreneur' acquiring a cheap garment at a jumble sale and transforming it for her own use (by shortening a hemline, dyeing the fabric or adding new accessories) may become commercialized as similar ideas are taken up for retail to the mass high-street market. Styles that originate in the flea-markets of Dalston Junction or Chapel Market (in north London) may later appear in the chain stores of Oxford Street and the West End. McRobbie cites the example of leggings:

> [Leggings] first appeared alongside gents' vests, in cream-coloured knitted cotton fabric, as winter underpants . . . in places like Camden Market. They had an elasticated waistband and button openings at the front. Punk girls began to buy them as summer alternatives to their winter ski pants. Dyed black, they created a similar effect. Then, stallholders dyed them and sold them in a dark, murky, grey-black shade. But they still suffered from the design faults which arise from adapting male lower garments for women. They were cut too low at the waist and frequently slid down. The fly front cluttered the smooth line across the

stomach and they were often too short at the crotch. It was not long, therefore, before the same stall-holders were making up their own models in the professionally-dyed brushed cotton fabric popularised through consumer demand for track suits and sweatshirts. By the summers of 1985 and 1986 these were being worn by what seemed to be the entire female population aged under thirty.

(McRobbie 1989: 44–5)

Other fashions, such as retro, have gone through similar 'cycles of consumption', moving from one domain to another and quoting liberally from other genres with little concern for historical accuracy or consistency.[6]

My second example is the well-worked terrain of Cindy Sherman's photographs, the interpretation of which has been fiercely debated by David Harvey, Rosalyn Deutsche and Doreen Massey, among others. Critics have debated whether Sherman is guilty of portraying women in sexist poses or whether her representations subvert patriarchal values by laying bare the ideological nature of their visual conventions. In a fascinating study of Sherman's work, Judith Williamson (1986) illustrates the inadequacy of any single reading of the artist's representations of women. She begins her essay with a wonderful anecdote:

When I rummage through my wardrobe in the morning I am not merely faced with a choice what to wear. I am faced with a choice of images: the difference between a smart suit and pair of overalls, a leather skirt and a cotton dress, is not just one of fabric and style, but one of identity. You know perfectly well that you will be seen differently for the whole day, depending on what you put on; you will appear as a particular kind of woman with one particular identity *which excludes others*. The black leather skirt rather rules out girlish innocence, oily overalls tend to exclude sophistication, ditto smart suit and radical feminism. Often I have wished I could put them all on together, or appear simultaneously in every possible outfit, just to say, How dare you think any one of these is *me*. But also, See, I can be all of them.

(Williamson 1986: 91)

This, she argues, is what Cindy Sherman achieves in her photography. Here, though, I want to emphasize Williamson's subsequent argument about the impossibility of judging Sherman's work without considering what the viewer brings to the photographs. For it is only in so far as we are aware of and understand the genre to which her photographs allude that we are capable of 'appreciating' the work. If you do not see the allusion to Hitchcock, Greenaway or whoever in her series of *Untitled Film Stills*, for example, you will not 'get the joke':

the viewer is forced into complicity with the way these 'women' are constructed: you recognize the styles, the 'films', the 'stars', and at that

moment when you recognize the picture, your reading *is* the picture. In a way, 'it' is innocent: *you* are guilty, you supply the femininity simply through social and cultural knowledge. . . . The stereotypes and assumptions necessary to 'get' each picture are found in our own heads.

(ibid.: 95)

But similarly, it is only in so far as we are capable of understanding the way that patriarchal ideologies operate in the field of visual representation that we are capable of subverting those meanings and substituting any form of alternative reading.[7]

Williamson's essay can be taken as a contribution towards a more active view of consumption, an aim which is shared by Frank Mort's (1989) short essay on the politics of consumption. Calling for an enlarged and more complex map of economic structures and processes, he asks what people actually *do* when they go shopping and suggests that it may be quite different from the 'official script' implied by triumphalist versions of Tory popular capitalism:

Commodities and their images are multi-accented, they can be pushed and pulled into the service of resistant demands and dreams. High tech in the hands of young blacks or girls making-up are not simply forms of buying into the system. They can be very effectively hijacked for cultures of resistance, reappearing as street-style cred or assertive femininity.

(Mort 1989: 166)

Similarly, Mort argues that advertising conducts an active dialogue with the market rather than assuming that consumption is foisted on a gullible public by media hype: product design and innovation, pricing and promotion, are shaped by the noises coming from the street (ibid.: 167). The vogue for *double-entendres* and other forms of word play, for advertisements that resemble 1950s movies or contemporary soap operas, all suggest that commercials are making increased demands of the public and that consumers are increasingly sophisticated in their ability to 'read' (and enjoy) the advertisers' coded messages (cf. Williamson 1982; Moore 1991).

The idea that young consumers possess considerable reserves of 'cultural capital' has been developed by Paul Willis (1990). Based on a twelve-month ethnographic study of young people in the English Midlands, Willis draws attention to the vibrant cultures of everyday life and to the symbolic creativity that takes place in apparently mundane activities. His concept of 'common culture' refers to the application of our human capacities and symbolic resources to the raw materials of our social and built environment in the production of meaning.[8] Drawing on this concept, he describes the way people use their diverse cultural backgrounds as 'frameworks for

living' and as repertoires of symbolic resources for making sense of their lives. Willis shows how *symbolic work* is an integral part of the *necessary work* of gaining a livelihood. His project amounts to an attempt to rehabilitate the concept of consumption, emphasizing its creative potential, 'to explore how far "meanings" and "effects" can change quite decisively according to the social contexts of "consumption", to different kinds of "de-coding" and worked on by different forms of symbolic work and creativity' (Willis 1990: 120). In practice, this translates into a series of empirical studies of the media, music, fashion and style which trace how things are actively *used* rather than passively *consumed*. Rather than seeing young people as a uniformly uncritical audience for television's seamless output, Willis argues that viewers interact with what they see on the screen: judging it, discussing it and constantly reworking the material in the context of their own lives ('What's *your* favourite ad?').

While young people may have little direct influence over what actually appears on their screens, the scope for 'symbolic creativity' is much larger in the context of music and other areas of popular culture in which the boundary between consumption and production is becoming increasingly blurred (cf. Laing 1990). As the knowledge and technology of musical experimentation (sampling and versioning, dubbing and mixing) continues to diffuse, concepts of originality, authenticity and authorship become increasingly problematic.

The symbolic creativity of 'common culture' is at its most active in the field of fashion, style and dress. For, as we have already seen, 'young people don't just buy passively and uncritically. They always transform the meaning of bought goods, appropriating and recontextualizing mass-market styles' (Willis 1990: 85). Willis argues that there is considerable potential for the development of an oppositional politics within the field of consumption; that the one-way power of communication has been disrupted, allowing for alternative readings and the production of new meanings in the process of consumption. More pessimistically, it could be argued that increasingly sophisticated marketing strategies and media technologies have allowed the market to penetrate into an ever-widening range of domains.

Willis's attempt to elaborate a more positive and active view of consumption is shared by the anthropologist, Daniel Miller (1987). Like Willis, Miller criticizes the overwhelming concentration on production in recent academic work and, like Hebdige, he is interested in the general relationship between people and things, arguing that it is through 'mass consumption' that people relate most directly to goods. Miller celebrates a perspicacity and subtlety in mass behaviour, a far cry from the passivity, illusion and denigration that have characterized many recent studies of popular attitudes towards consumption.

Whereas Hebdige theorizes consumption in terms of appropriation and

transformation, Miller employs the Hegelian terminology of externalization (self-alienation) and sublation (reabsorption). Using these concepts and drawing on an impressive range of philosophical sources, Miller's overall aim is to portray the 'seriousness' of modern mass culture, to explore the range of meanings that a single object can acquire through its recontextualization in a range of cultural settings, and to tease out the process by which objects are constituted as social forms. For Miller, as for Willis, consumption is a larger and less transient social process than is recognized in studies that confine the concept to the point of sale. Drawing on the work of Pierre Bourdieu (1984), Miller argues that consumption provides a means of social differentiation where taste functions as a marker of class.

Empirically, Miller's work has gone in a number of directions: investigating the changes that council tenants in north London have made to the kitchen space with which they were provided by the state; exploring the reception of a popular TV soap opera among a group of low-income Trinidadians; and analysing the symbolic meaning of *wining* (a sexually-explicit form of dancing in Trinidad). Miller details the process of *bricolage* by which people experiment with common materials to produce a range of new meanings. Despite his commendable emphasis on the diversity of individual consumers, his concept of personal identity remains problematic. In the study of council house tenants, for example, he explains how one flat is focused on the television, another on the dining table, a third on the children's toys; that one resident is a fanatic football supporter, another keeps an exotic range of pets, while a world champion hairdresser lives next door to a fancy-pigeon breeder and so on (Miller 1987: 7–8). While Miller explores the furnishings and style choices associated with these different 'lifestyles', he seems not to recognize the possibility of *multiple identities* within the same individual.[9] Perhaps not surprisingly, the significance of this has not been lost on the advertising industry who are increasingly addressing their products to specific market niches.

Many authors have suggested that the market is becoming increasingly segmented (by gender, age, ethnicity and so on). Advertisers are therefore targeting increasingly specific groups and aiming to associate their products with particular lifestyles: it is no longer a matter of 'keeping up with the Joneses' but of differentiating ourselves from them. Much of this literature implies that individuals have single, uncomplicated identities that can readily be addressed if only the right message can be devised. But there is a growing literature that shows that personal identities are far more complex and shifting than this simple model would suggest: that people are capable of 'holding down' multiple, apparently contradictory identities at any one time as the context changes. Several authors have suggested that this is a characteristic of the transition from modernity to postmodernity (see, for example, Giddens 1991; Rutherford 1990; Featherstone 1991). More

rarely, the spatial constitution of self-identity and difference is also recognized:

> We are not in any simple sense 'black' or 'gay' or 'upwardly mobile'. Rather we carry a bewildering range of different, and at times conflicting, identities around with us in our heads at the same time. There is a continual smudging of personas and lifestyles, depending where we are (at work, on the high street) and the spaces we are moving between.
>
> (Mort 1989: 169)

I will return to this theme in the following section on the spatial basis of gender identities. But I want first to express some reservations about the 'heroic' interpretation of consumption as an active, participatory and creative process. Miller's argument that 'consumption is now at the vanguard of history' (1989: 213) strikes me as a particularly exaggerated claim, for example, while some versions of Willis's 'common culture' thesis are also equally guilty of overstatement. An impression can be given by some of this literature that shopping is a truly subversive activity with revolutionary potential. The idea has even been taken up in recent advertising campaigns with slogans like 'Habitat is Revolting' or 'Shoppers of the World Unite'. These are extreme examples, perhaps, but more subtle versions of the same idea are becoming commonplace.

A similar tendency to exaggerate the positive, active dimensions of consumption has been remarked in Sivanandan's (1990) essay, 'All that melts into air is solid: the hokum of New Times', in which he lashes out at the post-Fordist vision of socialism associated with the magazine *Marxism Today*.[10] Sivanandan caricatures the politics of New Times as 'consumer socialism', obsessed with consumption and style, arguing that it has much in common with Thatcherite conservatism. He condemns the vision of a politics which is restricted to the personal, where the only public statements are about individual identity, and where political action is limited to decisions about what to buy or to refuse to buy.

Sivanandan reserves his strongest criticism for Stuart Hall's argument that 'greater and greater numbers of people (men *and* women) – with however little money – play the game of using things to signify who they are' (Hall 1989: 131). He counters this position by asking how it would apply to poor people in 'Third World' countries or to the growing number of homeless people on the streets of London. Do they use cardboard boxes to signify that they are homeless? Poor people do not 'find meaning' or 'express themselves' by consuming goods; they cannot afford to. They know just how shallow all this recent preoccupation with style and consumption can be.

One final yawning gap in much of the literature on consumption is its inadequate attention to questions of gender. Rosemary Pringle (1983) goes

some way towards filling this gap. She begins by stressing the inadequacy of theories of consumption that stress only the concept's (long-standing) connotations of extravagance and waste. She cites Raymond Williams's (1976: 78) observation that in almost all its early English uses, *consume* had an unfavourable sense, meaning to destroy, to use up, to waste, to exhaust. As Williams shows, the unfavourable connotations of 'consumption' have persisted. Part of this attitude, Pringle argues, derives from the view that consumption belongs to a female and hence trivial or subordinate arena: 'Consumption stands for destructiveness, waste, extravagance, triviality and insatiability – in fact for all the things that men traditionally hate or fear about women' (Pringle 1983: 86). Yet most studies of consumption fail even to acknowledge that women do most of the work of consumption. Marx, for example, referred to consumption as the *consummation* of production, its sexual symbolism going completely unrecognized. Later studies have similarly failed to consider the emotional and sexual connotations of the consumption process.

Pringle argues that consumption is as active an exchange as production. She rejects the notion of consumption as a single act of purchase in which a commodity is 'used up' when it is bought. It is the object's symbolic meaning that is consumed rather than the material object itself. Pringle therefore divides the consumption process into a number of phases: acquisition or purchase; transformation and servicing; and a final phase of destroying, appropriating or 'using up' (ibid.: 91). Much of this work is, of course, performed *by women* (often for men). Shopping, for example, has rarely been represented simply as a functional activity but as a source of sexual fulfilment and personal identity. Housework is invested with emotional meaning and advertisements regularly play on common understandings of gender roles and sexual identities. Let us try to explore some of the ways that gender identities are constituted through the process of consumption, a process in which space is a fundamental if neglected dimension.

GENDER IDENTITIES

While several authors have noted the existence of geographical variations in gender roles and relations, there is relatively little geographical work on the spatial constitution of gender identities (but see McDowell and Massey 1984; Bowlby *et al.* 1986). Among the exceptions are several studies (e.g. Rose 1984; Warde 1991) that focus on the opportunity that gentrification provides for the development of new patterns of consumption which may be of particular benefit to women, helping them to juggle the demands of paid work and (unpaid) childcare. But even these studies have not succeeded in working through the relationship between changing gender *relations* and changing gender *identities*.

Some of the most interesting work in this respect has been conducted among Latin American women. Sarah Radcliffe's (1990) research on female peasant union leaders in Peru challenges any simple notion of gender-specific issues and illustrates how the mobilization of different women has taken place in relation to a wide range of interests, articulated through ethnic identity, gender, location and family position, among others. Radcliffe explores the contexts in which different bases of identity become salient, accepting the reality of *multiple identities* and *negotiated conceptions* of gender. Since her work has not been replicated in other contexts, we must turn to other means of exploring these issues.

One possibility is to examine changing representations of gender and their associated spatial domains. It is possible, for example, to illustrate the shifting boundaries between public and private, home and work, visible and invisible, but much harder to investigate the meaning of these changing boundaries and their significance for particular men and women. Elsewhere (Jackson 1991b), I have shown how images of masculinity that originate in one domain may shift over time, entering new domains and taking on new meanings as they are 'read' by different audiences. One of my examples was the English National Opera's poster of the half-naked body of stage-technician, Karl Phillips, leaning against a gently inclining classical column. His dreadlocks may be novel but his gaze and pose are familiar from other contexts, specifically the twilight world of homoerotica and 'physical fitness' magazines. But there is a much longer history of 'men on pedestals' (Lewis 1985) to which this image can also be related. Apart from some newspaper articles and letters to the editor, however, we have little idea of how the poster was read by different audiences. Did it appeal equally to men and women, gay and straight? How far does the effectiveness of the image rely on the creation of covert homosexual desires and sexual fantasies among those who would claim to be exclusively heterosexual? Why has an image that seems more at home in the world of popular culture been used to advertise a more 'elevated' art form, like opera? And how does the iconography of the male nude relate to wider issues about the body politic?

Another equally striking image allows us to pursue the argument one stage further including some evidence, however slight, of how different audiences 'consume' a particular image. I refer to the controversial image of a heavily pregnant movie star, Demi Moore, which appeared on the cover of the fashion magazine *Vanity Fair* in August 1991. The image itself can be contextualized as part of a more general change in popular attitudes towards pregnancy and childbirth involving the contested boundaries between public and private space. An image of a pregnant woman which appeared on the inside pages of *Vogue* magazine went virtually unremarked while Benetton's recent photograph of a baby whose umbilical cord was still attached created much more of a stir.[11] In this context, the

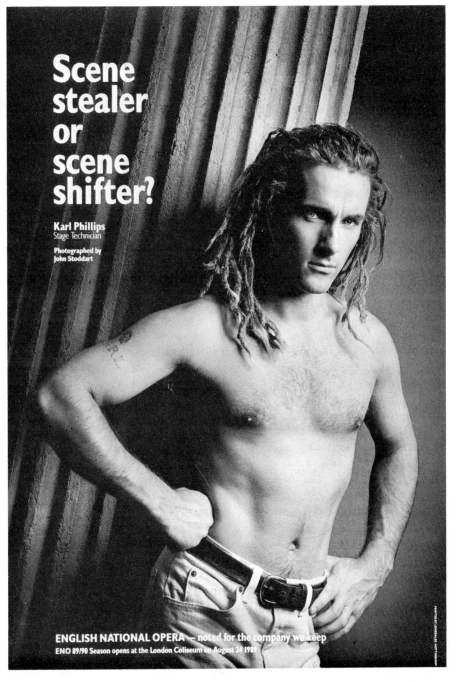

Figure 13.1 Scene stealer or scene shifter? English National Opera advertisement.

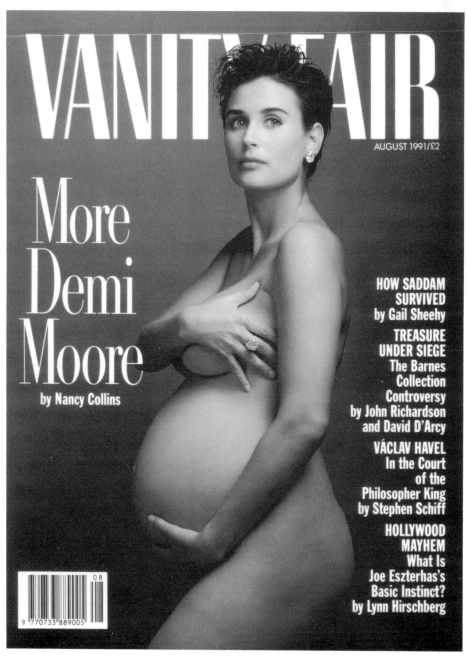

Figure 13.2 *More Demi Moore.* Cover picture from *Vanity Fair,* August 1991.

amount of press attention devoted to *Vanity Fair*'s image of Demi Moore's pregnant body is a little surprising, ranging from outrage to admiration.

The magazine was withdrawn from some supermarket shelves in Canada and the US, to be sold under a plastic wrapping (*Toronto Sunday Star*, 4 August 1991). Under the headline 'Nude and pregnant: is it pretty or porn?', the same newspaper asked whether pregnancy represented 'the New Chic'. The story was also featured as a lead item on CBC radio's current affairs programme, 'As it Happens'. *Vanity Fair* was delighted with all the brouhaha, recording record-breaking sales of over a million copies (up from the usual 800,000). The magazine's New York office was taking over 100 calls a day, two-thirds in favour of the cover, one-third against.

In Britain, the *Independent on Sunday* (14 July 1991) asked a selection of people if they were offended by this picture. Emma Nicholson MP thought it 'absolutely beautiful, a triumph of womanhood and a celebration of life . . . the most natural thing in the world'. Other people, such as David Sullivan, publisher of the scurrilous *Sunday Sport* newspaper, found the picture 'in bad taste':

> I think the picture is totally unacceptable on a cover in Britain in 1991. It should have been on the inside with a warning sticker, not thrust down people's throats in the newsagent's. A lot of people would find it offensive, though I don't personally.
>
> (*Independent on Sunday*, 14 July 1991)

A civil servant, Paul Costello, remarked that those people who found the picture offensive were simply 'a hangover from the Victorian thing of keeping pregnant women confined'. This Victorian view was mirrored in the comments of finance director, Martin Warren:

> It's awful. I saw Demi Moore in *Ghost* only a couple of weeks ago and I thought she was a lovely and beautiful lady. Then the next thing I see is her displaying herself all over the front cover of *Vanity Fair*. It is both unnecessary and distasteful. Pregnancy is a private matter and should stay that way.
>
> (*Independent on Sunday*, 14 July 1991)

A few weeks after *Vanity Fair*'s controversial cover appeared on the news-stands, the satirical magazine *SPY* published a cleverly retouched photograph of Demi Moore's partner, the movie star Bruce Willis, apparently also heavily pregnant (September 1991).

It is possible, of course, to read too much into the interpretation of such photographs. But even these few remarks allow some insights into how people's attitudes to gender identities reflect their different 'subject positions', raising questions about the social and spatial constitution of gender

identities as well as gender relations. I am not arguing simply that there are geographical variations in what it means to be a man or a woman, but that our very notions of masculinity and femininity (in all their subtle variations) are actively constituted through distinctions of space and place, public and private, visible and invisible.

The point is most readily established by reference to another paper by Frank Mort (1988) in a collection of essays concerned with 'unwrapping' masculinity. Mort begins by insisting on a plurality of gender identities, refusing the neat dichotomy of two mutually exclusive forms dictated to us by nature and subject to a range of social sanctions. In place of biological essentialism, Mort argues that what we are as men and women is not natural or God-given, but socially constructed. Masculinity is a process, not a static and unchanging identity, actively constituted in the market-place, the fashion house and the street. And while Mort accepts that 'all of this is regionally specific' (1988: 207), he takes the argument about spatially constituted gender identities one stage further. Specifically, Mort focuses on changing consumption cultures, 'at the point where the market meets popular experience and lifestyles on the ground' (ibid.: 215). And, in a remarkable passage, he argues that:

> Urban geographers have been telling us for a long time that space is not just a backdrop to real cultural relations. Space is material, not just in physical terms. It carries social meanings which shape identities and the sense we have of ourselves. For young men (and young women) it is the spaces and places of the urban landscape which are throwing up new cultural personas – on the high street, in the clubs, bars, brasseries, even on the [football] terraces. It seems as if young men are now living out quite fractured identities, representing themselves differently, feeling different in different spatial situations.
>
> (Mort 1988: 218–19)

We may quibble with the details of his analysis, but why have geographers been so reluctant to explore the territory that is mapped out in this passage? There are rich opportunities here for new research, and social geographers are surely well placed to make a distinctive contribution.

CONCLUSION: RESEARCH LACUNAE

While sociologists have debated the nature of consumer culture, the politics of collective consumption and the significance of consumption sector cleavages (see, for example, Warde 1990), they have paid scant attention to the *geographies of consumption*. In conclusion, therefore, I wish to outline some of the lacunae in current research on consumption and to suggest some ways of moving the argument forward.

First, I reiterate the need for studies of consumption to take questions of gender seriously, not as a reluctant tack-on but as fundamental to every stage of analysis, transforming the very object of study. There is much to be gained from a specifically feminist standpoint, with its commitment to a political as well as an academic project. The contributions of Meaghan Morris and Rosemary Pringle have been noted here, but there is ample scope for new work (and for the revision of theories that are gender-blind if not downright sexist).

Second, there is a need to rid the study of consumption from its overwhelming condescension towards the views of 'ordinary people'. Theorists cannot afford the luxury of assuming that they know how consumers read the landscape or react to the advertisers' intended messages. Ironically, the advertising industry is less condescending than academia in this respect. Advertisers are conducting increasingly sophisticated 'market research' which acknowledges the constitutive role of the consumer in the creation of their products and in moulding the language of advertising. By contrast, academics have held complacently to the view that they know best, that the meaning of a shopping mall is a matter for abstract semiotic analysis rather than empirically grounded ethnographic work. This criticism is not restricted to the field of consumption: it is a characteristic of a broader intellectual 'descent into discourse' (Palmer 1990) where the iconographic analysis of representation has all but taken the place of ethnographic analysis of social action. I am not arguing that social scientists can ever have unmediated access to other people's consciousness but that we should always try to relate symbolic representations to material interests. In this respect, I am closer to David Harvey's (1989) project in *The Condition of Postmodernity* than my previous criticisms may suggest. But I would also endorse a concerted effort to explore new methods of understanding the relationship between cultural and economic change.

Third, is the question of method. Here, there have been numerous recent experiments with textual strategy, but far too little concern with other phases of our research, which are no less contentious. Cultural and media studies are gradually moving away from a purely quantitative approach to audience research, increasingly emphasizing the range of diverse contexts in which views 'consume' mediated texts and imagery. Following David Morley's (1986, 1991) pioneering work on the domestic context of much television viewing, the old-style audience survey, with its monolithic conceptions of an undifferentiated 'viewer', are being replaced by a more active conception of a plurality of audiences, a multiplicity of encodings and decodings, a variety of cultural competences and a diversity of readings. Morley achieved this theoretical breakthrough by means of some important methodological innovations: employing in-depth interviews in people's homes rather than more context-free questionnaires. Morley's study has led to a more ethnographic understanding of television

audiences, reconceptualized as active social subjects, engaging with tele-vision in stubbornly contradictory ways (see also Ang 1991).

Geographers are now beginning to contribute to this burgeoning litera-ture, including my colleague at UCL, Jacquelin Burgess who has adapted the psychoanalytic technique of group analysis to explore the role of the media in shaping people's environmental values (Burgess *et al.* 1988). In two related projects on attitudes towards 'open space' in the London Borough of Greenwich and on the redevelopment of a stretch of Thames grazing marsh in Essex, Burgess and her colleagues have explored the production and consumption of environmental meanings in the media. Rather than assuming a top-down model where producers and managers' meanings are communicated to a passive public, Burgess's research em-ploys Richard Johnson's idea of a 'circuit of culture' (Burgess 1990), from the production of texts, through their diverse readings by different social groups in the context of their lived cultures and social relations, feeding back in turn into the production of new texts. The work is exemplary in its serious attention to both production *and* consumption, in the development of new, context-specific research methods ('focus groups'), and in its sensitivity to spatial issues combined with a thorough grounding in the literature of cultural studies. If we are to develop a more critical approach to the cultural politics of consumption within a revitalized social geog-raphy, then this work should be acknowledged as having provided at least a provisional map of the way forward.

My final point relates to the way that ordinary places are implicated in the cultural politics of consumption. For example, John Clarke (1984) has offered a preliminary sketch of the contrasting geographies of leisure in the British resort towns of Blackpool and Eastbourne, one racily working class, the other staid and middle class (see also Clarke and Critcher 1985). Several authors have examined media representations of new towns, enter-prise zones and development areas, under the rubric of 'selling places' (see, for example, Burgess 1982; Watson 1991). More recently, Rob Shields has explored some 'alternative geographies of modernity' in *Places on the Margin* (1991). After an ambitious theoretical introduction which attempts to combine Bourdieu, Foucault and Lefebvre in a single theory of 'social spatialization', Shields provides four illuminating case studies. These concern the geographies of the 'Dirty Weekend' in Brighton on England's south coast; of Niagara Falls, the 'Honeymoon Capital of the World'; of Canada's 'True North Strong and Free'; and of England's North–South divide. It is an ambitious work of synthesis which takes seriously the problem of combining the 'political-economic' and the 'cul-tural' without reducing one to the other. It is on this terrain that a new social geography of consumption must be built. My argument here has been that the concept of cultural politics is an essential tool in the construc-tion of such a geography.

NOTES

1 A previous version of this paper was presented at the 12th Nordic Conference on Critical Geography (Stockholm, September 1991). It was later published in the journal *Nordisk Samhällsgeografisk Tidskrift* and is being republished here, in revised form, thanks to the generosity of the editor, Jan Öhman. Thanks also to Göran Hallin for inviting me to the conference and to Jon May, Sarah Radcliffe and Peter Wood for their comments on an earlier draft.
2 On the 'new' ethnography, see Clifford and Marcus (1986), Marcus and Fischer (1986) and Clifford (1988). For feminist arguments that prefigure these debates, see Hartsock (1983) and Mascia-Lees *et al.* (1989).
3 For an elaboration of this critique, see Jackson (1991a), Deutsche (1991) and Massey (1991).
4 Both Shields (1989) and Hopkins (1990) offer such a reading of the West Edmonton Mall. I owe the criticism of an 'assumed reading' to Jon May.
5 Originally published in the journal *BLOCK*, no. 4, 1981.
6 McCracken (1990) includes a discussion of clothing-as-language in his recent collection of essays. As an anthropologist, employed at the Royal Ontario Museum in Toronto, there are interesting parallels between his work and that of Daniel Miller (discussed below).
7 More recently, Laura Mulvey (1991) has provided a new interpretation of Cindy Sherman's work which revolves around the politics of the body. Reviewing the recent exhibition of Sherman's work at the Saatchi Gallery in London, Mulvey draws attention to the social and spatial properties of Sherman's work:

> The journey through time, through the work's chronological development, is also a journey through space. Sherman dissects the phantasmagoric space conjured up by the female body, from its exteriority to its interiority. . . . [O]nce the process of bodily disintegration is established in the later work, the early, innocent, images acquire a retrospective uncanniness.
>
> (Mulvey 1991: 139)

8 Compare Stuart Hall's definition of culture as the way we 'handle' the raw material of our social and material existence (in Hall and Jefferson 1976: 10).
9 The exception is a passing comment that 'consistency of self or object is not a noticeable feature of the modern age' (Miller 1987: 208).
10 The paper was reprinted, much abbreviated, in *The Guardian* (10 February 1990) under the title 'Melting Marxism'.
11 Benetton's earlier 'United Colors of Benetton' campaign, introduced in 1989, also sparked controversy. Their depiction of a black woman suckling a white child was withdrawn, following protests in the US, because of its evocation of slavery.

REFERENCES

Ang, I. (1991) *Desperately Seeking the Audience*, London and New York: Routledge.

Bourdieu, P. (1984) *Distinction: A Social Critique of the Judgement of Taste*, London: Routledge & Kegan Paul.

Bowlby, S., Foord, J. and McDowell, L. (1986) 'The place of gender relations in locality studies', *Area* 18: 327–31.

Burgess, J. (1982) 'Selling places: environmental images for the executive', *Regional Studies* 16: 1–17.

—— (1990) 'The production and consumption of environmental meanings in the mass media: a research agenda for the 1990s', *Transactions of the Institute of British Geographers* 15: 139–61.

Burgess, J., Limb, M. and Harrison, C. M. (1988) 'Exploring environmental values through the medium of small groups', *Environment and Planning A* 20: 309–26, 457–76.

Clarke, D. (1991) 'Towards a geography of the consumer society', School of Geography, University of Leeds, Working Paper no. 3.

Clarke, J. (1984) ' "There's no place like . . .": cultures of difference', in D. Massey and J. Allen (eds) *Geography Matters!*, Cambridge: Cambridge University Press, pp. 54–67.

Clarke, J. and Critcher, C. (1985) *The Devil Makes Work: Leisure in Capitalist Britain*, London: Macmillan.

Clifford, J. (1988) *The Predicament of Culture*, Cambridge, MA: Harvard University Press.

Clifford, J. and Marcus, G. (eds) (1986) *Writing Cultures*, Berkeley: University of California Press.

Cooke, P. (1990) *Back to The Future*, London: Unwin Hyman.

Cosgrove, D. and Jackson, P. (1987) 'New directions in cultural geography', *Area* 19: 95–101.

Deutsche, R. (1990) 'Men in space', *Strategies* 3: 130–37.

—— (1991) 'Boys town', *Society & Space* 9: 5–30.

Featherstone, M. (1991) *Consumer Culture and Postmodernism*, London: Sage.

Giddens, A. (1991) *Modernity and Self-Identity*, Cambridge: Polity Press.

Gregory, D. (1989) 'Areal differentiation and post-modern human geography', in D. Gregory and R. Walford (eds) *Horizons in Human Geography*, London: Macmillan, pp. 67–96.

Hall, S. (1989) 'The meaning of New Times', in S. Hall and M. Jacques (eds) *New Times*, London: Lawrence & Wishart, pp. 116–34.

Hall, S. and Jefferson, T. (eds) (1976) *Resistance Through Ritual*, London: Hutchinson.

Hartsock, N. (1983) 'The feminist standpoint', reprinted in S. Harding (ed.) (1987) *Feminism and Methodology*, Milton Keynes: Open University Press.

Harvey, D. (1989) *The Condition of Postmodernity*, Oxford: Basil Blackwell.

Hebdige, D. (1979) *Subculture: the Meaning of Style* London: Methuen.

—— (1988) *Hiding in the Light*, London: Routledge.

Hopkins, J. S. P. (1990) 'West Edmonton Mall: landscape of myths and elsewhere-ness', *Canadian Geographer* 34: 2–17.

Hutcheon, L. (1989) *The Politics of Postmodernism*, London and New York: Routledge.

Jackson, P. (1989) *Maps of Meaning*, London: Unwin Hyman.

—— (1991a) 'Mapping meanings', *Environment and Planning A* 23: 215–28.

—— (1991b) 'The cultural politics of masculinity: towards a social geography', *Transactions of the Institute of British Geographers* 16: 199–213.

Laing, D. (1990) 'Making popular music: the consumer as producer', in A. Tomlinson (ed.) *Consumption, Identity, and Style*, London and New York: Routledge, pp. 186–94.

Lewis, P. (1985) 'Men on pedestals', *Ten. 8* 17: 22–9.

McCracken, G. (1990) *Culture and Consumption: New Approaches to the Symbolic Character of Consumer Goods and Activities*, Urbana, IL: Indiana University Press.

McDowell, L. and Massey, D. (1984) 'A woman's place?', in D. Massey and J.

Allen (eds) *Geography Matters!* Cambridge: Cambridge University Press, pp. 128–47.

McRobbie, A. (1989) 'Second-hand dresses and the role of the ragmarket', in A. McRobbie (ed.) *Zoot Suits and Second-hand Dresses: An Anthology of Fashion and Music*, London: Macmillan, pp. 23–49.

Marcus, G. E. and Fischer, M. M. J. (1986) *Anthropology as Cultural Critique*, Chicago: University of Chicago Press.

Mascia-Lees, F. E., Sharpe, P. and Ballerino Cohen, C. (1989) 'The postmodernist turn in anthropology: cautions from a feminist perspective', *Signs* 15: 7–33.

Massey, D. (1991) 'Flexible sexism', *Society & Space* 9: 31–57.

Miller, D. (1987) *Mass Consumption and Material Culture*, Oxford: Basil Blackwell.

Miller, R. (1991) ' "Selling Mrs Consumer": advertising and the creation of suburban socio-spatial relations, 1910–1930', *Antipode* 23: 263–301.

Moore, S. (1991) *Looking for Trouble: On Shopping, Gender and the Cinema*, London: Serpent's Tail.

Morley, D. (1986) *Family Television: Cultural Power and Domestic Leisure*, London: Comedia.

—— (1991) 'Where the global meets the local: notes from the sitting room', *Screen* 32: 1–15.

Morris, M. (1988) 'Things to do with shopping centres', in S. Sheridan (ed.) *Grafts: Feminist Cultural Criticism*, London: Verso, pp. 193–225.

Mort, F. (1988) 'Boy's own: masculinity, style and popular culture', in R. Chapman and J. Rutherford (eds) *Male Order: Unwrapping Masculinity*, London: Lawrence & Wishart, pp. 193–224.

—— (1989) 'The politics of consumption', in S. Hall and M. Jacques (eds) *New Times: the Changing Face of Politics in the 1990s*, London: Lawrence & Wishart, pp. 160–72.

Mulvey, L. (1991) 'A phantasmagoria of the female body: the work of Cindy Sherman', *New Left Review* 188: 136–50.

Nicholson, L. J. (ed.) (1990) *Feminism/Postmodernism*, London and New York: Routledge.

Palmer, B. (1990) *Descent into Discourse: the Reification of Language and the Writing of Social History*, Philadelphia, PA: Temple University Press.

Pringle, R. (1983) 'Women and consumer capitalism', in C. V. Baldock and B. Cass (eds) *Women, Social Welfare and the State in Australia*, London: Allen & Unwin, pp. 85–103.

Radcliffe, S. A. (1990) 'Multiple identities and negotiation over gender: female peasant union leaders in Peru', *Bulletin of Latin American Research* 9: 229–47.

Rose, D. (1984) 'Rethinking gentrification', *Society & Space* 2: 47–74.

Rutherford, J. (ed.) (1990) *Identity: Community, Culture, Difference*, London: Lawrence & Wishart.

Sack, R. D. (1988) 'The consumer's world: place as context', *Annals, Association of American Geographers* 78: 642–64.

Sayer, A. (1989) 'The "new" regional geography and problems of narrative', *Society & Space* 7: 253–76.

Shields, R. (1989) 'Social spatialization and the built environment: the West Edmonton Mall', *Society & Space* 7: 147–64.

—— (1991) *Places on the Margin: Alternative Geographies of Modernity*, London and New York: Routledge.

Sivanandan, A. (1990) 'All that melts into air is solid: the hokum of New Times', *Race and Class* 31: 1–30.

Soja, E. (1989) *Postmodern Geographies*, London and New York: Verso.

Warde, A. (1990) 'Production, consumption and social change: reservations regarding Peter Saunders' sociology of consumption', *International Journal of Urban and Regional Research* 14: 228–48.

—— (1991) 'Gentrification as consumption', *Society & Space* 9: 223–32.

Watson, S. (1991) 'Gilding the smokestacks: the new symbolic representations of deindustrialised regions', *Society & Space* 9: 59–70.

Williams, R. (1976) *Keywords*, London: Fontana.

Williamson, J. (1982) *Decoding Advertisements*, London and New York: Marion Boyars.

—— (1986) 'A piece of the action: images of "woman" in the photography of Cindy Sherman', in J. Williamson, *Consuming Passions*, London and New York: Marion Boyars, pp. 91–113.

Willis, P. (1990) *Common Culture*, Milton Keynes: Open University Press.

Women and Geography Study Group (1984) *Geography and Gender*, London: Hutchinson/Institute of British Geographers.

Between earth and air: Value, culture and futurity

Steven Connor

David Harvey's *The Condition of Postmodernity* is a very important book, one that offers a way of grasping and imaginatively organizing the condition of postmodernity, in all its pullulating indefiniteness. His work begins to supply that 'conceptual map' of postmodernism, for which Fredric Jameson has wistfully yearned, but been unable to supply. Hitherto, Jameson has been able to offer only a map in the future tense, which can cling as a centring principle only to centrelessness itself. Interestingly, the issue of conceptual mapping is bound up for Jameson with the question of a postmodern political art:

> The new political art – if it is indeed possible at all – will have to hold to the truth of postmodernism, that is to say, to its fundamental object – the world space of multinational capital – at the same time at which it achieves a breakthrough to some as yet unimaginable new mode of representing this last, in which we may again begin to grasp our positioning as individual and collective subjects and regain a capacity to act and struggle which is at present neutralized by our spatial as well as our social confusion.[1]

David Harvey's account of the relationship between space and place, suggesting that placelessness and locality are actually bound dialectically together, is closer than he might care to hear to that of Jean-François Lyotard, who has also written about that imbrication of multinational capital with the resurgence of nationalism and localism which is so powerfully elaborated in Harvey's work.[2] I want however to try to focus on one particular issue which I think slides away, rather uncharacteristically from Harvey's grasp – the issue of artistic and cultural practice. This relates to questions not only of space but also of time in postmodernity and especially the question of future time.

The problem in writing about and consequently trying to reimagine the coefficiencies of space and time is that one's language always carries its own assumptions about space and time with it, always inhabits and implies its own territories and itineraries. I am inclined very strongly to agree with

what I take to be Harvey's emphasis on the materiality of space–time relations and his suspicion of purely discursive accounts of the experience and construction of these relations. But when it comes, as it does come at the end of Harvey's paper today, to the question of *imaginary* new spaces and new space–time co-ordinations of the future ('how we imagine communities and places of the future becomes part of the jigsaw of what our future can be', he tells us),[3] then the spatiality of narrative and metaphor may have a due interest and importance.

Harvey speaks of the need to heal the scission of the universalist dimension of Enlightenment reason, modernism and Marxism on the one hand and the Heideggerian emphasis on embodied dwelling in particular places on the other. Although he is drawn to the Heideggerian account, seeing its historical importance as a reaction to the decentring forces of multinational capital in the twentieth century, Harvey is acutely conscious of the political dangers of such an account, when it becomes a fetishized mythology of place or nation. But I want to suggest that Harvey's own language regularly attests to a form of grounding which, if not Heideggerian itself, shares a metaphorical substance with it. It is a language which continually sets grounding, depth, radicality and foundation against the airy insubstantiality or miasmatic opacity of the cultural. He speaks of the 'pervasive base' which place-bound identity provides, and of 'the invariant elements and relations that Marx defined as fundamental to any capitalist mode of production', which are 'omnipresent beneath all the surface froth and evanescence, the fragmentations and disruptions, so characteristic of present political economy'. The proliferating epiphenomenality of the postmodern is imaged not only as airborne ('froth and evanescence'), but also as a sickening mire underfoot, an opaque world of supposedly unfathomable differences in which geographers have for so long wallowed'.[4]

The point is that space and place, totality and ground, are related in complex ways that cannot be reduced to the kind of simple opposition suggested here; and this is, in fact, one of the most important strains of Harvey's argument. One particular danger is that the force of cultural resistance to multinational capital, often manifested in a desire to reaffirm the particularity of place, will turn out to be an offshoot from the process of global homogenization itself – he has suggested today, for example, that the promotion of place and region in postmodern urban design is 'precisely about the selling of place as part and parcel of an ever-deepening commodity culture', and, again, that 'the quest for authenticity, a modern value, stands to be subverted by the market provision of constructed authenticity, invented traditions and a commercialized heritage culture'.[5] In other words, it is very hard to be sure that you have ever really reached ground level in a world which is undergoing the process which Baudrillard calls 'satellization'.

The reason that I stress this problem is that, for Harvey, it has a particular relation to the question of cultural practice in postmodernity – by which I mean both art in the narrow sense and the practices of cultural politics more generally. For Harvey – and here I am drawing on *The Condition of Postmodernity* rather more than on his conference paper (see 'From space to place and back again', ch. 1 of this book), – cultural practice is subject to the equivalent dangers of modernist reification on the one hand – the retreat into place, and the spatializing consolations of myth – and postmodernist deterritorialization on the other, which merely reproduces without resisting the giddy rhythms and flows of capital itself. The choice is between the protofascism of the mythical earth (Pound, Eliot, Lawrence, etc.) and the skidding alienation of postmodern flight (I am thinking here of Tom Docherty's recent promotion of postmodernist over modernist art in precisely these terms, recommending flight and deterritorialization over the fixations of earthbound identity).[6] To give this dilemma the horns which Harvey has done, these are the competing claims and rival dangers of place and space.

The complexity of relation between place and space which I have read out of Harvey's account is presented in *The Condition of Postmodernity* as a dialectical opposition, an opposition between modernism and postmodernism themselves. This is the point at which the other dimension of Harvey's magisterial argument must be summoned up – the question of time and here, especially, of futurity. For what else is a dialectic other than a conflict that is enacted through time, an argument with a future? The question of time is, of course, as important to Harvey's argument in *The Condition of Postmodernity* as the question of space, and has a particular relationship to the question of aesthetic-cultural value.

For most Marxist writers on modernity, the aesthetic-cultural realm has had a central, if problematic importance. This is because of the extent to which the aesthetic-cultural foregrounds the question of value, that question which is so hard for Marxist theorists and aestheticians to ignore. There is within Marxist criticism a tradition of uneasy respect for the aesthetic work, if only because of its strange, paradoxical resistance to its own status as commodity. For Terry Eagleton, for example, it is precisely because the aesthetic object exhibits so openly, even flaunts its commodity status, insisting on its magical detachment from its historical origins and contexts, that it offers a certain, circumscribed resistance to the processes of commodity exchange – even if that resistance can only take the form of a fetishism that is another kind of capitulation to the logic of the commodity.[7]

The question of aesthetic-cultural value has a particular relationship to the question of time in the regime of flexible accumulation, as Harvey specifies it. The 'unitary principle' of late modernism and postmodernism, which in this respect are continuous for Harvey, is Marx's notion of 'value in motion'. It is, of course, the brutal reduction of all forms of value to

serial exchangeability by means of the money form which enables this extraordinary mobility of values in modernity. Harvey's distinctive contribution has been to point out the ways in which the revolutionary compression of space by advanced capitalism (the reduction of space to time), combines with the attempt to cope with the chronic problems of overaccumulation by compressing time, especially reducing the rate of turnover, to produce a crucial involution in the sphere of value. For the use of the credit and banking system to create profit, by means of betting on, or discounting the future (as, for example, in currency dealings, bond markets and futures markets), puts money itself, the universal medium of exchange, into doubt, drawing it into what Marx referred to as the 'general corruption' of exchange and speculation. As Harvey points out (*The Condition of Postmodernity*: 106–7), this drawing into exchange of the very medium of exchange creates considerable uncertainty as to the 'value of value' itself.

Aesthetic-cultural practice has an interesting relation to this. For in one sense, as Harvey observes, the expansion of capital into the cultural sphere is one of the most striking ways in which capitalism can harness the future, by shortening the time-scale of consumption and accelerating the cycles of need and desire in fashion (ibid.: 285). But, at the same time, certain parts of the aesthetic-cultural realm, especially the art market, can function in precisely the opposite way. For Harvey, the art market can be seen as a guarantee of long-term security amidst the general flux of an inflationary era, a way 'to store value under conditions where the usual money forms were deficient' (ibid.: 298). This is an interesting contradiction: the commercialization of culture is both a means of discounting the future into the present, of accelerating time, and also a means of sustaining the present into the future, of decelerating time. We should not be surprised at this dichotomy, perhaps, since it relates closely to the complex dichotomy between the idea of place and space that we have already looked at. Culture as 'fictitious capital', in Marx's interesting phrase, as speeded-up time, is part of the art of the surface, of an airborne aesthetics as opposed to a grounded ethics; but culture as grounding is a fetishism, a denial of time which can become an equivalent aestheticization.

Running through Harvey's account is a desire to affirm the possibility of value in itself, the use-value posited by Marx, though it seems this can never articulate itself in forms which are not instantly alienated into one or other of these aestheticisms. I'd like to suggest the possibility of estimating the value of aesthetic-cultural practice in a rather different way, which does not seek or promise to deliver us whole from the nightmare of general corruption. Here (again surprisingly, perhaps) the recent work of Jean-François Lyotard intersects with the account of capitalist time given in *The Condition of Postmodernity*.

Lyotard argues, like Harvey, that the dominion of the discourse of economics in the world today expresses itself in terms of an instrumentali-

zation that not only requires the medium of time in which to operate, but actually makes time a commodity. According to this analysis, profits are not only realized over time, but involve the gain of the abstract or 'stocked-up time' which is money or goods.[8] The labour and production costs of any good are seen by Lyotard as so much lost time which must be redeemed in the form of this profit, which can then be exchanged for real time. In the economic structure of thought which dominates the world, any activity, event, or 'cession' in the present is considered as a form of loan, or investment, which must be paid back, or include within itself the fact of its economic return. The aim of this system is therefore always to narrow the gap between the 'cession' and the 'counter-cession' of return or profit, to produce a gain of abstract time over real time. Value therefore comes to consist, especially in advanced multinational capitalism, not in specific yields or products but in the very speed of the economic process itself – literally the 'rate' of exchange rather than with the objects of exchange. This is as true of ideas and of philosophical texts as of anything else:

> In the economic genre, the rule is that what happens can happen only if it has already been paid back, and therefore has already happened. Exchange presupposes that the cession is canceled in advance by a counter-cession, the circulation of the book being canceled by its sales. And the sooner this is done, the better the book is.[9]

In a world in which value is speed, such uses of language as the philosophical or the poetic seem to Lyotard to promise the wasteful integrity which offers a resistance to what he has recently called the 'neg-entropic' urge to store up and control time. If the principle of reason is to rush to its goal with the minimum delay, the principle of philosophy and art may still be:

> not at all to determine the reply as soon as possible, to seize and exhibit some object which will count as the cause of the phenomenon in question. But to be and remain questioned by it, to stay through meditation responsive to it, without neutralising by explanation its powers of disquiet.[10]

In such forms of language, as in contemporary theoretical discourse like deconstruction and Deleuzian nomadism, 'time remains uncontrolled, does not give rise to work, or at least not in the customary sense of the verb "to work" '.[11] In contrast to a generalized positivity in which value has always already arrived, such discourse would attempt to delay the arrival or eventuality of value in the interests of keeping alive the transacting of the 'arrive-t-il?', of the always-virtual 'event'.

Obviously, this wasteful or nonproductive time of speculation can and perhaps always must be assimilated *in the end* to some form of outcome and therefore be sedimented as a kind of value. But Lyotard's account here is not a redemptive one, does not propose like most avant-garde theories to

abstract art and culture altogether and absolutely from the play of exchange and the consideration of future utility. He asks for a time in which conclusions and economic returns are suspended, and put into question, rather than denied. Delay here is inserted into the interval between non-time and the resolution of economic return, giving or maintaining a kind of extension to the moment of uncertainty at which value is in the process of being decided. If the automated time of international capital is approaching equivalence with Marx's 'twinkling of an eye', with the instantaneity of thought itself, then some forms of art and culture may serve as that 'dynamite of the tenth of a second' which Walter Benjamin found embodied in film, keeping open the gap between present and future.[12]

This gives Marx's idea that we should take our poetry from the future a different inflection. For now the future is not imagined as a fund of fixed returns and values against which the present may borrow, but a more radical openness, a 'future imperfect', in Geoffrey Bennington's phrase.[13] As Terry Eagleton has recently suggested, opening to the radical indeterminacy of the future means a paradoxical abandonment of positive utopias:

> Clairvoyants and soothsayers are always lackeys of the ruling class. Their job is to peer into the future and advise the ruling class that they have it in their pockets and that the future will be just like the present, only more so. Today's idolatrous soothsayers are the long-term analysts and forecasters of monopoly capitalism.[14]

From this point of view, the political value of aesthetic-cultural pactice may lie not so much in its exemplification of the possibility of some utopian future of unity of being, as in its very resistance to the installation of the future in the present. Of course, such a suspension of value may itself appear as a premature hallucination of a utopia of free and undetermined value in the present, and, as such, an irresponsible voluntarism. But this is why I wish to speak not of the absolute dissolution or liberation of values (in the way that deconstruction is universally supposed to speak) but of the active and concrete effort to subject value and values to evaluation, to maintain the question of value, always between the alternatives of dissolution and foundation, air and earth.

Given the predominance of economic-utilitarian models of profit and outcome in most theories of the political value of art and culture, this may still seem to some like a utopian evasion, an attempt to pep up that modernist account which sees it as the mission of the avant-garde to keep itself austerely and watchfully aloof from the contaminations of the marketplace and every form of instrumental value. But if the kind of value-reflexivity I am evoking here does indeed involve the resistance to every simple incorporation into the structures of value under capitalism, it is also to be rigorously distinguished from the attempt to transcend value, or to

assert the value of the transcendent, in the name of the alleged 'autonomy' or 'disinterestedness' of the aesthetic. Rather, certain kinds of aesthetic-cultural practices and objects allow a reflection on the very evaluative apparatus which keeps the distinction operative between incorporation and autonomy, the economic and the cultural. Such a reflection is not in the interests of a dialectical elevation beyond such antinomies, but perhaps is better imagined as an attempt to excavate, or dig oneself deeper into the double-bind of flight and grounding.

It would hardly be logical to claim a special, or even a privileged place for aesthetic-cultural practice in such a project, though I do think that the paradoxical place of art within twentieth-century commodity culture confers certain epistemological advantages. And it should hardly be necessary to say that this project does not, and could not, take place in mid-air, in a frictionless space in which all values are equivalently suspended. Such a project always has its presuppositions and points of ethical leverage – in this case, the presupposition that it is better, more valuable, to be able to determine (which is also to question) the play of value than to be determined by it. The political purpose of such an enterprise is not to arrive at the serene possession of shared values or grounds, but rather to make possible the collective questioning of value otherwise than under the conditions of violent exclusion and systematically distorted communication (to adopt a Habermasian locution) which obtain under capitalism. The evaluation of value should be accompanied by and also itself constitute an attempt to create the conditions where such an evaluation might properly begin. For such a destination is really a threshold; not a present tense waiting to arrive but the opening of a transition to a future.

NOTES

1 F. Jameson, 'Postmodernism: or, the cultural logic of late capital', *New Left Review*, 1984, 146, p. 91
2 Jean François Lyotard, *Le Postmoderne expliqué aux enfants: Correspondance, 1982–1985*, Paris, Galilée, 1986, pp. 62–3.
3 David Harvey, 'From space to place and back again: reflections on the condition of postmodernity', see ch. 1, p. 28.
4 Harvey, *The Condition of Postmodernity: An Enquiry Into the Origins of Social Change*, Oxford, Basil Blackwell, 1989, pp. 188, 179; 'From space to place', p. 5.
5 Harvey, 'From space to place', pp. 8, 12.
6 T. Docherty, *After Theory: Postmodernism/Postmarxism*, London and New York, Routledge, 1990.
7 T. Eagleton, 'Capitalism, modernism and postmodernism', in *Against the Grain: Selected Essays, 1975–1985*, London, Verso, 1986, p. 140.
8 Lyotard, *The Differend: Phrases in Dispute*, trans. Georges Van Den Abbeele, Manchester: Manchester University Press, 1988, p. 176.
9 ibid., pp. xv–xvi.
10 Lyotard, 'Time today', trans. G. Bennington and R. Bowlby, *Oxford Literary*

Review, 1989, vol. 11, nos 1–2, pp. 17–18.
11 ibid.
12 W. Benjamin, 'The work of art in the age of mechanical reproduction', in *Illuminations*, trans. Harry Zohn, London, Fontana, 1970, p. 238.
13 G. Bennington, 'Towards a criticism of the future', in D. Wood (ed.) *Writing the Future*, London and New York, Routledge, 1990, pp. 17–29.
14 T. Eagleton, 'Marxism and the future of criticism', in D. Wood (ed.) *Writing the Future*, London and New York, Routledge, 1990, p. 18.

Chapter 15

Postmodernity, architecture and critical practice

Micha Bandini

Postmodernism has become in many people's minds just another facet of our contemporary world. Like global warming or inflation, it is there to be acknowledged as part of our life. It has become a construct built on images and words in such a manner that it perpetuates its own cultural legitimacy. Its status makes its investigation compulsory. It has become one of the intellectual conventions of our times.

While almost everybody deprecates the media hype which spawned it, only a few remember that the only way to combat postmodernism as a cultural convention is to formulate a critical practice that assigns importance to the cultural producer's positioning in respect to the processes of the modern aesthetic.[1] This is particularly important in architecture where, traditionally, criticism has played the role of the designer's accomplice rather than that of the challenger, and where still a large part of contemporary history is closer to hagiograpy than to balanced appraisal. And, because architecture is transmitted through its images, it is in the mechanisms of the production and the investigation of such images that the reasons for both the fortune and paucity of the postmodern label can be found.

If one wants to understand the reasons why postmodernity has taken hold as a cultural convention[2] and why there is a necessity to dismantle it, if a rational and productive debate on architecture is to take place, then it is paramount to investigate that critical attitude which reduces 'spaces' into 'texts' then legitimizes the rereading of these 'texts', as if they were excerpts, in order to create debates that focus on appearances rather than on the role of architecture in contemporary society. The postmodern phenomenon in architecture is not only one which emphasizes representation but also one of ideological attitudes which bind critics and designers in an ambiguous formalism, in a removed critical stance where the ideological responsibility of 'positioning', which is an inherent part of the ethic of the modern project, is avoided.

Such an attitude, or better the lack of it, closely mirrors that which is experienced in culture at large. The only common trait one can find amongst those who profess some allegiances towards 'the postmodern

condition' is a relaxed disinterest towards parameters underpinning categories of judgement.[3] From Jean-François Lyotard to Richard Rorty, for the postmodernists, the rejection of any form of totality results in a cultural relativism which avoids any kind of social critique whilst the dismissal of categories of meta-language allows narrative to take predominance without having to establish any difference between truth, rhetoric and the (false) authority of tradition.

Moreover, the avoidance of 'positioning' is not without danger. Whilst aesthetic categories other than architecture might find respite, from time to time (and history is full of such examples), from engaging with issues of power and wealth distribution, for those disciplines which *are* engaged with the built environment, avoidance means eschewing all components but the aesthetic. Because of this, to accept postmodernism as the cultural convention within which to operate critically, amounts today to a belief that the 'reality' of a building exists within the proposed narrative and its historical referents, rather than within the resolved representation of its social, economic and cultural components.

Even if almost self-evident, I think it is important to remember that while a text or a traditional work of art often exists bi-dimensionally or at most three-dimensionally, it is the prerogative of good architecture to create a space fit for habitation. That space needs to be experienced, it needs, so to speak, to be 'lived through'. But this 'living through' component is difficult to capture in photographs or drawings. For publication purposes, the most powerful images of architecture are those which bring into the façade the discourse they want to express, those where one can detect in the elevation, and not in the section, the will to represent. Moreover, not only passing fashions in architecture (as the interest in *architecture parlante*' or attempts to reduce compositions to linguistic structures) but the classical construction of architecture itself allows this reductive flattening to persist. This ambiguity is maintained because to appraise past buildings through their adherence to the canon or their ability to transgress from it, is so embedded in the Western tradition that one has to make a conscious effort not to do so in front of new architectural products. Symmetry, geometric projections and formal balance are all part of the 'bag of tricks' that designers and critics deploy. But such devices of composition and appraisal can only be deployed easily when a building conforms to these laws *or* when it is reduced, through the bi-dimensional flattening of its photographic image by the appraisal system, to a text.

Having (literally) flattened architectural 'spaces' into 'texts', the contemporary critic can then start appraising those with techniques similar to those deployed for the other arts. For the critic is now able to deal with a domesticated architecture, one which no longer asks to be experienced and verified in its social, political, structural, environmental and spatial roles but one which merely represents a formal attitude. As such, it

is easier to apprehend (one needs to know so much less about designing!) and to assimilate to other cultural phenomena. The critic for his/her appraisal can borrow discourses from other disciplines as one would with a novel, a painting, a movie or an installation. The critic who claims the power to read architecture as a 'text', implicitly claims that his/her interpretation is as important as 'the matter' questioned. The 'matter' becomes an 'object-text' which can be understood without being experienced within society, the 'text-object' becomes part of that series of artistic icons which are maintained in their cultural status by appraisals of successive generations of critics. The critic who accepts that such a phenomenon as postmodernism really exists as a serious architectural proposition, is the critic who vindicates to him/her self the power of interpreting designed spaces as if these were sonnets or Renaissance masterpieces – the power to interpret rather than the task of understanding.

In doing so, not only can he or she deceive the cultural market (and often its creative producers) into thinking that architecture conforms to the given episteme of the moment, but this critic also avoids confronting the ideological implications of making and, more importantly, appraising architecture. Such avoidance I believe to be typical of the postmodern condition. In fact, it is not the playing with past references or the jumbling together of forms which constitutes both the appeal and the malaise of postmodernism, but the convention that is by now ingrained into cultural consciousness – that clear programmes are impossible in contemporary society because there is no common consensus the designer can represent.[4] And, in the absence of widespread critical attitudes based upon the necessity both of 'positioning' and of understanding before interpreting, formalist experimentations are allowed to flourish and take the place of more substantial ones.

Architecture is not produced solely by drawing or writing. A large part of what we call architecture is actually a building or is conceived with the possibility of being built. The simple fact of bringing into the process of creativity the added dimension of the constraints which the materiality of architecture imposes on us considerably changes the nature of architectural production from a quasi-free act (as in most of the visual arts in contemporary times) to one which, by being more linked to a complex hierarchy of requirements, is paradoxically more traditional and rooted in culture. The nature of the site, construction techniques, planning codes, finances, the brief and the programme all have an internal logic which is the product of historical modifications and the stratification of conventions. The task of design, that of developing single requirements into a unity that will take into account their internal logic, is, by the complexity of its nature, that of a representation of cultural forces and not merely one of styling them. It is the 'buildability' of architecture which produces a transformation of culture, both from a material and an ideal point of view. Designers, critics,

organizers, teachers and historians, by interpreting and transforming the material on which they choose to operate, create culture. But what is the difference between the creation of an object and that of a text? For me, interpretation in the first instance means transformation while in the latter it means understanding.

In a sense, the other visual arts never ask as much of theories of explanation as architecture does. While painting, photography or sculpture might make demands on the metaphysics underlying art history to tell them how to see the world in order to represent it, it is not a *conditio sine qua non* of their *modus operandi*. In architecture's case, the situation is more complex because of the materiality of the design discipline.

Moreover, for the contemporary historian/critic, intellectual uneasiness arises not only from the methodological and theoretical uncertainties of his or her own critical domain, but also from the lack of security and direction experienced by the designer. The convention of militant criticism, which the postmodern condition exacerbates, here reveals all of its dangers: both critics and designers are weakened by a mirrored uncertainty, both play at the epistemological level a 'transference' and 'counter-transference' game which ultimately leaves depleted the object of their concern: architecture. The inability to create a large framework for cultural discussion, disparities between levels of reception, a general uncertainty where to locate one's own intellectual production, all these factors conspire to exaggerate the only mean of release so far devised: to increase formal alternatives within the accepted boundaries. By so doing, the architectural object becomes 'transferred' from becoming the product of a designer's theory into becoming the source of a critic's epistemology. It becomes, both for the designer and for the critic, a text: an autonomous source of metaphysical meaning divided, by its own chosen language, from that materiality in which there are both the sources of its cultural boundaries and the possibilities of a communicable, non-teleological debate.

One of the means by which such confusion of epistemological levels occurs is because the traditionally accepted usage of architectural history is to underpin the theory of architecture which is used to support design. In the process of interpretation of architecture, theory is seen as a source of authority; this authority, derived by the tradition of history, is used by the architectural producer to gain access to meta-historical categories, thus to absolute values. Militant postmodernist criticism, by denying the historiographic debate and by reinforcing the conventional usage of the history of architecture in architectural design, depletes itself of what is most needed today: the ability for architecture to verify itself, its goals, its aims, through a debate in which assumptions are rationally based and lead to verifiable positions. And if the aim of critical appraisal is to further a progressive debate, the distinction between understanding and transforming becomes crucial. Only through this distinction is it possible to expose the ambiguous

relationships of the false consciousness of the critics who aim 'to transform' as designers do, and forget the real cultural power which comes from careful 'understanding', the kind of understanding which, by constantly being able to verify itself, leads to the opening-up of those formal, economic, social, cultural and technological boundaries which frame the reality of designers and design.

The argument so far pursued – that most of the postmodernist phenomenon relies in the reduction, by its critics, of the nature of architecture itself, so that it can be assimilated to other discourses where the critic has more power to intervene with his own interpretation – has not addressed the fact that two interwoven cultural levels contribute to the postmodern condition *vis-à-vis* architecture. One is more active at the level characterized by Jencks, Harvey and Eagleton in their depictions of the appearance of postmodern architectural products; the other lives more at the level of the personal sensitivity of its producers and it has its roots in the post-structuralist, philosophical experimentations of the last two decades.

As there is a 'populist' image of postmodernism, so too is there a 'high-brow' one. But whilst the former would probably not mind being labelled as such, the latter label carries negative connotations of disengagement from cultural quality. For these designers are pursuing a formal language that refuses any borrowing or interpreting from classical styles but rather is trying to reinterpret both the message and the forms of the modern tradition.

What makes these experiments particularly interesting is that several contemporary designers known for their formal dexterity and their commitment to a theoretical approach to designing, have chosen architectural 'signatures' which, in being highly personal and an expression of their perceived alienated individual condition, facilitate their alignment with the forefront of that philosophical current of contemporary thought which, by refusing meta-categories of judgement and a belief in both the totalities and the communicability of ethical parameters, can be loosely and conventionally termed postmodern.[5]

Who then are the real postmodernists; those who make their designs from ironic skirmishes with a borrowed history, or those who pursue the leads suggested by contemporary philosophical discourses which attack modernism at its source by contesting the very legitimacy of the modernist project?

The question is not rhetorical, even if there is often no clear distinction between producers and products (some designers might choose to belong to both categories or to develop in time from one to the other), but it points out clearly that, first, it is not form but clarity of 'positioning' which can help mark the dividing line and, second, that the use of form is an integral part of that 'positioning'.

A building which epitomizes the irreverent pastiche legitimized by the

postmodern condition is John Outram's Dockland Pumping Station. Stuck in the middle of an anodyne, three-storey public housing project, a stone's throw from Canary Wharf's imposing skyline, its façade is a gentle and witty send-up of many classical conventions. It doesn't mimic the Greek classical order but draws its sources for its over-dimensioned capitals from Egyptian polychromy. It openly announces the coloured cardboardy volutes as decorations, and it declares in the façade its functional role (with its ever-revolving fan, unfortunately never perceived as such in photographs). With the interior and the paved courtyard speaking of the nearby River Thames, this is a building which both cares for its context and transcends it. Like Ledoux's Paris 'barrières', this is an example of an *architecture parlante* where the architect invents, from many sources, a language suited to the occasion and contributive to contemporaneous debates: a building which is irreverent, fun and perfectly suited to brighten its little suburban corner. John Outram is here able both to entertain and to fulfil a purpose, as its whimsical forms do not overstep the limits of its brief, making it a worthy urban addition to an otherwise grey area.

John Outram's approach to the past is far from that better-publicized attitude towards history so often presented by Venturi and Scott-Brown. But, perhaps because over-theorized or perhaps because too informed by that flattening of the historical perspective so common in the USA, Venturi and Scott-Brown's over-intellectualized populist approach ridicules tradition rather than celebrates it. This is evident both when their architectural language attempts to 'joke' (as in Oberlin College) and when they attempt a seriously dignified urban solution (as in the National Gallery extension). Here the knowledge of the evolution of the order and of its applications in the façade produces a syncopated rhythm of 'stuck-on' classical motifs without any reference to that integration of harmonic proportions between interior and exterior which is one of the points of evolution of Western classical architecture. It is difficult to know if this is the result of Venturi and Scott-Brown's own North American 'positioning' or, even by their own standards, a less than happy example of it. And yet this has been hailed, by those with the power to make decisions and by those with the critical knowledge to influence, as a positive example of appropriate urbanity. Robert Venturi has been considered one of the most thoughtful of contemporary architects, having produced both seminal designs and influential theoretical considerations, but one whom most critics have chosen to appraise for formal dexterity rather than for fitness of usage or correspondence between theory and practice, thus they have challenged neither his form nor the congruity of it with his theories.

To challenge the conventions that have sustained Western architecture, and which have shaped our perception of it, is one of the primary tasks of Peter Eisenman's cultural search. As, for Eisenman, every project is a theoretical attempt to define his position in the meandering path which the

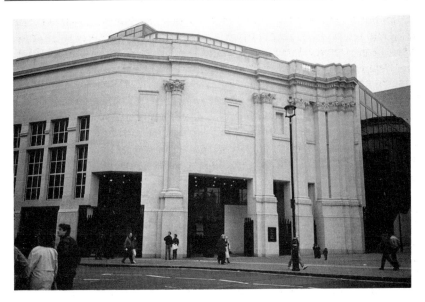

Figure 15.1 The extension to the National Gallery in London.

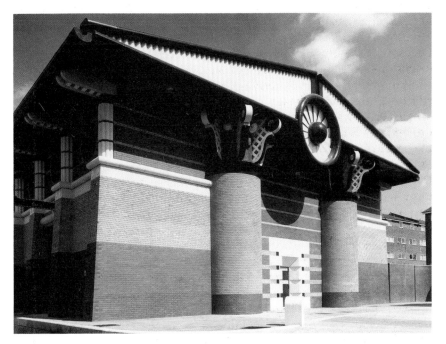

Figure 15.2 John Outram's Dockland Pumping Station, Isle of Dogs, London.

contemporary mind chooses for its representations, it was unavoidable that he would arrive to challenge the system of architectural representation itself after a series of projects where he tested both the legacy of the historical avant-garde's formal vocabulary, and his own perceived alienation. This he accomplishes in a theoretical project called 'Fin d'Ou T Hou S' where he programmatically opposes the perceived rationality of Western tradition by aligning himself with the Derridan deconstructionist strategy and by stressing the internal-to-the-project morphological processes of decomposition and transformation.[6] How little this project understands of Derrida and how easily formal gaming takes precedence over real epistemological understanding has been acutely analysed by Geoff Bennington when he writes: 'It might be that in some sense he is proposing a more or less rigorously "deconstructive" architecture; this clearly does not imply that the discursive links of such an architecture with the work of Derrida are successful.'[7] But this cultural gap between sources of legitimation and their usage, this continuous flattening of the historical and cultural perspective is itself part of this convention we call postmodernism and is possibly one of its most pernicious features. Without analysis, how can there be knowledge and thus progress; or are we condemned, in life as well as in architecture, to an alienated and ideologically unsound condition?

All the above architectural producers, either 'populist' or 'high-brow', belong, either formally or theoretically, to that cultural convention which can be loosely termed the postmodern condition. Much critical practice has been devoted to their production and even more to the relationship these products establish amongst themselves by weaving, so to speak, a net of common inferences which is difficult to penetrate, verify and assign quality parameters to.

Thus the epistemological quest of finding criteria of judgement receives little attention and yet, only by agreeing on such parameters would it be possible to surmount the tautological impasse that prevents the emergence of questions about quality. The fact that the lack of such critical practice is both legitimized by postmodernism and legitimizes itself through its authority, only increases the complexity of the task of those who advocate a framework for a communicable debate in seeking 'understanding' rather than 'transforming'. This also occurs because intellectual paucity in contemporaneous intellectual production is reinforced by the usual desire, to call to task polemically all antecedents and thus reducing the richness of their material in order to do so. Modern critical practice finds itself under fire as many cultural products which we associate with our conventional image of modernism perpetuate the legacy of a relationship between theory, history and design where design is underpinned by theory with the assistance of history. Furthermore, a history of architecture is produced which is not fully aware of contemporary historiographic debates

within the historical field,[8] nor does it know how to further the most interesting experiments of art history.[9]

'Ignorance breeds contempt' – this is as true in criticism as it is in design, but is this inevitable? And is it also inevitable to accept the postmodern condition as the only possible representation for a difficult human (and architectural) way of seeing and being?

NOTES

1 D. Harvey's own position in this respect seems emblematic of most cultural critics. Whilst on the one hand he quotes Baudelaire as a source of authority, on the other he relies for his own understanding of the architectural postmodernist phenomenon on the interpretation of those who fail to see the implications of such a quote for their own work. The quote reads:

> As Baudelaire was very quick to see, if flux and change, ephemerality and fragmentation, formed the material basis of modern life, then the definition of a modernist aesthetic depended crucially upon the artist's positioning with respect to such processes. . . . The effect of any one of these positionings was, of course, to alter the way cultural producers thought about the flux and changes as well as the political terms in which they represented the eternal and immutable. The twists and turns of modernism as a cultural aesthetic can largely be understood against the background of such strategic choices.
> (*The Condition of Postmodernity*, Oxford, Basil Blackwell, 1989, p. 20)

2 It does transcend the limits of this contribution to demonstrate how weak cultural boundaries contribute to the reinforcement of cultural conventions and how these operate within architectural criticism. For an explanatory case study, see my 'Typology as a form of convention', *AA Files* no. 6, May 1984, pp. 73–82. It is nevertheless interesting to note that whilst David Harvey's refutation of the inevitability of the postmodern condition focuses, at the philosophical level, on a scholarly debate, as far as architecture is concerned his polemic is very much pitched at the journalistic level. For example, Harvey focuses mainly on the formal appearance of postmodernist architectural appearances, as when he writes: 'The postmodern penchant for jumbling together all manner of references to past styles is one of its more pervasive characteristics. Reality, it seems, is being shaped to mimic media images' (ibid.: 85). This critical appraisal closely accepts Charles Jenks's thesis that postmodernism is:

> double coding: the combination of modern techniques with something else (usually traditional buildings) in order for architecture to communicate with the public and a concerned minority, usually other architects. . . . The solution I perceived and defined as Post Modern: an architecture that was professionally based and popular as well as one that was based on new techniques and old patterns.
> (*What is Post-Modernism?*, London, Academy Editions, 1986, pp. 14–15)

3 The degree of consensus around what constitutes postmodern can perhaps be verified in the following attempt by Terry Eagleton:

> There is, perhaps, a degree of consensus that the typical post-modernist artefact is playful, pluralist, self-ironizing and even schizoid; and that it reacts to the austere autonomy of high modernisim by embracing the

language of commerce and the commodity. Its stance towards cultural tra-
dition is one of irreverent pastiche, and its contrived depthlessness under-
mines all metaphysical solemnities, sometimes by a brutal aesthetic of
squalor and shock.

T. Eagleton, 'Awakening from modernity' review in *TLS*, 20 February 1987 of
J.-F. Lyotard, *Le Postmoderne expliqué aux enfants*, Paris, Galilée, (1986) and
J.-F. Lyotard and J. L. Thebaud, *Just Gaming*, Manchester, Manchester
University Press.

4 Designers, because of the inherent ambiguity of their craft, are very vulnerable
to changes in the cultural episteme. When Eagleton (op. cit.) ironically writes:

We are now in the process of awakening from the nightmare of modernity,
with its manipulative reason and fetish of the totality, into the laid-back
pluralism of the post-modern, that heterogeneous range of life styles and
language games which has renounced the nostalgic urge to totalize and
legitimate. Just as the post-modernist art-work abandons the consoling
closure of a 'metalanguage', ironically cutting its own propositions, so science
and philosophy must jettison their grandiose metaphysical claims and view
themselves more modestly as just another set of narratives,

he voices exactly that cultural malaise which justifies the lack of positioning in
contemporary architecture *thus* the jumbling of styles.

5 It may be helpful to note here that the notion of a loose convention is as valid for
philosophy as it is for architecture. From Lyotard to Guattari, from Derrida to
Baudrillard, most contemporary critical thinkers who do not fit the Habermasian
categories are loosely referred to as deconstructionist and/or postmodernist.
Subtle distinctions, in all disciplines, belong to the *cognoscenti*.

6 Nina Hofer's introduction closely follows Eisenman's own ideas, as when she
starts the essay by quoting his words:

What can be the model for architecture when the essence of what was effective
in the classical model – the presumed rational value of structures, represen-
tations, methodologies of origins and ends and deductive processes – have been
shown to be delusory? What is being proposed is an expansion beyond the
limitations presented by the classical model to the realization that architecture
as an independent discourse, free from external values; that is, the intersection
of the meaningful, the arbitrary and the timeless in the artificial.

She then continues:

The first premise of the Fin d'Ou T Hou S is that the world can not longer be
understood in relation to any 'absolute' frame of reference devised by man. If
one accepts this presupposition, then the concept of extrinsic or relative value
becomes meaningless and traditional rationalism merely arbitrary. Fin d'Ou T
Hou S suggests that the architectural object must become internalised so that
its value lies in its own processes. . . . Here Fin d'Ou T Hou S is presented as
a score of its process; text is provided in the form of a presentation and
critique of decomposition as architectural process and an explanation of the
analysis and processes discovered in the initial configuration.

(N. Hofer, Introduction to P. Eisenman 'Fin d'Ou T Hou S',
Folio V, London, Architectural Association, 1985 p. 3)

7 Bennington's essay is seminal both for understanding the relationship between
architectural and contemporary philosophical discourses and for opening up
within this the notion of 'event' which is fundamental for that relationship. See

G. Bennington, 'Complexity without contradiction', *AA Files* 15, September 1987, p. 17.

8 Whilst Sigfried Giedion in *Space, Time, Architecture: the Growth of a New Tradition* (Cambridge, MA Harvard University Press, 1941) follows a reductive interpretation of the Hegelian Zeitgeist, neither Nikolaus Pevsner in *Pioneers of the Modern Movement: from William Morris to Walter Gropius* (London, Penguin, 1959) nor Henry-Russell Hitchcock in *Modern Architecture* (Payson and Clarke, 1929) in their influential books bother to explain the methodological framework underpinning their interpretations. This is particularly important if one remembers that it is on those books that generations of architects and architectural historians were trained. One has to wait for Leonardo Benevolo's *Storia Dell' Architettura Moderna* (Bari, Laterza, 1964) for the perception of the Annales work to influence architectural history, and much later on for the work of Manfredo Tafuri and the Venice school of architectural history to tackle, both through philosophical enquiries and through detailed case studies, the boundaries and problems besetting contemporary historical and critical practice in architecture.

9 The lack of attention that the Warburg tradition has received (since Wittkower's studies on the Renaissance which, through Colin Rowe, influenced that generation of British architects who became the protagonists of post-Second World War British reconstruction) from contemporary architectural criticism is, in this respect, indicative.

Chapter 16

News from somewhere

Robert Hewison

This chapter takes a different approach to that of other authors in that it is not intended to be theoretical: it is anecdotal, even autobiographical. The reason for my inclusion in this volume (and for my being invited to speak at the 'Futures' conference in 1990, on which this volume is based) is that I happen to have written a book called *Future Tense* (Hewison 1990).

When I started work on the book, I had no conception that I was working on a utopian project. The book, which is itself anecdotal (and covertly autobiographical), came out of the particular concerns that are the result of my hybrid existence as an independent cultural historian who subsidizes his books with various forms of journalism. The primary concern in almost everything that I have written is: what are the conditions in which it is possible for an artist – applying that term as widely as possible – to function, and second, how are these conditions, favourable or otherwise, reflected in the work that results?

In *Future Tense*, the most pressing problem quickly became: how is it possible to write a book about postmodernism that anyone would want to read, and what are the conditions in which it is possible to survive financially while writing it? I had already addressed the question of creativity for the contemporary artist, at least obliquely, in my previous book *The Heritage Industry* (Hewison 1987), where I had asserted that the onward march of new museums (a new one had opened every fortnight for two decades) points to the imaginative death of this country. Britain's obsession with its past is profoundly entropic. That is to say, it encourages a creeping cultural inertia. As the past grows around us, creative energies are lost. Worse, as the past receives more and more care and attention, it becomes more and more attractive, and the present, correspondingly less so.

As to the future, it did appear that fewer and fewer people were thinking about it – except with apprehension and unease. The approach of the second millennium provokes apocalyptic thoughts, although, at present, minds seem more set on the prospect of environmental disaster than on the

promise of revelation that apocalypse is supposed to bring. My argument was that if we were to combat the entropy of the past, then our cultural focus had somehow to be wrenched round towards the future.

But it must be said straight away that predicting the future is a fairly futile occupation. It is bad enough trying to keep up with the present. If your subject is the present, all sorts of things can go wrong in the dreadful length of time that the manuscript is out of your hands. I had made something of an emblem out of the global aspirations of Saatchi & Saatchi, who almost immediately the text was finished started to plunge from leading world advertising agency to near bankruptcy. Another exemplary location, Tobacco Dock in Docklands, subsequently went into receivership. The events in Eastern Europe which, whatever their eventual outcome, demonstrate the possibility of sudden, cataclysmic change, were outside my brief, but they happened almost entirely while the book was in production.

What was important was not predicting the future, but finding ways in which we might begin to think about it all. And to do that required some discussion as to why the future is so little regarded. What, I wondered, had helped to produce the prevailing pessimism, the discourse of death that Dick Hebdige has identified: 'death of the subject', 'death of art', 'death of reason', 'end of history' (Hebdige 1988: 210).

The answer lay in what is described as the contemporary postmodern condition. I am not going to conduct yet another exercise in dating and definition but a clue to our present discontents may well lie in that simple prefix, 'post'. We are not living in a New Age, but in the aftershock, the aftermath, possibly even the afterthought of one. Whatever it is, we are living in the AFTER. The 'after' is a difficult place to describe, since it is defined by what it is not, hence that sense of living in a void. Certain aspects of cultural theory seem to reinforce that sense of helplessness: language speaks us, we are castaways on a sea of ideology, in which our individual identities are no more than the froth of a wave. We are floating, lost in Jamesonian hyperspace, heading inexorably for Baudrillard's black hole.

Yet the very fact that Baudrillard can go on television to celebrate his nihilistic ecstasy of communication, or that however helpless we may feel in theory, here we all are, palpably and materially discussing the future of writing about the future, implies a certain distance between the clarity of these philosophical projections and the messy confusions of present contingency. There is an uneasy fit – dare I say it? – between the purity of theory and the experience of actuality.

The project therefore became one in which the present situation was simply described in order to be denounced. Enough of that had been done in *The Heritage Industry*. It was necessary to look for those places where the postmodern condition, once an attempt had been made to describe it,

had either not become absolute, or where the fragmentation of the after-shock of modernism had produced resistances to the prevailing banaliza-tion and commodification of contemporary culture. The first step was to look for alternative versions of the present, the second was to look for possible alternative hypotheses about the future.

In both cases, though more in the case of the former (other versions of the present) rather than the latter (visions of the future), it was possible to find examples of artists who were making creative use of the conditions in which they were having to work. People may quarrel with the choice, but it is the product of the particular contingencies of my situation: I was trying to reflect something brought out of experience, rather than theory. The fact of the matter is that you have to bring your news from somewhere.

The alternative versions of the present were, of course, rearrangements of the material of the present. Hence my rearrangement of two terms applied within twentieth-century modernism – social realism and surrea-lism – into 'social surrealism'. However much the artists cited – from Derek Jarman to Salman Rushdie to Howard Barker – may be seen as conven-tional choices from within the perspective of what used to be called the avant-garde, none of them can be said to have been clasped to the bosom of the society that produced them. Furthermore, I argued that these works reflected the problem of the conditions of the twentieth century as much as a solution to them. But they were reasons for hope.

As to hypotheses about an art of the future, it appeared that the institutions of power and capital had so totally taken over public space – characterized within the general scheme of argument as 'the city' – that an alternative vision was more easily to be found within the site of at least nominal autonomy – the body. To quote, appropriately enough, the archi-tect, Nigel Coates, 'The body is, after all, the most readily available territory of expression' (Thakera 1988: 106). It is also the principal location of individual identity, and it was those artists and critics who challenged previous assumptions about personal identity – and the structures of power and language which confirmed those identities – who emerged as the most discontented with present modes of expression, and who appeared to be the most committed to the search for a new territory in which to ground new forms of expression.

Women artists and critics in particular have been trying to find a new space and a new language with which to describe that space, while hoping to avoid the subjection of that space and the colonization of that language by the old imperatives of male domination. I was encouraged by Alice Jardine's concept of *Gynesis*: 'a map of new spaces yet to be explored' (Jardine 1985: 52). But when someone starts to talk about new spaces, new territories, new languages, without quite being able to describe them, they are arguing as much through image and metaphor as they are through evidence and logic. The dry discourse of reason begins to run with the less

channelled streams of the imagination. My book is constructed through a sequence of images. But these are not arbitrarily chosen. These are the images most often deployed in the accounts I have read of the postmodern condition.

The sequence begins with the screen: the spectacle of the situationists, the smooth operational surface of communication of Baudrillard, the depthless present of Jameson's hyperspace. But the image of a smooth surface of reproduction is succeeded by one of disruption – the metaphor of the fracture or crack. If I have made any contribution to the discussion of postmodernism, I believe it is by simply pointing out how frequently the words 'break', 'gap', 'fracture' and 'interstice' appear in writings on the subject. They are images found in works of the most rigorous theory. Note that the final chapter in David Harvey's book is called 'Cracks in the mirror, fusions at the edges' (Harvey 1989: 356).

The crack in the screen – which is often the focus of critical interest and is usually identified as a source of potential change – opens out towards the wider space of new territory, to be occupied by new forms. If then, we were to step back and trace all these fractures and faultlines, it may be possible to see a new pattern, a new network emerge. Somewhere between Jameson's cognitive mapping and Jardine's 'map of new spaces yet to be explored', the idea hardens that there is somewhere to go, that it is – to use a favourite flourish of the politicians – possible *to move forward*. And if the conviction forms that there is somewhere to explore, then I believe that expeditions will eventually assemble and set out.[1]

To base a book that purports to be non-fiction on a sequence of imagery – even if that imagery is extracted from the heart of the non-fictional critical discourse with which the book attempts to engage – means in the end that you are relying on rhetoric. In some senses, the book attempted to use the strategies of a novel. But the purpose of rhetoric is to persuade; the purpose of fiction is to open up the possibilities of the imagination. To that end, it was necessary to imagine what could not ultimately be completely described: the image of the network translated back into the idea of an operable, non-dominative pluralism, sustained by a critical culture that has not been adequately defined either. These things remain in the future.

The purpose of such projects as the one collectively addressed at the 'Futures' conference is to step outside the present in order to try to see it as a whole. Once we can see it as a whole, we can then begin to imagine alternatives to it. The postmodern condition, it is argued, is one in which either existence is so fragmented, or the supervening structures of language and ideology so powerful, that this is no longer achievable. This postmodern pessimism must be resisted at all costs.

Anyone who attempts a syncretic vision must expect to be challenged both on that vision and on the details that constitute the broader synthesis, but the critical reception of *Future Tense* has suggested that people are

reluctant to make the imaginative effort involved in the search for a new vision. Reviewers have picked away at it from the point of view of their own narrow specialisms, and failed to acknowledge the wider purposes of the project. It is emblematic of the fragmentation of the postmodern condition that people cannot see the new territory for the old trees.

It may be that all syncretic visions are doomed to failure, that ultimately no explanations are possible. Yet that in itself is an explanation – and however impossible it may turn out to be, the 'Futures' conference demonstrated a determination to continue the search. Artists and writers experience something similar daily. They are shaping the world as it shapes them. But they are also engaged in another process, which is to imagine the unimaginable, and by so doing, to help to bring the impossible into being. By saying that we *must* think about the future, perhaps we will begin to do so.

To conclude however, I will quote from Fredric Jameson's book, *Postmodernism, or, The Cultural Logic of Late Capitalism*. In a chapter entitled 'Utopianism after the end of Utopia', he argues that:

> in our time, where the claims of the officially political seem extraordinarily enfeebled and where the taking of older kinds of political positions seems to inspire widespread embarrassment, it should also be noted that one finds everywhere today – not least among artists and writers – something like an unacknowledged 'party of Utopia': an underground party whose numbers are difficult to determine, whose program remains unannounced and perhaps even unformulated, whose existence is unknown to the citizenry at large and to the authorities, but whose members seem to recognize one another by means of secret Masonic signals.
>
> (Jameson 1991: 180)

It was after I had read this passage, a year after writing *Future Tense*, that I began to see that I might have been engaged in a utopian project, after all.

NOTE

1 I should like to record that, listening to the debate at the Tate Gallery, there was a strong sense that the caravanserai of this particular conference was reluctant to fold its blankets and set out; that the cultural wagons were still in a circle and that the missionaries of this clerisy were unwilling to leave the seminary. When I extemporized this comment during the conference, I was reproved from the floor for such imperialistic and patriarchal imagery.

REFERENCES

Harvey, D. (1989) *The Condition of Postmodernity: An Enquiry into the Origins of Cultural Change*, Oxford: Basil Blackwell.

Hebdige, D. (1988) *Hiding in the Light: On Images and Things*, London: Routledge.

Hewison, R. (1987) *The Heritage Industry: Britain in a Climate of Decline*, London: Methuen.

—— (1990) *Future Tense: A New Art for the Nineties*, London: Methuen.

Jardine, A. (1985) *Gynesis: Configurations of Woman and Modernity*, Ithaca, NY: Cornell University Press.

Thakera, J. (ed.) (1988) *Design After Modernism: Beyond the Object*, London: Thames & Hudson.

Jameson, F. (1991) *Postmodernism, or, the Cultural Logic of Late Capitalism*, London: Verso.

Part V

Thinking futures

Chapter 17

The future of thinking about the future

Ruth Levitas

This article addresses the question of whether utopian thinking is possible under contemporary conditions. It concludes that it is difficult but necessary. Discussions of utopia are, however, so prone to misinterpretation that it is always necessary to begin with a clarification of how the term is being used. Colloquially, utopia carries the double sense of perfection and impossibility. In most versions of Marxism, utopia implies drawing up blueprints for the future and supposing that they can be realized through sheer force of will; impossibility and voluntarism mean that utopia is counter-revolutionary. Whether utopia is actually a feature of Marxism or compatible with or antagonistic to it depends on which Marxism you are talking about as well as what is meant by utopia. Anti-utopian arguments, such as Karl Popper's, identify utopia with blueprints of future societies which inevitably, if attempts are made to realize them, lead to totalitarianism, and include Marxism in this category. In contemporary utopian studies, definitions of utopia may focus on form, on content or on the function of utopia.[1]

What is meant here by utopia is to be understood more broadly as the desire for a better way of living expressed in the description of a different kind of society that makes possible that alternative way of life. There may be many reasons for finding utopian thought interesting, but the political importance of utopia rests on the argument that a vision of a good society located in the future may act as an agent of change. Politically, utopia is important because of its potential role in social transformation. The absence of utopian thinking may then be construed as a problem because it paralyses political action or prevents it from cohering into a force capable of effecting fundamental change. As William Morris put it, it is 'essential that the ideal of the new society should always be kept before the eyes of the working classes, lest the *continuity* of the demands of the people should be broken, or lest they should be misdirected'.[2]

Both David Harvey in *The Condition of Postmodernity* and Fredric Jameson in *Postmodernism, or, the Cultural Logic of Late Capitalism*, on which Harvey draws, argue that postmodernity creates difficulties about

thinking about the future. The spatial replaces the temporal, while the fragmentation of experience underlines the contingency of all interpretations of the world and renders problematic any commitment to an alternative, let alone an alternative future. The condition of postmodernity is one in which the future presents itself as foreclosed – or indeed fails to present itself at all. If this is true, then we might expect that the utopian imagination finds little place in the postmodern world.

I want to argue that the claim that postmodernism and/or postmodernity have extinguished the utopian imagination is not altogether true, and this for two reasons. First, utopian speculation continues although there have been changes, and quite important changes, in the space that utopia is able to occupy in contemporary culture. Second, the causes of these changes are not to be located solely or even primarily in the ideological sphere. They are not caused by a failure of the utopian imagination, but result from a more concrete problem, that of the difficulty of identifying points of intervention in an increasingly complex social and economic structure, and of identifying the agents and bearers of social transformation. It is difficult, therefore, to imagine and believe in the transition to an imagined better future. The problem about contemporary utopias is not that it is difficult to produce imaginary maps of the future, but that it is difficult to produce adequate maps of the present which permit images of a connected but transformed future.

I also want to argue that since utopia is necessary for the reasons outlined above, in so far as postmodernism as a style and postmodernity as a condition or general mode of experiencing the world negate or undermine thinking about the future in utopian terms, they are ideological in the strictly Marxist sense of obscuring reality and sustaining the status quo. This point is implicit in both Jameson and Harvey, who see postmodernity as a product of late capitalism, although the theme is more strongly present in Jameson's work.

First, utopia. There have been a lot of pronouncements on the death of utopia recently. Many people – including Vaclav Havel – think this is a good thing. The equation utopia = Marxism = Stalinism = socialism helps to write off utopia and support the view that there is no alternative to free-market capitalism. The death of utopia, however, has also been pronounced by people who are at least partly in favour of it, from Karl Mannheim in 1929, in *Ideology and Utopia*, to Krishan Kumar in 1987, in *Utopia and Anti-Utopia in Modern Times*.

If we look at the history of utopia, however, we can see that the reality is rather more complex. Utopia changes its form and function, and indeed its location, with the context in which it arises. Early utopias include the earthly paradise of Eden located in the east, a golden age myth followed by a fall from grace which explains and legitimizes the non-utopian nature of actual life. They also include Celtic myths of the Isles of the Blessed,

located in the west – which, Christianized, give rise to the *imrama*, tales of the travels of Irish monks, including the voyage of St Brendan. St Brendan's isle is in fact included (in the west) on the Mappa Mundi, which also shows Eden in the east (and Jerusalem at the centre of the world). The medieval poem *The Land of Cokaygne* also locates utopia in the west.[3]

Two points about these utopias are important to the present argument. First, they are not located in the future, but in a spatial rather than a temporal elsewhere. Second, they are not located in the future because the function of utopia is not always one of change. In the case of *Cokaygne*, the function is clearly one of compensation, not even critique. In consequence, fantasy has a free rein, depicting geese which fly around crying 'all hot, all hot', and larks which fly ready-cooked into the mouth, smothered in stew and heaped with cinnamon. Thomas More's *Utopia*, in keeping with the travellers' tales of the time on which it is modelled, is also located elsewhere in space rather than elsewhere in time. But because it is intended as critique, not as an escapist fantasy, the constraints of plausibility are stronger for More. It is only with the advent of ideas of progress and the belief in some degree of human control over social organization that the location of utopia in the future, as a point to which society either inexorably tends or can be pushed by human action, becomes a possibility. A pressure then emerges for the content of utopia to be plausible, not just as an internally consistent system which is formally possible, but as a really possible world whose emergence from the present state of affairs is credible.[4]

The point of this digression into the history of utopias is that there is strong reason to suppose that contemporary utopias differ from those of the utopian socialists (Owen, Fourier, Saint-Simon), or those of Edward Bellamy in *Looking Backward*, or William Morris in *News from Nowhere*. All of these writers believed in a redeemed world in the forseeable future, and all of them had views about how it could be brought about. Bellamy and Morris differed radically about the process of transition, Bellamy positing a gradual and bloodless evolution, and Morris a proletarian revolution (in which the violence is initiated by the state); but both believed in their transformed future as at least possible. *News from Nowhere* concludes: 'if others can see it as I have seen it, then surely it may be called a vision rather than a dream'. But since, for contemporary thinkers, the idea of progress no longer dominates, and since the future is either viewed as an arena of decline, or an arena which is (perhaps for that reason) out of bounds, it is difficult for utopia to occupy the space of an imagined alternative future which serves to transform the present.

This does not mean that utopia has declined. There have, in fact, been large numbers of utopias written in recent years. Significantly, many of the most successful of these have been written by women – Ursula Le Guin's

The Dispossessed (1974) and Marge Piercy's *Woman on the Edge of Time* (1975), among others. But although these are set in the future (as well as, in the case of *The Dispossessed*, elsewhere in space), they are dislocated from the present. Moreover, the very separation from the present and the fact that these are not literal versions of alternative futures are underlined by ambiguities of commitment in the texts themselves (present also in More). The fantasy element in contemporary utopia is strong, and both these books are frequently shelved by booksellers as science fiction. In some more recent utopias, the element of fantasy is stronger still: Sally Miller Gearhart's *The Wanderground* (1985) is a separatist society in which the women develop skills of telepathy between themselves and with other species, as well as powers of telekinesis. This is still identifiable as a utopia, but there are also strong utopian (and dystopian) elements in such fantasy novels as Clive Barker's *Weaveworld* (1987).

Tom Moylan has argued, in *Demand the Impossible*, that recent utopias, many of which are feminist, represent a new genre of utopia, which he calls critical utopias, whose form and content resist co-option by the status quo. These characteristics enable them to produce an estrangement effect, to call into question the taken-for-granted reality of everyday life. Such utopias depart from the narrative form typical of Morris and Bellamy, shifting about in time, offering alternative futures and presenting both those futures and the present in an ambiguous light. Both alternative and originating societies emerge as backgrounds to the action of the characters, rather than being the main focus – so the emphasis is on action rather than on structure. In so far as the transformation is addressed, the agency is collective action, and Moylan writes that 'in the critical utopia the . . . heroes of social transformation are presented as off-center and usually as characters who are not dominant, white, heterosexual, chauvinist males but female, gay, non-white and generally acting collectively'.[5] Moreover, the alternative societies in question are typically decentralized and pluralist in form. (It is salutary to remember, however, that utopia is not the exclusive preserve of the left, and contemporary utopias do include Andrew MacDonald's fascist utopia *The Turner Diaries*, the most pernicious and revolting book I have ever read, as well as the better-known and more conventionally right-wing novels of Ayn Rand.)

Moylan argues that the form of the critical utopia renders it more exploratory and less open to charges of totalitarianism, and more capable of producing estrangement and thus stimulating the will to transformation, which is the strongest function of utopia. This is partially true. Contemporary utopian writing reflects a belief in the radical indeterminacy of the future, both in presenting alternative futures, and in the slightness of discussions of transition. Moreover, the emphasis on collective questioning within utopia itself serves to disarm criticisms of utopia as static, perfect

and totalitarian. The provisional nature of the utopian hypothesis concedes that 'a dream is a door to a world unknown'.[6]

But one can read these strengths also as weaknesses. The transformed form of utopia can be seen as a manifestation of the postmodern condition itself: the abandonment of a grand narrative linking present with future and affirming a clear set of values, and in its place a fragmentary, ambiguous utopia which acts as an inconclusive critique of the present, while not confidently asserting that there is a real possibility of anything better. Moreover, even where they are located in the future, such utopias are, like most utopian or intentional communities which have been set up within history, what may be called interstitial utopias. That is, they occupy the spaces allowed to them by other, dominant groups in their own time. In Raymond Williams's terms, they are predominantly alternative rather than oppositional, and can be tolerated while only partially co-opted by the dominant culture.[7] Le Guin's Anarres is on a not particularly fertile or mineral-rich moon which dissidents were allowed to colonize; the same theme occurs in her *The Eye of the Heron* (1980). Piercy's utopia is at war with its neighbours. Gearhart's exists in the hills, where women have escaped from the cities where men rule, and is similarly embattled.

Jameson comments briefly on the renewal of utopian thinking, with particular reference to *The Dispossessed* and Ernest Callenbach's *Ecotopia* (1978). He claims that Margaret Atwood's *The Handmaid's Tale* (1986) is 'the first feminist *dystopia* and thereby the end of the very rich feminist work in the Utopian genre as such' – a very contentious view of the relationship between utopia and dystopia, and one which is belied by the demonstrable continuation of utopian writing. More interestingly, he sees these books as illustrative of a more widespread Marcusian utopianism in which the Great Refusal is decentred from class and dispersed to a 'vital range of micropolitical movements . . . whose common denominator is the resurgent problematic of Nature in a variety of (often anticapitalist) forms'. Jameson suggests that this is connected with the shift from temporal to spatial thinking – a shift which he construes as more positive than negative, despite conceding its ambiguity. We can, he says,

> see in all these varied Utopian visions as they have emerged from the sixties the development of a whole range of properly spatial Utopias in which the transformation of social relations and political institutions is projected onto the vision of place and landscape, including the human body. Spatialization, then, whatever it may take away in the capacity to think time and History, also opens the door onto a whole new domain for libidinal investment of the Utopian and even the protopolitical type.[8]

Zygmunt Bauman, discussing the fate of utopia in 1976, suggests that the kind of oppositional cultural practice which Moylan sees in the critical utopia should be viewed with greater scepticism. Cultural criticism can also

be read as the result of socialism's (and socialists') retreat from the field of political struggle, representing a 'divorce between cultural challenge and socialist politics'.[9] Similarly, the spatialization to which Jameson refers, the identification of the body and the self as sites of struggle, despite their oppositional qualities (particularly in relation to feminism), also can be read as representing a retreat from questions of social and political transformation to the construction of the self. The personal ceases to be sufficiently political if and when we 'take away the capacity to think time and history'.

My own view would be that there is now a real difficulty about images of a utopian future performing a function of catalysing social change, and that utopia has retreated from this role to the more limited (though still vitally necessary) ones of estrangement, critique and escapism. It is not that there is a difficulty about imagining alternative societies which would be better; it is that it has become difficult to believe in them as possible, and to trust them as desirable. The corollary of this is that contemporary utopias are not inhibited from including generous (and sometimes unpalatable) helpings of fantasy. Ernst Bloch, the Marxist philosopher who has done most to argue for the importance of utopia, makes an important distinction between abstract and concrete utopia, between the elements within utopian images which are purely escapist, compensatory, wishful thinking and those which are transformative and will-full in the sense of driving forward to action and a real, possible, transformed future; between expressions of desire and expressions of hope.[10] In so far as it contains more of the former and less of the latter, utopia is not dead, but it is in a political sense weakened.

This brings me to my second point, the identification of why this has happened. Moylan's assertion that because utopia may still produce estrangement, it can produce change, can be seen as arising from the wish that this may be so. It is itself a utopian statement (and abstract utopian at that). But the wish that utopia, in the guise of the literary utopia, or other cultural or even overtly political forms, may be the key bearer of social transformation warrants closer consideration. Here it is useful to return to Marcuse, though in a rather different way from Jameson.

Marcuse, like other writers of the Frankfurt school, particularly in his later work, sees art as the bearer of utopia. The way in which he does this is far more optimistic than, say, Adorno, who sees art as offering only glimpses of a utopia which is unattainable. Adorno sees art's utopia, the counterfactual yet-to-come, as 'draped in black':

It goes on being a recollection of the possible with a critical edge against the real; it is a kind of imaginary restitution of that catastrophe, which is world history; it is freedom which did not come to pass under the spell of necessity and which may well not come to pass ever at all.[11]

Marcuse is more optimistic. Art is the socially sanctioned realm of fantasy. But it is not only critical of existing reality. It also posits an alternative and can act at least indirectly as an agent of transformation: 'Art cannot change the world, but it can contribute to changing the consciousness and drives of men and women who could change the world.'[12] The role of art is the expression and cultivation of Eros, that aspect of human nature which is the basis of sensual and creative instinct in human beings, and which itself, in *Eros and Civilisation*, is held to be the source of the hope that humanity will ultimately refuse to tolerate the repressive reality of capitalism.

But the reason why Marcuse ends up placing such a heavy burden upon the sphere of art is that he has abandoned the conventional Marxist agency of transformation, the proletariat, because he maintains that it has been incorporated into capitalism through the spread of consumer goods and the cultivation of stabilizing needs. The point is not that Marcuse was wrong to doubt the revolutionary potential of the Western working class, but that, like other writers (including Andre Gorz), once Marcuse sets out down the road of not-the-proletariat, he finds himself in grave difficulties over conceptualizing a credible transition from here to the promised land. Gorz offers us the non-class of non-workers.[13] Marcuse offers us the Great Refusal, a general term for all oppositions which can be seen to be protests against the unnecessary repression entailed in the performance principle, and which would include those movements now generically referred to as the new social movements. Art, in the broadest sense, is part of this refusal, and in Marcuse's later work, the most important part.

This requirement that art be the carrier of revolution, and the fear of what will happen if it is not, is thus directly related to the problem of agency. Yet while art may produce estrangement, the question of social transformation demands a more direct consideration of who is going to do the transforming and how. This takes us back to Moylan and the critical utopia. The groups that are here identified as the collective agents of change in these ambiguous and fragmentary works are 'female, gay, non-white' – the groups which form some of the constituencies of the new social movements and which, together with students and the Third World proletariat, were also bearers of the Great Refusal. It is not accidental that women, as one of these groups, should be the source of much contemporary utopian writing.

Yet this diversification of constituencies of oppression is itself a manifestation of that fragmentation which characterizes the so-called postmodern world, otherwise known as late capitalism. Some see the fissiparity of political action as the result of the 'fragmentation of the self', which is also held to be characteristic of contemporary experience. If such a condition exists as a specific historical condition (i.e., other than as a transhistorical feature of human nature as implied by psychoanalysis, and other than as a fancy way of talking about role conflict), it seems much more likely that the

causality is the other way round. In any case, it does not make it any easier to identify either points of intervention in the system which might lead to transformation (as opposed to sites of struggle where limited gains may be won) or groups of people capable of making those interventions. As Stuart Hall puts it:

> The multiplication of new points of antagonism, which is characteristic of our emerging 'post-industrial' societies, while making available new potential sites of intervention, further fragments the political field, dispersing, rather than unifying the different social constituencies.[14]

Jameson himself addresses the question of agency, but with no more satisfactory outcome. In the last instance, appeal is made to a potential international proletariat – which is still in the making, and thus which is also unimaginable and indescribable:

> The postmodern may well . . . be little more than a transitional period between two stages of capitalism, in which the earlier forms of the economic are in the process of of being restructured on a global scale, including the older forms of labor and its traditional organizational institutions and concepts. That a new international proletariat (taking forms we cannot yet imagine) will reemerge from this convulsive uphea-val it needs no prophet to predict: we ourselves are still in the trough, however, and no-one can say how long we still stay there.[15]

Jameson goes on to say that his own appeal for cognitive mapping is 'in reality nothing but a code word for "class consciousness" – only it proposed the need for class consciousness of a new and hitherto undreamed of kind'.[16]

The great strength of Jameson's and Harvey's analyses of postmodernity is their insistence that this mode of experiencing the world is to be understood sociologically, as a product of late capitalism. The implication is that the claims of postmodernism – including the anti-utopian rejection of meta-narratives – are not to be taken at face value. The weakness is that in neither case is the way in which global capitalism is mediated as postmodernity sufficiently explicated; and in neither case does the analysis offer a 'cognitive map' with any paths marked on it. If the 'cognitive map' is to be understood simply as a code for class consciousness (of however undreamed of a kind), then Jameson does his own argument a great disservice by replacing what is at least potentially an analysis of real forces and agents for change with rhetoric. Only abstract, not concrete, utopia is possible here.

Politically, this question of agency is far more pressing, and far more intractable, than the problem of the utopian imagination. There was a brief flurry of optimism at the end of 1989 as it appeared that 'the people' could rise up with lighted candles and overthrow repressive regimes; but the

expansion of international capitalism quickly obliterated any suggestion that this would bring about a liberatory alternative. The main reason why it has become so difficult to locate utopia in a future credibly linked to the present by a feasible transformation is that our images of the present do not identify agencies and processes of change. The result is that utopia moves further into the realms of fantasy. Although this has the advantage of liberating the imagination from the constraints of what it is possible to imagine as possible – and encouraging utopia to demand the impossible – it has the disadvantage of severing utopia from the process of social change, and severing social change from the stimulus of competing images of utopia. The effect of this weakening, the dimming of the star of utopia, is to limit the challenge to the status quo. The solution, however, is not to call for more and better utopias, more and better images and maps of possible futures. These will follow when we have better analyses of the present which identify possible points of intervention, paths and agents of change. The fault lies not in our stars, but in ourselves.

NOTES

1 The problem of the definition of utopia, both in contemporary utopian studies and in relation to Marxism, is discussed in Ruth Levitas, *The Concept of Utopia*, London, Philip Allen, 1990.
2 William Morris (with Belfort Bax), *Socialism: Its Growth and Outcome*, London, Swan Sonnenschein, 1893, p. 278.
3 A translation of *The Land of Cokaygne* is given at the end of A. L. Morton's *The English Utopia*, London, Lawrence & Wishart, 1952, pp. 279–85. The status of the account of the voyage of St Brendan is discussed in Tim Severin, *The Brendan Voyage*, London, Hutchinson, 1978.
4 This argument is developed at greater length in Ruth Levitas, 'Sociology and utopia', *Sociology*, vol. 3, no. 1, 1979.
5 Tom Moylan, *Demand the Impossible*, London, Methuen, 1986, p. 45.
6 Leon Rosselson, 'Bringing the news from nowhere', on *Bringing the News from Nowhere*, Fuse Records, CFC390, 1986.
7 See Raymond Williams, 'Base and superstructure in Marxist cultural theory', in *Problems in Materialism and Culture*, London, Verso, 1980.
8 Fredric Jameson, *Postmodernism, or, the Cultural Logic of Late Capitalism*, London, Verso, 1991, p. 160. This collection of essays takes its name from the article published in *New Left Review* in 1984.
9 Zygmunt Bauman, *Socialism: The Active Utopia*, London, Allen & Unwin, 1976.
10 Ernst Bloch, *The Principle of Hope*, Oxford, Basil Blackwell, 1986.
11 Theodor Adorno, cited in David Drew's introduction to Ernst Bloch, *Essays in the Philosophy of Music*, Cambridge, Cambridge University Press, p. xl.
12 Herbert Marcuse, *The Aesthetic Dimension*, London, Macmillan, 1979, p. 32.
13 Andre Gorz, *Farewell to the Working Class: An Essay on Post-Industrial Socialism*, London, Pluto Publishing, 1982.
14 Stuart Hall, 'Thatcher's lessons', *Marxism Today*, March 1988, p. 27.
15 Jameson, op. cit., p. 417.
16 ibid., pp. 417–18.

REFERENCES

Atwood, Margaret (1986) *The Handmaid's Tale*, London: Virago.

Barker, Clive (1987) *Weaveworld*, Glasgow: Fontana.

Bellamy, Edward (1888) *Looking Backward*, Boston: Tickner.

Callenbach, Ernest (1978) *Ecotopia*, London: Pluto.

Kumar, Krishan (1987) *Utopia and Anti-Utopia in Modern Times*, Oxford: Basil Blackwell.

Le Guin, Ursula (1975) *The Dispossessed*, London: Panther.

—— (1980) *The Eye of the Heron*, London: Panther.

MacDonald, Andrew [aka William Pierce] (1978) *The Turner Diaries*, Washington: National Alliance Books.

Mannheim, Karl (1979) *Ideology and Utopia*, London: Routledge & Kegan Paul (1st English edn 1939).

Marcuse, Herbert (1955) *Eros and Civilisation*, New York: Vintage Books.

Morris, William (1905) *News from Nowhere*, London: Longman (1st edn 1890).

Piercy, Marge (1978) *Woman on the Edge of Time*, London: Woman's Press.

Chapter 18

Communism: Should the mighty ideas be falling with the statues?

Judith Williamson

The whole world watched the statue of Lenin swinging indecorously on the end of a crane, its legs left behind on the plinth and its torso wavering almost horizontal like some bulky creature learning to fly.

If this was a vision which gave pleasure to the Lithuanian people, it also gave Western culture something it desperately wanted. The broken statue must have been beyond the wildest dreams of any lay-out artist or logo deviser: the press has been frantically busy coming up with Gorby Downfall motifs (rapidly replaced by Return of Gorby motifs) and now here, like a perfect ideogram, is a concrete symbol of the End of Communism.

Statues are strange things; politics congealed into culture, great static objects standing for ideas, movements, event and power, none of which are static. That's the tension which fires Shelley's brilliant poem *Ozymandias*:

> . . . Two vast and trunkless legs of stone
> Stand in the desert . . . Near them, on the sand,
> Half sunk, a shattered visage lies . . .
>
> .
> And on the pedestal these words appear:
> 'My name is Ozymandias, king of kings:
> Look on my works, ye Mighty, and despair!'
> Nothing beside remains.

When I was very little and heard this, I thought Ozymandias was saying to despair because it was all ruined. Only as an adult did I grasp the temporal irony: he was saying despair because he was so powerful, and years later, his statue lies in pieces in the desert. Yet Shelley suggests that despite the death of the man and the demise of his monuments something does live on. The sculptor managed to capture something of the spirit of Ozymandias, a sense of his values (which are mean and cruel): 'those passions . . . /Which yet survive, stamped on these lifeless things, / The hand that mock'd them and the heart that fed'. In other words, passions and values can outlast both the material object that embodies them, and the power which put that object there in the first place. Shelley may have been able to elaborate such

distinctions in a fourteen-line sonnet, but in our muddled cultural jargon it has become hard to distinguish between an object, an idea, a word, a regime, a person, an event, a movement, an organization, a small group of bureaucrats and a country. Thus communism 'is', variously, Lenin, the Soviet Union, the Communist Party of the Soviet Union, the Central Committee of the Communist Party of the Soviet Union, a statue of Lenin, the 1917 revolution, the Bolshevik movement, Karl Marx, Stalinism, or whatever regime has held sway in the Soviet Union at any time in the past. More to the point, its 'death' is apparently constituted by the removal or demise of any or several of these things.

Ever since the Berlin Wall came down, newspapers have been proclaiming multiple Deaths of an Idea: a feature in *The Guardian* last year claimed that 'the myth of socialism has collapsed', while the *Sun* rather more robustly ran a Curtains for Communism special. This elision of political concepts with particular governments is highly selective: no one (except the far left) called Watergate, the Chilean coup, or even the downfall of Mrs Thatcher, crises of capitalism. Yet if anything is a system that can only be understood in practice, it is capitalism. Capitalism is not a set of moral principles that were developed as ideas, and named, *before* there was a chance for living them out; no one said, brothers and sisters (or bosses and workers), Let's Build Capitalism. Certainly there were ideas attached to the rise of that economic mode (individualism, competition, free trade), but the system itself developed piecemeal rather than through a conscious attempt to act on certain principles.

Communism, however, was a developed and much discussed political idea long before any group got the chance to try and implement it in one country (a contradiction in terms, as Trotsky pointed out, given that an equitable economic system can only make sense if understood globally). The Soviet Union doesn't represent communism, merely a momentous historical attempt – and failure – to put it into practice: the idea was there long before 1917 and still will be after 1991. Communism, like fairness, is a moral concept and just because people act unfairly the concept doesn't go away, neither does the word that denotes it lose its meaning. Yet, according to the dominant voices in our culture, 'communism' (and, many would say, 'socialism') is no more. In a recent *Guardian* Society article, David Pischaud wrote of communism as 'the god that failed the Left' but, interestingly, went on to say, '*Whether it is called collectivism, solidarity, or common decency*, once social services have become available on the basis of need there are few prepared to return to provision dependent on income or wealth' (my italics), and he quoted a poll which revealed that 'half the population wished to see more spending on services even if this meant increased taxation.' This sounds remarkably like 'from each according to their means, to each according to their needs'.

Globally, there has never been a more pressing time to implement

communist/socialist principles in dealing with international debt, ecological crisis, AIDS, the threat of nuclear catastrophe; and never have people been more aware of the value of those principles. So, while the USSR grapples with dramatic social and political problems, the West is faced with a semantic one: what to call communism now that it no longer exists, but is still necessary.

NOTE

1 This was first published as Judith Williamson's 'Second Sight' column in the *Guardian*, 29 August 1991.

Training some thoughts on the future

Dick Hebdige

SPECULATION * STOP * NOW * STOP

I want to consider three things: first, going beyond fatalism; second, what I shall call the virtual power of metaphor; and third, what Raymond Williams called the *ordinariness* of everyday culture and the place of the ordinary within critical thinking.

First, fatalism. When you put an 's' on the end of the word 'future', you really have to dispense with the old fatalistic thinking about what was always bound to happen. People used to say that, especially intellectuals on the left, after any event of historical importance: 'Oh, that was bound to happen'. Suez? It was bound to happen. American defeat in Vietnam? Bound to happen. After 9 November 1989 one thing, if nothing else, is certain: nothing, absolutely nothing, apart from our own eventual departures from the scene, is *ever bound to happen*. When the Berlin Wall fell, in a sense it fell on all of us, though one of the formations it fell directly on top of was that whole formation of hopelessness represented by that fatal version of postmodernism which saw the end of everything everywhere in everything – apocalypse if not now, then tomorrow or the day after tomorrow through nuclear war, binary logic, television, simulation. That whole frozen, event-less, dystopian, imaginary left-over from 1950s systems-theory was finally and utterly shattered when the lumps of concrete, hacked off the edifice of the Berlin Wall through the concentrated collective force of all those little hammers, medium-sized pick-axes and bloody great power drills, came raining down upon it. Nothing but nothing is ever *bound* to happen.

And when the Berlin Wall/mirror shattered, suddenly a lot of other things smashed too. The most important thing that got obliterated was the cast-iron reality of the postwar bipolar order which had been literally cast in concrete since 1961 – secured, and guaranteed, symbolized, reflected, held in place in the terrible mirage of the wall. All those ideological investments, all those ideological and geopolitical maps inscribed as if in stone around it. All melted into air. The evaporation of what felt like solidly opposed identities – East vs. West, Them vs. Us – was exposed as

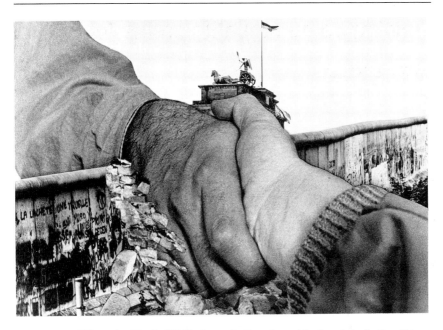

Figure 19.1 When the Berlin Wall/mirror shattered, suddenly a lot of other things smashed too. Photo-montage by Peter Kennard.

illusory immediately after the Wall came down, when Tory MPs began haranguing the BBC about the way BBC newscasters had taken to referring to Politburo hardliners like Ligachev as 'conservatives'.

We are living, as they say, through a crisis of cognitive mapping. That crisis was made absolutely clear on the evening when a BBC newscaster, describing the flight across the Saudi border of a group of Japanese a few days after the invasion of Kuwait, announced that 'the first *Westerners*' had escaped from Saddam's Iraq. There is nothing postmodern or posthistorical about this particular orienteering problem. It's not symptomatic of some general decline in the coherence of the cogito. It's got nothing to do with a general loss of the sense of temporal continuity or psychic groundings. It's not that Eurocentric rationality has suddenly given up the ghost. The mapping crisis is rather the direct product of a literal historical decentring as that geopolitical formation that used to be called the West is forced up against new and quite other historical horizons. For the growing numbers of politicized artists, critics and intellectuals who are determined to 'rub history against the grain' and who remain consciously other to the powerfully centralizing, legitimating institutions, the point is not to oversee the collapse of the periphery as exotic relic into the fatal orbit of the centre, but to take the centre to the periphery, to see the idea/ideal of the centre and the institutions of the centre taken to the edge, broken down and taken over *by* the periphery. The border is not just another metaphor.

But having said that, it's also important to say that metaphors never are, never have been, *just* metaphors tacked on as ornamental extras to a substantive core of communicable sense. Metaphors are themselves an essential (if unstable) component of *realpolitik*, acting as focalizing agents capable of drawing together diverse, even antagonistic constituencies. The construction of imaginary communities is accomplished thanks to metaphors. And figurative language has a particular kind of virtual power. Witness for example, Geoffrey Howe's railway metaphor introduced at a fringe meeting at the Tory Party Conference in October 1990 to drive home his conviction that after 1992 and EMF entry there could be no stopping between Stages 1 and 3 of the Delors plan: that we literally couldn't get off the train until we arrived at a destination called single European currency in the heart of a federal Europe. Once it had worked up a head of steam, Howe's engine metaphor did indeed prove to be unstoppable. By the evening of the day in which Howe delivered his speech, most of the senior Conservative politicians interviewed in news bulletins had either jumped on the train or in front of it, had tried to find the emergency brake or insisted, contrary to stationmaster Howe's announcement, that it was a stopping train that could also, if needs be, be reversed. By Saturday's edition of Radio 4's *Any Questions*, Paul Boateng was arguing with Howe about who had been left on which platform and, in retaliation, Howe accused the Labour Party of queuing up with the wrong fare at the wrong ticket window. The metaphor was shunted into a veritable Charing Cross of overgrown defiles and sidings. Yet despite all the delays and reroutings, it was still streaking forwards a fortnight later when Norman Tebbitt attempted to divert it into the sea by invoking, for some reason known only to himself, the uncannily apposite conjunction of the *Titanic* and his grandparents when he said in an interview for ITN that 'I wouldn't recommend anyone to buy a ticket on that train any more than I would have wanted my grandparents to buy a ticket on the *Titanic*', adding with a jab at pathos, presumably by way of elucidation, 'because I wouldn't be here now if they had'. Thatcherism went down in the great railway disaster, an entire historical tendency carried off by a runaway train.

Historians in the future who are seeking to find out how Mrs Thatcher's Tory Party got derailed so dramatically in the autumn of 1990 may well interrogate Sir Geoffrey's original invocation in an attempt to deduce why and how it happened in that particular way at that particular time. Whatever the judgement of history, it seems likely that Howe both did and didn't know what he was doing when he stoked the engine of that metaphor and set it running off inexorably in a direction expressly designed to infuriate the Party Leader. You can't help discerning a certain dreamy kind of agency motivating the figurative choice here – half coded challenge, half revenge fantasy – Mr Howe as Casey Jones climbing up into the cab to restore the nation to its proper place in Europe; little Geoffrey getting out his train set when he was supposed to be tucked up in bed in order to get back at an

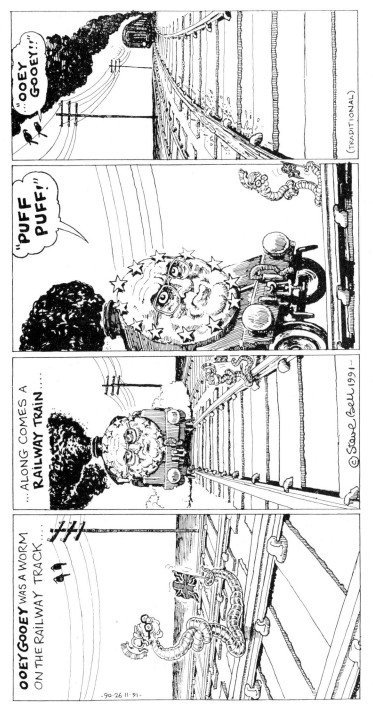

Figure 19.2 Howe's engine metaphor did indeed prove to be unstoppable. Cartoon: Steve Bell.

Figure 19.3 René Magritte's *Time Transfixed*. Reproduced courtesy of The Design and Artists Copyright Society.

overbearing but neglectful nanny. But, whatever the intention, and however knowingly divisive the strategy, once set on its tracks the figure takes on a life of its own, erupting like the locomotive in that painting of Magritte's into the domestic interior of the Tory Party at Bournemouth, at one with itself as a monstrous incarnation of alterity which crashes through the fabricated firescreen of consensus, through the palpably, crazily misguided notion that a major controversy could seriously be represented to the nation as containable differences of opinion in an otherwise united cabinet. It goes into the tunnel of Mr Howe's speech as a clockwork childhood toy and it comes screaming out the other end as the train from hell. That indeed is how metaphors work, as time-bombs or viruses or seeds or sleepers which, if activated, disseminated, sown or woken up at the right time, will blow up, catch on, take root or spring into action some time in the future, some time after the moment of their enunciation. That's what I mean by the virtual power of figurative language.

The future is without form, shape or colour: it demands yet exceeds all

figuration. It *is* in a sense what Slavoj Žižek calls 'the sublime object of ideology'.[1] We might begin to talk in this context of determining and overdetermined figuration, about the prospective figural capacity or the realizable load-bearing capacity of particular metaphors and images: their deictic or performative functions, their literal relation to thinking possibility, to thinking possibilities. We might talk about the inscription within particular uses of language of structured and structuring potentialities, of alternative or even antithetical futures, hiding, waiting, in the same array of signifying elements, the same array of pent-up social forces, in a figural relationship *between* signifying elements and pent-up social forces, which is almost there, virtually there, waiting for syntactical articulation.

If we are really to take on and make something of this more dynamic relationship to language as virtual space, if we are to rethink language as action and as event, if we are to begin really exploiting the actively performative (not just the referential) functions of communication, then the various ways in which different futures are *imagined* will themselves be something we have to begin thinking seriously about. We shall have to establish how particular discursive strategies open up or close down particular lines of possibility; how they invite or inhibit particular identifications for particular social fractions at particular moments. As one part of that kind of critical audit, we might like to consider how differently located (and hence in both senses provincial and partial) accounts of contemporary culture work to mask their partiality by leaning on established kinds of academic authority and presenting themselves not as provisional observations at all but as universally valid assertions of historical fact.

The brilliance of Michel Foucault's thesis about disciplinary surveillance, for example, shouldn't be allowed to conceal the fact that Bentham's Panopticon, the building on which Foucault's infernal vision of modernity is built, never actually got built. Meaghan Morris has shown how this tendency to generalize from particular examples in forms of cultural commentary ends up, for instance, idealizing particular service environments. We read about *the* shopping mall, *the* motel, etc.[2] But I'd also like to argue that the same thing happens to whole regions, whole landscapes. Think of how the desert gets turned into metaphor in postmodernist rhetoric where it functions as the place of origins, endings and hard truths: the place at the end of the world where all meanings and values blow away; the place without landmarks that can never be mapped; the place where nothing grows and nobody stays put. Radically different desert cultural traditions, precise indigenous knowledges about particular wilderness ecologies get subsumed beneath the definite article – *the* desert as globalized prediction of what, it's being implied, is really waiting for us out there in the future. Underneath our homely illusions the desert. Underneath the pavements the beach, as they used to say in 1968. Now twenty years later, underneath the pavements just the sand. The desert gets played in this way as a fatal prediction.

Yet it's important to note that when the metaphor gets cashed in for political purposes it's turned very differently. I'm thinking of the theory of global warming, where the prospect of a dead world is invoked not as a lure to inaction but as a warning to be heeded, not as a fate to be embraced but as a fate to be averted, by lobbying for legislation designed to limit the use of CFCs, by applying pressure on car company designers to modify fuel systems, through the articulation of a political will intent on the long-term modification and regulation of consumer behaviour and demand.

But the most problematic instance of the ways in which real places and real historical events get turned into metaphors, the worst example of the construction of a paralysing metaphor in postmodern rhetoric is, perhaps, the metaphor of 'Auschwitz': Auschwitz not as the Nazi concentration camp which operated as a death camp in Poland from 1942 to 1945 but as the place of the disaster, as transcendental signifier of dread beyond representation, lifted after Adorno's comment on the impossibility of lyric poetry after Auschwitz to the status of an absolute interdiction on all of what were formally called the aspirations – and which are now reduced to the pretensions – of the Enlightenment, to 'civilization', 'reason' and 'progress'. Auschwitz functions in postmodern rhetoric as a bar on hope because the way it is used blocks the possible redemption of *both* past and future. The alleged connections between modernity, instrumental rationality, demagoguery, the German masses' access to the democratic process in 1932 and faith in technocratic science are not only asserted but asserted as *necessary* in such a way that these connections get laid out in straight lines and bolted back on to the railway lines that transported people through the gates of the camp in the first place. The precise historical details recovered for instance in Claude Lanzmann's documentary *Shoah*, all those questions Lanzmann asks of the survivors – Who exactly went to which camp? How were transports organized? Were the trains heated or not heated? – get lost in the invocation of a single word carelessly thrown into a polemic intended to discredit not just a perverted form of pseudo-scientific rationality (the Nazi ideology of race) but reasoning itself, reasoning as the intersubjective process through which people everywhere collectively try to make sense of the world in which they find not just themselves but each other. Through a travesty of remembering, Auschwitz gets turned into a sign of the disaster which was *always* waiting to happen in modernity in such a way that not only is the survivor's survival set at nothing but so, too, is the original sacrifice of the millions who died there. It is as if – quite simply – they had died for nothing. Benjamin's voice comes back from the disaster to remind us of what is still at stake here:

> Only that historian will have the gift of fanning the spark of hope in the past who is firmly convinced that *even the dead* will not be safe from the enemy if he wins and this enemy has not ceased to be victorious.[3]

When thinking about the future of thinking about the future, it is also necessary to remember not to forget – and the process of remembering may be, precisely, repetitive, pedantic, tied to the recitation of what appear, on the face of it, trivial, mundane, banal details.

There's been a lot written of late about the banalization process: not just about the banalization of culture through television, democracy, the loss of traditional forms of cultural authority and so on, but the alleged banalization of theory as evidenced, for instance, in a certain kind of silly cultural studies which sacrifices a bit too much of the sceptical 'pessimism of the intellect' for a boy-scoutish whistling-in-the-dark kind of 'optimistic willing'. What is characterized as the banal argument of the kind of cultural studies that simply asserts the power of the people while denying people access to actually empowering strategies is said to go like this: Everything looks bad now but – never mind – the people will win in the end. Murdoch and Co. rule the airwaves, but through native savvy and thanks to the uncertainty principle in semiotics, in the end the people will win. While I acknowledge that too much dependence on the same rhetorical and argumentative devices may deplete rather than open up what Raymond Williams called the 'resources of hope', I personally feel that more debilitating still is the persistence of certain ingrained and institutionally applauded critical priorities, habits and certainties, which close off possibilities by confirming the validity of existing exclusionary institutional criteria and academic styles of thought. The future of thinking positively about the future means working, as Larry Grossberg puts it, to articulate social possibilities. But I'd also suggest that in order to articulate social possibilities, you first have to take certain risks, to give up certain certainties. One of the certainties you have to give up on is the confidence inspired by the perfection of a certain style of critique which never puts a foot wrong because it never puts a foot forward. Another one of the certainties you have to give up on is the certainty that goes with always establishing a position by negating and superseding what's already been said, alternatively that one kind of intellectual confidence that needs questioning is the confidence which comes from feeling able to reproduce the world in a redeemed, transfigured state only at the theoretical level.

Coherence of a kind (not all kinds of coherence) might be the enemy of thinking possibility. None of this means that it's possible simply to limbo dance under the door of critical responsibilities by having recourse to the kind of elegant, reflexive gymnastics offered by an armed-on-all-fronts style of deconstruction. Instead we might, as Barbara Herrnstein Smith recommends: 'try to make a difference rather than score points, to take a risk and intervene in order to deconstrict as well as deconstruct'.[4]

Finally, we might also try to stand *in the crowd* rather than out from it, banal as that may sound, and simply listen. I believe in the banality of evil – Lanzmann's meticulous documentation of the Holocaust, to cite just one

project in the process of remembering that disastrous history, demonstrates that conclusively for anyone who cares to watch – but I do not believe in the evil of banality. In fact, I'd recommend salvaging banality in its original sense of common, open to all – as a democratic virtue for the future – and that may entail another mundane turn too, back towards the dull compulsion of sociological probabilities as well as forwards into vividly imagined possibilities.

Because, perhaps, the ultimate other of modernism is not so much or not only the exoticized, feared but desired fringe – those others against whom Western science and reason defined itself and on whose backs and through whose labour and by whose sacrifice the modern world was made, but the ordinary ('culture is ordinary' Raymond Williams once entitled an essay), the mediocre, the unglamorous, even the petty bourgeois (think of how much aristocratic disdain gets distilled into that adjective 'petty'). Charlotte Brunsdon and Andrew Ross in different case studies – Brunsdon on research into taste reactions to satellite dish installations in the UK[5] and Ross in a look back at the double exile by the American left of the lower-middle-class Rosenbergs after their arrest (he argues that the executed Rosenbergs may have been denied vital support and sympathy because they were simply not cosmopolitan enough to be attractive figures for the intellectual left)[6] – have indicated, as does the work of Pierre Bourdieu, the extent to which the taste formations of the numerically and politically significant lower middle class have been consistently marginalized and delegitimated in cosmopolitan left discourse. In a sense we have been paying for that delegitimation in this country for the last twelve years. And if we don't want to lose out for another twelve, maybe we had better start to look long and hard at what John Major has to say about the classless, meritocratic, blue-collar future he's mapping out at this very moment for Britain.

But to close to one side of the occasional drama thrown up in what, in the normal run of things,[7] is the dull quotidian round of party politics in Britain, there is still the dream of the transcendence of the banal through the banal, the dream of the transcendence of everyday life through the transformation of everyday life. The metaphor of the journey – the hard road and the river – is the most trite, overused, banal metaphor imaginable for the way we move forward through time; yet it is also worth remembering the power of this metaphor as a focus for collective as well as personal identification in an always unfinished narrative of historical loss and redemption, as a lens through which the past is given shape and direction and hence redeemed as it delivers us here, now, in front of a future which is pulled sharply into focus as a virtual space – blank, colourless, shapeless, a space to be made over, a space where everything is still to be won.

NOTES

1 Slavoj Žižek, *The Sublime Object of Ideology*, London, Verso, 1989.
2 Meaghan Morris, 'Metamorphoses at Sydney Tower', in *New Formations*, no. 11, summer 1990.
3 Walter Benjamin, 'Theses on the philosphy of history', in *Illuminations*, London, Fontana, 1973.
4 Barbara Herrnstein Smith, 'Value without truth-value', in J. Fekete (ed.) *Life After Postmodernism*, London, Macmillan, 1988.
5 Charlotte Brunsdon, 'Satellite dishes and the landscapes of taste', paper given at the International Television Studies Conference, London, 1991 in *New Formations*, no. 15, winter 1991.
6 Andrew Ross, 'Reading the Rosenberg letters', in *No Respect: Intellectuals and Popular Culture*, London, Routledge, 1989.
7 The Conference was held on Friday and Saturday, 23 and 24 November 1990, at the end of the week in which, having failed to secure the requisite number of votes, Mrs Thatcher withdrew from the Conservative Party leadership contest. John Major had just announced his intention to stand against Michael Heseltine and Douglas Hurd for the second vote which took place on 27 November 1990.

Index